This book was made possible through
the generous assistance of:

Eastman Kodak Company

HOLLYWOOD
ROOSEVELT HOTEL

AMERICAN
EXPRESS
Travel
Management
Services

Timothy White

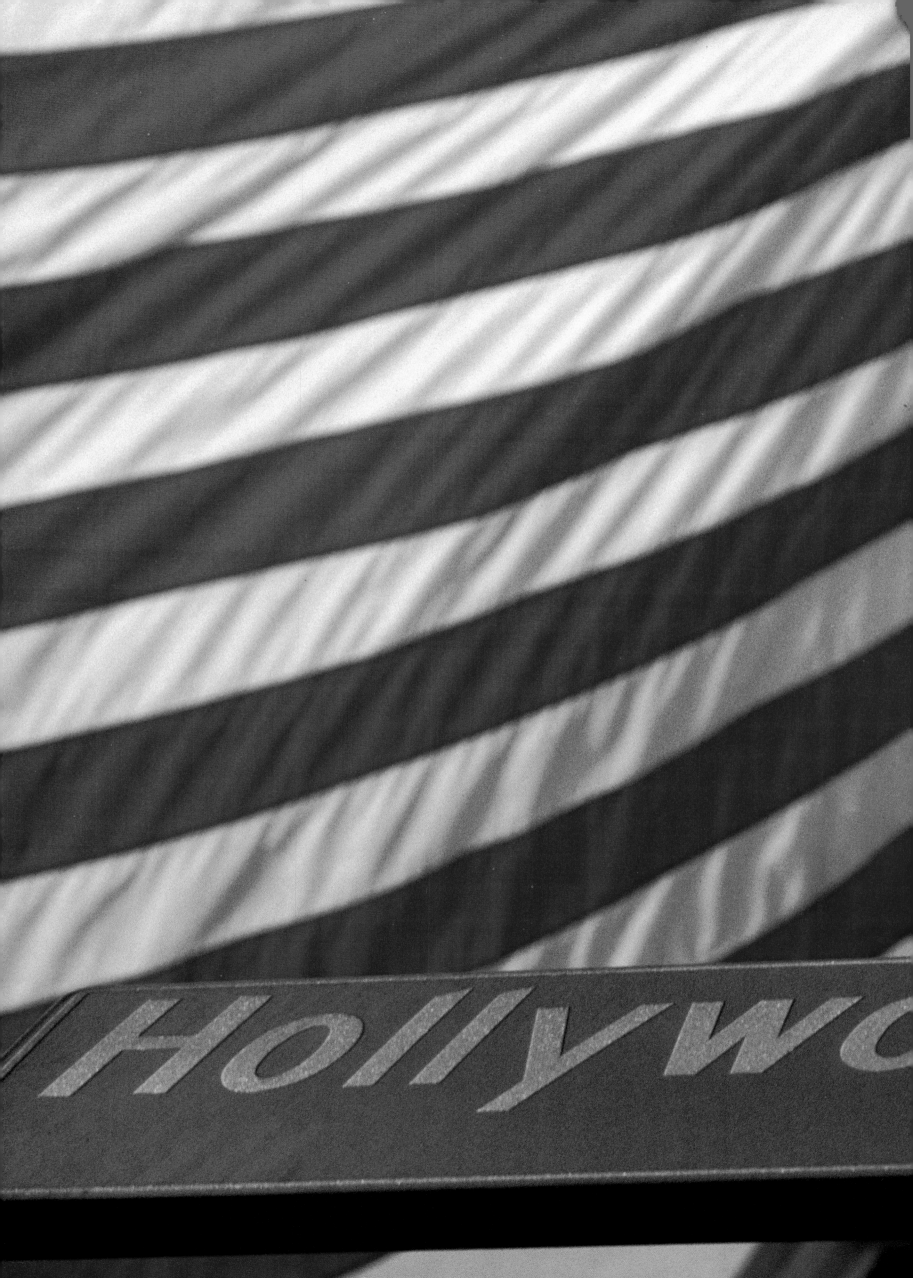

Scott Thode

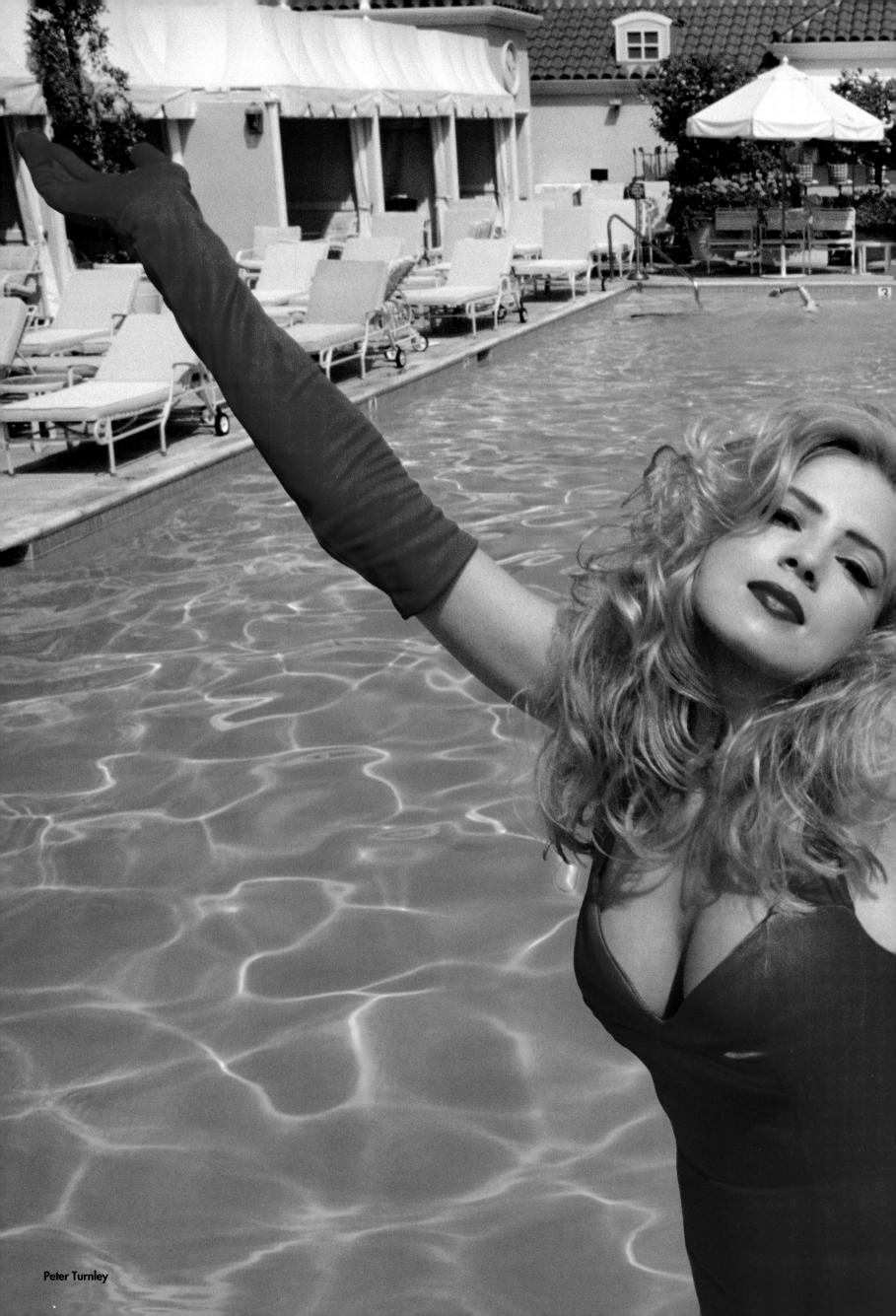

Peter Turnley

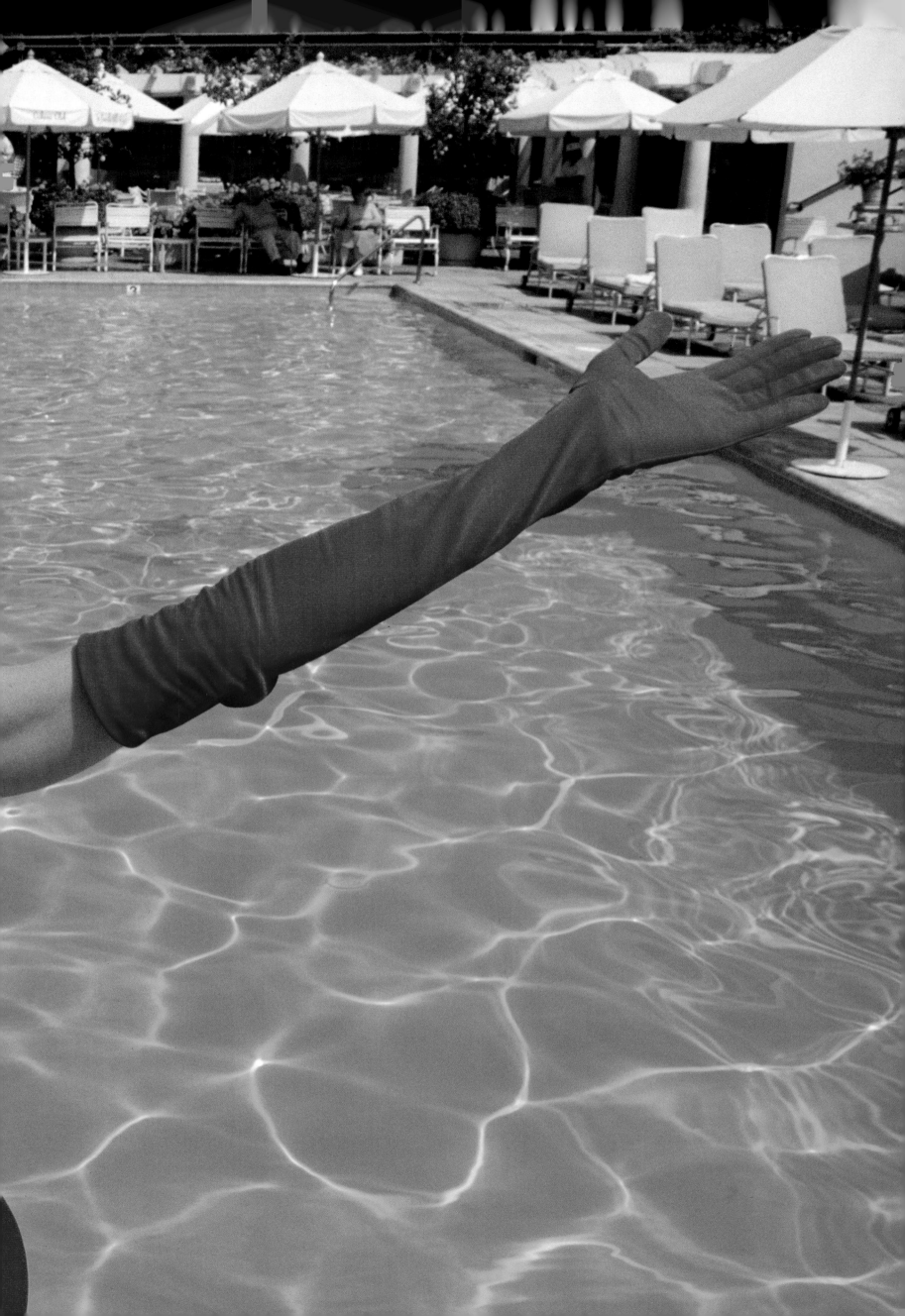

Steven-Charles Jaffe

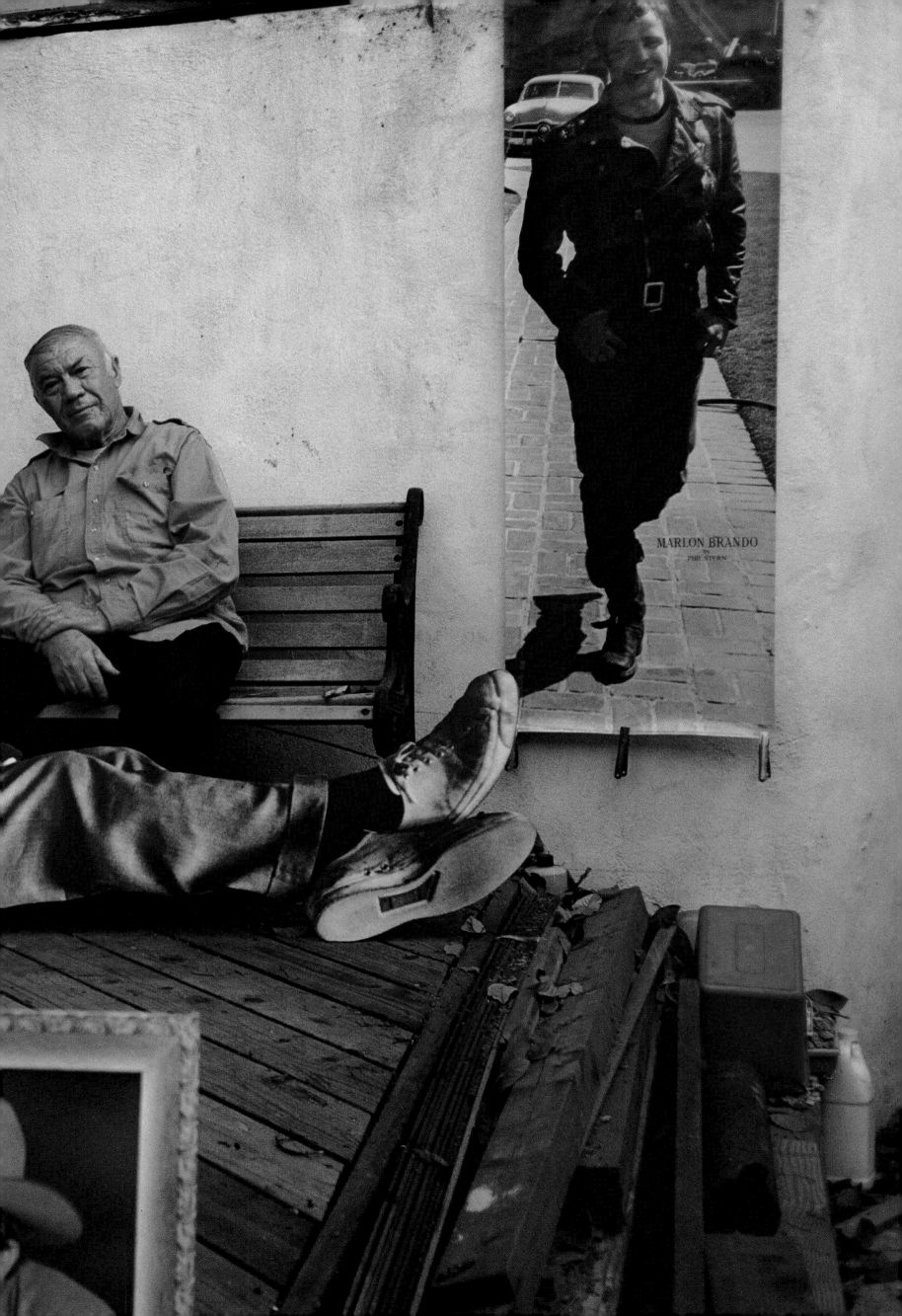

MARLON BRANDO
by
PHIL STERN

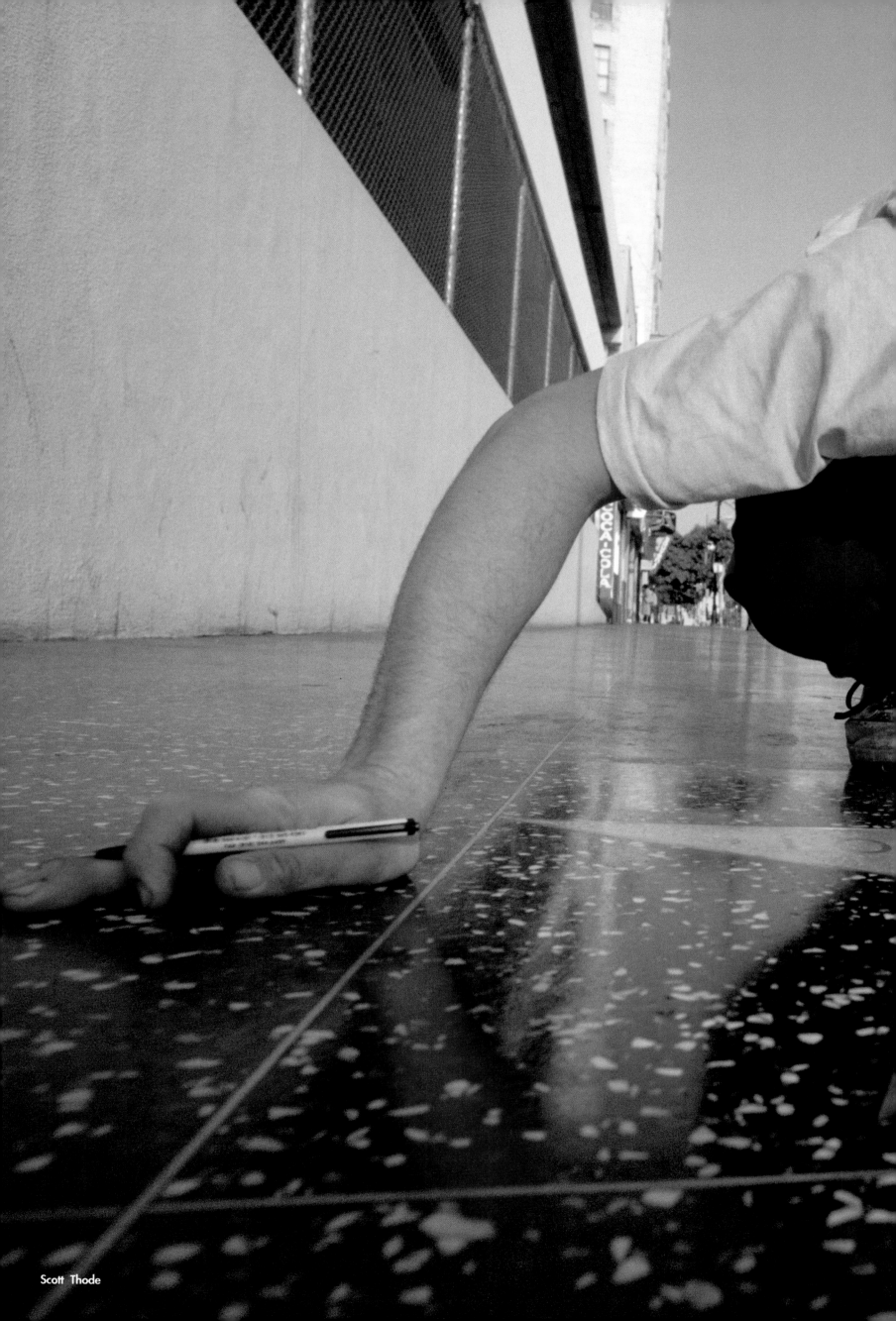

Scott Thode

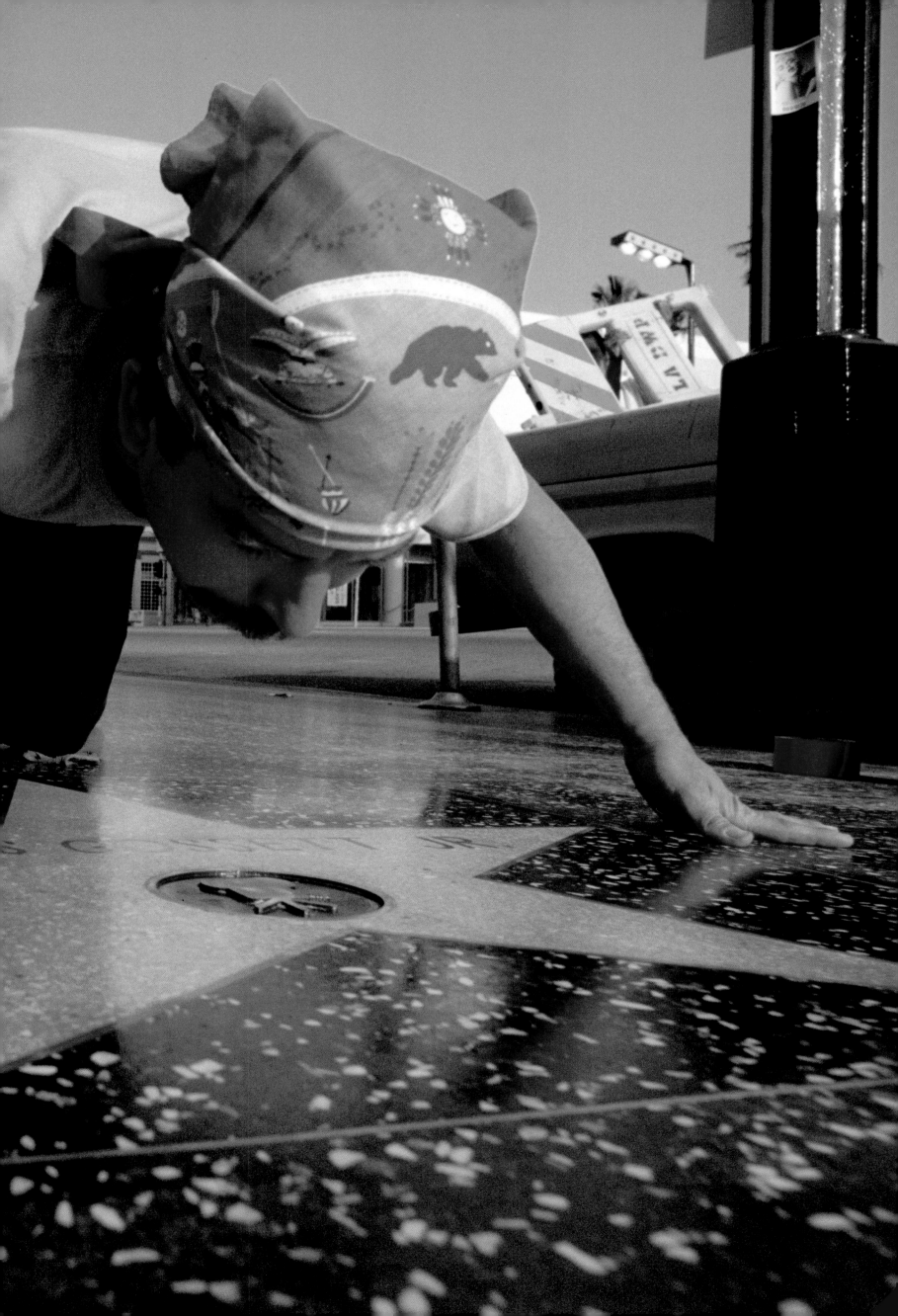

BARBRA STREISAND NICK NOLTE

THE PRINCE OF TIDES
7 ACADEMY AWARD NOMINATIONS
including
7 BEST PICTURE

COLUMBIA PICTURES PRESENTS A BARWOOD/LONGFELLOW PRODUCTION A FILM BY BARBRA STREISAND "THE PRINCE OF TIDES"
BARBRA STREISAND NICK NOLTE BLYTHE DANNER KATE NELLIGAN JEROEN KRABBÉ MELINDA DILLON JASON GOULD
RUTH MORLEY SHELDON SCHRAGER JAMES NEWTON HOWARD DON ZIMMERMAN, A.C.E.
PAUL SYLBERT STEPHEN GOLDBLATT, A.S.C. CIS CORMAN · JAMES ROE PAT CONROY
PAT CONROY AND BECKY JOHNSTON BARBRA STREISAND · ANDREW KARSCH BARBRA STREISAND

REGENCY

Chateau
Marmont

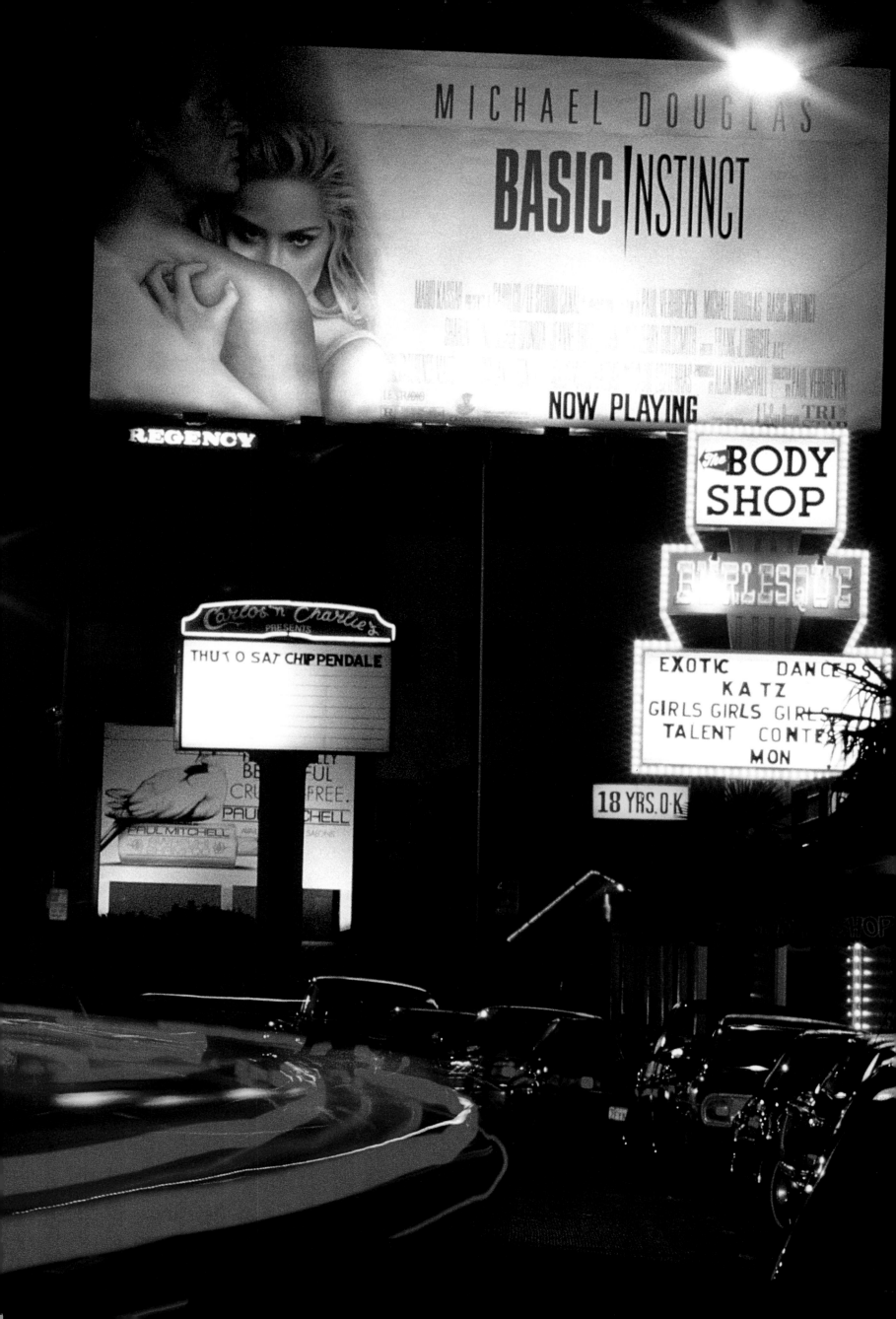

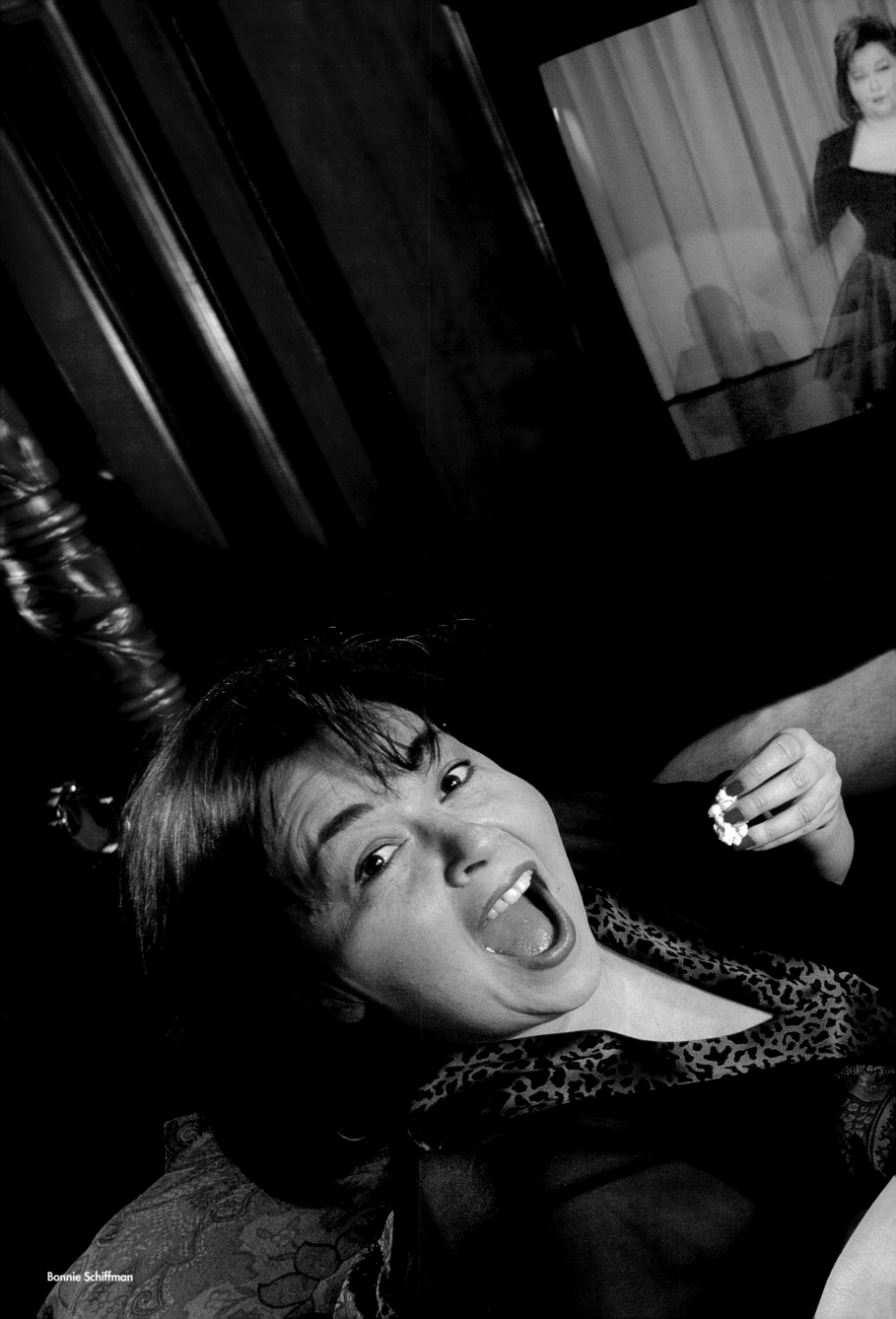

Bonnie Schiffman

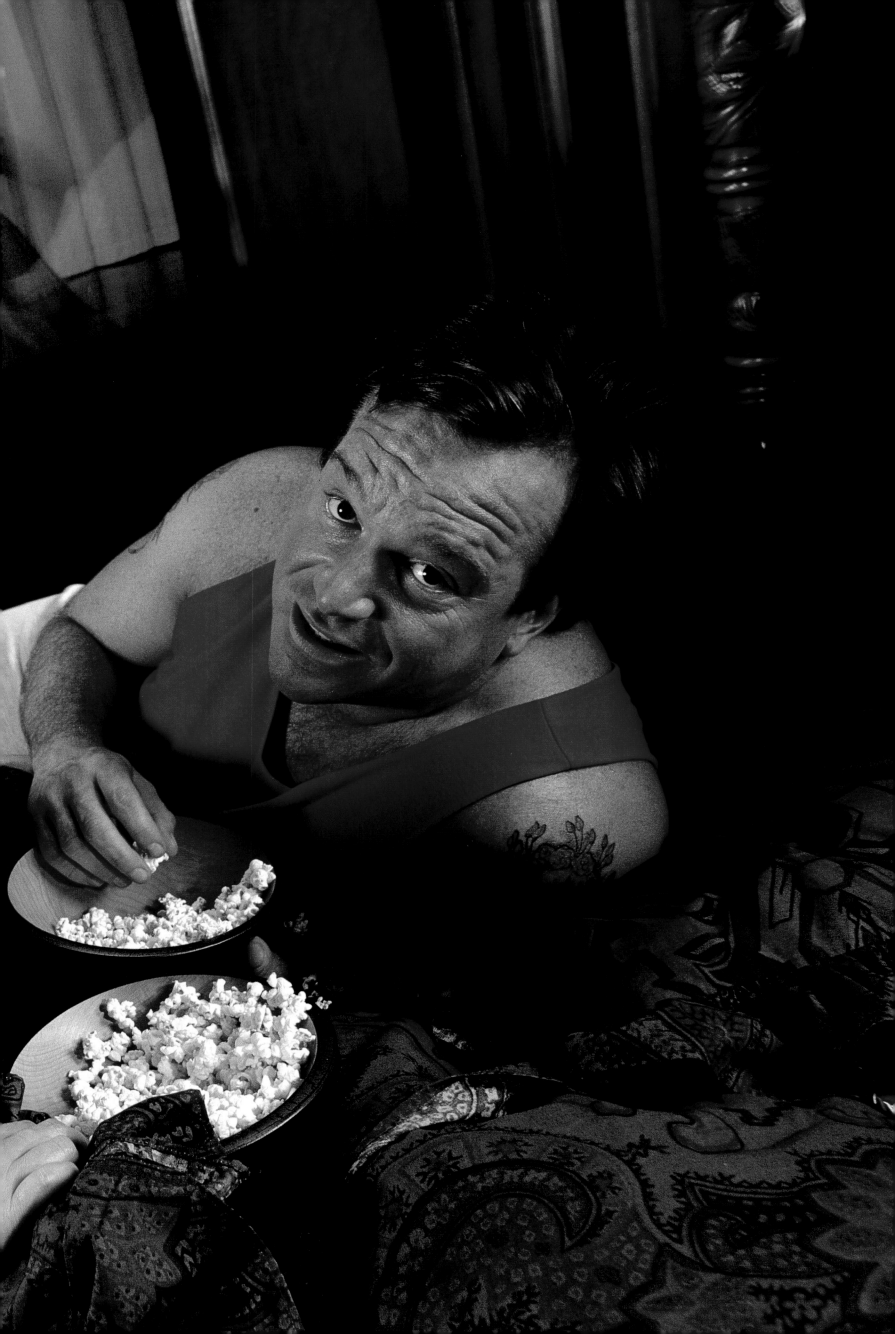

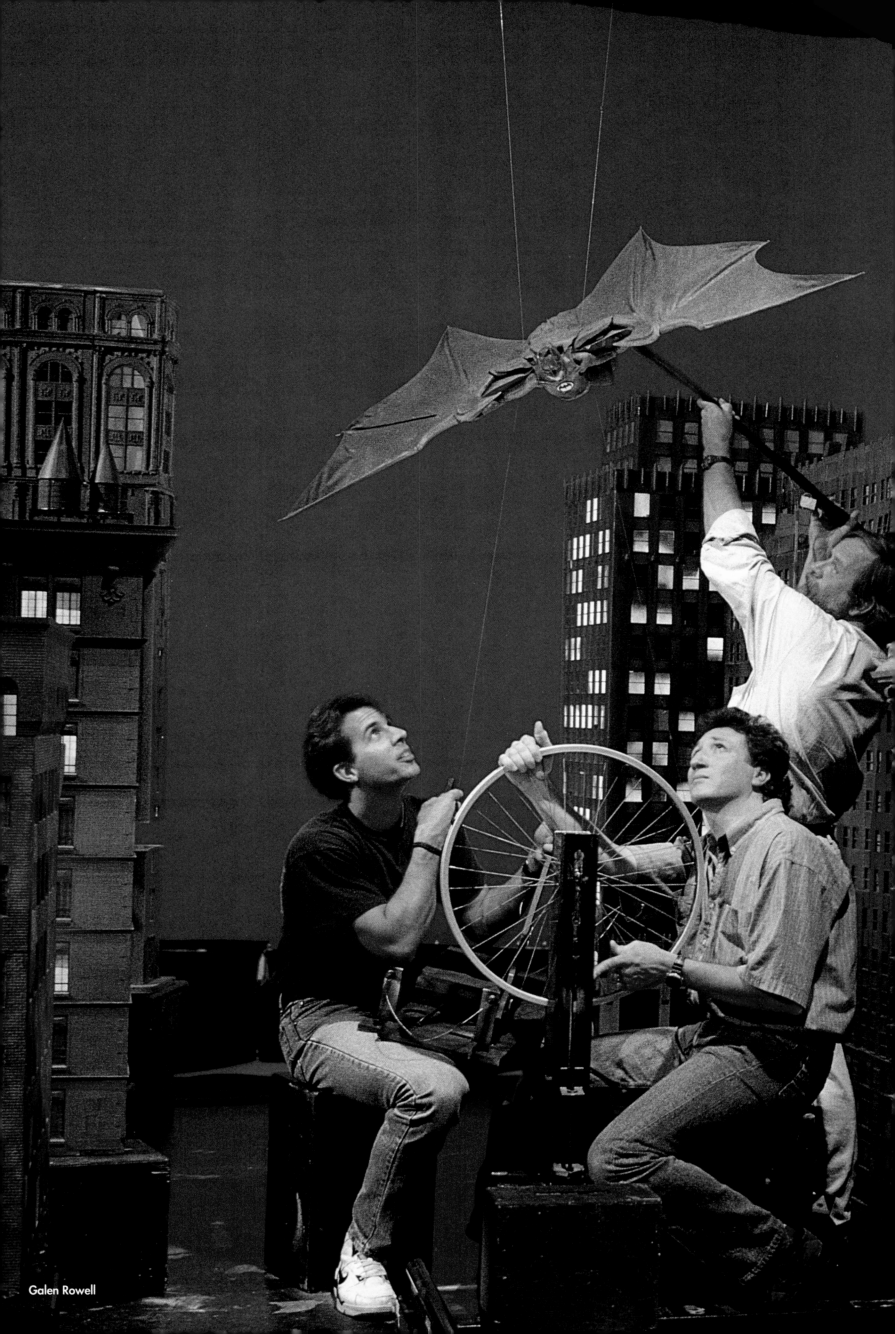

Galen Rowell

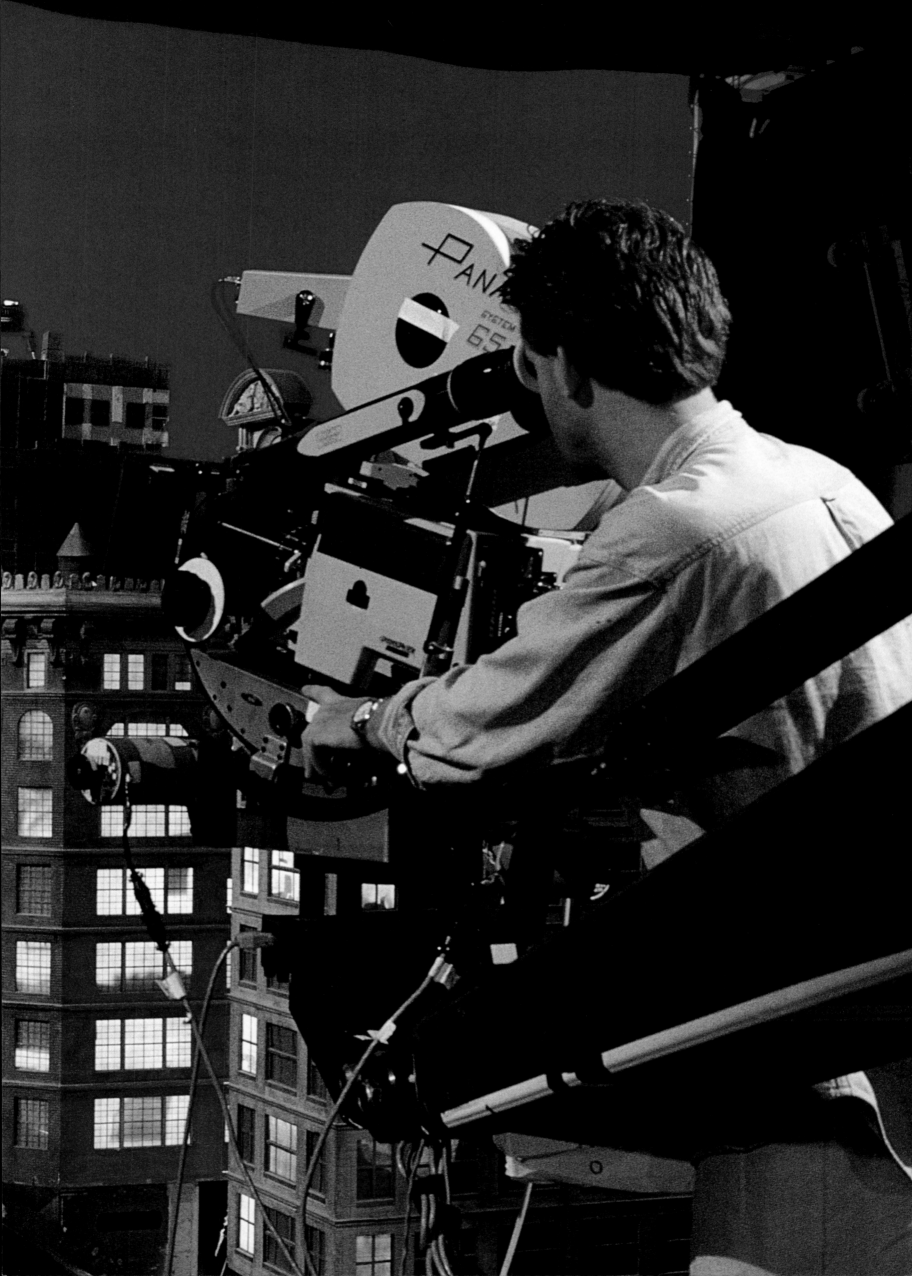

A *Day in the Life of Hollywood* is the twelfth book in the extraordinary series that began in 1981 with *A Day in the Life of Australia*. Since then, *Day in the Life* photographers have focused their lenses on many countries: China, Spain, Japan, Italy, the Soviet Union, and, most recently, Ireland. This year, we looked to the stars. We began by inviting 75 of the most talented photographers from around the world to join us in southern California. With the help of our sponsors—Eastman Kodak Company, the Hollywood Roosevelt Hotel, and American Express Travel Related Services—and with additional support from the Bedford Hotel in San Francisco, Nike, Raleigh Studios, and the Sunset Marquis Hotel, photographers were given the plane tickets, hotel rooms, film, and logistical support needed to do their best work. Their assignment: to shoot America's entertainment capital from every conceivable angle. The shoot day would start promptly at midnight on May 20, 1992, and continue for 24 hours.

Sometimes Hollywood seems to exist mostly in the imagination—both among those who promote the dream and among those who have been influenced by it through the countless movies, television shows, and records produced here and distributed around the world. As we were told over and over, Hollywood is a state of mind. Nevertheless, we drew it on the map, taking as our boundary the so-called Studio Zone extending 30 miles in all directions from the corner of Hollywood and Vine. In the end, though, this book is about the people who inhabit the entertainment industries. Our job was to chronicle both the illusion and the everyday life of this unique and volatile place.

The biggest obstacle came in gaining access to the imagemakers we sought to photograph. Hollywood, after all, is a town of gatekeepers. Just as the studios are protected by uniformed guards, movie stars, recording artists, and television personalities are shielded by an entourage of agents, publicists, business managers, personal assistants, and, yes, bodyguards. It became the task of the project's talented assignment editors to penetrate this elaborate armor and gain entrance into the secret recesses of this closeted industry town.

It took two months to generate the hundreds of assignments needed to keep every photographer occupied on May 20. Every studio backlot was fair game, as was every film and TV show in production. Ultimately, photographers travelled to the set of John Singleton's *Poetic Justice* and Barry Levinson's *Toys*. They rode in limos with the rich and famous and in pet limos with the animals of the rich and famous. They visited the homes of the old guard (Jimmy Stewart, Virginia Mayo, Vincent Price) and the new (Goldie Hawn, Roseanne Arnold, Lily Tomlin)—and the even newer (Megadeth, Benny Medina, Jason Priestley). They went to auditions, recording sessions, casting calls, acting classes, rehearsals, commercial shoots, game shows, and movie premiers. They took meetings with movie executives, agents, personal trainers, animators, costume designers, female impersonators, bug wranglers, and porn stars. They shot portraits of screen personalities (Robin Williams, Harrison Ford, Mary Hart, Mariel Hemingway, Don Johnson, Joe Pesci, Ron Silver, Sean Young), character actors, look-alikes, and wannabes. They shot the billboards, the landmarks, the freeways, the gravesites. They roamed the tourist attractions and probed the private enclaves. They captured 24 hours in the life of a very public and yet intensely private town, accompanied and documented, I might add, by over 35 film crews—local, national, and international—for news stations and documentaries around the world.

More than 100,000 pictures came back at the end of the day. A week later, 10 picture editors from leading newspapers, magazines, and photo agencies converged in San Francisco to whittle down a mountain of slides, prints and negatives. Within days, they had eliminated all but several hundred of the best photographs from our one-day shoot. From there, the designers, writers, and editors took over. Accompanying their work, on publication, will be a documentary we have co-produced with ZM productions for Showtime, a CD-ROM , and a feature segment on ABC-TV's *PrimeTime Live*.

This project is the culmination of the creative energies of literally hundreds of people, a single window opening onto countless vistas. In that sense, it is as close to filmmaking as book publishing ever can be. I hope that you find our collective vision as complex, illuminating, and intriguing as Hollywood itself.

—Lena Tabori, Publisher

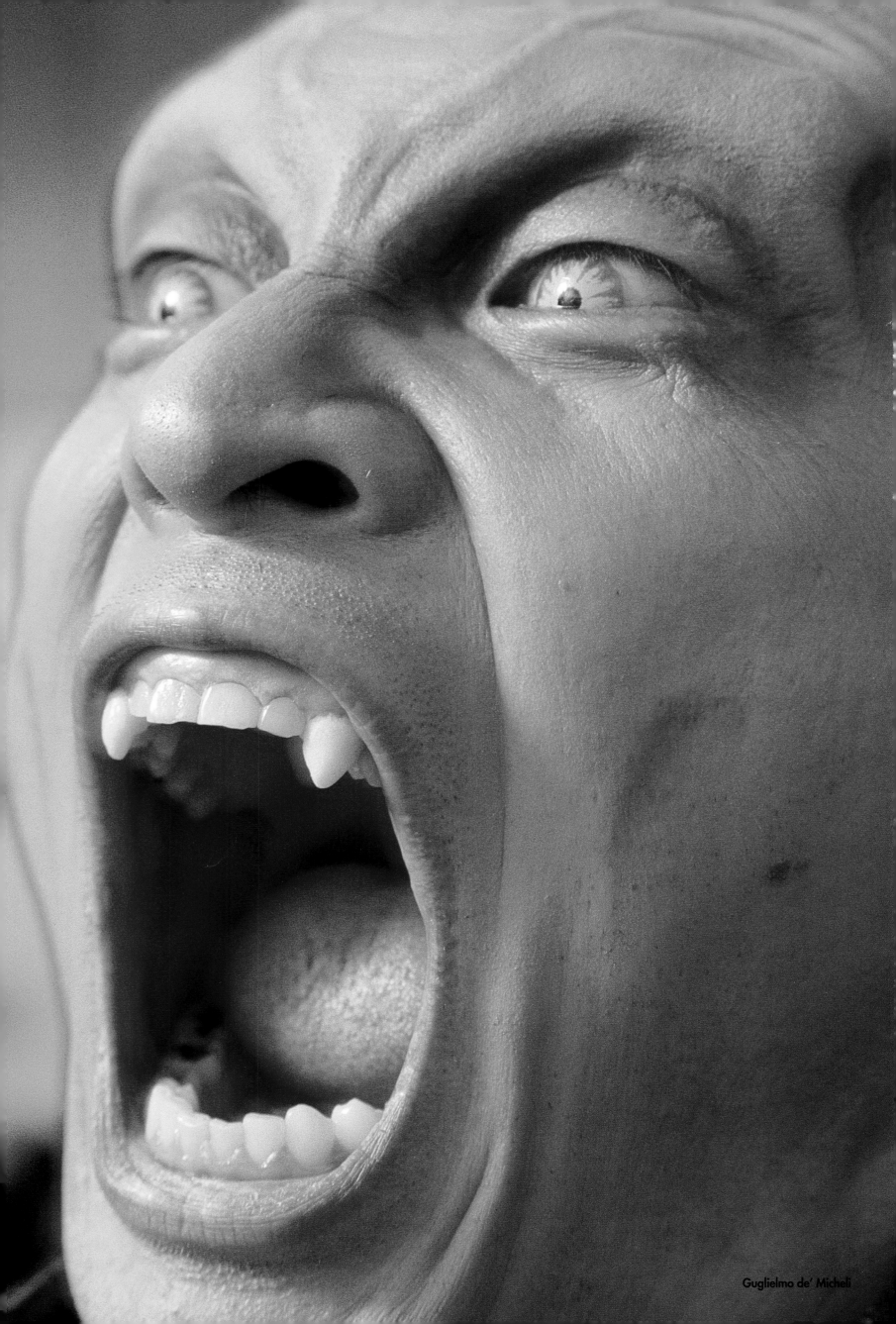

Guglielmo de' Micheli

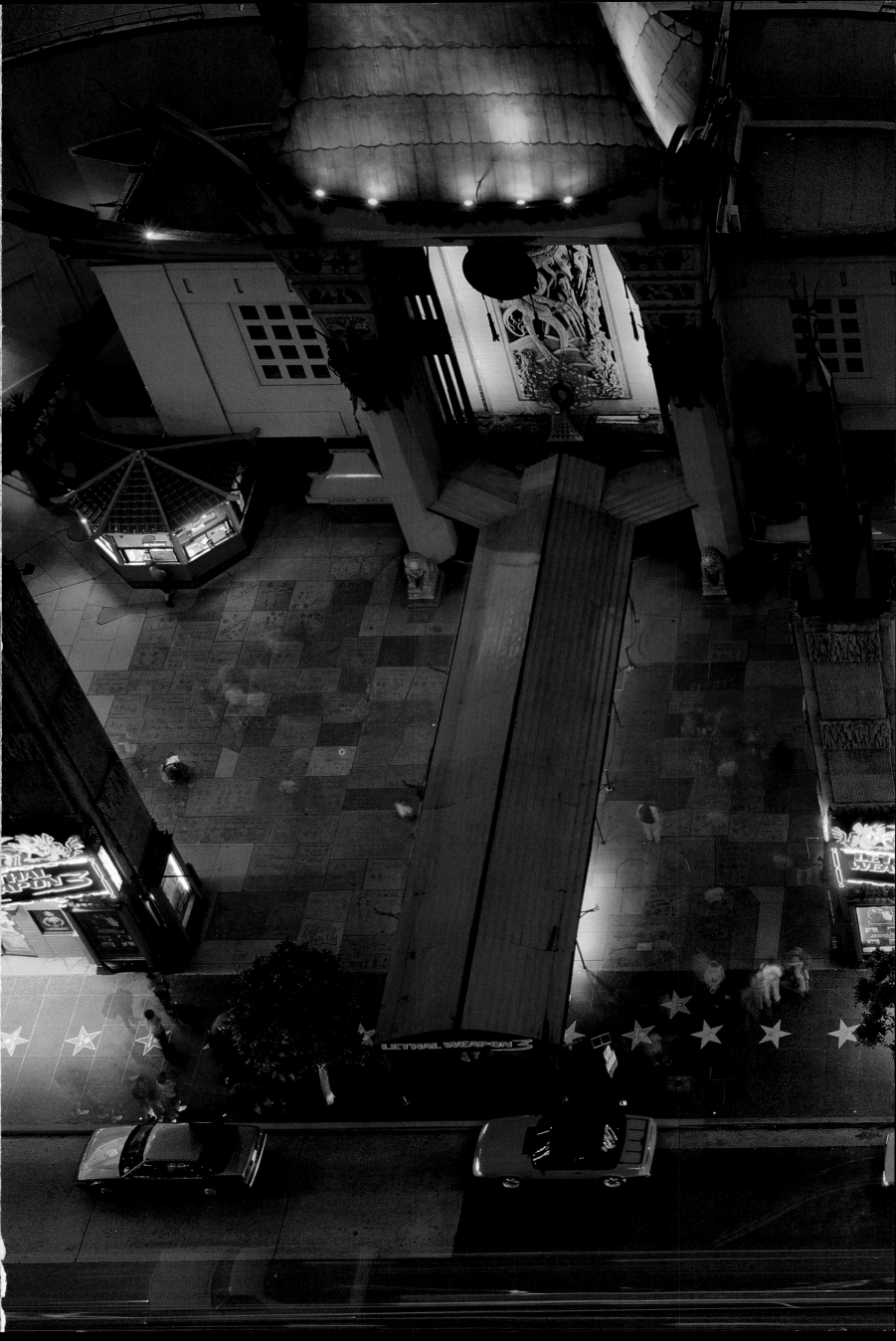

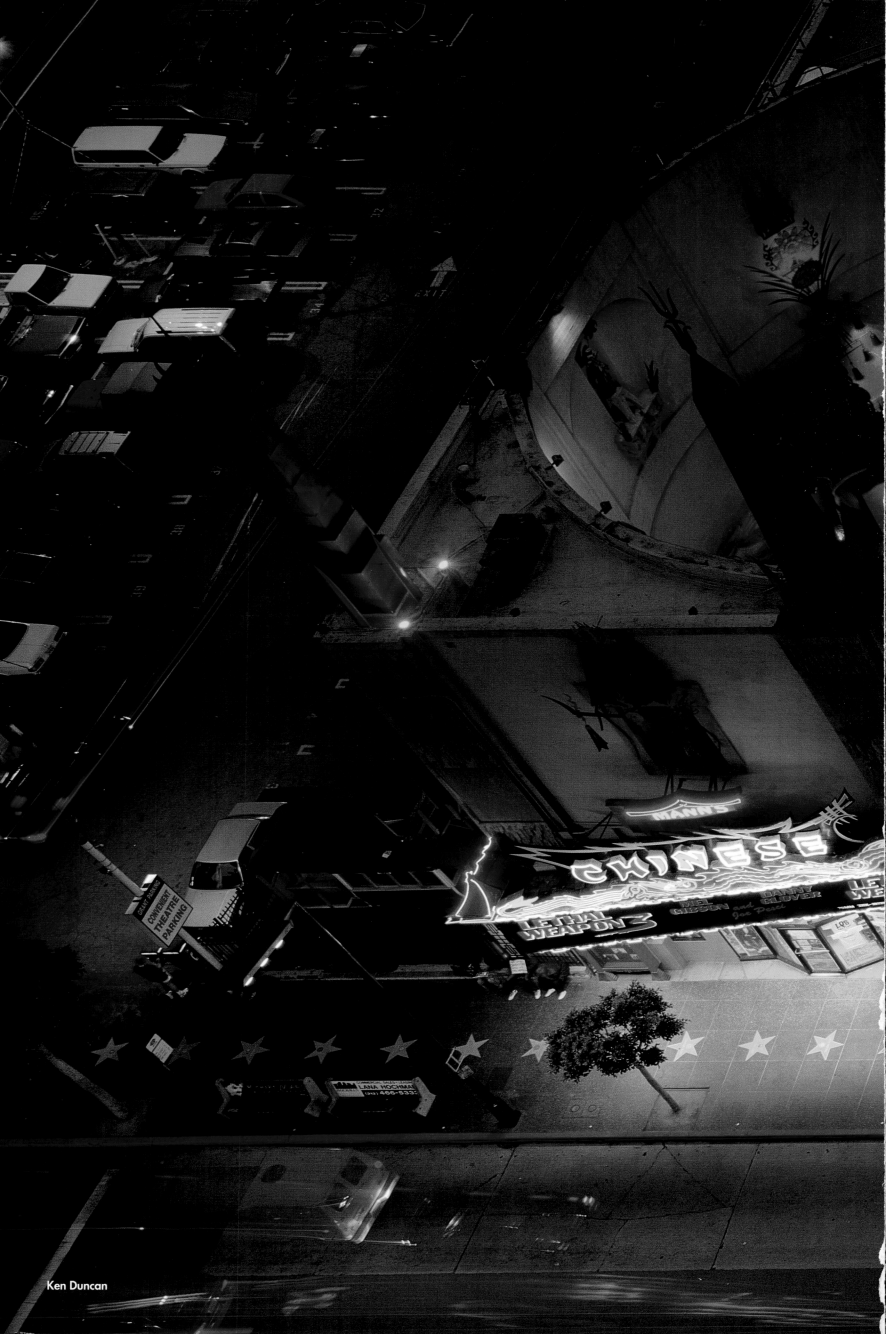

Ken Duncan

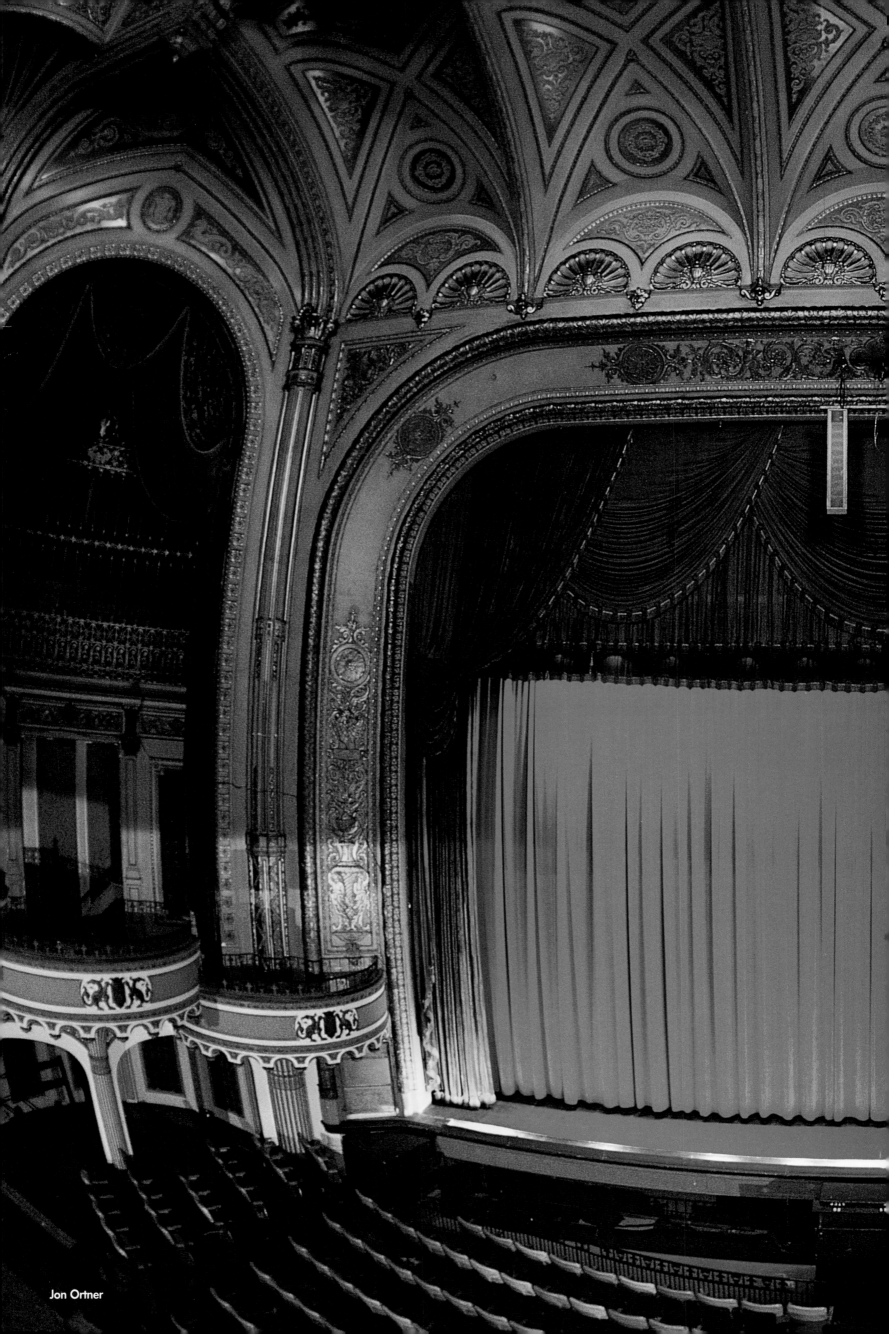

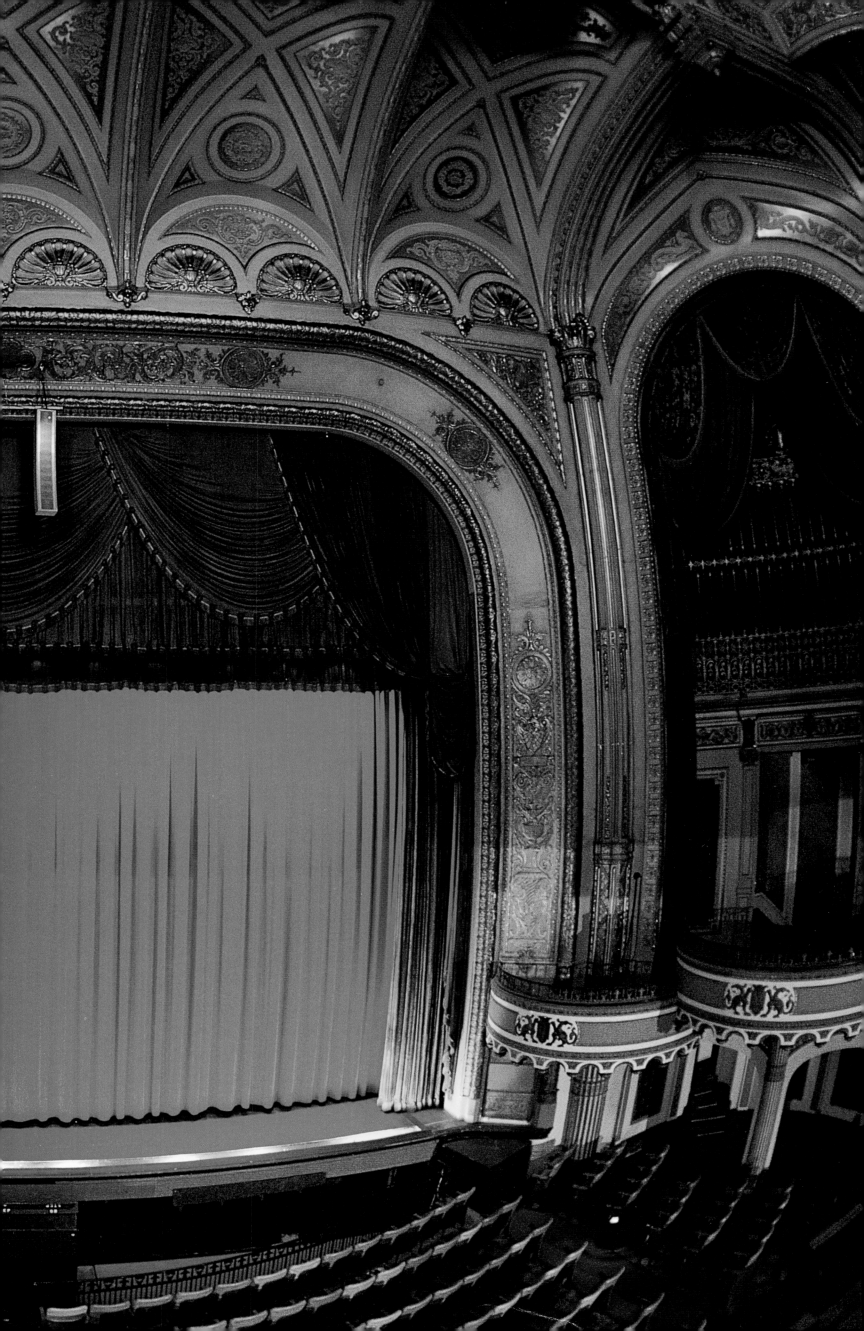

A Day in the Life of
HOLLYWOOD

As seen by 75
of the world's leading photographers on
one day, May 20, 1992

Essays by
Charles Champlin
Mark Matousek
Linda Sunshine

Interviews by Andy Marx
with
Benny Medina
Joe Roth
John Singleton

CollinsPublishersSanFrancisco

A Division of HarperCollins*Publishers*

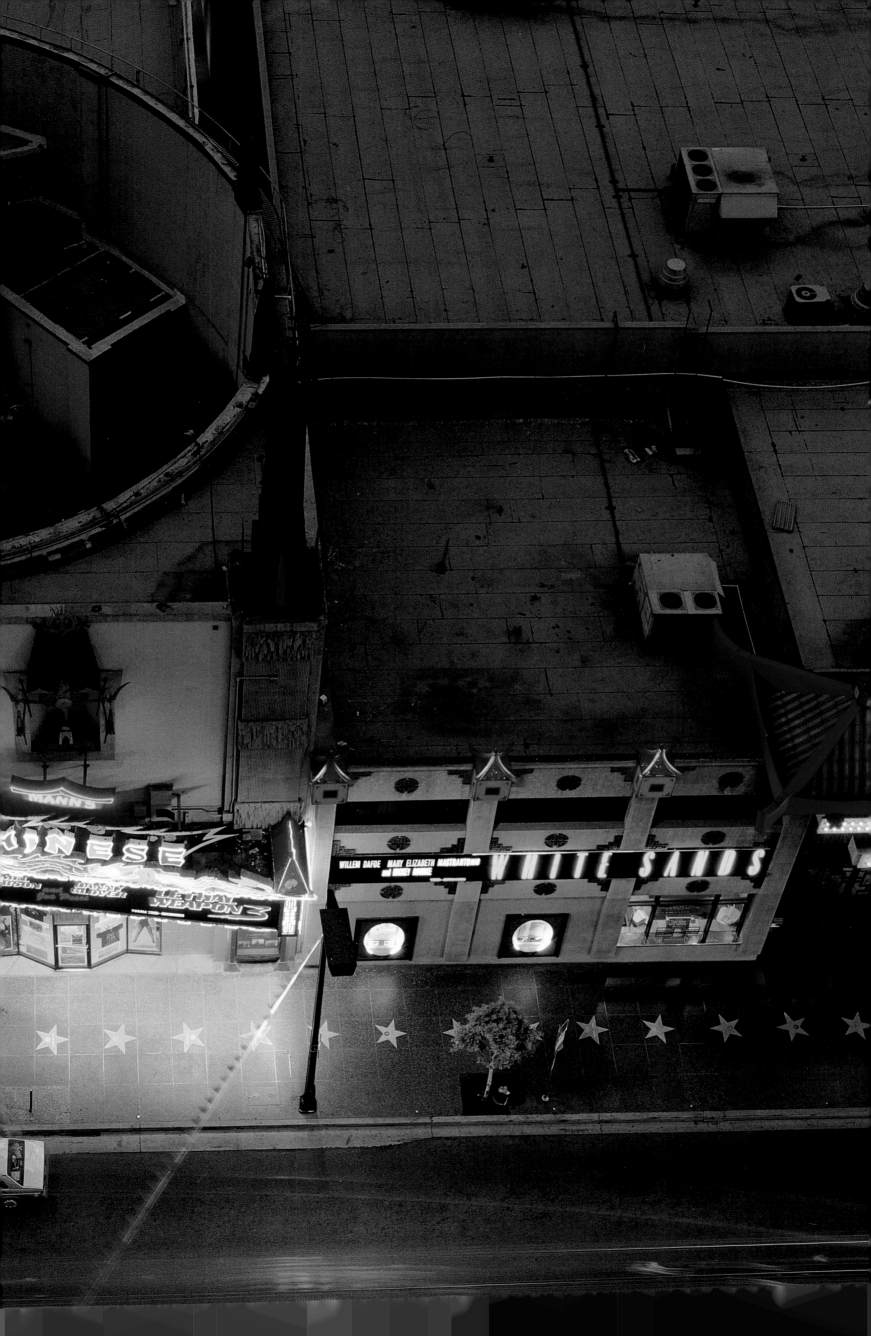

Captions for preceding pages:

Page 1
Lighting the stage on a
Culver Studios set.
Photographer:
Timothy White

Pages 2-3
Flying the flag on the
corner of Hollywood
Boulevard and Highland
Avenue.
Photographer:
Scott Thode

Pages 4-5
Ex-porn star Traci Lords,
poolside at the Beverly
Hills Hotel.
Photographer:
Peter Turnley

Pages 6-7
Legendary Hollywood
photographer Phil Stern
sits on the deck of his
home, surrounded by
some of his famous
portraits from the '40s
and '50s.
Photographer:
Steven-Charles Jaffe

Pages 8-9
In preparation for an
afternoon dedication
ceremony, Mike Fusari
polishes the sidewalk star
of Lou Gossett, Jr.
Photographer:
Scott Thode

Pages 10-11
Movies, burlesque shows,
pricy restaurants and
boutiques, and the
Château Marmont
beckon to travellers on
the Sunset Strip.
Photographer:
Mark Richards

Pages 12-13
In the privacy of their
bedroom, Roseanne and
Tom Arnold preview
Roseanne's performance
on the Johnny Carson show,
taped earlier in the day.
Photographer:
Bonnie Schiffman

Pages 14-15
Batman flies in *Batman
Returns*, thanks to the
special-effects crew at Boss
Film Corporation.
Photographer:
Galen Rowell

Page 17
After two hours in make-
up, actor Cary Tagawa
roars as Zylyn the Grakka
Warrior in the television
pilot *Space Rangers*,
scheduled to run on CBS.
Photographer:
Guglielmo de' Micheli

Pages 18-19
Built in 1926, the 2,000
seat Orpheum played
vaudeville acts as late as
1950. Today it features
American films with
Spanish subtitles for an
audience that is 80
percent Latino.
Photographer:
Jon Ortner

Pages 20-23
An aerial view of Mann's
Chinese Theater on
Hollywood Boulevard.
Photographer:
Ken Duncan

Right
Dennis Hopper, 56, takes
a blue velvet break during
night production of *Money
Men*, which also stars
Wesley Snipes.
Photographer:
Peter Sorel

Library of Congress Cataloging-in-Publication Data

A day in the life of Hollywood : as seen by 75 of the wor
leading photographers on one day, May 20, 1992.
 p. cm.
 ISBN 0-00-255055-5
 1. Hollywood (Los Angeles, Calif.)—Pictorial wc
2. Hollywood (Los Angeles, Calif.)—Social life and custor
—Pictorial works. 3. Los Angeles (Calif.)—Pictorial work.
4. Los Angeles (Calif.)—Social life and customs—Pictoria
works. I. Collins Publishers San Francisco.
F869.L86H653 1992
979.4'94—dc20 92-27829

Printed and bound in Japan by Dai Nippon Printing Co.,

First printing September 1992

10 9 8 7 6 5 4 3 2 1

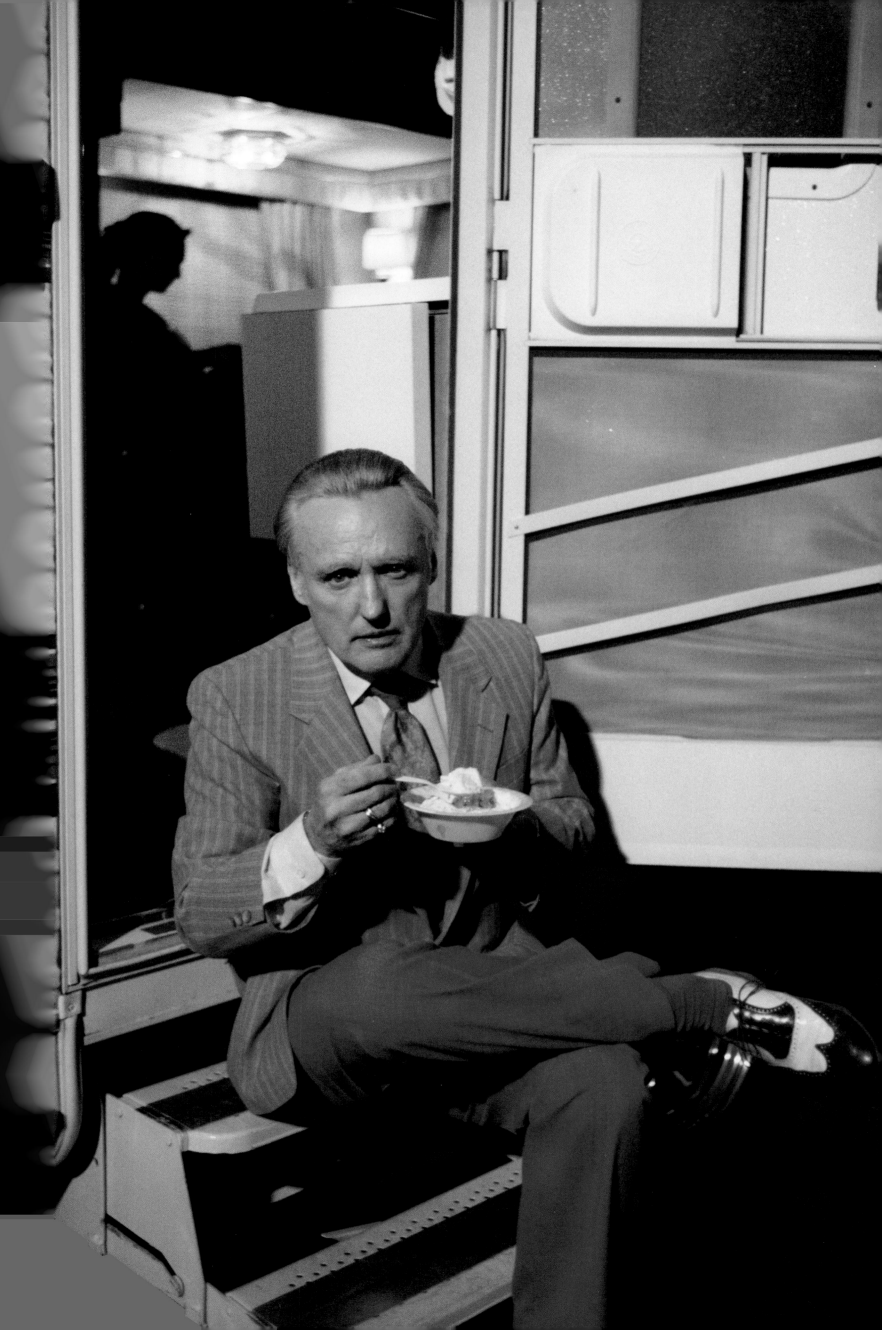

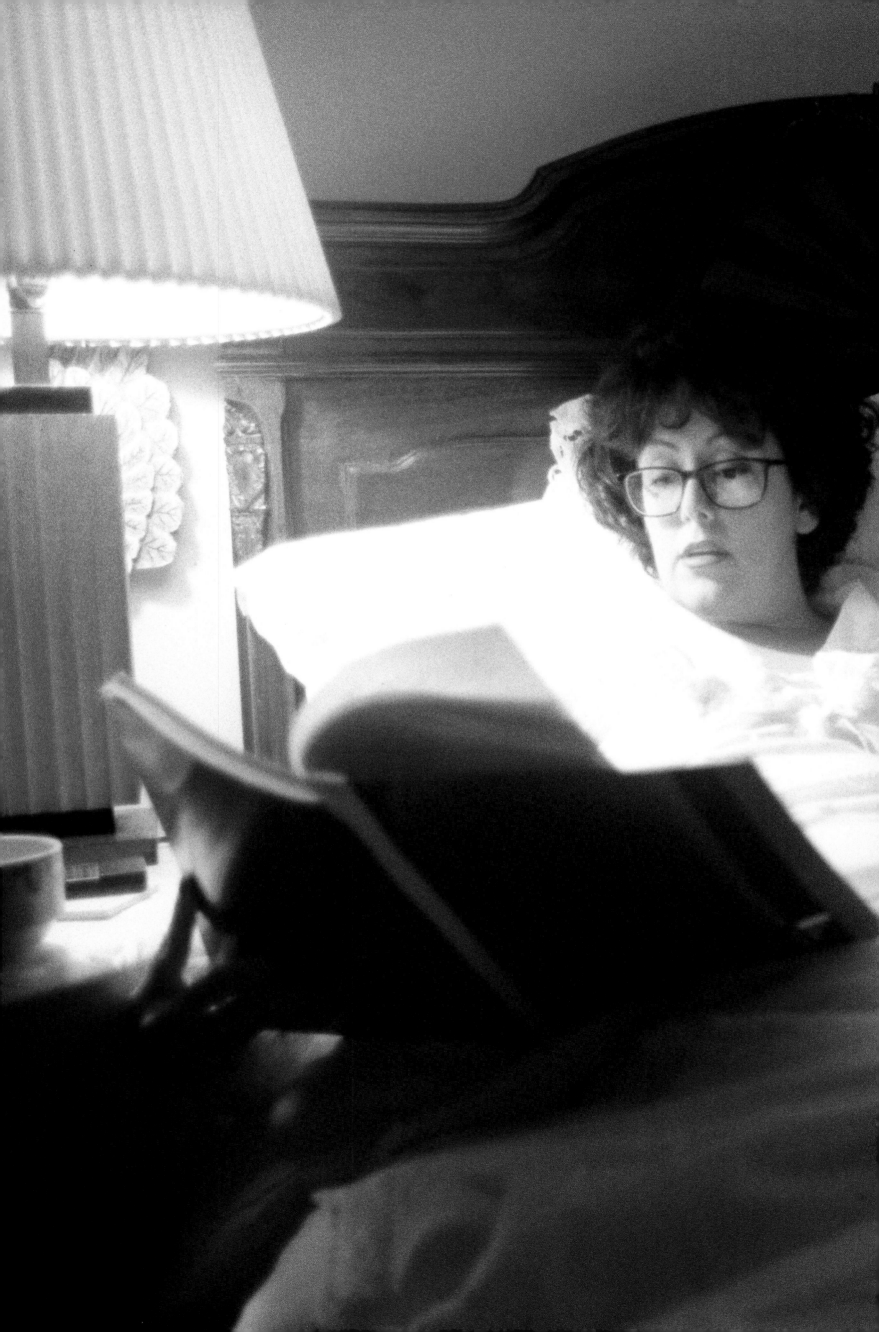

Left

William Morris agent
Cynthia Campos-
Greenberg reads a script
at 2:00 a.m. while her
husband, Robert
Greenberg, sleeps, and
Bean the cat considers his
options. Campos-
Greenberg reads
innumerable scripts every
week, many of which litter
her home in the Holly-
wood Hills. She describes
her work as "the art of
putting together people
with ideas."
Photographer:
Stephen Goldblatt

Following, pages 28-29

Actress Brooke Shields,
27, concentrates on
sinking the six ball in the
corner pocket at the
Hollywood Athletic Club
while out on a date with
singer Michael Bolton. The
club was strictly men-only
when it opened in 1926,
but within a few years
Katharine Hepburn and
Esther Williams were
regulars. Restored in
1990, the Club is now a
lively late-night spot
complete with restaurant,
bar, and private rooms for
parties.
Photographer:
Michael O'Neill

Following, pages 30-31

Day breaks along the
Hollywood Hills, the
Hollywood sign just
becoming visible in the
pre-dawn light.
Photographer:
Galen Rowell

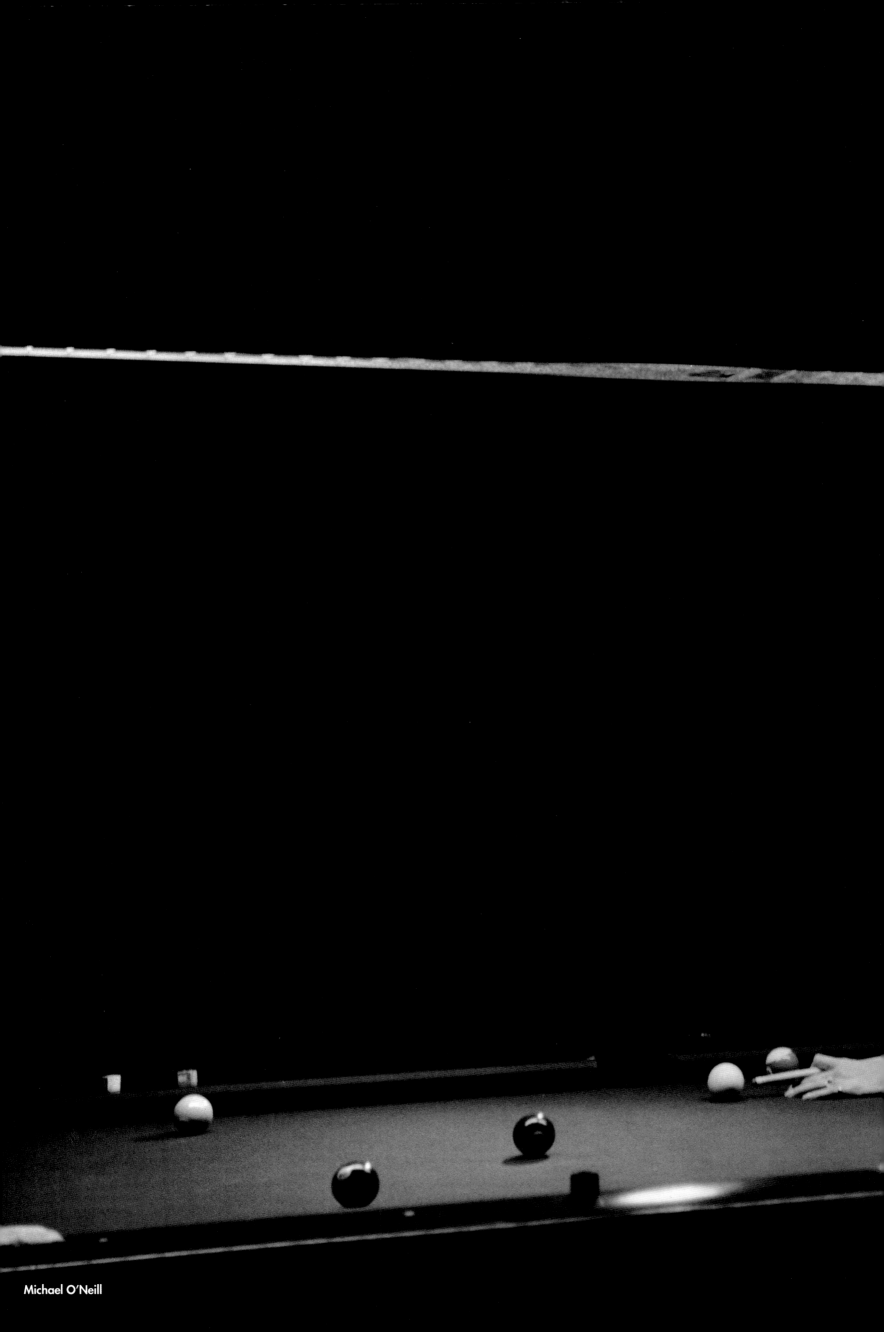

Michael O'Neill

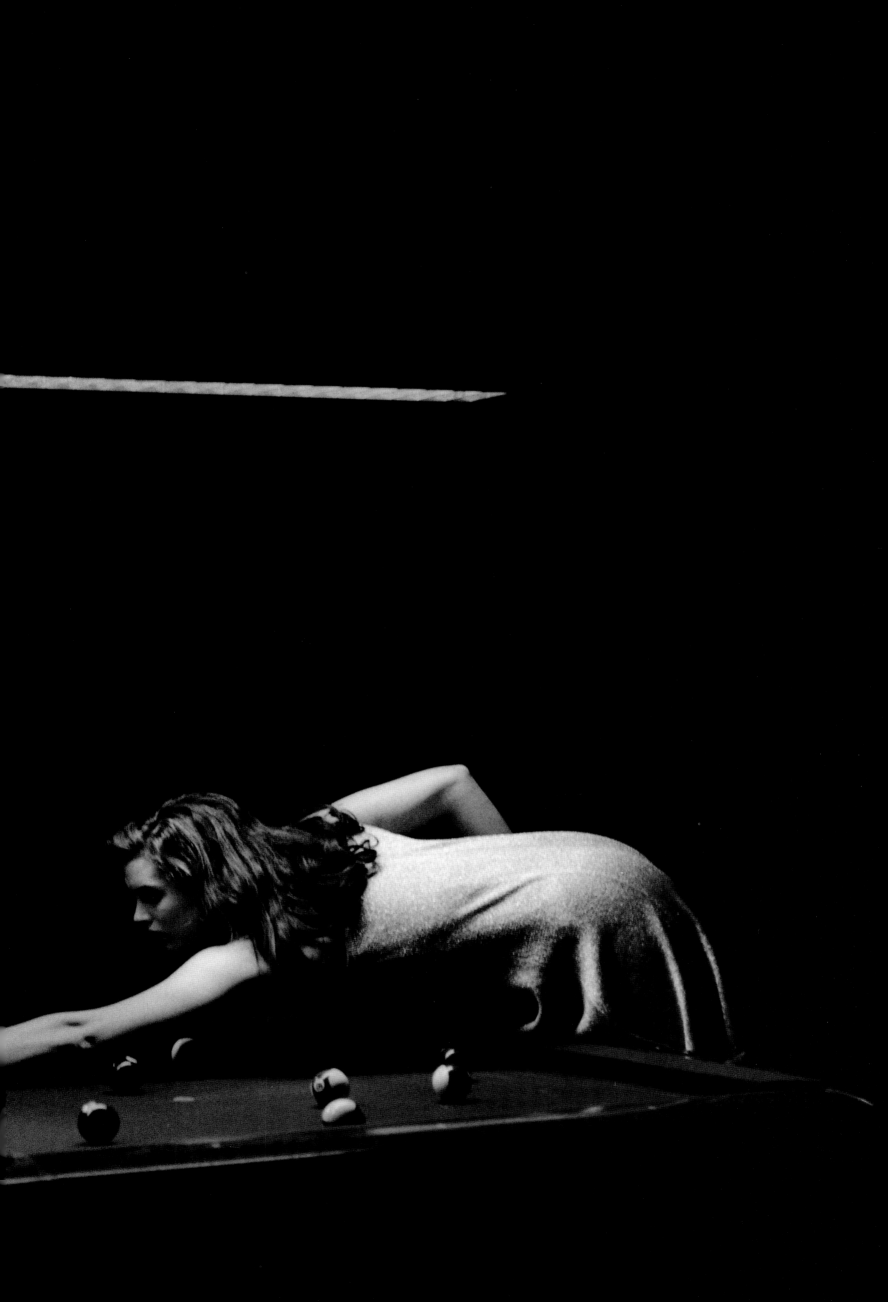

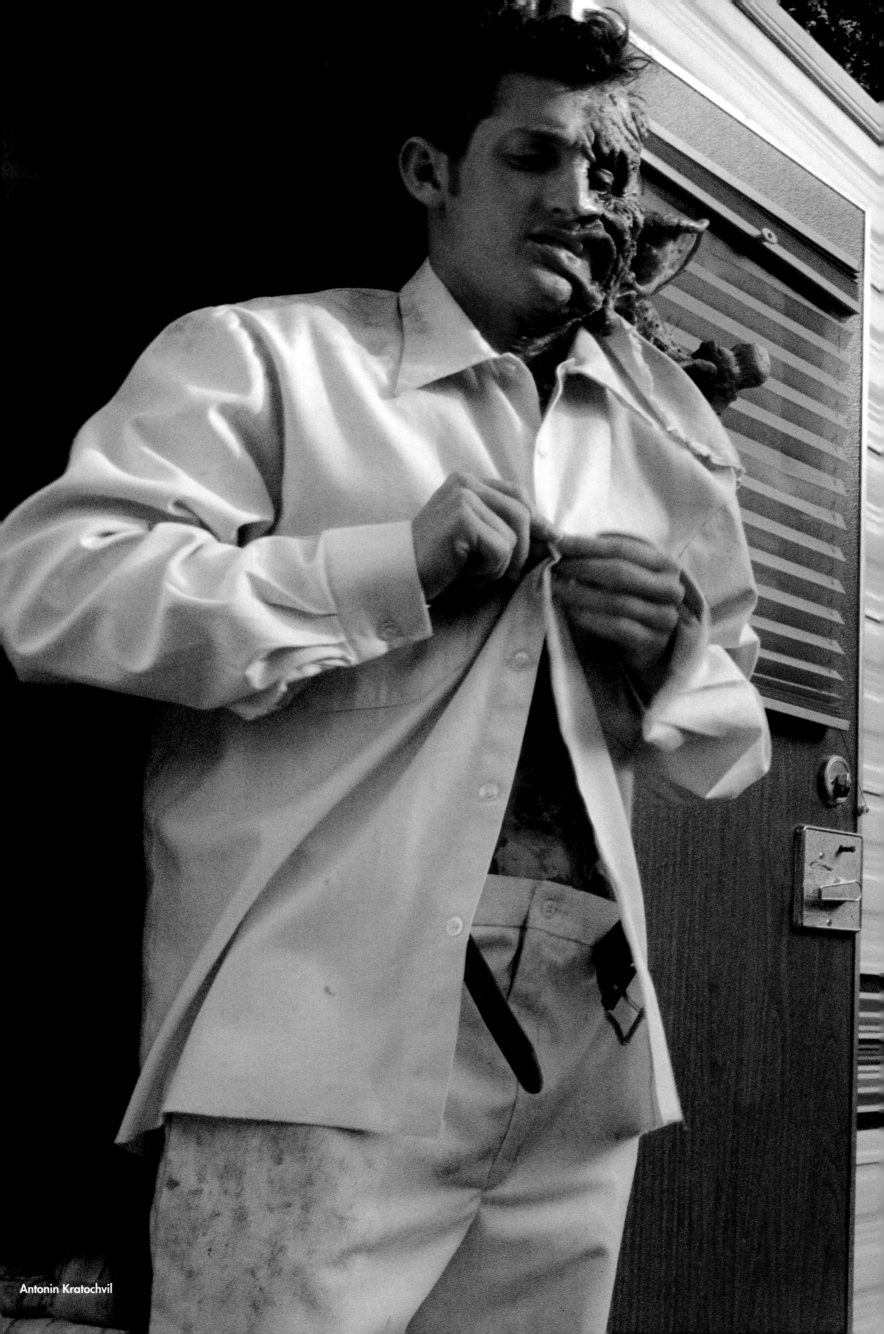

Preceding, pages 32-33

Alex Winter, of *Bill and Ted's Excellent Adventure* fame, goes to work on location in Malibu. Each morning, Winter spends three to four hours getting into make-up for his starring role in *Hideous Mutant Freekz*, the movie he also co-wrote and is co-directing. He says his makeup (designed by Bill Corso of X Effects) is so comfortable that he can sleep in it—and once did, during a marathon three-day period when he was too busy to get out of costume.
Photographer:
Antonin Kratochvil

Left

Peter Guber, 49, Chairman and CEO of Sony Pictures Entertainment, which includes both Columbia Pictures and TriStar Pictures, poses inside his impeccably appointed Japanese beach home in Malibu before leaving for work in his chauffeur-driven Range Rover. Most of the time, Guber, his wife Lynda, who runs the non-profit Education Trust, and their two daughters Jodi and Elizabeth (both in their 20s) live in Bel Air, saving the beach house for weekends. The Gubers also own a home in Aspen, Colorado.
Photographer:
Philip-Lorca DiCorcia

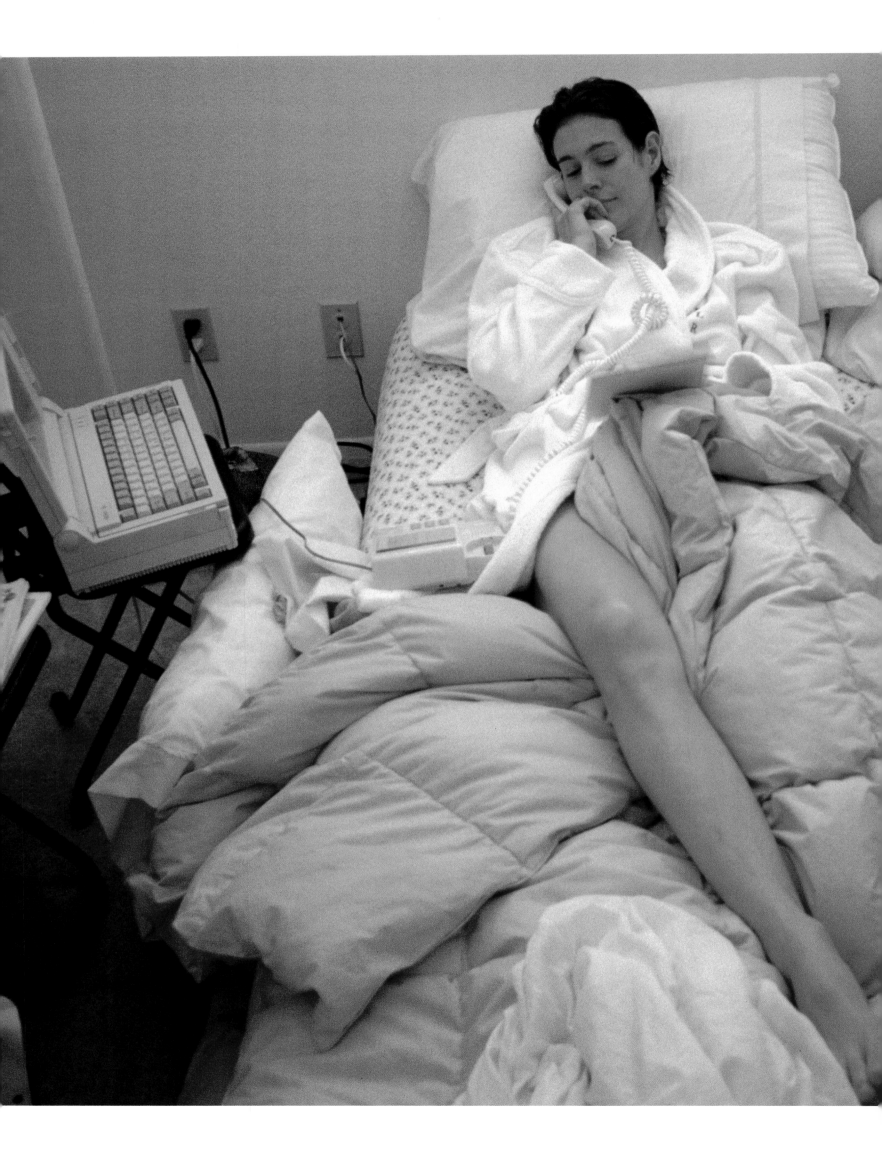

Left

From the spartan Santa Monica apartment she shares with Robert Lujan, her husband of three years, actress Sean Young, 33, starts the day with a round of phone calls to her agent, lawyer, secretary, horse trainer, and house-keeper. During most of the year, the couple live in Arizona, but Young is currently starring on an L.A. stage in *Stardust.* Confused by her image as a difficult, high-strung actress, Young considers herself easy to work with. "I always work hard," she says, "and I always show up with a positive attitude." Young uses a computer to communicate with her advisors and employees so that they "have no excuse" for failing to get her the information she needs.
Photographer:
David C. Turnley

Following, pages 38-39

In the bedroom of his Beverly Hills home, movie and television producer and manager Sandy Gallin, 52, says the Jewish morning prayers wearing a *tallis,* a prayer shawl, and *tefillin,* small leather boxes attached to his head and arm which contain passages from the Old Testament (*top*). His other morning rituals include yoga with instructor Gurmukh Kaur Khalsa (*bottom*), medita-tion, and working out on the Stairmaster—all in the company of Mickey, one of his three Boston terriers.
Photographer:
Joyce Ravid

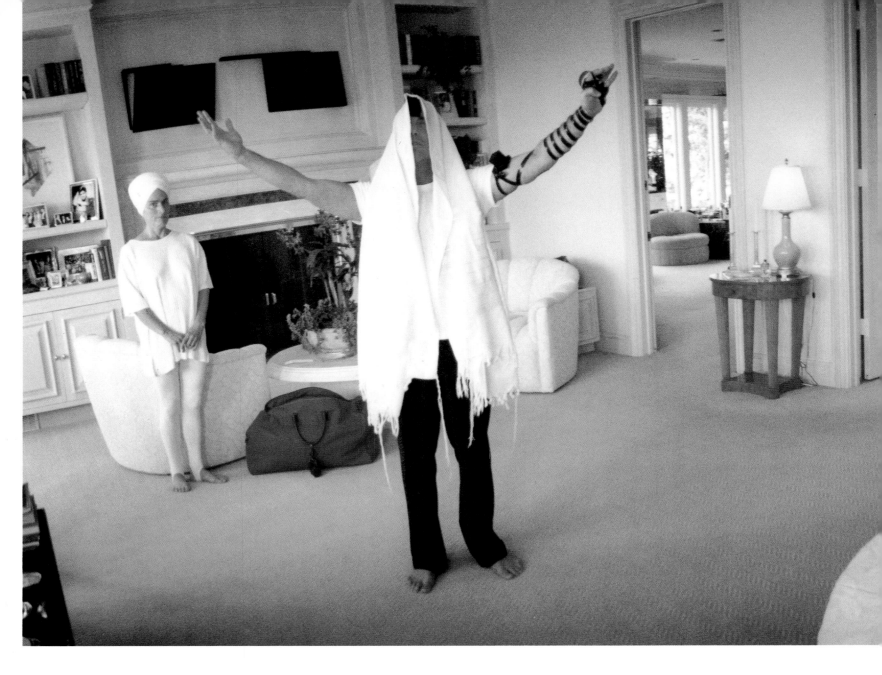

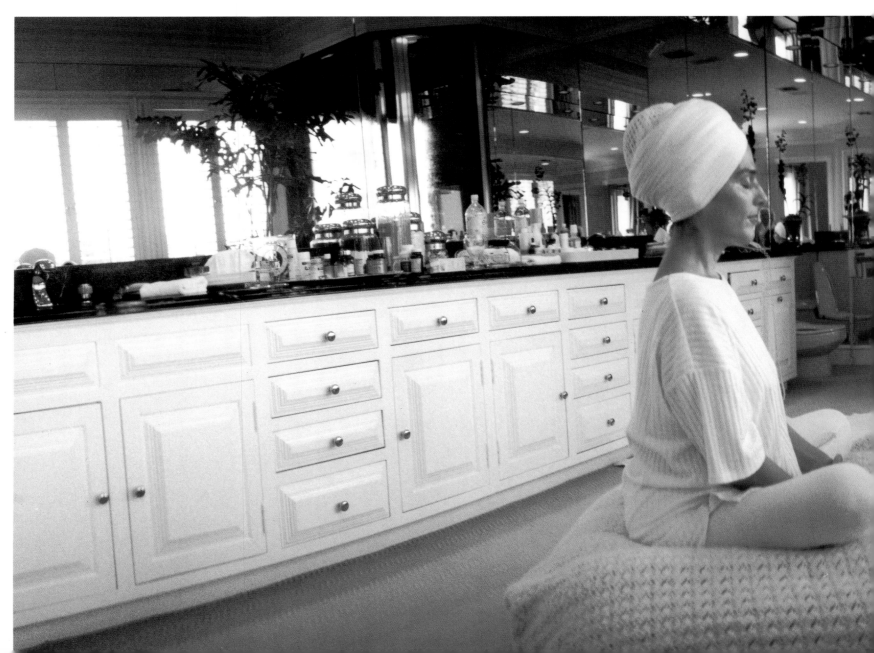

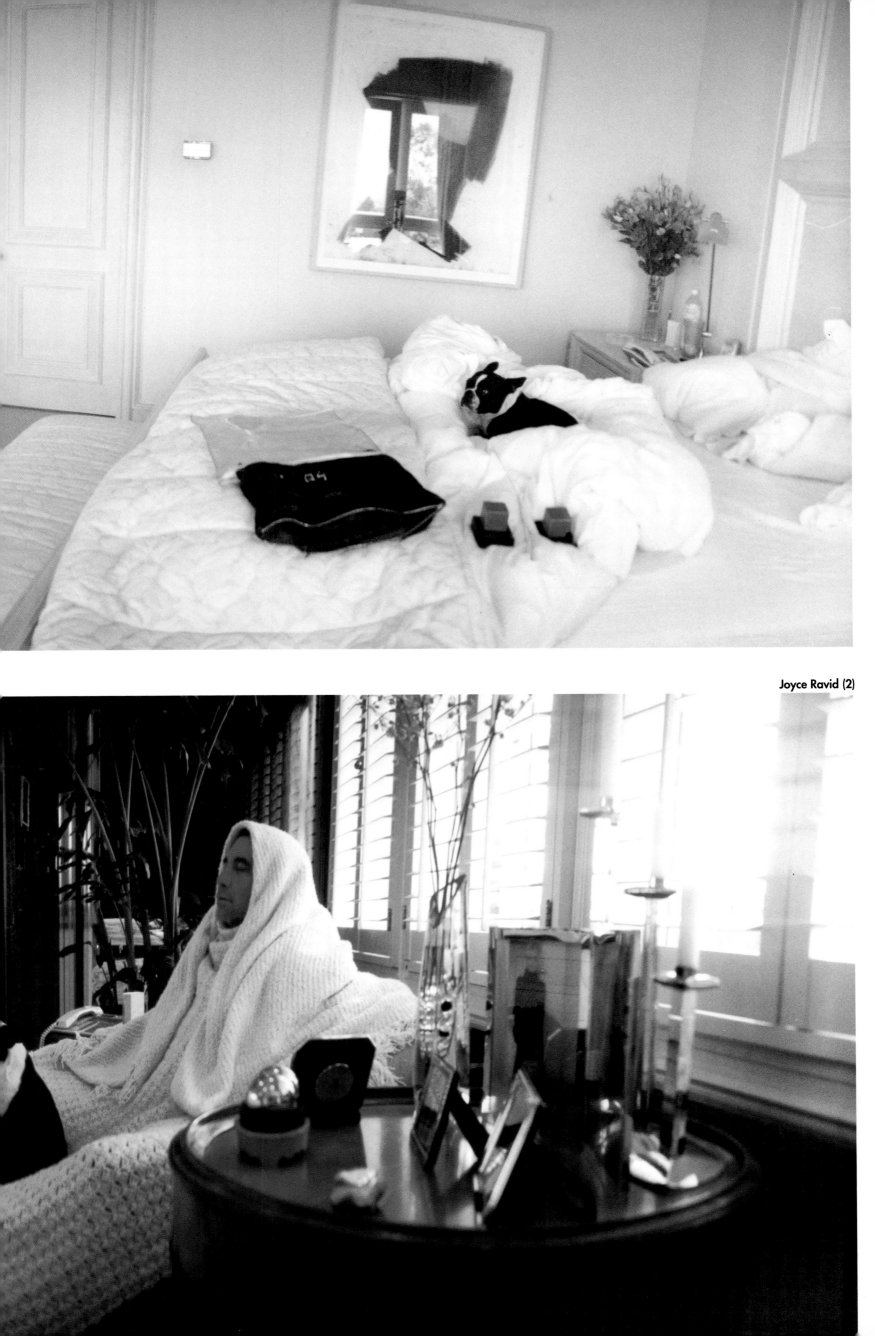

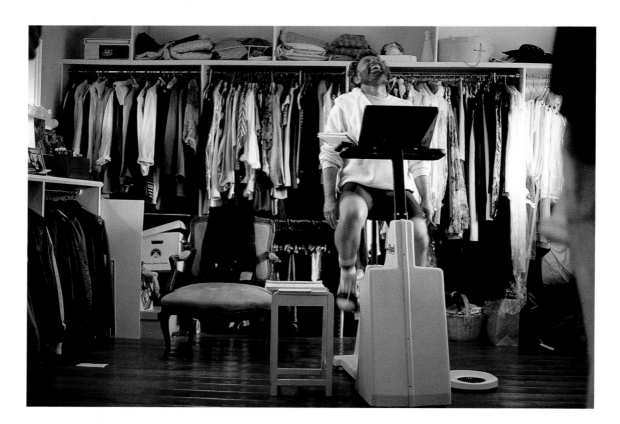

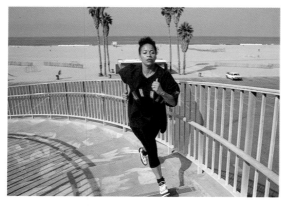

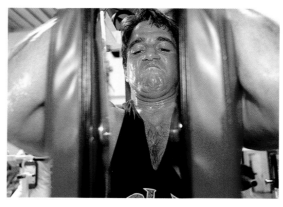

Above, top

Hollywood wakes up early and works hard to keep in shape. Sid Ganis, 51, president of marketing and distribution for Columbia Pictures, is up by 5:30 a.m. After half an hour with his dumbbells, he rides an exercise bike in the closet of his Pacific Palisades home for another half-hour, usually reading a script and watching the *Today* show while he pedals to nowhere.
Photographer:
David Burnett

Above, bottom

Choreographer, actress, and producer Debbie Allen, 42, jogs across the pedestrian walkway over Highway 1 in Santa Monica every morning, although, if she had the time, she would prefer to take a dance class. When she can't jog, she climbs the 200 steps that run up to San Vicente Boulevard from the beach, which is, she says, "a hateful exercise."
Photographer:
Anthony Barboza

Above, bottom

Actor Tony Danza, 41, works out at Gold's Gym in Venice, which was made famous in the 1975 movie *Pumping Iron* starring Arnold Schwarzenegger. Danza likes Gold's because with "loud music playing and lots of young people, working out here is like performing." In fact, Gold's has become so popular that tourists have been known to spend as much as $5,000 per visit on clothing that bears the gym's name.
Photographer:
Catherine Karnow

Right

Evi Quaid, 29, takes a dive while her husband, actor Randy Quaid, 39, admires the view from their home high in Beverly Hills. Randy worked till 3:00 a.m. the night before on a scene in *Hideous Mutant Freekz* where a giant frog tongue was supposed to fly through the air and land on his face. "My impression of the Hollywood world," says Evi, "is that it's a lot of hard work and not much glamor."
Photographer:
Véronique Vial

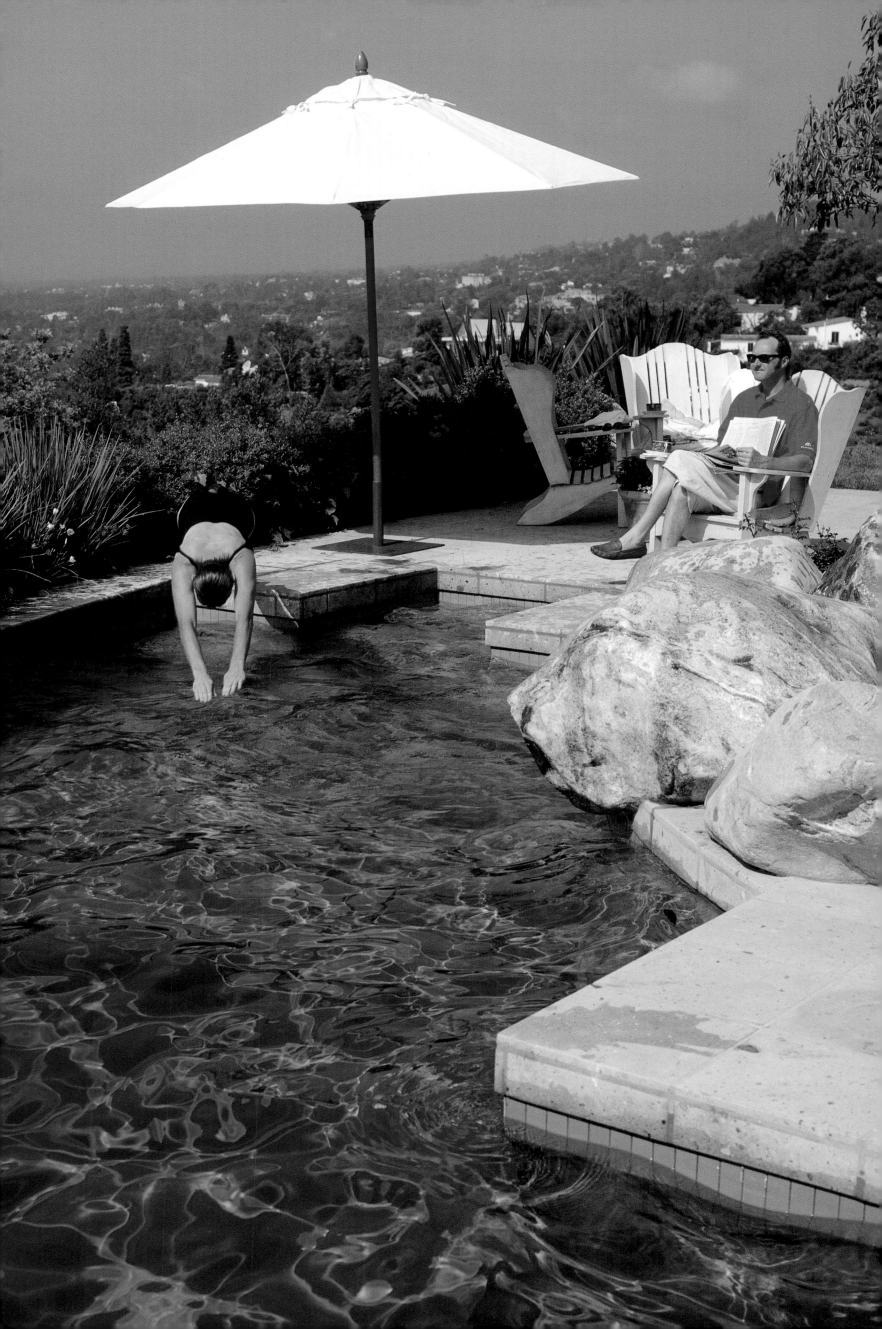

Right

Hugh Hefner, 64, carries his son Marsten out the door of the Great Hall in the Playboy mansion, followed by the family pets: Dior, the Doberman; Leilynd, a Labrador retriever; and Bridgett, an Irish water spaniel. The Great Hall in this Gothic-Tudor mansion, built on 5.3 acres in L.A.'s exclusive Holmby Hills district, cost $500,000 to decorate and includes an antique chandelier, marble floors, floor-to-ceiling French windows, oak paneling carved by noted sculptor Donald Knoll, artwork by Matisse and Dali, and several baby strollers and rolling toys used for lawn play.
Photographer:
Michael O'Neill

Following, pages 44-45

Actress Mariel Hemingway, 28, coaxes breakfast into the mouth of her daughter, Langley "Beano" Crisman, 2, while her other girl, Dree Crisman, 4, ponders the situation and plays with her food. Hemingway is currently starring in the television series *Civil Wars*, which requires leaving the house by 4:30 a.m. and sometimes not returning until 8:00 p.m. That schedule, she says, "makes me focus on the time I spend with my family, to make it special."
Photographer:
Neil Leifer

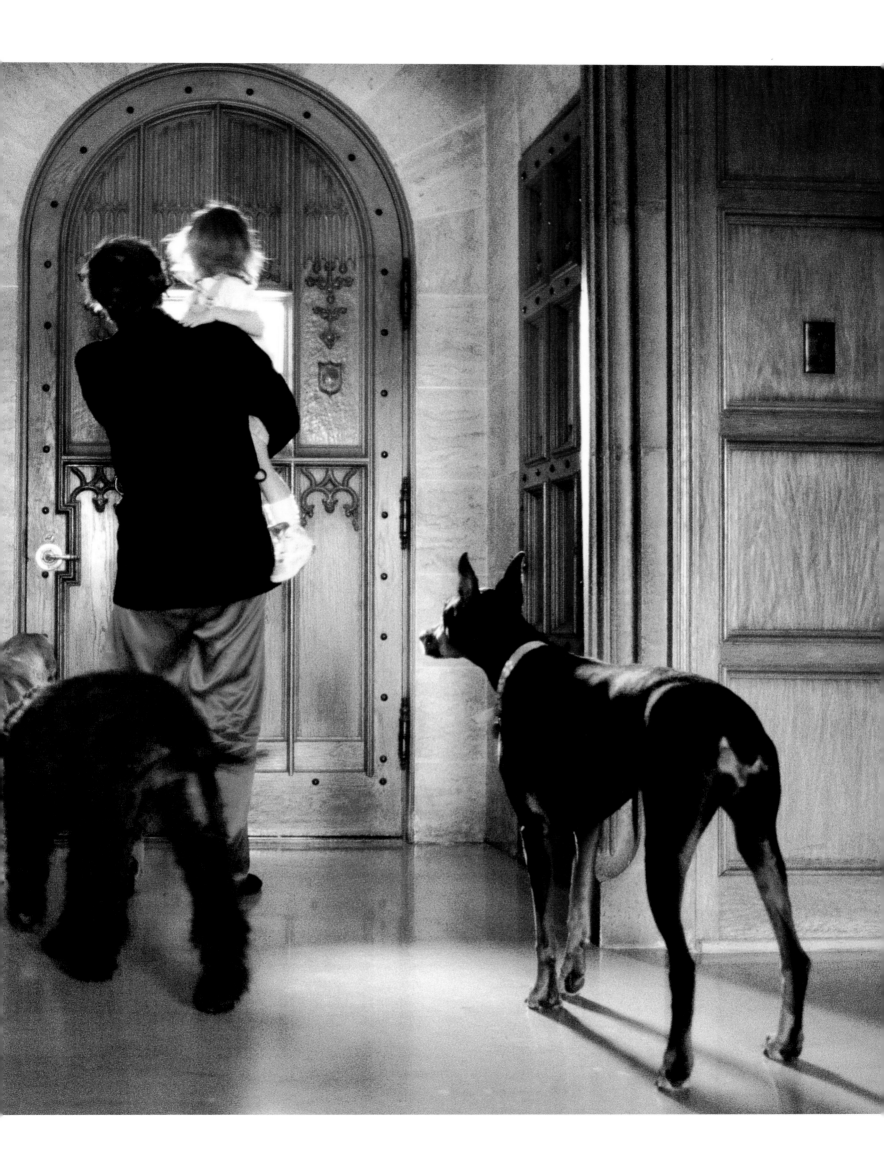

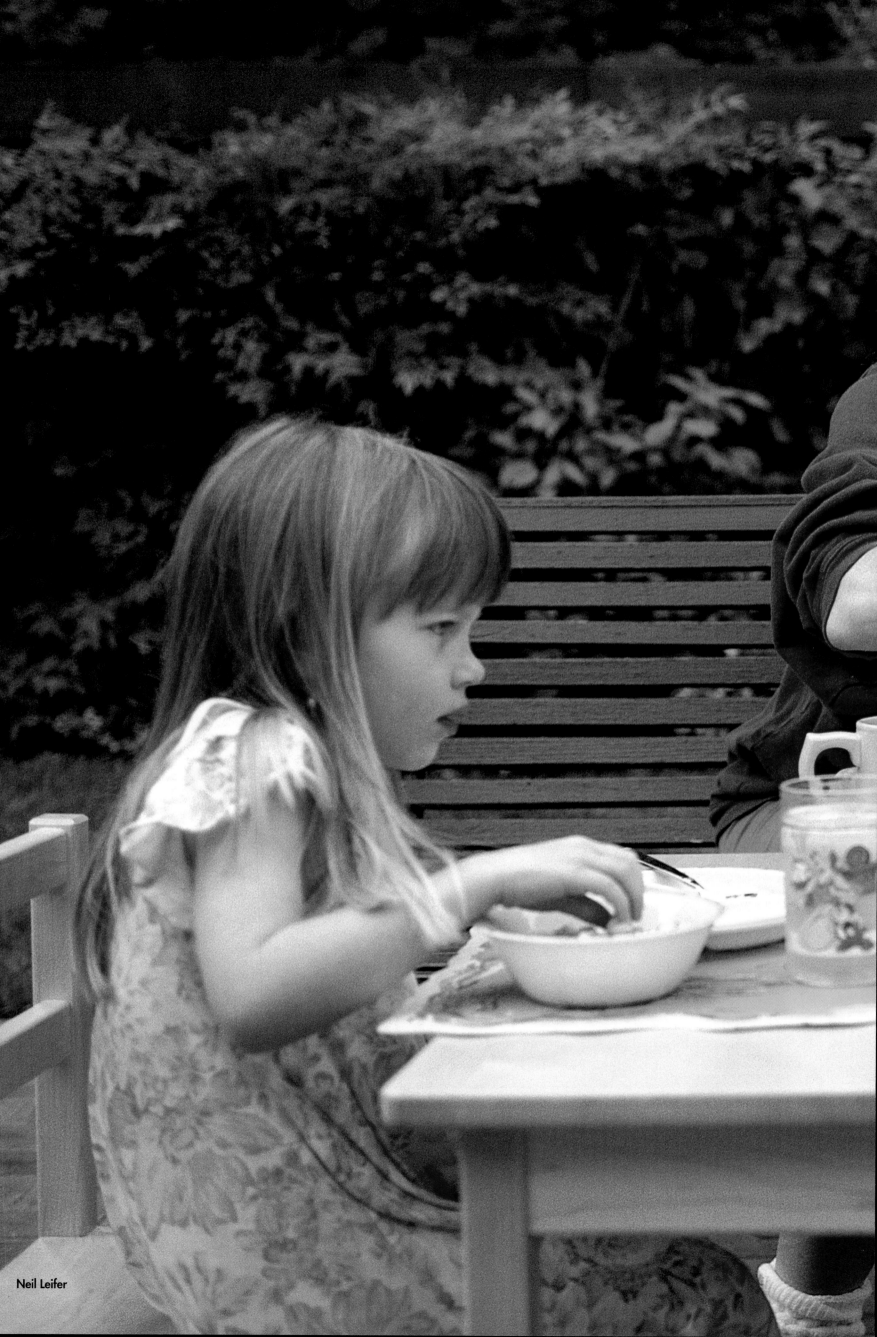

Neil Leifer

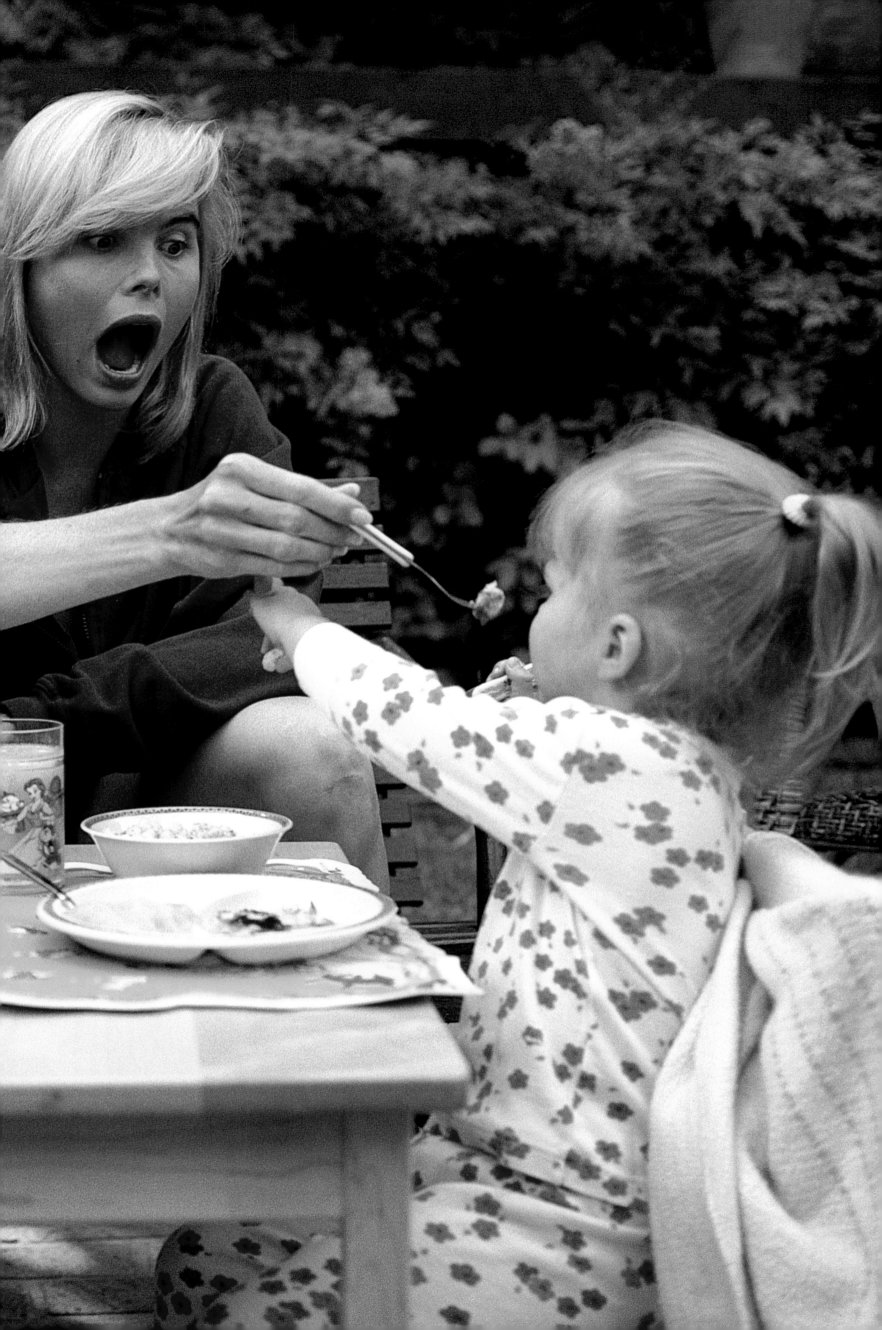

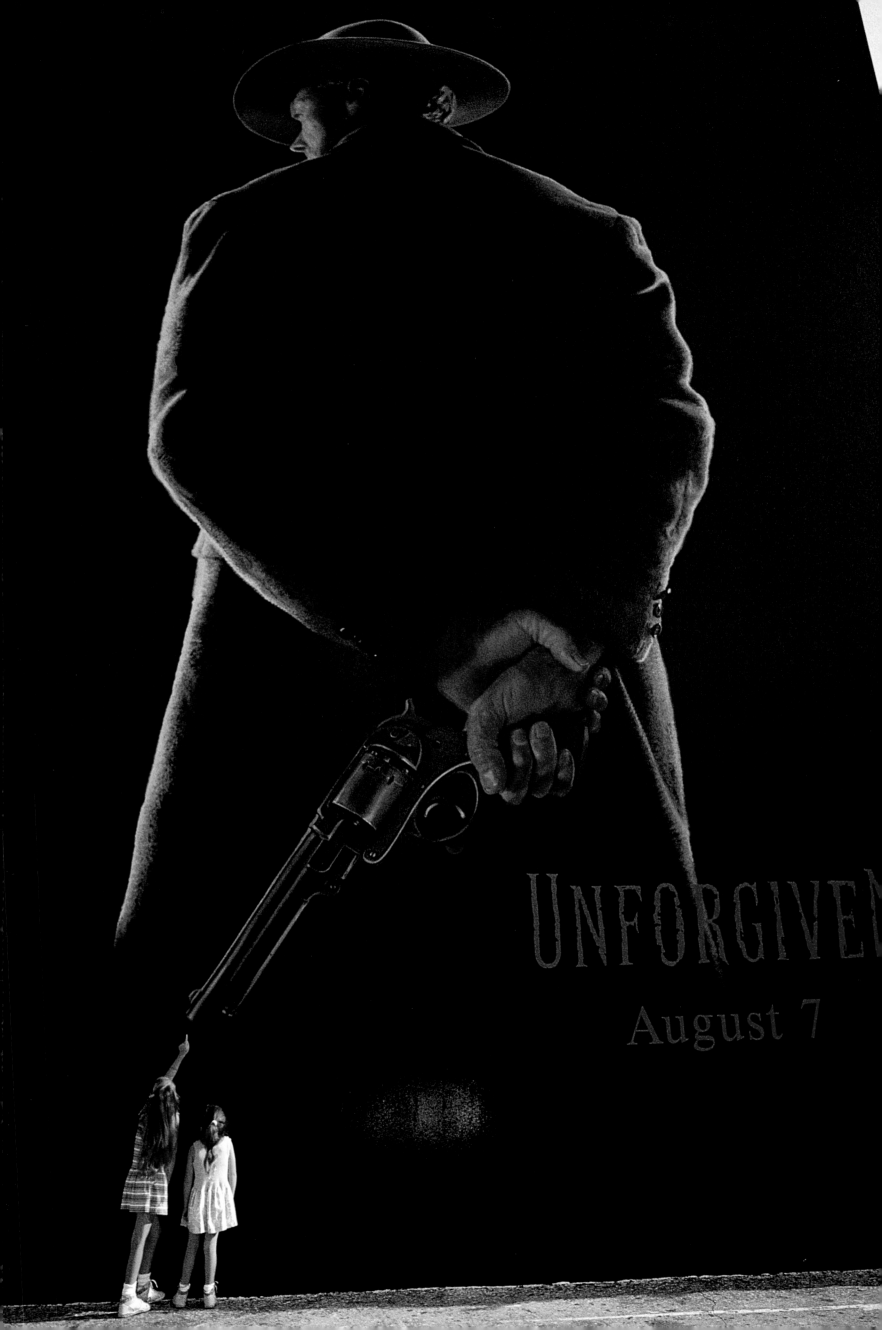

Left

Ashley Beckwith, 6, and
her sister Britanny, 4,
were not the only people
in Hollywood to notice
this startling billboard in
front of the Warner Bros.
studio in Burbank. As
part of a "teaser" cam-
paign for *Unforgiven*,
starring Clint Eastwood,
Morgan Freeman,
Richard Harris, and
Gene Hackman, it was
run without any names
or film credits. The
posters went into
circulation in March, and
the response from
theater managers was so
phenomenal that
Warner Bros. hoped to
use the concept for all of
the film's advertising.
Because of contractual
obligations, however, a
new poster appeared
two weeks before the
film opened, naming
names and giving credit
where credit is due.
Photographer:
Claus C. Meyer

Right, top

Bonnie Bruckheimer, 41,
and her 8-week-old
daughter, Miranda
Martell, set off for work
at the Disney studios.
Bruckheimer is a partner
with Bette Midler in All-
Girl Productions and was
the producer of *Beaches*
and *For the Boys*. She
drives a Volkswagen
station wagon, "the
classic mom-mobile,"
she says.
Photographer:
Annie Griffiths Belt

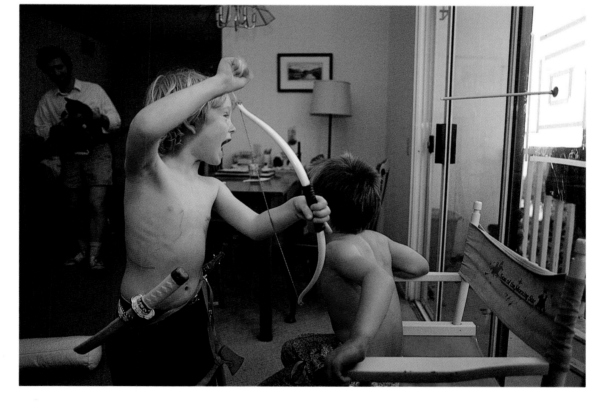

Left, bottom

Benjamin Medeiros, 6,
shoots an arrow over the
head of his friend Alexi
Parker, 6, while his dad,
Michael Medeiros, 42,
watches from the sidelines.
Benjamin has lived in
California for three years,
ever since his actor dad
and actress mom, Cordis
Heard, moved here to
further their careers. He
likes the mini-mall and
donut shop next to his
Santa Monica house, but
he misses New York's big
buildings and complains
that there's "nothing to
remember" in L.A.
Benjamin considers
himself lucky that his
parents are actors
because they're home
so much.
Photographer:
Randy Olson

Following, pages 48-49

According to the
California Department of
Transportation, every
day an average of
210,000 vehicles travel
the Hollywood Freeway
at this Sunset Boulevard
interchange.
Photographer:
Larry C. Price

Following, page 50

Behind the scenery on
the Universal Studios
Hollywood tour.
Photographer:
Jeff Jacobson

Following, page 51

Palm trees and their
reflected glory on
Hollywood Boulevard.
Photographer:
Claus C. Meyer

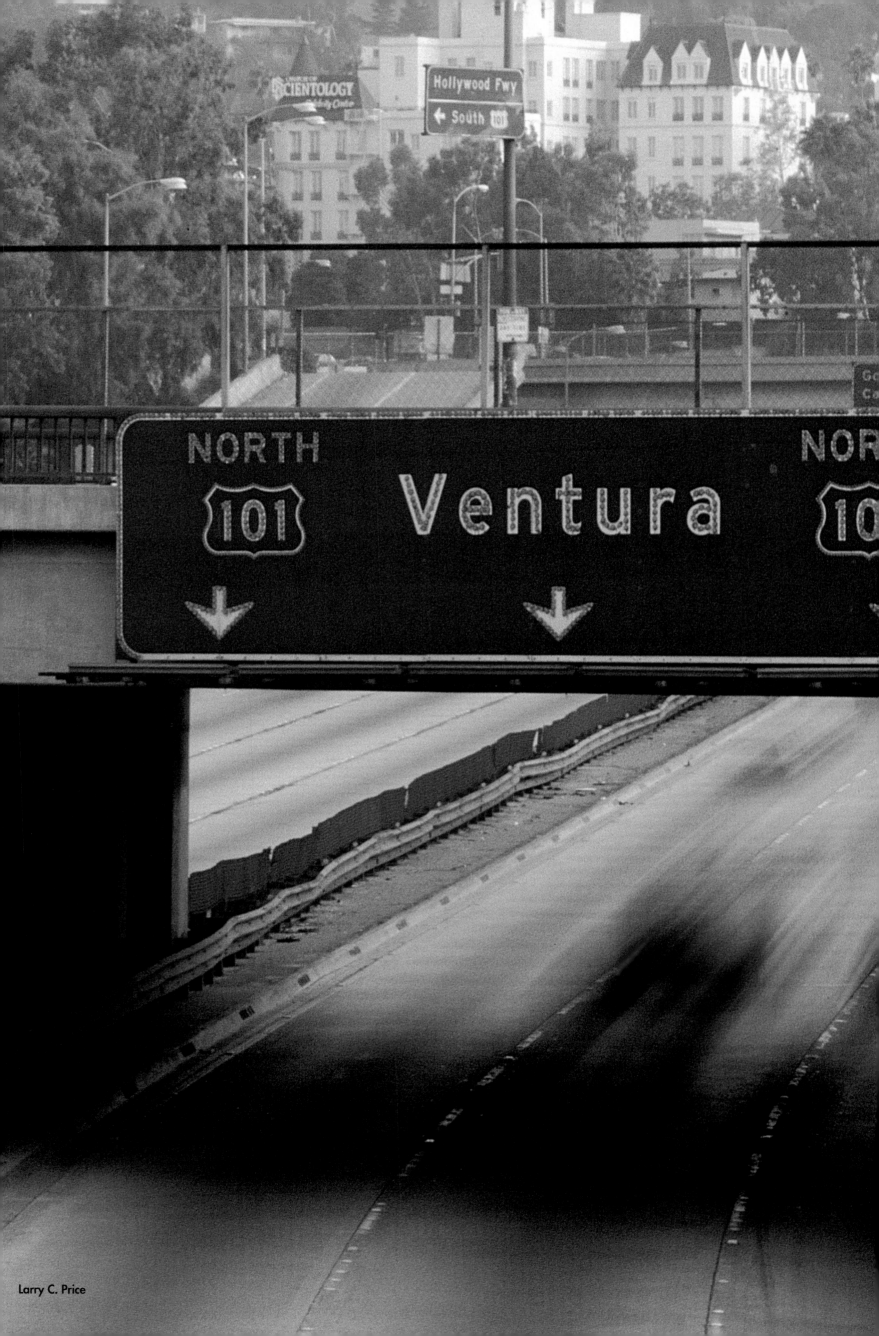

Larry C. Price

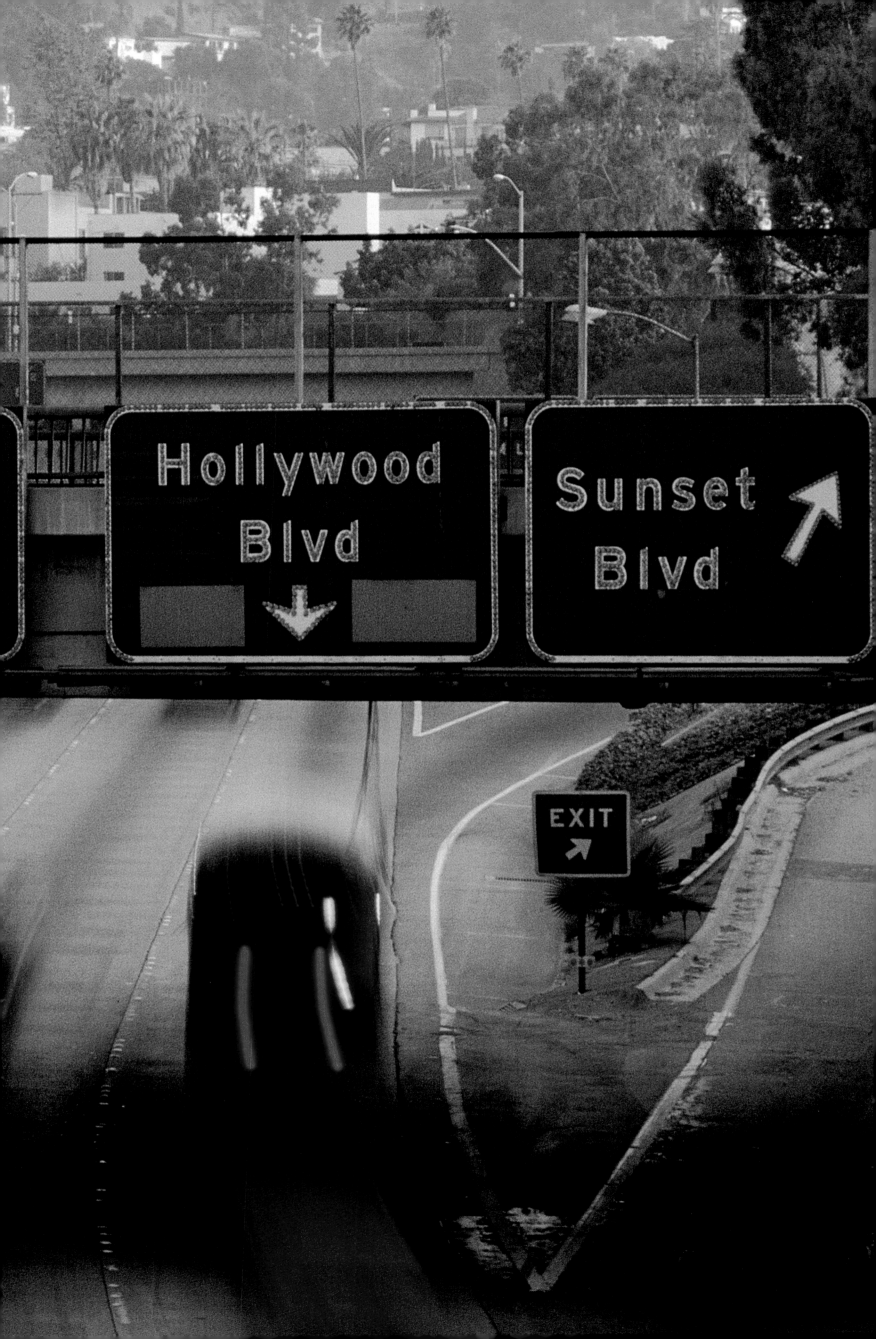

Jeff Jacobson

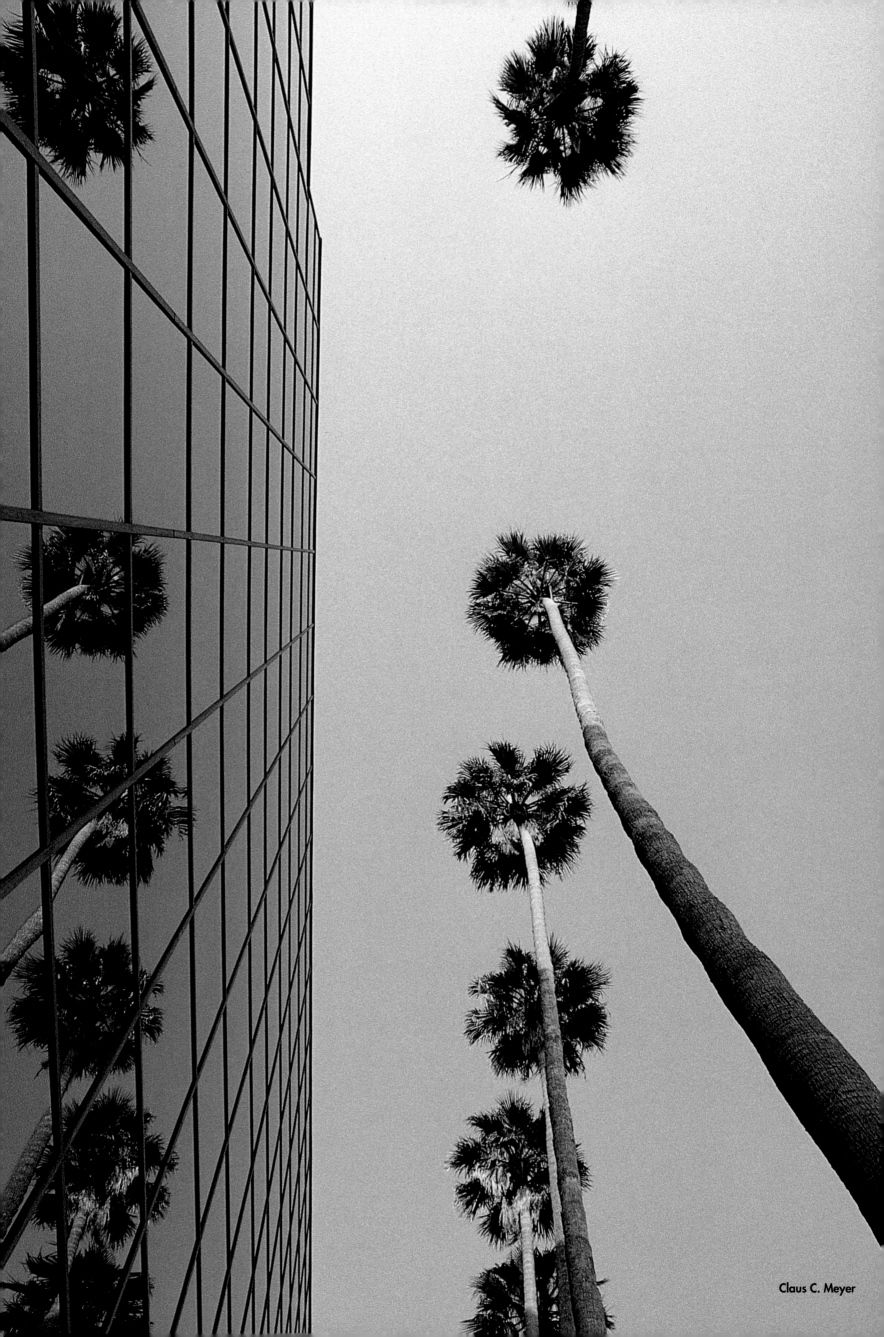

Claus C. Meyer

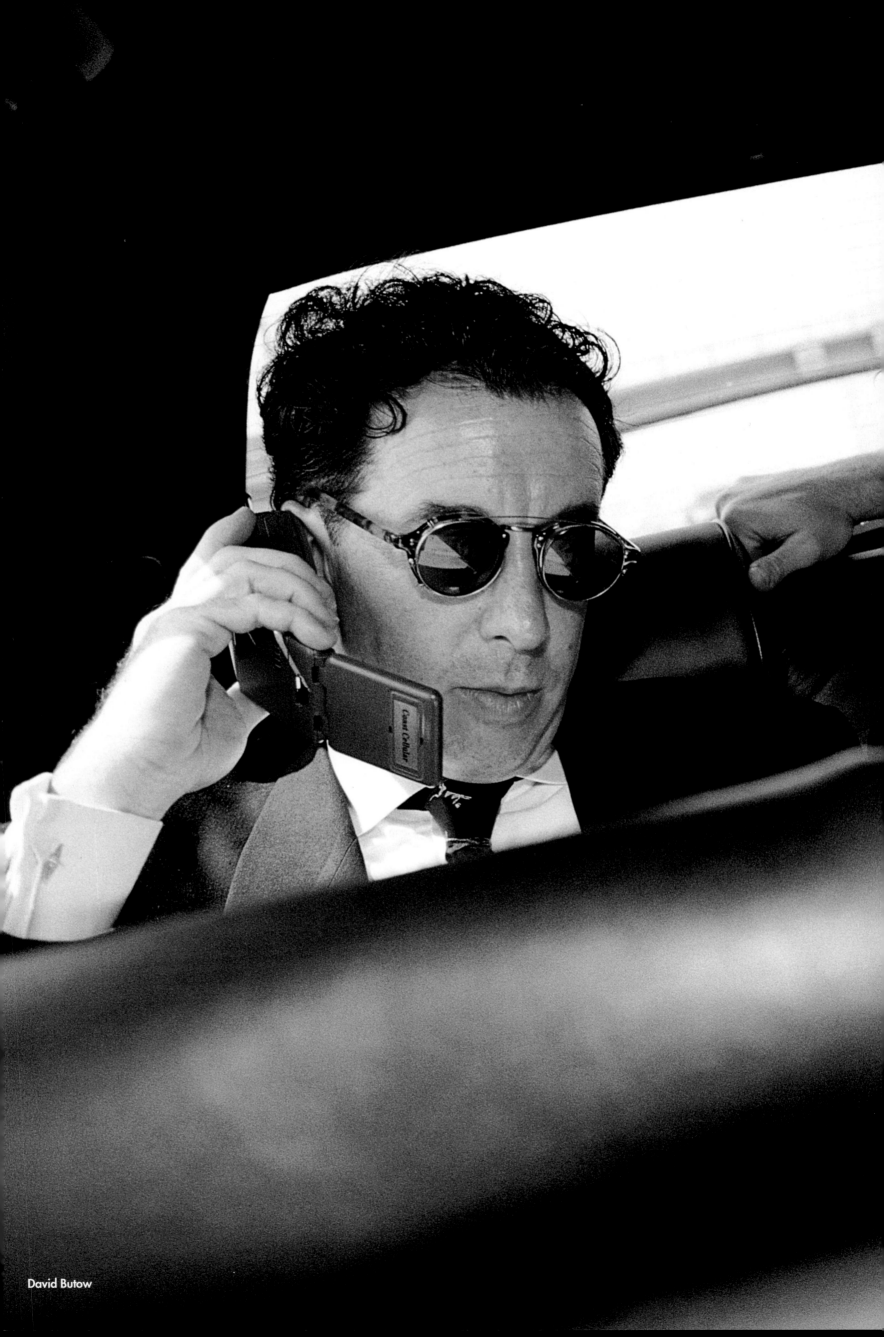

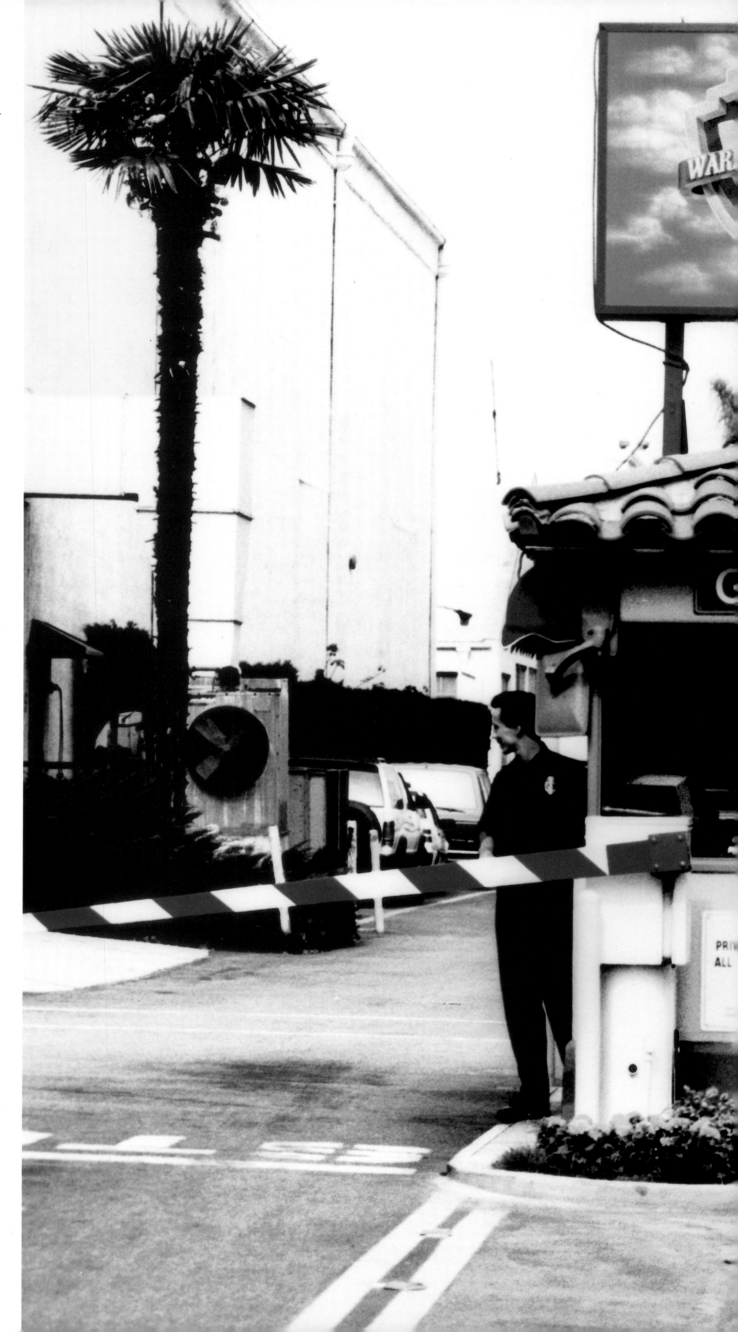

Preceding, pages 52-53

Columbia Pictures executives Mark Canton, chairman, Stephanie Allain, vice president of production, and Michael Nathanson, president of worldwide production, take the office with them as they travel by limousine to the set of *Poetic Justice,* a film directed by John Singleton and starring Janet Jackson in her movie debut.
Photographer:
David Butow

Right

Gate 2 at the Warner Bros. studio never closes and is staffed in three eight-hour shifts. Typically, 5,000 to 8,000 vehicles pass through the gate on each shift, giving security guards approximately five to ten seconds to identify every driver. "It's a judgment call," says officer Ray Ferrante, an 11-year veteran, noting that it's always a challenge to determine who has legitimate business on the lot and who doesn't. Ferrante cites the time Sean Young, dressed as Catwoman, stormed the gate, demanding to see director Tim Burton, as an example of one touchy situation.
Photographer:
Ken Regan

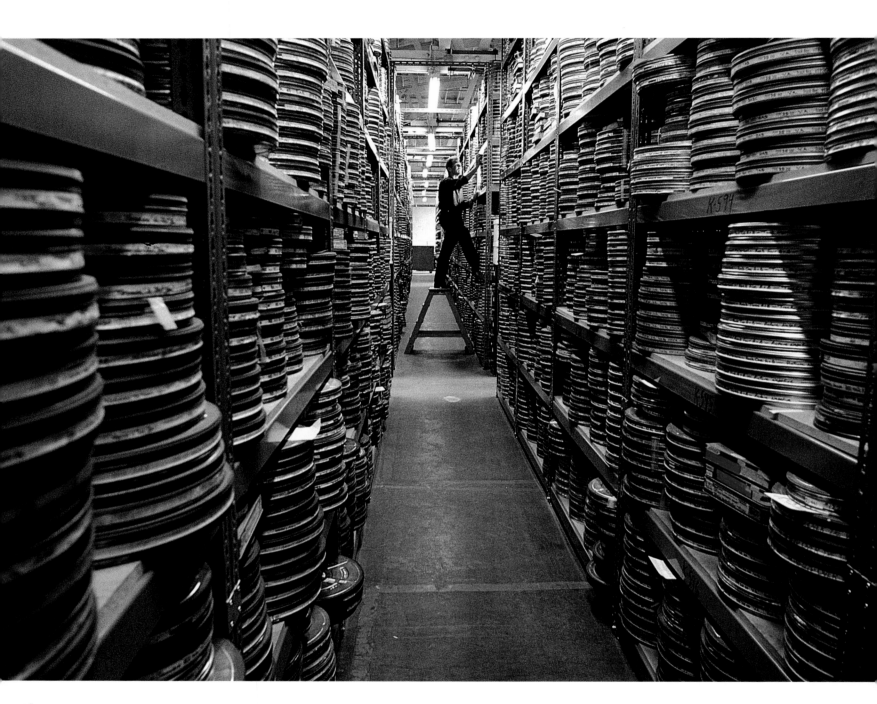

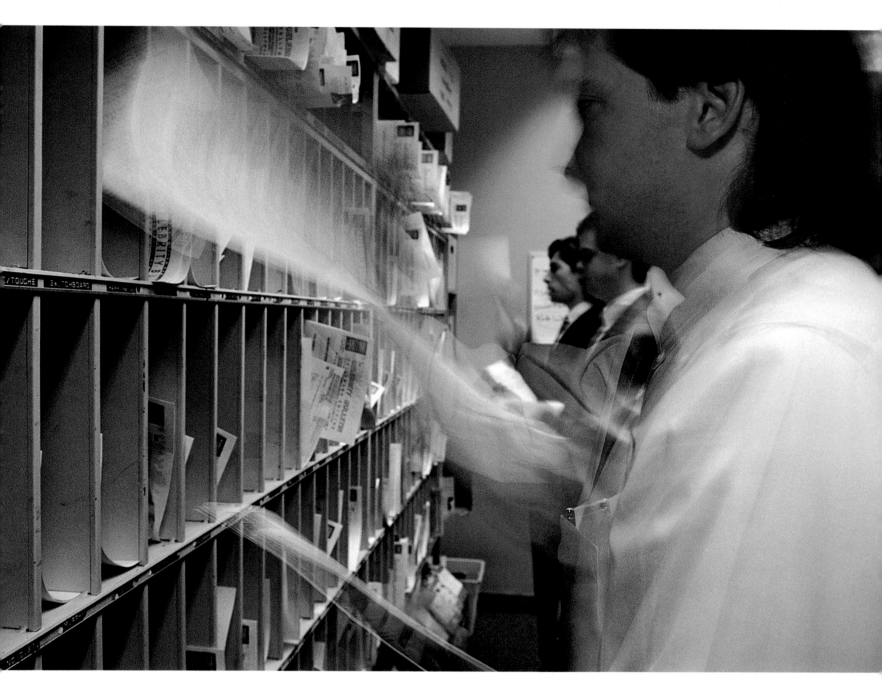

Above

The mail room at William Morris may look like any other, but in fact it is one of Hollywood's prime breeding grounds for talents like David Geffen, Michael Ovitz, and Barry Diller—all of whom started their careers in this very room. Most of the major agencies in Hollywood have training programs where graduates from Harvard, Yale, and Princeton photocopy scripts, deliver dry cleaning, pick up danish, and work like slaves for $150 a week. Trainees are usually fresh out of school because, as Bill Robinson, who runs the training program at the International Creative Management agency, says, "it's very humiliating work, and humiliation can be better handled by the young." It is extremely difficult to win acceptance into any of the training programs, and about half the recruits drop out or are fired before advancing to the status of agent.
Photographer:
David Butow

Left

Brandon Tartikoff, 43, chairman of Paramount Pictures, totes basket case Arsenio Hall, 32, whose talk show tapes five days a week at Paramount Studios. "Arsenio and I recreated the old Hope and Crosby shot to signify the collegial, old Hollywood atmosphere that still exists at Paramount," says Tartikoff. In the 1940s, Hope pedaled a bike with Bing on the handlebars to publicize one of their famous "Road" pictures.
Photographer:
Joe McNally

Above, top

Bicycles make it easy to get around on the 45-acre backlot at Sony Pictures for construction and production crew members who need to travel from stage to stage and, sometimes, for busy stars. Executives usually travel in golf carts.
Photographer:
Diego Goldberg

Above

Don Simpson, 45, co-producer of such formidable box office hits as *Flashdance*, *Beverly Hills Cop*, and *Top Gun*, poses outside Maxfield, an exclusive clothing boutique and gift shop. Simpson points out that he usually dresses in jeans, but tonight he was on his way to a premier.
Photographer:
Merlyn J. Rosenberg

Risk at the Helm

From an interview with Joe Roth, Chairman, Twentieth Century Fox

In the job I have now as chairman of the studio, managing a $2 billion, 1,300 person company that makes, markets, and distributes 25 movies a year, my basic actions are reactions. Much of my job, as opposed to when I was strictly a producer or director, which is about creating, is now about reacting to ideas. It's the difference between playing offense and defense in a football game. There's a sense that you're on a giant ship and you're behind that little wheel.

The amount of pressure and the amount of pain in a job like this is enormous. Of the 25 movies you put out in a year, five or six are going to work, another five or six are going to be all right, a slight disappointment, and everything else is going to be somewhere from a disappointment to a tragedy—and that's considered a good year. The last two years have been the number one and number two years in terms of operating profit in the 77-year history of Twentieth Century Fox, and still the amount of disappointment is staggering.

I miss directing and producing and I think eventually I will go back. When you're on a movie, it has its own life. The process has a beginning, a middle and an end. When you're finished with it, you go on to something else. Here it continues every day. At any given time, 15 movies are being prepared, 80 scripts are being written, four movies are shooting, and three are in post-production. When *Home Alone* opened, I was past its success on the third day. I was already worrying about the next seven pictures. There isn't much time to savor the victory.

I try to get the idea right first and do the math second, as opposed to doing the math first and the idea second. I try to think through the movie before I figure out the business part of it.

Everything changed with *Star Wars*. When people started to see that you could make a return of 100 times your investment, Wall Street got real interested in Hollywood. There's always been a very delicate balance between the financiers and the creative people. *Star Wars* tipped the balance in favor of the bankers. That's where we are now. The bankers are inside the walls.

In the old days, a studio head made his movies, and everybody was under contract, and he did what he felt was right, and after 200 movies you could evaluate how he had done. Now ideas are too quickly evaluated in terms of their profitability, and I think it's a lot more difficult to figure out the business than that. When this turned into a megabucks industry, the trigger on creativity got shorter.

Can this be changed? The only way to reverse it is if there's overwhelming evidence that it doesn't work. We obviously don't make enough good movies, because there aren't enough hits. When something pleases the audience, it does extraordinarily well. If we made more movies that pleased the audience, we could sell more tickets.

Look at all the wonderful, really memorable movies over the past 10 or 15 years. More often than not, you'll find a real struggle to get the picture made. There's something wrong with that. Time and time again, a movie that really breaks the mold is much harder to get made. But if you shut off that avenue, you're just going to narrow your audience. Sequel after sequel. You don't widen your audience that way. The way to broaden the audience is to take risks.

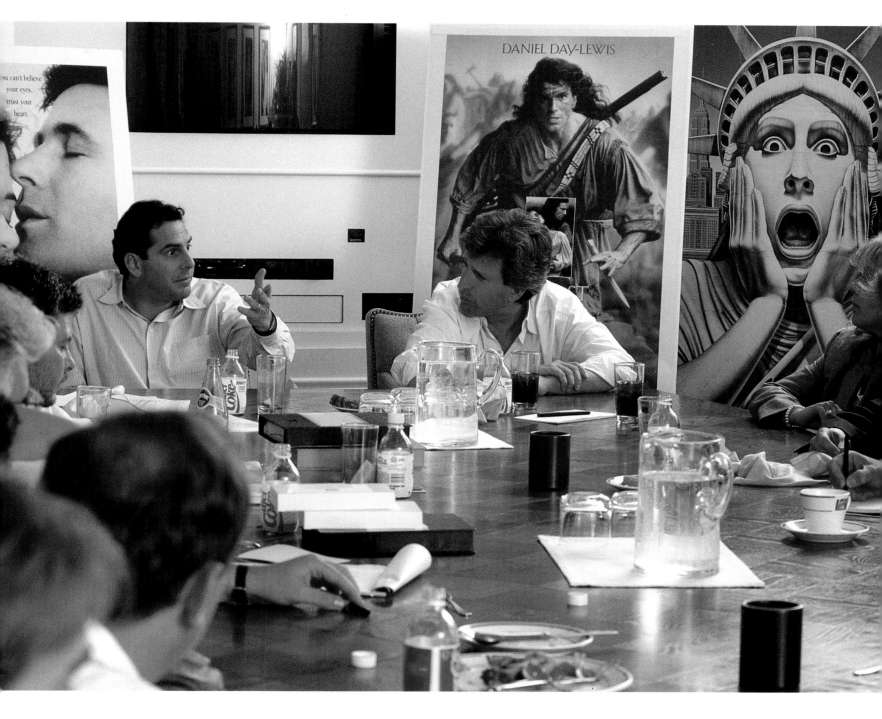

Above

Executives at Twentieth Century Fox attend a monthly marketing meeting to review the trailers, posters, print ads and TV spots for *Prelude to a Kiss, The Last of the Mohicans, Home Alone II,* and *Unlawful Entry*. At the head of the table are Roger Birnbaum, President of Twentieth Century Fox International, and Joe Roth, Chairman of Twentieth Century Fox.
Photographer:
Douglas Kirkland

Rick Smolan

David Butow

David Butow

In Hollywood you don't have a meeting, you take it. A simple turn of phrase, but one which hints at the riches and glory that can accrue to those who master the art. Pitch meetings, marketing meetings, creative meetings, agency meetings—these are the places where ideas are floated, decisions taken, careers made and wrecked.

At top, producer Brian Grazer welcomes a pitch by writers David Sheffield and Barry Blaustein for a comedy boxing film to be called *Knockout*. Thirty-five agents in

the motion picture department at the William Morris Agency (*above*) crowd into their regular Wednesday-morning executive meeting. Sidney Ganis and John Kehe (*facing page, top*) meet to consider poster designs for the movie *Hero*. Meanwhile, producer actress Diane Ladd attends a pre-production gathering to discuss the film *Mrs. Munck* and art directors at BLT design go over preliminary ad treatments for the TriStar picture *Mr. Jones* (*facing page, bottom*).

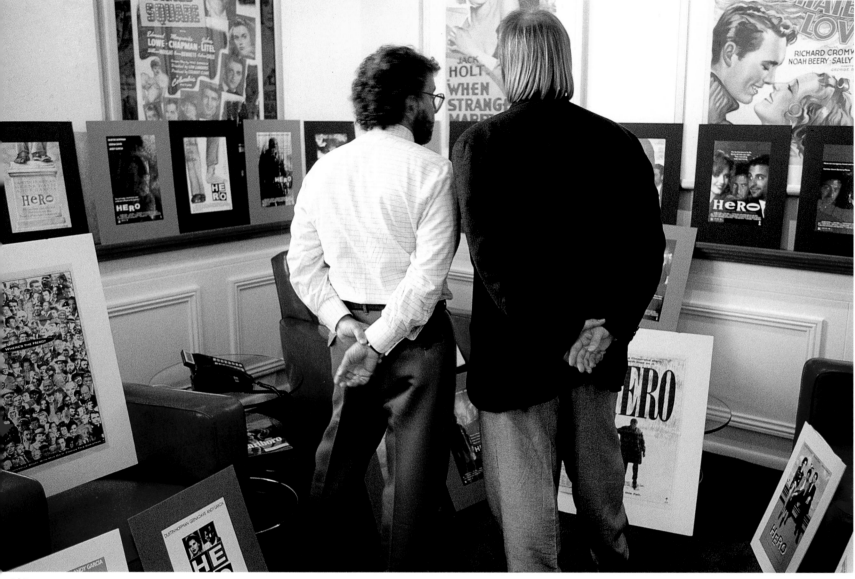

David Burnett

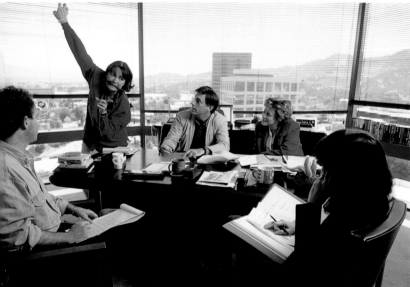

Michele Singer

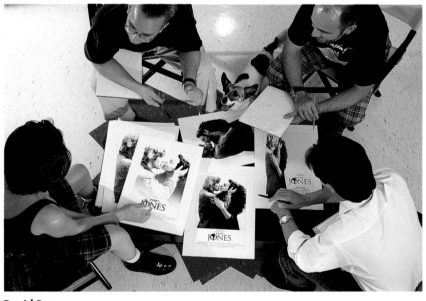

David Butow

Diego Goldberg

On the Backlot with a Sony Walkman
By Linda Sunshine

My assignment was to spend May 20 on the backlot of a major movie studio and write about what goes on behind the scenes. Here are a few of the fantasies I had about this job: Hobnobbing with producer/directors like James Brooks, Rob Reiner, and Penny Marshall. Bumping into Jack Nicholson, Geena Davis, Nick Nolte, and Barbra Streisand. Catching a glimpse of Warren Beatty changing his baby's diapers. Lunching next to Arnold Schwarzenegger. Discussing films with Martin Scorsese. Selling this essay to the studio. Casting Michelle Pfeiffer to play me in the movie.

I was assigned to the Sony Pictures lot. Once upon a time, it belonged to MGM, so I would be spending the day where *Gone with the Wind* was filmed, where Mickey Rooney repeatedly said, "Let's put on a show!", where Myrna Loy and William Powell drank martinis and walked their dog Asta. My first stop would have to be the hedge near the Irving Thalberg building where Katharine Hepburn was introduced to Spencer Tracy and she said, "You're rather short, aren't you?" (The producer Joe Mankiewicz replied, "Don't worry honey, he'll cut you down to size.")

While the old MGM lot does not have spacious, charming areas recreating western towns or New York streets, it has a more spectacular history than any other lot in Hollywood. This is the studio built by the original Fisher King, Louis B. Mayer; the unequivocal apex where there were more stars than there are in heaven. Sony may be the landlord here, but, once past the gatekeeper and the sign at the door, all of the streets and buildings are named for the old MGM stars: Joan Crawford, Greta Garbo, and Judy Garland.

Judy Garland's former office is now occupied by Clyde Phillips, who currently writes and produces the television show *Parker Lewis Can't Lose*. The two-story building is buried deep within the canyon of sound stages on the backlot. "From this office window," says Phillips, "I have watched *Hook*, Stephen King's *Sleepwalkers*, and Bram Stoker's *Dracula* come and go. I've seen pirates, horses, vats of blood, aliens, Nicholson and DeVito, flapper girls, and old-time teamster trucks. It's a bit like being in a time machine. I just sit here, but the world goes by at a century an hour out there."

The real-life movie playing outside Phillips's window is what I expected to see during my day at the studio but, unfortunately for me, May 20, 1992, was not a happening day, as they say in Hollywood. No movies were being shot, no movie stars were being made up, no fat men with big cigars were sitting around screaming, "You'll never work in this town again!" Here's what I discovered after spending a day in Hollywood: sometimes nothing happens here. But, to be fair, even the boredom has a different texture in Hollywood, because this is a town fueled by the promise of possibility.

"Hollywood is a business that employs tens of thousands of people," says Phillips. "I'll be walking across the lot at 10 o'clock at night and I'll hear echoes of my show throughout the sound stages, because somebody up there is working in some little room. That's not a very glamorous job; neither is the job of some guy who's a teamster or a driver. But, you know what? I'd rather be a driver in Hollywood and get the chance to drive Dustin Hoffman or Robert Altman than be a driver out there in the real world." So would many other people who work on this lot.

Of course, droves of people come to Hollywood to be movie stars. (Frank Lloyd Wright once said: "Tip the world over and everything loose falls into L.A.") But there are also scores of other people who come to Hollywood to do the everyday work of the movies. Take Matt Moss, for example. Matt is a welder who runs the metal shops at Sony. He has worked at Warner, Universal and Paramount. Most recently, he built the staircase for *The Fisher King*, the stairs in *Honey, I Blew Up The Kid*, and the structure inside the immense staircase on *Edward Scissorhands*. Moss became interested in building sets when he took a tour of the Universal studio at the age of eight. Just like a wannabe actor, Moss migrated from Tennessee in order to be involved in the movies. Call him a wannabe welder.

In some measure, the essence of Hollywood is about going after your dream and holding on if you find it. Craig Gentry is a second-generation set painter on the lot. His dad worked at Warner Bros., his daughter works in the makeup department at Warner, and his son is learning the craft of set painting at Columbia. "It's not like painting houses, it's artistic," claims Gentry. "We do character aging, graining, marbleizing, whatever the era of the picture. I go to the movies to see my sets. They give us a little screen credit: Set Painter. Stand-by Painter. I feel like I'm in the movies." When he can, Gentry also works as a movie extra. "I was in *S.O.B.* and *The Great Race*," he says with pride. "I played a painter." Call it type-casting.

The ghost of productions past makes work in a movie studio different from work anywhere else in the world. John Angelo is employed in the warehouse, but he started as a dancer on Broadway and, at 11, was dancing at MGM in movies starring Gene Kelly and Cyd Charisse. *Les Girls* was his last film. Later in his career, he choreographed Las Vegas shows. "I did acts for some of the best stars, and then one day a friend of mine called and said, 'Would you like to work in the prop department?' And so, 15 years later, here I am pushing a broom in the prop department."

Unlike warehouse workers in other parts of the world, I suppose, Angelo loves his job. "I have fun with the work and I still feel connected to the movies. I know a lot of people on the lot and see all my old friends, the old dancers. I belong to the gypsy society—all the old dancers who get together once a year. I keep up with all my friends in the business. You have to. They're your links and once your links go, you're gone."

All through his years in Hollywood, John has taught drama. Three of his students teach his acting method in universities. "I studied with the greats—Sandy Meisner, Uta Hagen, the original Actors Studio when Eli Kazan was there," John says. "I teach acting classes for children and adults, professional and non-professional. I also write children's plays. My latest is called *Santa Claus Goes on Diet*. I feel the business has given me something, and now I must give something back by teaching other people. It's a give and take world, and if we take too much, it's going to take us."

Dedication and passion are the hallmarks of working on a backlot. Audrey Blasdel-Goddard has been with Columbia for 22 years, and she is currently in charge of Property, Greenery, and Drapery. She hasn't taken a vacation day in nine years. "I love this business and I feel like I'm in the movies too. If you don't feel like you're in the movies, you don't belong here. Nobody that I know works just for a paycheck. I mean, yes, you do that, too. But that really isn't your prime reason for being here. I have a masters in sociology but all I ever wanted to do was to be in this business. If you work in our field, it doesn't matter where you work, you're in show business."

Sid Ganis, President of Marketing and Distribution, not only thinks of himself as being in show business but describes himself as a showman, and he talks like one, too. "Show business, it's a business, yes, that comes from the outside and it's about show, too, and that comes from the inside," he told me. "I don't know how to explain it and it probably won't make good copy, but I was in New York city recently and we saw *The Will Rogers Follies*. Two-thirds of the way through it, I turned to my wife and said, 'It's about show business! I love show business!' (Now Sid is practically yelling, thumping his hand emphatically on his knee.) I forget how much I LOVE show business. It is a spotlight—everyone wants to be in the spotlight. It's inexplicable. I guess it's about ego, I guess it's about validation. I guess it's about heroics."

People here get really enthusiastic when they talk about their work, and Sid's comments reminded me of a recent article in *Vanity Fair*. Warren Beatty was asked to define success, and he replied, "You don't know if you're working or playing."

Several rungs down the corporate ladder and less of a showman is Doug Belgrad, a Creative Executive at Columbia Pictures. At Columbia, there are only three Creative Executives. In fact, according to Doug, there are only 30 to 50 Creative Executives in the entire industry.

He describes his job like this: "I read scripts, write notes, attend meetings, and talk on the phone." Talking on the phone is a major responsibility of any Hollywood executive. Phones are everywhere, in cars and hip pockets. In Hollywood, telephones are even fashion accessories.

Technology runs rampant on the Sony lot, probably more so than at any other studio. Sony engineers helped design the post-production facilities here and, according to Steve Cohen, manager of sales and marketing for these facilities, there's no other digital sound system like this one anywhere in the world. The room rents for $900 an hour. *Basic Instinct* was the last major film they dubbed in this room, and it took two-and-half months of eight-hour days. (Figure it out.)

The system is certainly impressive. The digital control board scales the entire room, a mass of buttons, lights, gizmos—in short, a techie's dream come true. On this day, engineers were working on *Mo' Money*, the new Damon Wayans film. They were preparing the film for foreign dubbing by taking out all the dialogue and music but putting back all the background sounds—footsteps, doors creaking, keys jingling, the general walla-walla or background noise of people coughing or the occasional car honk. It was interesting to watch for twenty minutes but, like many jobs on a movie lot, unbelievably tedious and time-consuming. No wonder there was a pool table in the room to cut the boredom between reels.

I wouldn't have minded playing a quick game of eight-ball myself. My day at Sony was winding down and I had yet to see one famous movie star. The closest I'd come was five minutes in the executive dining room of TriStar. At the last minute, Mike Medavoy, chairman of TriStar, had granted permission for a photographer to shoot a picture of him having lunch with Fred Spector, an agent from CAA. I tagged along for the event.

I did a quick survey of the room and can report that the walls of Medavoy's dining room are covered with dozens of framed photographs of him and such stars as Goldie Hawn, Steven Spielberg, Dr. Seuss, and Danny DeVito, and that both executives had a salad for lunch. While we waited for the waiter to appear for the shot, Medavoy began speaking fluent Spanish to the photographer, Diego Goldberg. Medavoy told him that

he'd lived in Chile until he was eight years old. I wanted to ask what it was like to be a young Jewish boy in Chile, but by the time Diego translated the conversation for me we were out of the building and across the parking lot. So much for investigative reporting.

By 6:00 p.m., the studio was closing for the day. Most of the people leaving the Irving Thalberg building carried jam-packed briefcases, and many of them had beepers attached to their belts. I thought it might be interesting to talk to some of the men and women who clean the offices late at night and literally get the inside dirt on what one finds in the garbage cans of the rich and powerful in Hollywood. But then I learned that the cleaning staff only spoke Spanish, so I had to abandon the idea—although it occurs to me now that I could have asked Mike Medavoy to act as my interpreter. (Not!)

I was feeling kind of disappointed when, only moments before I left the back lot, James Brooks drove by in a golf cart. It had taken all day, but, still, it was a thrill finally to spot someone from my fantasy list.

In one of the all-time great films about movie fantasies, *The Purple Rose of Cairo*, Mia Farrow falls in love with a fictitious movie hero who takes her hand and lifts her onto the screen. She says, "My whole life I wondered what it was like on the other side of the screen." Me, too.

So, did my day at Sony change the way I look at the movies? To find out, I went to see *Basic Instinct*, a TriStar release, that evening. This film had almost caused a riot when it opened in my neighborhood back home. Aside from the repulsive ice-pick scenes, I was unimpressed by this bisexual-on-a-murderous-rampage saga, but maybe I wasn't in the right frame of mind to judge. As I sat watching the movie, all I could hear was the sound of leather heels on pavement, keys jangling, doors creaking shut. The dialogue and music faded into the background while all the movement sounds seemed to dominate the sound track. My perspective had changed, because now I knew about the guy who sits at a control board all day making sure that the creaking door sound is appropriately eerie or that the jangling keys have the proper tonality. I felt like Alice on the other side of the looking glass. I felt like an insider. I felt like I was in the movie business, too.

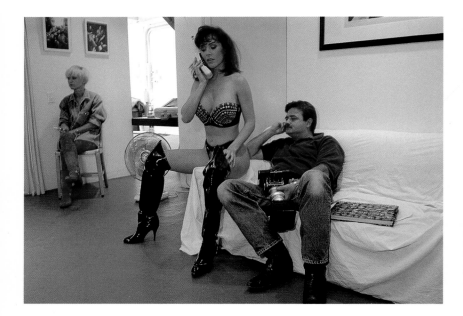

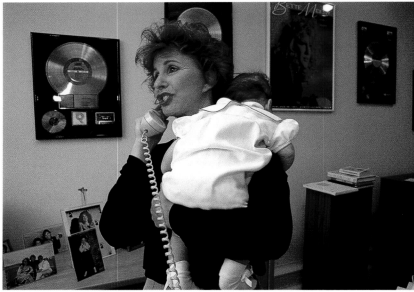

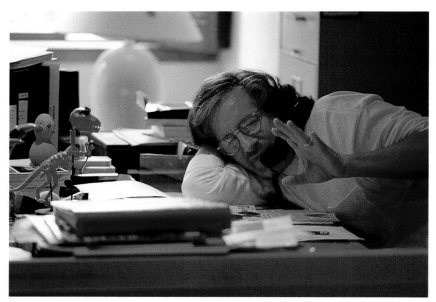

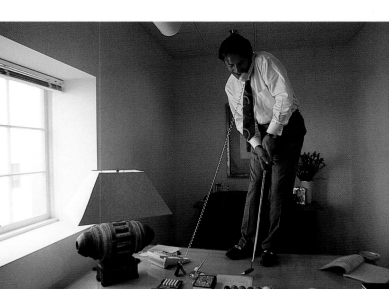

Preceding, pages 64-65
Stephanie Robinson, marketing and special-projects assistant to Sony's Sid Ganis, spent part of her day on May 20 squiring visiting photographers around the Culver City backlot. With her mobile phone, beeper, and Filo-Fax, any old crate in any old vacant sound stage could serve as an instant office.
Photographer:
Diego Goldberg

Above, top
Taking a break from a photo shoot for *Easy Rider* magazine, model Summer Knight chats on the phone with her boyfriend and X-rated co-star Nicholas Rage while photographer Raiko Hartman and make-up artist Christine Copeland wait for the next camera setup. Summer was spotted by *Penthouse* while working as a g-stringed hot dog vendor in Florida. At 31 she made her adult-magazine modeling debut and has since appeared in 25 XXX-rated films and videos.
Photographer:
Peter Turnley

Above, bottom
Steven Spielberg borrows a phone in the art depart-ment at Amblin, his production company, to return one of the innumerable calls he receives every day. His first assistant, Bonnie Curtis, estimates that 80 percent of his calls are legitimate, and the remainder are from strangers—many of whom impersonate such people as Martin Scorsese or Sharon Stone in order to get through to him. She adds that the fake calls are rarely threatening; mainly they're from fans or aspiring filmmakers.
Photographer:
David Hume Kennerly

Above, top
At All-Girl Productions, based at the Walt Disney Studios, Bonnie Bruckheimer often brings her daughter Miranda to meetings and cuddles with her during phone calls. On May 20th, Bruckheimer was making plans for Bette Midler's appearance on one of the last *Tonight* shows to star Johnny Carson, which aired on May 21.
Photographer:
Annie Griffiths Belt

Above, bottom
Actor Don Johnson attempts to sink a putt into a coffee cup in his office at Paramount Studios. Best known for his role as Sonny Crockett on *Miami Vice*, Johnson is also a producer. He is currently developing a half-hour pilot called *Flip Side* and a television movie entitled *In the Company of the Dark*. His next acting job is a remake of *Born Yesterday* co-starring his wife, Melanie Griffith.
Photographer:
Joe McNally

Right
Mandi Medrich, 23, wh‹ teaches at the Sunset Ranch in the Hollywood Hills, sits astride Mac (h‹ full name is Macaroni but his owner prefers th‹ diminutive) while talking to her boyfriend, Hutch Work. Mandi spent the morning training actress Vivian Wu for her riding scene in a Teenage Mutant Ninja Turtles sequel. Clients pay $20‹ per month to board thei‹ horses here; phone calls (from the convenient pa‹ phone) are additional.
Photographer:
Ken Duncan

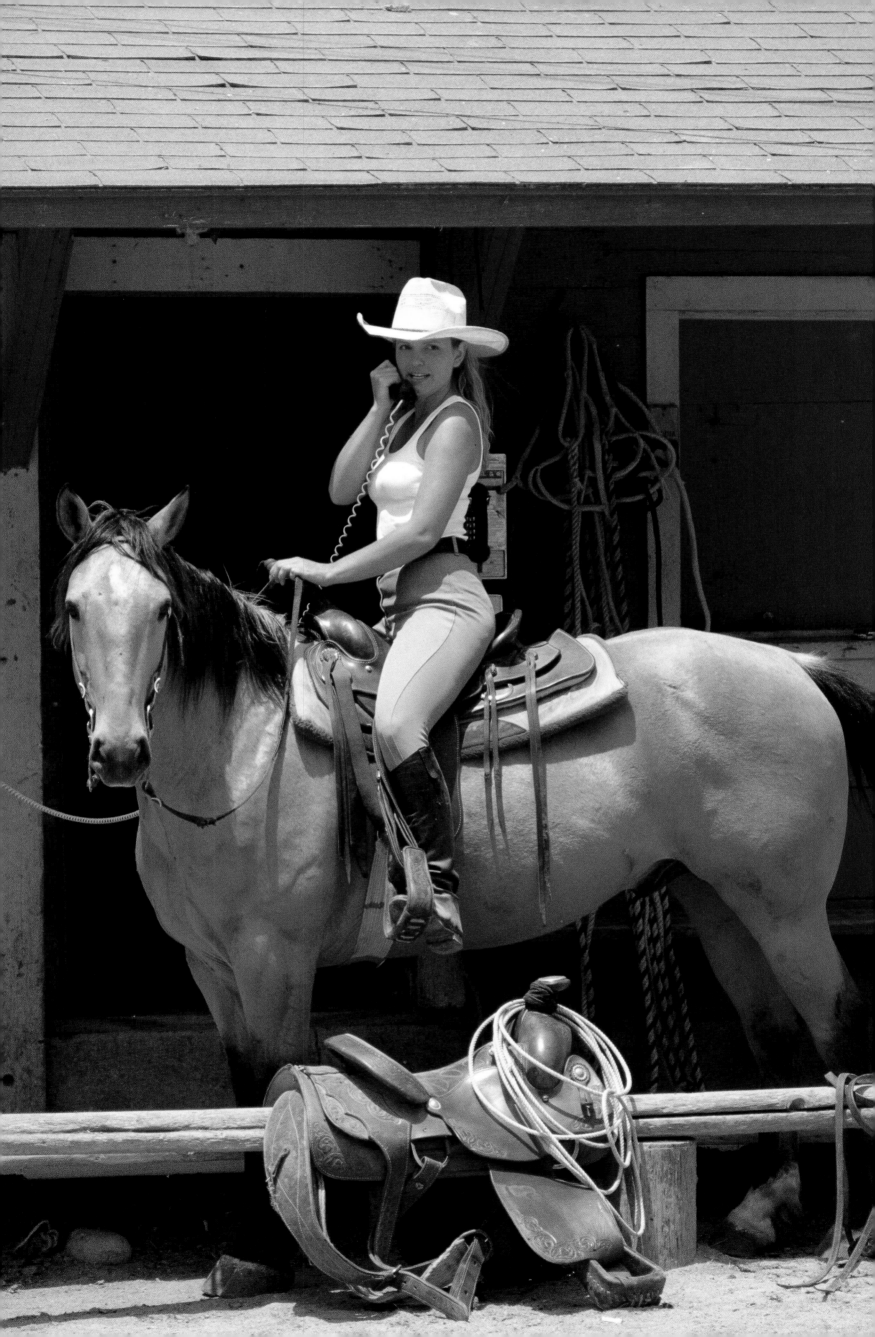

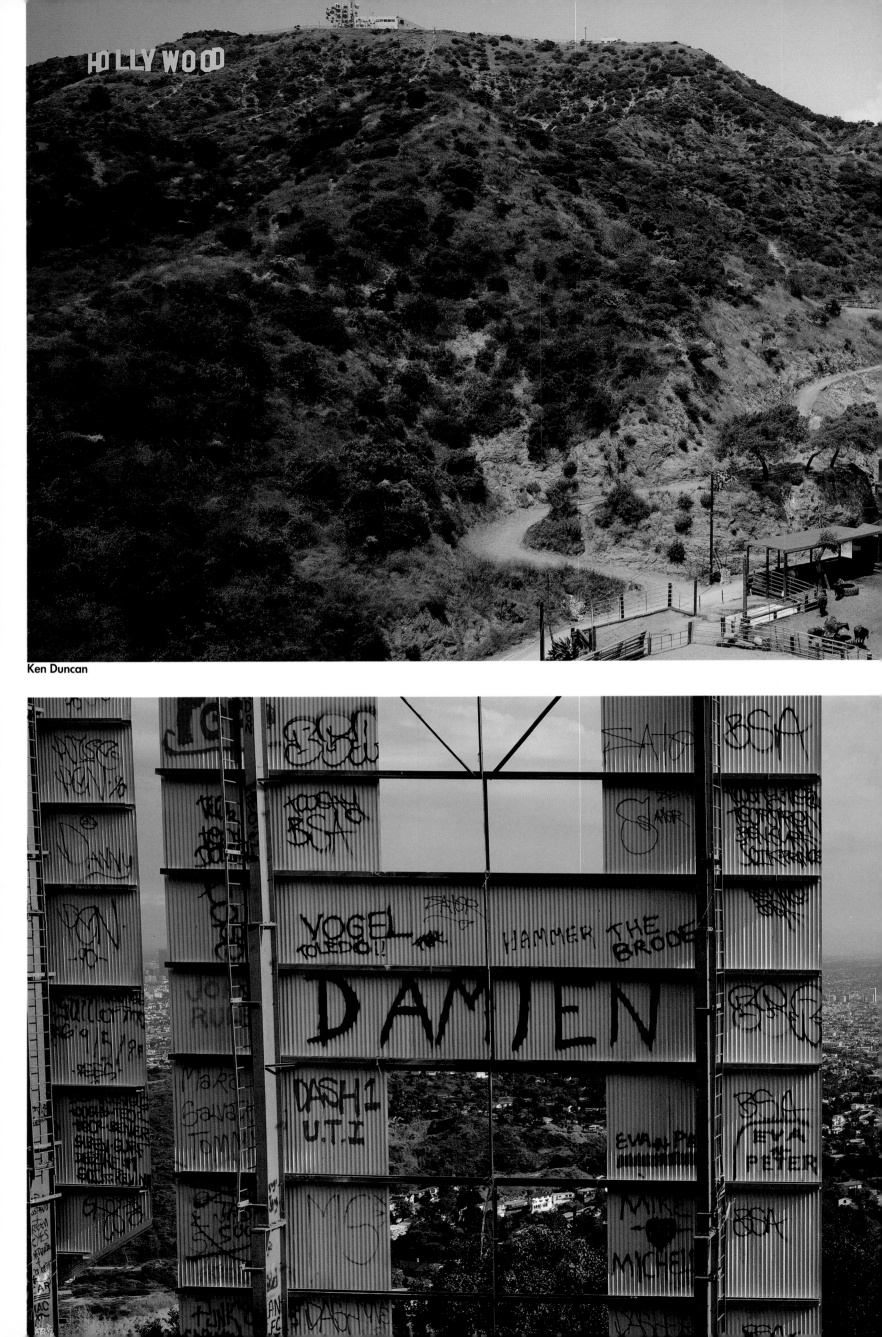

Ken Duncan

Peter Sorel

Preceding, top

The Sunset Ranch may look like a movie set, but it is, in fact, a working stable. For the past 100 years, the Sunset has been renting, training, and boarding horses; today it boards 60 head for rental and 25-30 for private owners. And what a location: the stable is next to the Hollywood sign and just minutes away from the Paramount, Universal, Warner Bros., and Disney studios. Casting directors bring hopefuls here to test their riding abilities, and the ranch is often used as a background for commercials, print ads, and TV and movie shoots. A few early episodes of *Beverly Hills 90210* were shot here, as were several Playboy videos.
Photographer:
Ken Duncan

Preceding, bottom

Each letter in Holly-wood's most famous landmark stands 50 feet high and 30 feet wide. Built in 1923 at a cost of $21,000, the sign, which originally read "Hollywoodland," was intended as an advertis-ing gimmick to attract buyers to a housing subdivision in Beachwood Canyon. In 1973, the City of Los Angeles declared the sign an historic cultural landmark. For many observers, though, the sign symbolizes the decadence of Hollywood; Nathanael West called it a "mammoth metal monument to this mecca of broken dreams." So it was for actress Peg Entwistle, who jumped off the letter "H" in September, 1932, at the age of 24. Contrary to popular rumors, Miss Entwistle's is the only recorded suicide from the landmark.
Photographer:
Peter Sorel

Right

The entire staff at Creative Artists Agency poses in the atrium lobby of their new $15 million I.M. Pei-designed headquarters at the intersection of Wilshire and Santa Monica Boulevard, an edifice which has been called "a Chanel suit amid polyester jumpsuits ... maybe the most beautifully made modern building Los Angeles has ever seen" by Paul Goldberger in the *New York Times*. The 26-foot-high mural by Roy Lichtenstein, based on Oskar Schlemmer's "Bauhaus Stairway," was commissioned especially for the space and painted on site. The sculpture in the background, "Crawling Cross," by John Chamberlain, is a recent addition. Founded with a $21,000 bank loan in 1975 by Michael Ovitz, 45, front and center, Ron Meyer, 47, to Ovitz's left, and Bill Haber, 49, who was in New York as this picture was taken, CAA today has a roster of 700 clients including Tom Cruise, Madonna, Sylvester Stallone, Robert De Niro, Steven Spielberg, Oliver Stone, Martin Scorsese, and Barry Levinson.
Photographer:
Henry Groskinsky

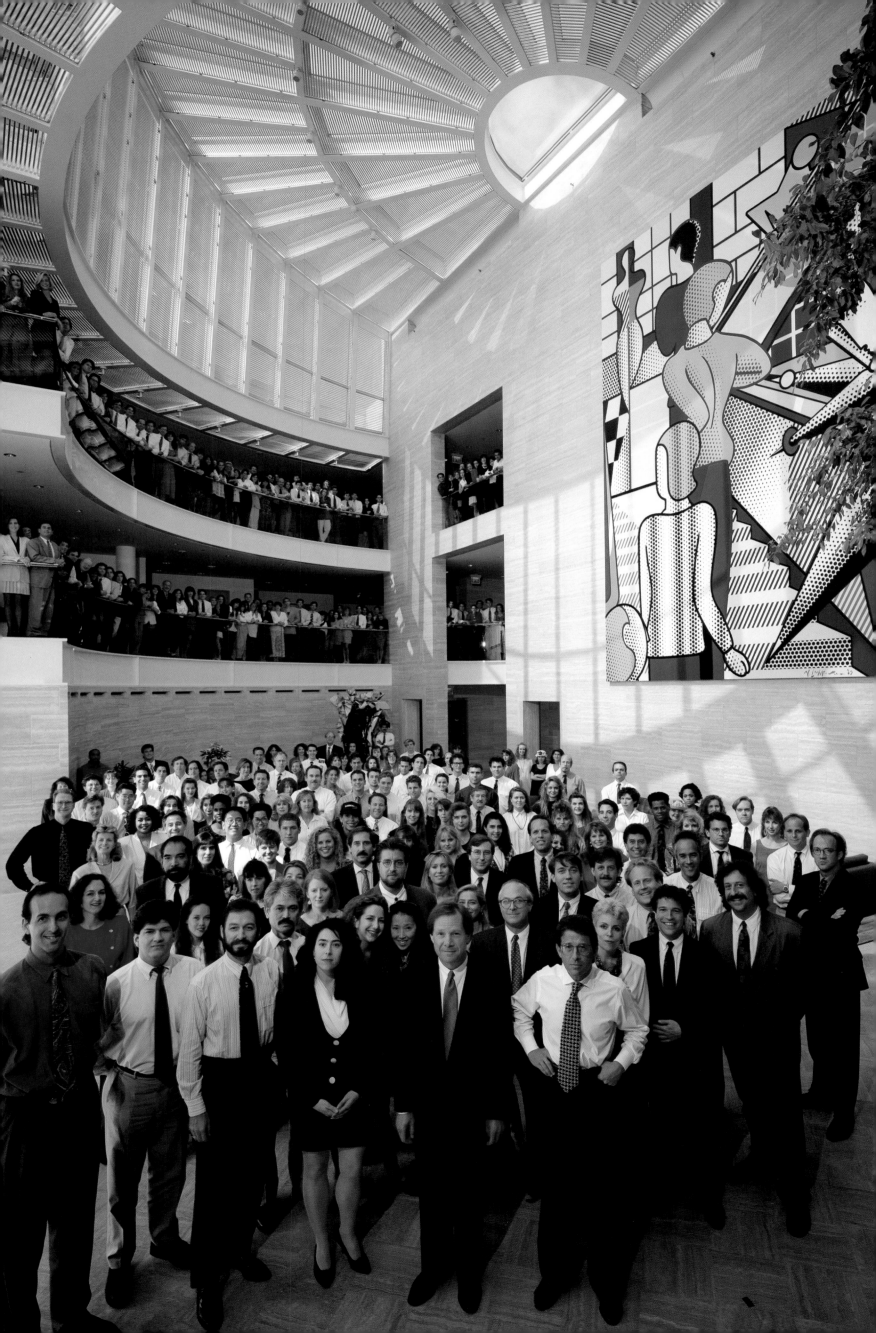

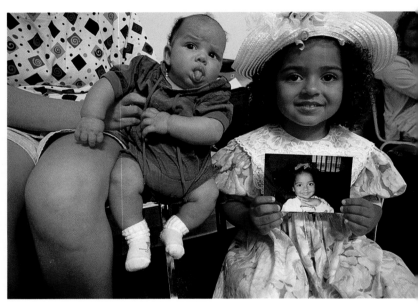

Above and right

At the Sheila Manning Agency, Brittany Smith, 5 (*left, top, with Sheila Manning*), Ashley Brown, 3 (*right, bottom*), and Rachel Heidt, 6 (*opposite*), audition at a "blind" casting call, where the client asked to see little girls dressed "disgustingly cute, as if for a beauty pageant." Manning thinks the ad agency was probably representing a clothing manufacturer, but the real purpose was kept secret from her. For this call, Ashley brought along her brother,

3-month-old Jordan Wade, and Brittany wore her own tiara.

Meanwhile, Native Americans Vanessa Brown, Jim Elk, and Frank Sotonoma Salsedo (*right, top*) auditioned for a Knott's Berry Farm ad and "beachcomber" Lana Schwab tried out for a Long John Silver fast-food spot. The results? Vanessa and Frank got hired, Jim did not. Lana got the job, but was later dropped by the client.

And who brought the pig? Kit Parventi, 27 (*left, bottom*), actress and animal activist, never

goes out to audition without Luma (short for Petaluma), a 7-month-old Vietnamese pot-bellied porker. "Most actors in Hollywood do not spend their time in auditions, acting classes, with their agents, or working, but on the freeway, on their way to those places," Kit says, "and it's nice to have a pig snuggled next to you while you are driving." And perhaps for consolation, since Kit didn't get the job.
Photographer:
Dana Fineman

Following, pages 76-77

Dawn Jeffory-Nelson, 39 (with her back to the camera), leads a monthly workshop for actors who happen to be deaf. The group meets regularly to discuss technique and to share current events and issues. The night's agenda included a heated debate about the casting of a hearing actor to play a deaf role in the film *Calendar Girl*.
Photographer:
John Loengard

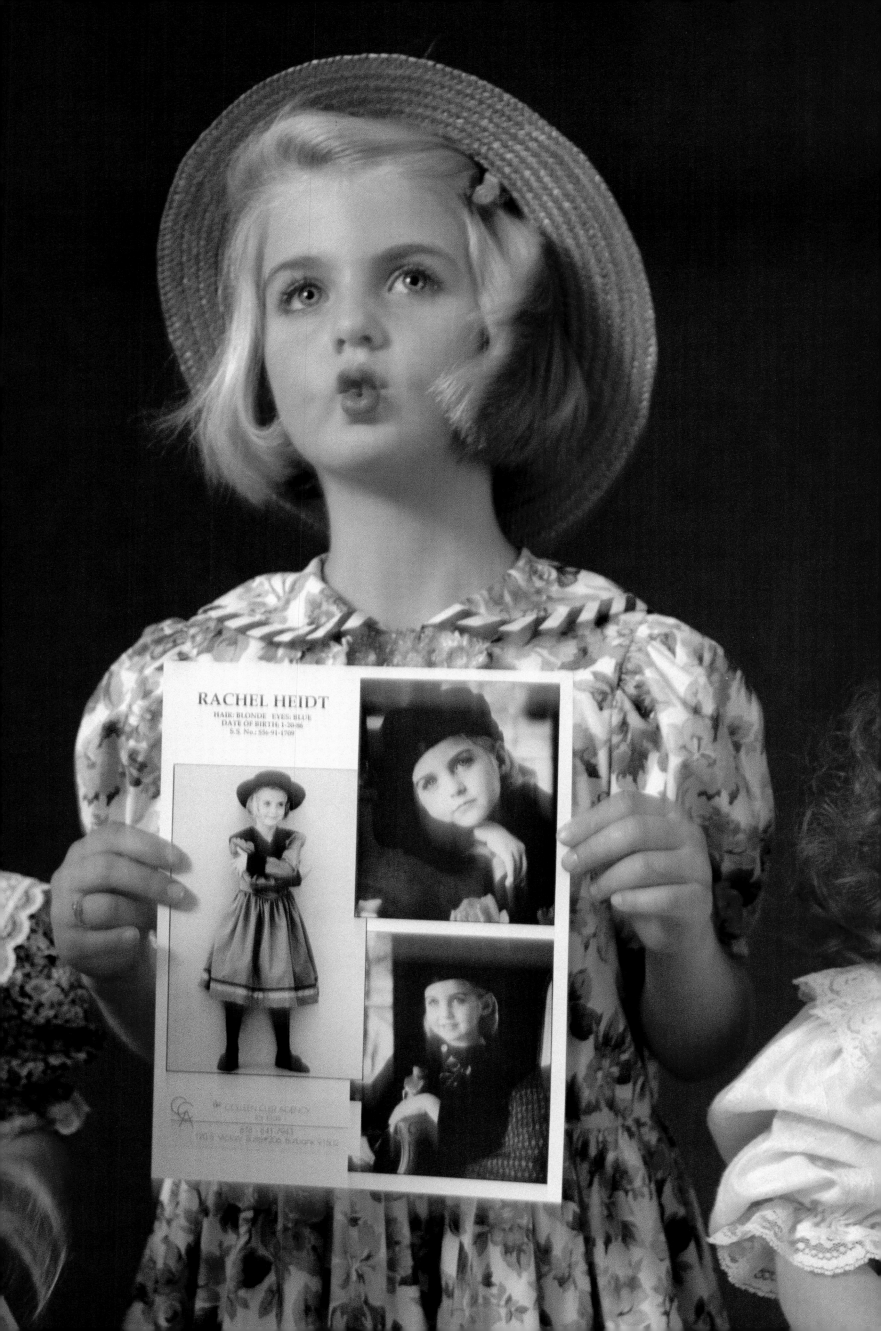

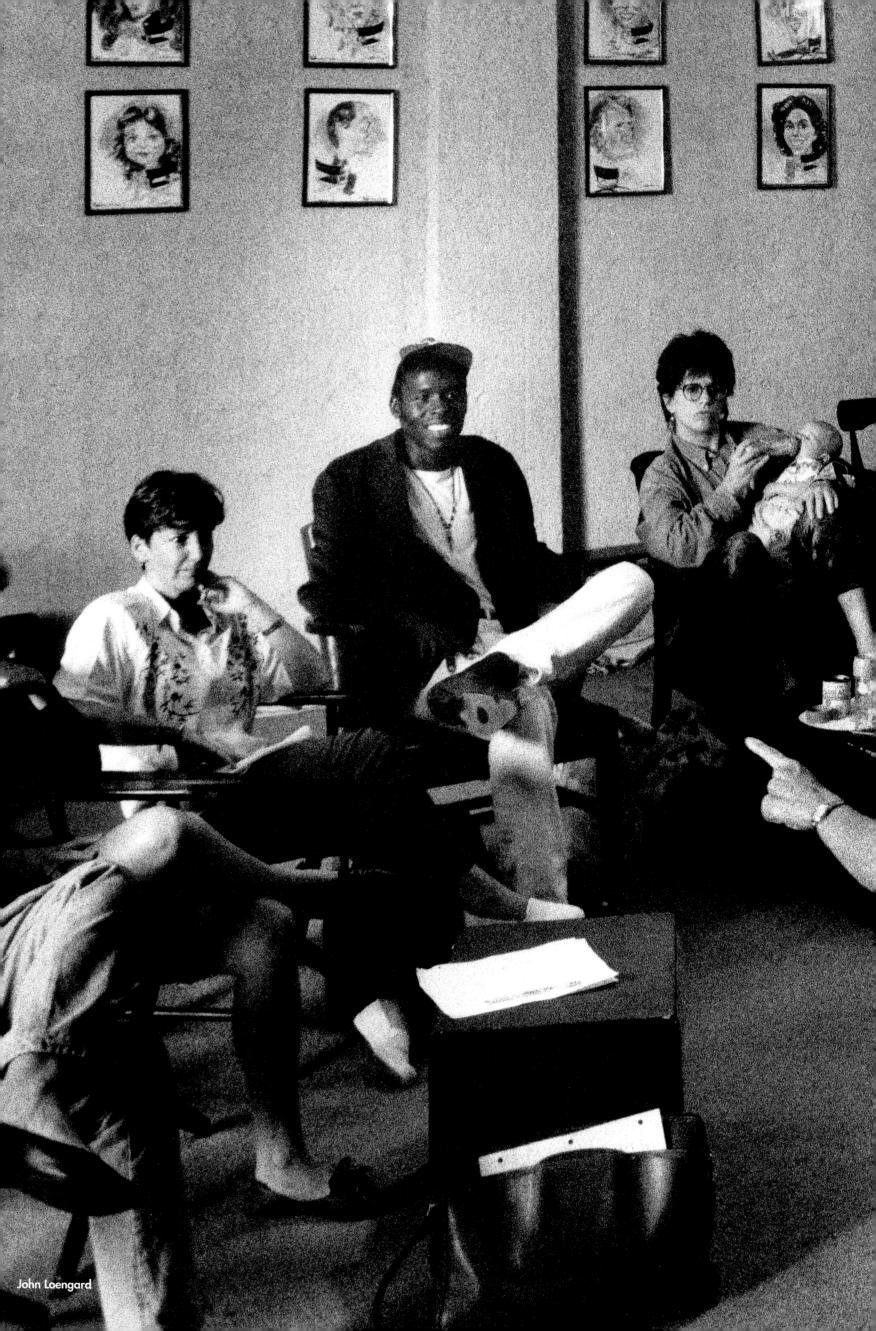
John Loengard

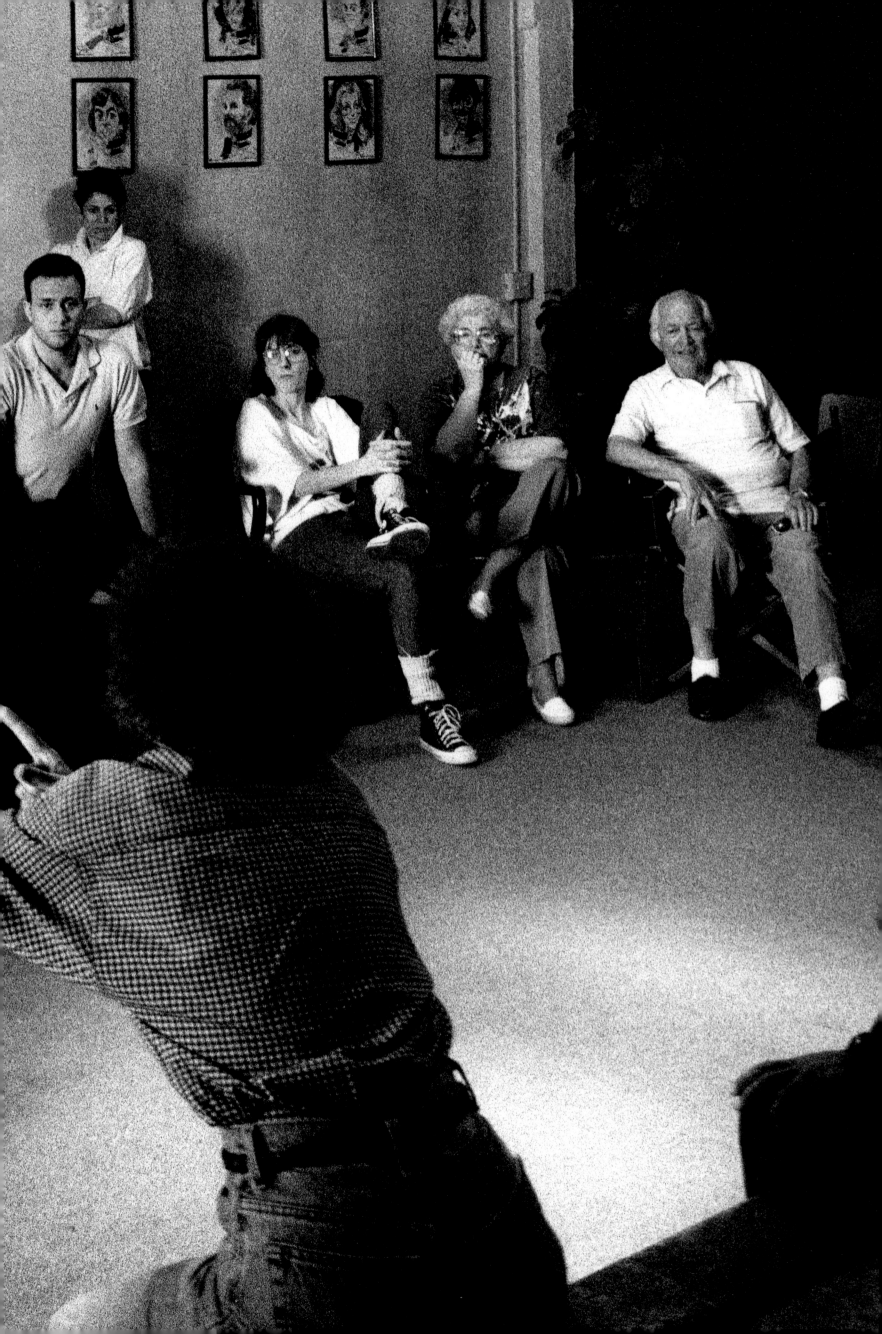

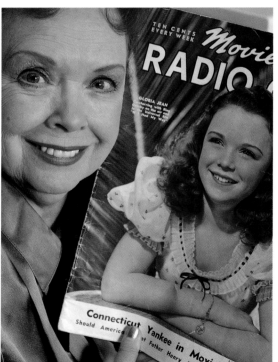

Above

Margaret Gardiner, left, and Angie McKinney, right, emote Tennessee Williams at the Wednesday evening performance class at the Estelle Harmon acting school. Founded in 1957, the funky, run-down school is the place where the Hollywood dream begins for many young actors and actresses. Harmon holds class size down to 20 students, who are each charged $505 per quarter. Some of her more successful graduates include Carol Burnett, Bill Bixby, and Sharon Gless.
Photographer:
Volker Hinz

Right

Former child star Gloria Jean, 64, holds a 1940 fan magazine on which she was the cover feature. Jean, who appeared in 40 movies, including *Never Give a Sucker an Even Break* with W.C. Fields, *If I Had My Way* with Bing Crosby, and *Copacabana* with Groucho Marx, saw her movie career stall and then dead-end in the early 1960s. For the past 26 years, she has worked as a receptionist at Redken Laboratories in Canoga Park, California.
Photographer:
Theo Westenberger

Right, top

Drama coach Helena Sorel trains Jasmine Lliteras, 12, who began modeling two years ago and worked so steadily that her mom and dad quit the real estate business and moved to Beverly Hills to manage her and her siblings Sunshine, 16, and Israel, 15. Though Sorel "does not expect great depth of feeling from a 12-year-old," she does "expect imagination ... if it's there, I will find it." Miss Sorel's former students include Marilyn Monroe, Cary Grant, Mitzi Gaynor, Rita Moreno and Robert Wagner.
Photographer:
Dana Fineman

Right, bottom

Aspiring child star Jamie Ann Slater, 6, pretends to be a dog after being asked to act like her favorite animal during an audition at the Sheila Manning Agency. Jamie who has worked professionally for about a year, goes on three casting calls a week. Her mother, Janet Slater, believes that since Jamie "has already been on so many job interviews, she's more prepared for the world than some people out of college."
Photographer:
Dana Fineman

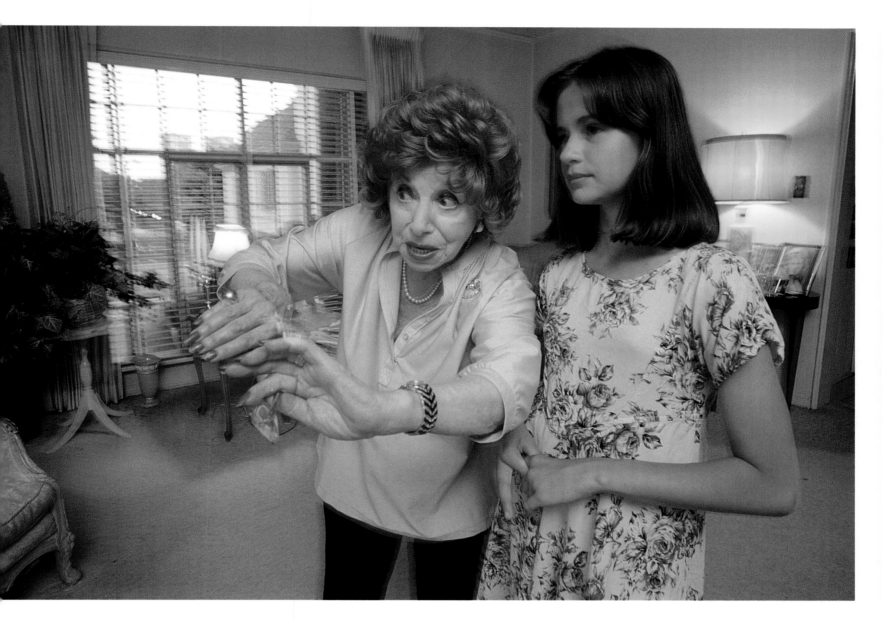

ollowing, page 80

"ve outlived my hair!" rieks comedienne yllis Diller, 75, in her ademark feathers and ight wig. Having built a reer around her looks, ller admits to two face ts, two nose jobs, cheek plants, a breast duction, a tummy tuck, eyeliner tattoo, and osuction. No wonder e was recently cognized by the merican Academy of smetic Surgery. A

mother of five, the author of four best-selling books, and an entrepreneur whose businesses range from jewelry to chili sauces, Diller began her career at 37 and was one of the first females to make it in stand-up comedy. Her rapid-fire comedic style may not be to everyone's taste, but Diller continues to work constantly.
Photographer:
Michael Grecco

Following, page 81

Can a newcomer stand out in a crowd without feathers or fright wig? For the past five years, casting director Lisa Fields has worked at Propaganda Films, one of the largest production houses of music videos (Michael Jackson), TV shows (*Twin Peaks*), feature films (*Wild at Heart*), documentaries, and commercials. At any given time, Fields is working on four or five projects; of the 500 head shots she receives a day,

300 are tossed if they don't "have an immediate effect." Casting today is changing, according to Lisa, from the whitebread American types of a few years ago to people who are more edgy, hip, and of mixed ethnic origin. She is proud of helping to discover John Corbett, the radio announcer on the hit show *Northern Exposure.*
Photographer:
Mark Richards

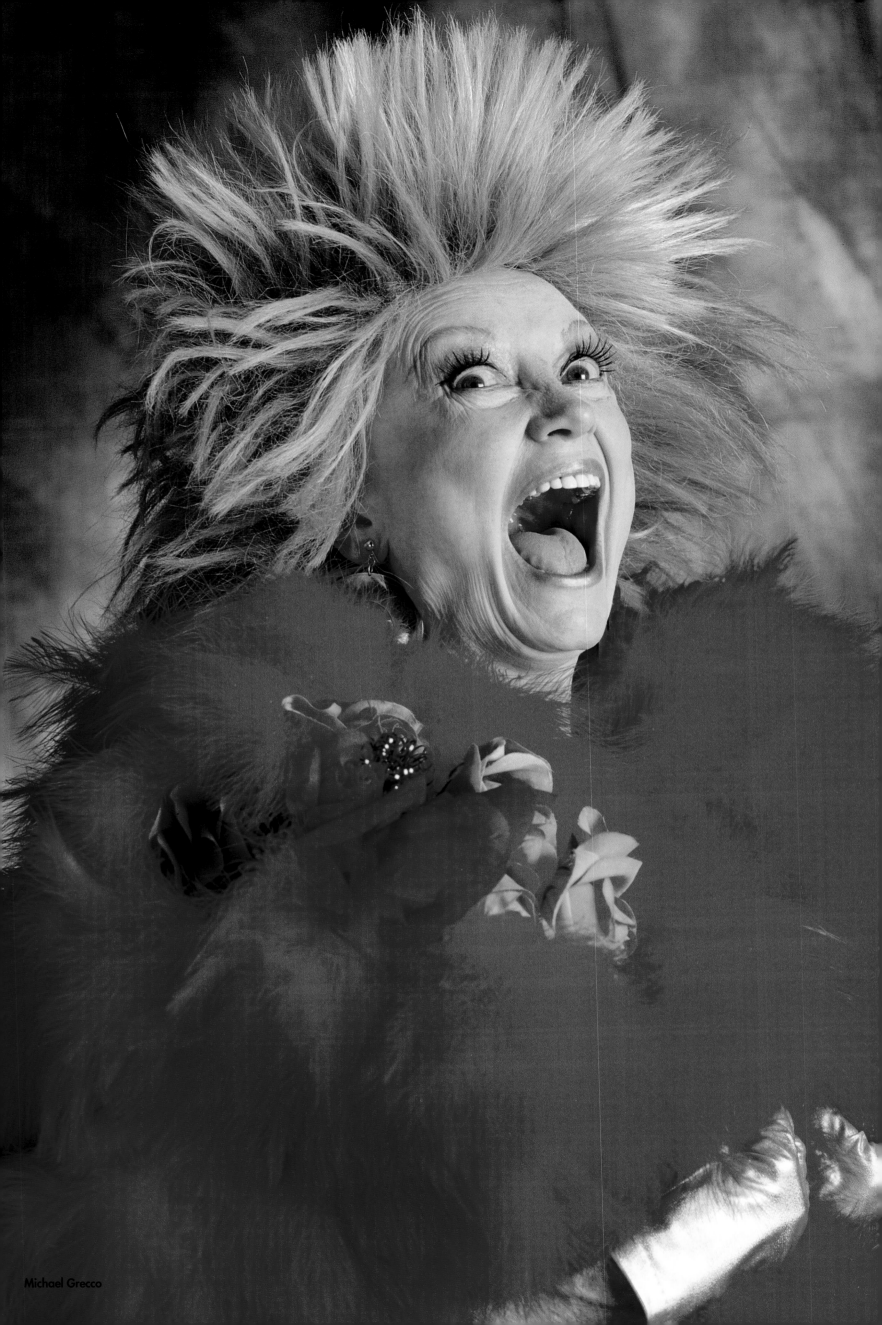

Michael Grecco

Mark Richards

Oportunity's Knocks

From an interview with Benny Medina, Warner Bros. Records executive

'm constantly surprised that what is either seemingly unreal or surreal becomes real. Just the fact that an idea today, a song today, a pitch today, a script today or a kid today could become a movie, a TV show, a hit record or star, is amazing. When I get away from Hollywood and the entertainment industry, I'm always surprised at how much of an effect the industry does have on the rest of the world.

To work in an arena like that is mindboggling. I don't think half of the people who are in the entertainment industry recognize how fortunate they are that they have positions in it. Unless you step outside of the immediate circle, then you don't realize how much of an effect you're having on different people. If you live in the center of the town, you only hear the town's gossip about what you're doing. But if you leave town, you hear what the world thinks about what you're doing, and that's decidedly different than the town's gossip or the town's comments or the town's criticism. It's bizarre because it's such a small community. It's not a community that's positive or communal in terms of pulling for each other. It's very competitive, and as a result it makes people a little insulated. It's a town insulated by its own self-importance.

The door for potential opportunity and success is constantly swinging open and shut. To step on the other side of it and find yourself in a successful position is really gratifying. But as soon as you get through that one door, there's another one swinging at you—and every one you take the chance on, you could potentially get trapped in. You develop this appetite to do more, to maintain a sense of competitiveness. Once you've seen one idea realized, you're like a mad scientist. You believe you can do it again.

If I ever thought about the difficulties of breaking into Hollywood, I never would have attempted it. To know how the business runs is, in my opinion, not an asset, because then you begin to follow the instincts of the business as opposed to your own. I think it's really important to be naive about the entertainment industry, in terms of creating things.

It's like looking at a mountain before you scale it. It seems impossible, so why present yourself with that impossibility before you even get started? Better just to go into it and see what the results are. You don't start off where you're going to end up. You've got to be patient with stuff you don't understand.

Right

Vaudevillians, exotic dancers, little people, look-alikes, magicians, musicians, and other "unusuals" gather at the Pasadena home of agent Coralei Junior, who places her clients in commercials, television shows, feature films, and theatrical shows both in the U.S. and abroad. She discourages her older performers from retiring: even at 101 years of age, her tap-dancing piano player can still perform, although the woman can no longer dance and play at the same time. "They die on stage, not in a rest home," says Coralei.
Photographer:
David Graham

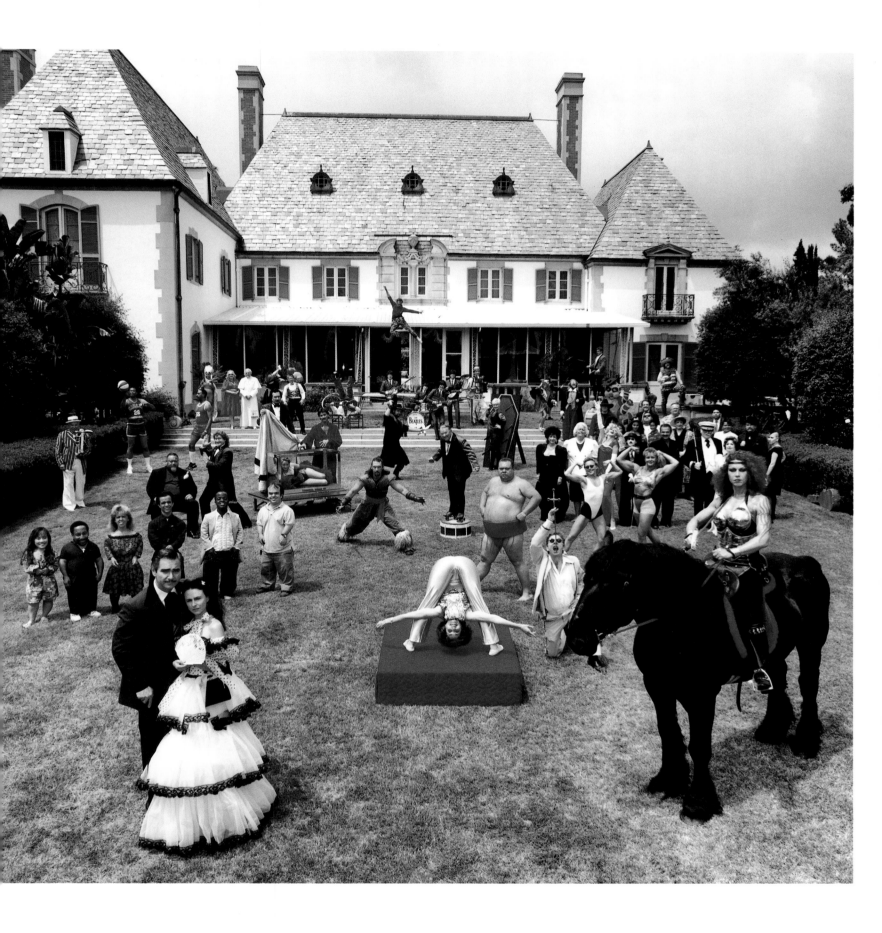

Right

At Repeat Performance, a store specializing in rentals of high-quality vintage clothing for movie and television shoots, costume designer Albert Wolsky stops for a moment to visit with the likes of George Raft, Gary Cooper, John Barrymore, and Joe E. Brown. Wolsky, who has won two Academy Awards, for *Bugsy* and *All That Jazz*, was shopping for a hat for Joan Cusack to wear in *Toys*. He designs clothes "through the eyes of the director" and likes using hats to give a sense of time and place. His favorite period for clothing? "Anything but today!" he insists.
Photographer:
Marcia Lippman

Following, page 86

Tina Ficaro and Tom Dickerson, motion picture costumers, hang costumes returned from the set of *Calendar Girl* in the Culver City wardrobe warehouse of Sony Pictures. With over 1.5 miles of hanging racks, the warehouse stores about 600,000 garments, including the $18,000 beaded gown worn by Annette Bening in *Bugsy*, a $50,000 fur from *Dracula*, and Madonna's baseball uniform from *A League of Their Own*. Some unique costumes also go on tour: the wardrobe from *Hook* is currently on display in Tokyo, *Ghostbusters* costumes decorate the Planet Hollywood restaurant in New York City, and the Smithsonian features costumes from *Glory*.
Photographer:
Diego Goldberg

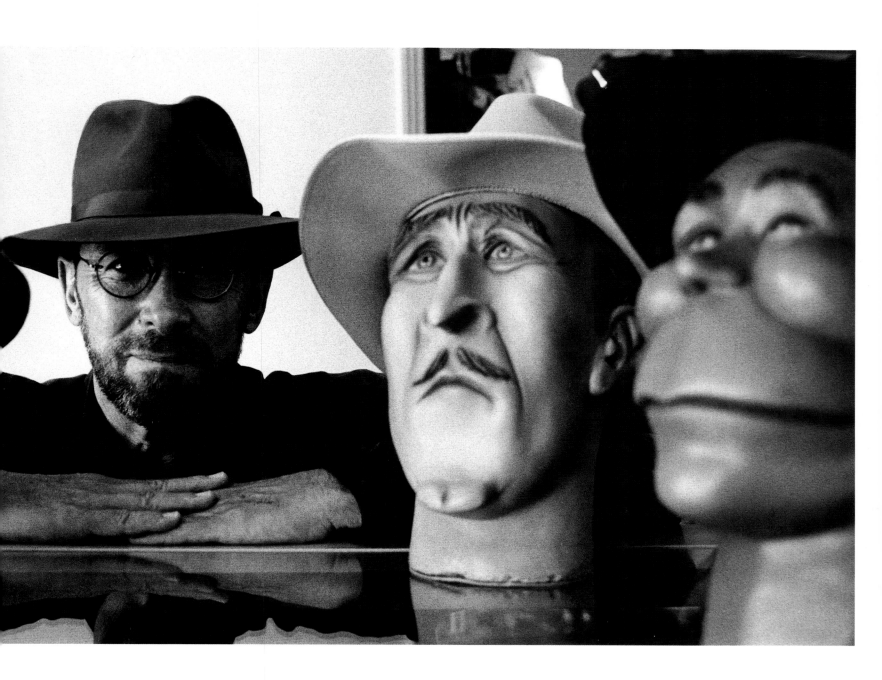

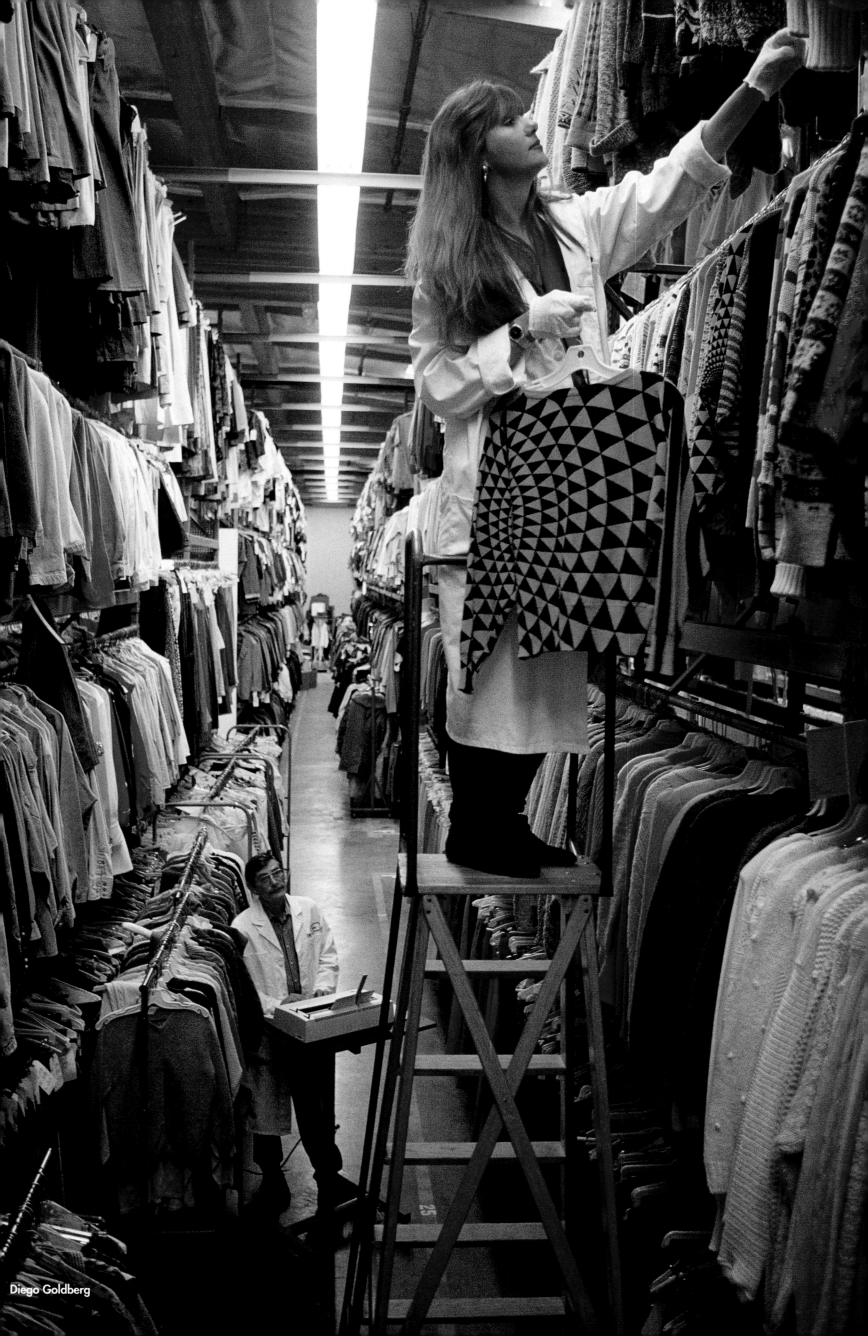

Diego Goldberg

ght

ne "educated feet" of
rdie Bryant, as they
ere dubbed by the
gendary Bill
Bojangles" Robinson,
em to levitate in a
ollywood dance studio.
world-class Jazz Tap
tist, Bryant came out of
tirement four years
go, when Sammy
avis, Jr. became ill, to
lp preserve the
niquely American art of
p dancing. Now 63, he
rforms, lectures, and
aches both inner-city
ouths and professional
ncers. "What's really
appening here," says
yant, "is that I'm
assing on my rhythms to
e younger generation."
otographer:
olker Hinz

ght, bottom

ousands and thousands
shoes, everything from
ain black Oxfords to
plicas of Apollo space
oots, are stored in the
ramount Studios
stume department.
otographer:
e McNally

Following, page 88

Fayard Nicholas, 78,
started tap dancing at the
age of three and has not
stopped. Fayard and his
brother Harold worked
from Harlem to Holly-
wood and around the
world as the Nicholas
Brothers for over 50
years. Fayard received a
Tony in 1989 for his
choreography in *Black
and Blue.* He and his wife
live in a retirement
cottage at the Motion
Picture & Television Fund
in Woodland Hills, which
provides medical and
social services and child
and retirement care for
the entertainment
industry.
Photographer:
Annie Griffiths Belt

Following, page 89

Los Angeles has always
been a city of extremes.
Movie stars like Arnold
Schwarzenegger earn
$10 million per film,
while 12.6 percent of the
people in L.A. live below
the poverty line. No-
where is this disparity of
fortune more obvious
than on Hollywood
Boulevard, where the
footprints of the stars are
paired daily with those of
the homeless.
Photographer:
Randy Olson

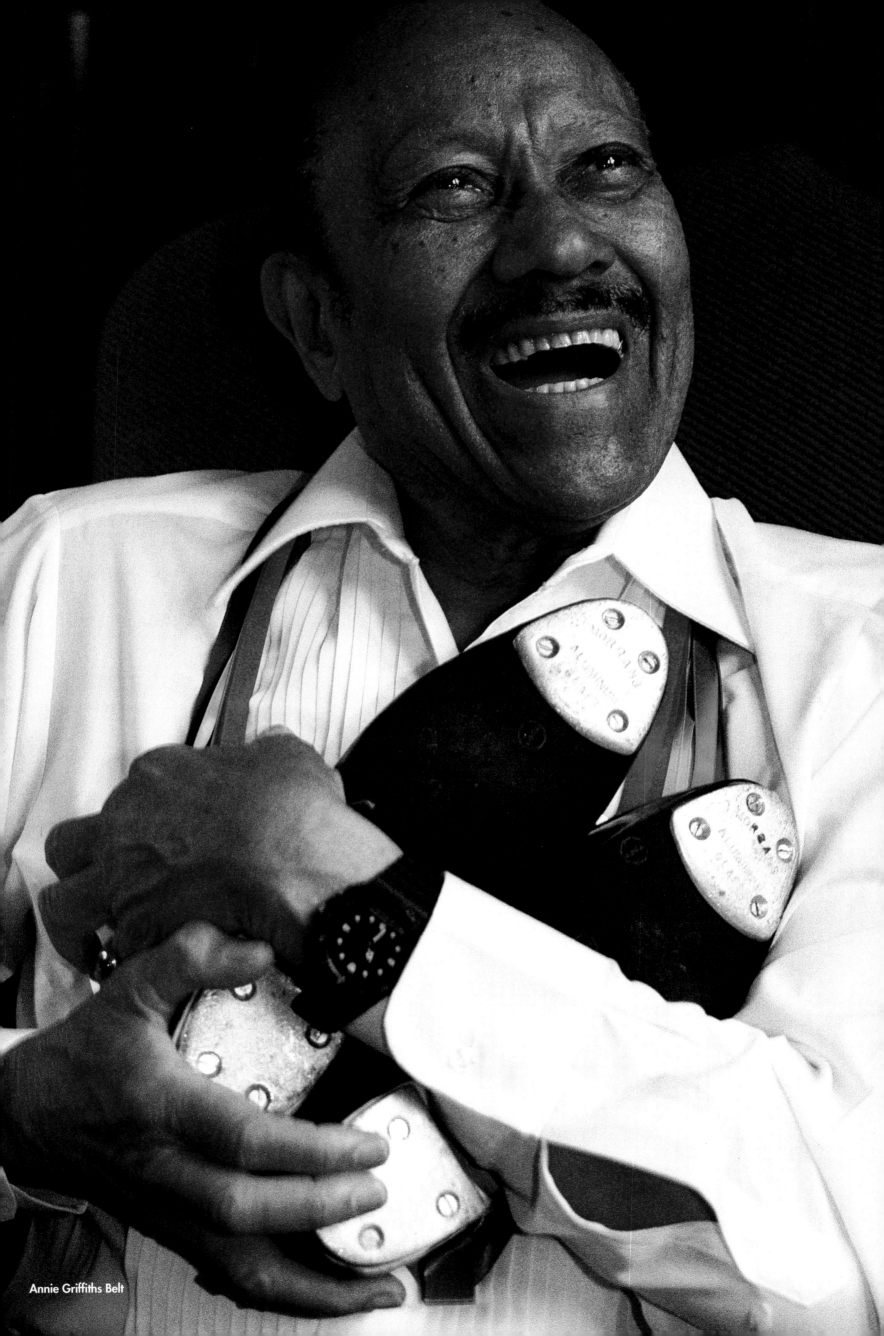
Annie Griffiths Belt

Right

At the Screenland Studios in North Hollywood, choreographer Kenny Ortega, 41, and a group of high-stepping dancers from Michael Jackson's "Dangerous" tour try out ideas for a new routine. He calls this process "doing a rough sketch" of a dance. Ortega worked on Madonna's "Material Girl" tour, as well as on the films *Hair*, *Dirty Dancing*, and *Newsies*. After spending several weeks with "Dangerous" in Europe, Ortega returned to the U.S. to direct *Hocus Pocus*, a non-musical which stars Bette Midler.
Photographer:
Jonathan Exley

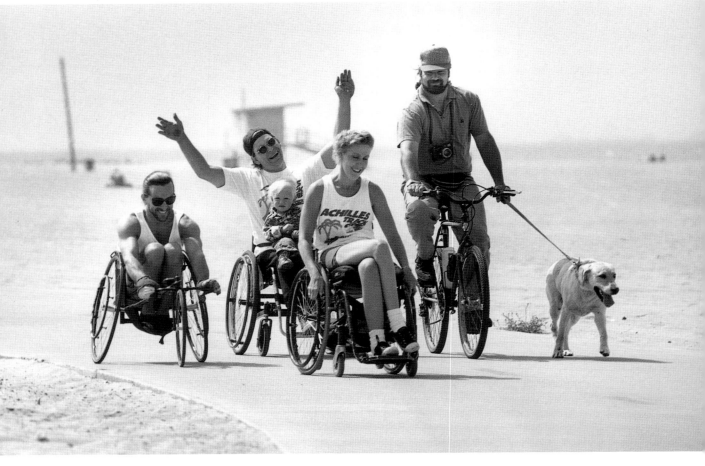

Right

On a beach in Santa Monica, the Achilles Track Club meets once a week to work out, hang out, and promote athletics for the disabled. Ellen Stohl, foreground, was the first paraplegic to be featured in *Playboy*. Actor and writer Alan Toy, pictured with his arms outstretched and his son John Henry on his lap, actively works to improve the image of the disabled in Hollywood. "Throughout history," he notes, "from Captain Hook to Captain Ahab to the Hunchback of Notre Dame, if you want to make a character evil, you make him disabled."
Photographer:
Dilip Mehta

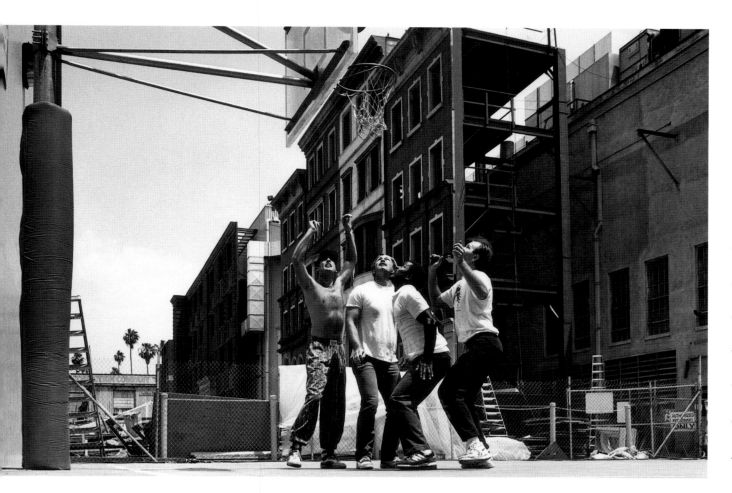

Members of a construction crew on the Paramount lot participate in a lunchtime pick-up basketball game at the "Ubu Memorial Arena." The half-court was named for the now-deceased, but ever-beloved, dog of producer Gary David Goldberg, who asked to have the court installed during the heyday of his hit show *Family Ties*. Goldberg and his staff use the court twice a week, but at other times it is open to anyone on the lot—including such regulars as Arsenio Hall and Woody Harrelson.
Photographer:
John Loengard

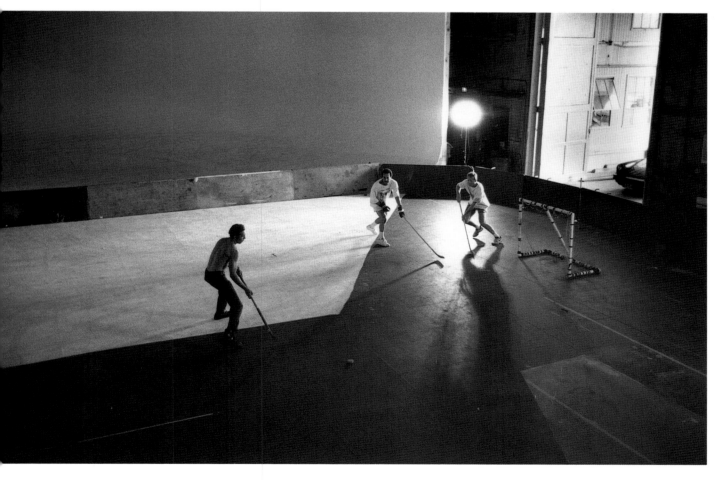

Every Wednesday at Hollywood Center Studios, owner Alan Singer and a group of executives, grips, and gofers find an empty sound stage, set some tables on their sides to create a ring, and engage in a heated round of floor hockey. The typical game lasts for about an hour and a half, but "if you can survive 10 minutes of this sport, you're in pretty good shape," boasts Singer. When in use by the studio, this stage rents for about $1,000 per day.
Photographer:
P.F. Bentley

Above

When Levi Strauss & Co. wanted three commercials featuring its oversized jeans for boys, Limelight Productions delivered. In each 30-second spot, a group of very large boys—boys the size of office buildings, in fact—skateboard, play basketball, and play in a rock band in downtown New York, San Francisco, Chicago, and elsewhere. First, the exterior settings were shot on location. Then the actors went to work, skating and playing against a plain green background erected on an enormous sound stage at Raleigh Studios. By filtering out the green color in post-production, the boys were made to appear to be doing their thing right downtown. Keeping the reflective mylar floor clean was essential in making the green background disappear.
Photographer:
Barry Lewis

Above, right

Stage hands at CBS Television City assemble the prize showcases for *The Price Is Right,* the game show that has been running for 21 years on national television. The 45 stage hands employed by the show begin work at 3:00 a.m. and, since the show is taped before a live audience, everything must be ready to move quickly on and off stage. Each show is rehearsed once, with no audience, before taping.
Photographer:
Jeff Jacobson

ollowing, pages 94-95

arrison Ellenshaw, a
*sual-effects artist at
*isney's Buena Vista
*isual Effects Lab, uses a
*azor blade to clean off
*glass matte he is
*ainting for a Disney
*eature. The cars and
*ucks in this scene were
*lmed previously, but the
*ees and the sky in the
*ackground didn't show
*p well. To fix the
*roblem, Ellenshaw
*ainted the glass with
*e silhouettes of trees

and a starry night sky.
The original shot was
then projected on a
screen from behind and
re-filmed through the
glass. Ellenshaw would
not reveal the name of
the movie, because "it
ruins it once you know a
shot is painted."
Photographer:
Jill Hartley

Following, pages 96-97

Director of Photography
Doug Milsome checks a
light meter on the set of
Body of Evidence, a
movie starring Madonna
as a gallery owner who
uses her body as a
murder weapon. Though
set in Portland, Oregon,
40 percent of the movie
was shot in this court-
room on a sound stage in
Culver City. According to
Milsome, "the challenge
is to give the room a new
look each day." To this

end, he used lighting to
recreate Portland-like
weather. What appears
to be sunlight in this
photo actually comes
from a 4,000-watt
xenon light. To help
create a hazy atmo-
sphere, Milsome
encouraged cast and
crew to smoke on the set.
Photographer:
Murray Close

Following, pages 98-99

The sets for Tim Burton's
$50 million *Batman
Returns* took up eight
huge sound stages at
Warner Bros., and even
that wasn't enough. The
65-foot-tall Gotham
Plaza, a bleakly futuristic
and decidely inhospi-
table rendition of
Rockefeller Center, was
one of the largest interior
sets ever built at the
studio. "One of the
design concepts of the
movie was to create the
illusion of massive
spaces," says production

designer Bo Welch.
Among the Plaza's unique
elements were the
machine-age statues
sculpted by Leo Rijn and
his crew, including a
colossus grinding the
gears of Gotham and four
fascist-style figures that
Welch dubbed "Misery,
Grief, Ecstasy, and Victory
... which actually refers to
my work process."
Photographer:
Marcia Lippman

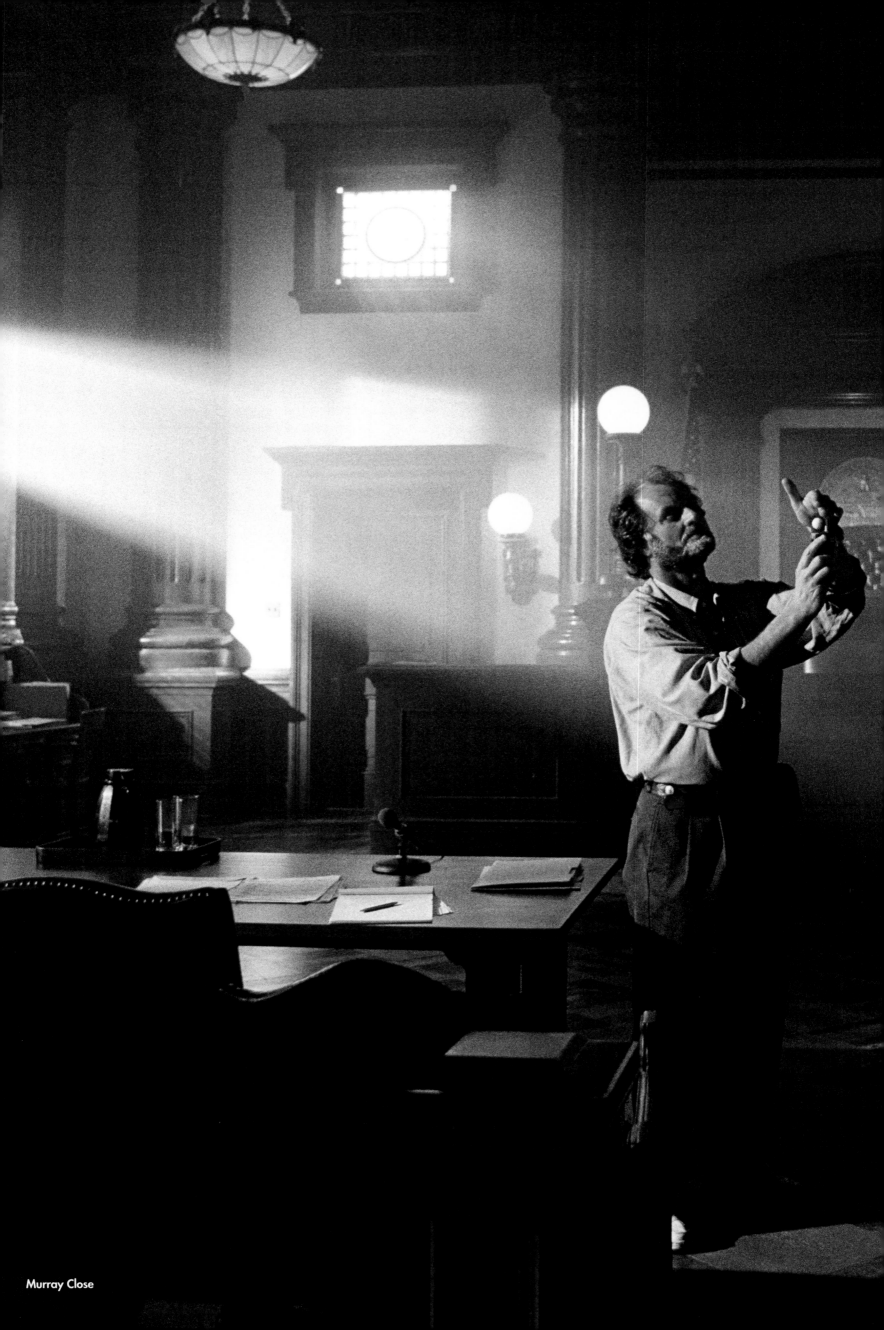

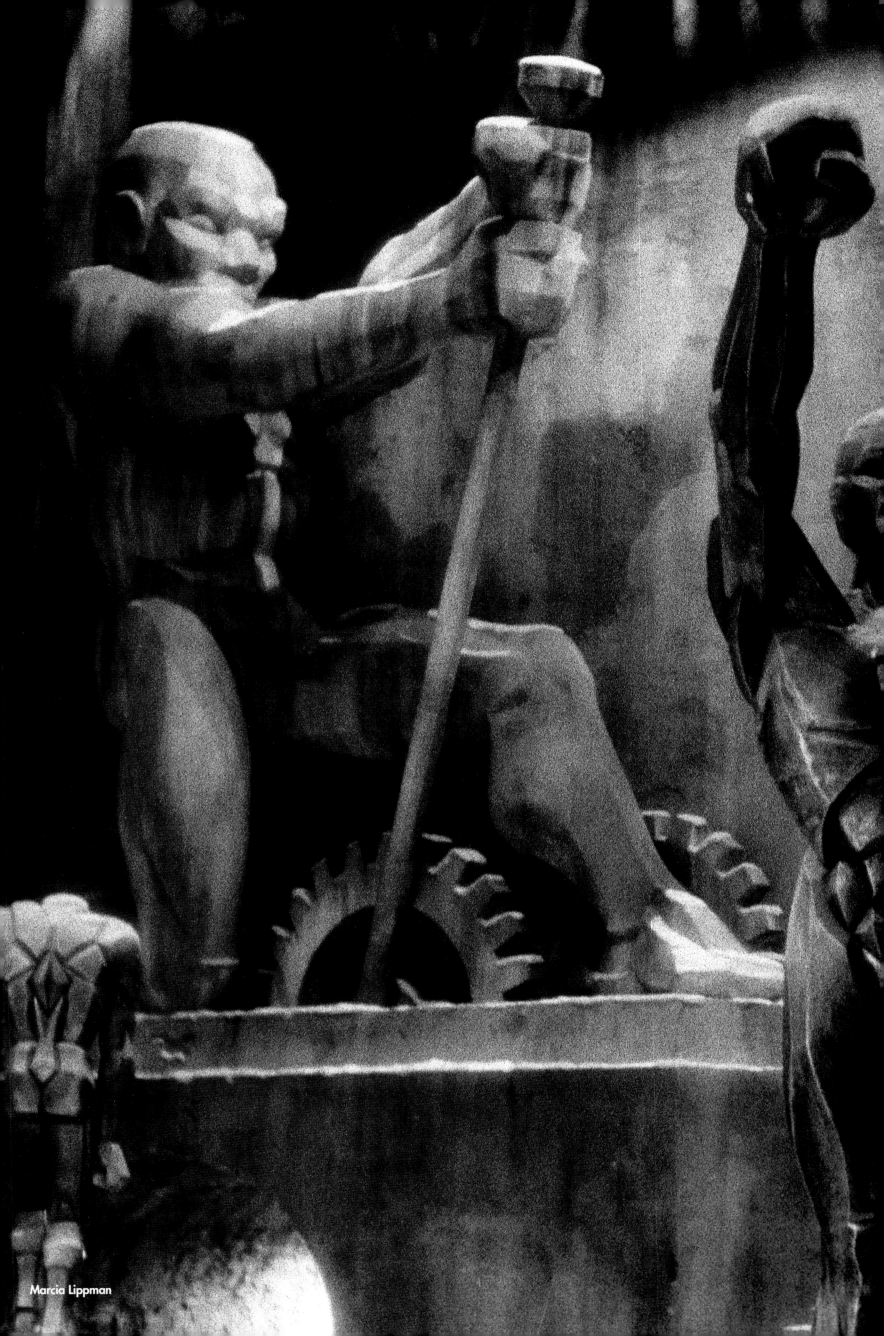

Marcia Lippman

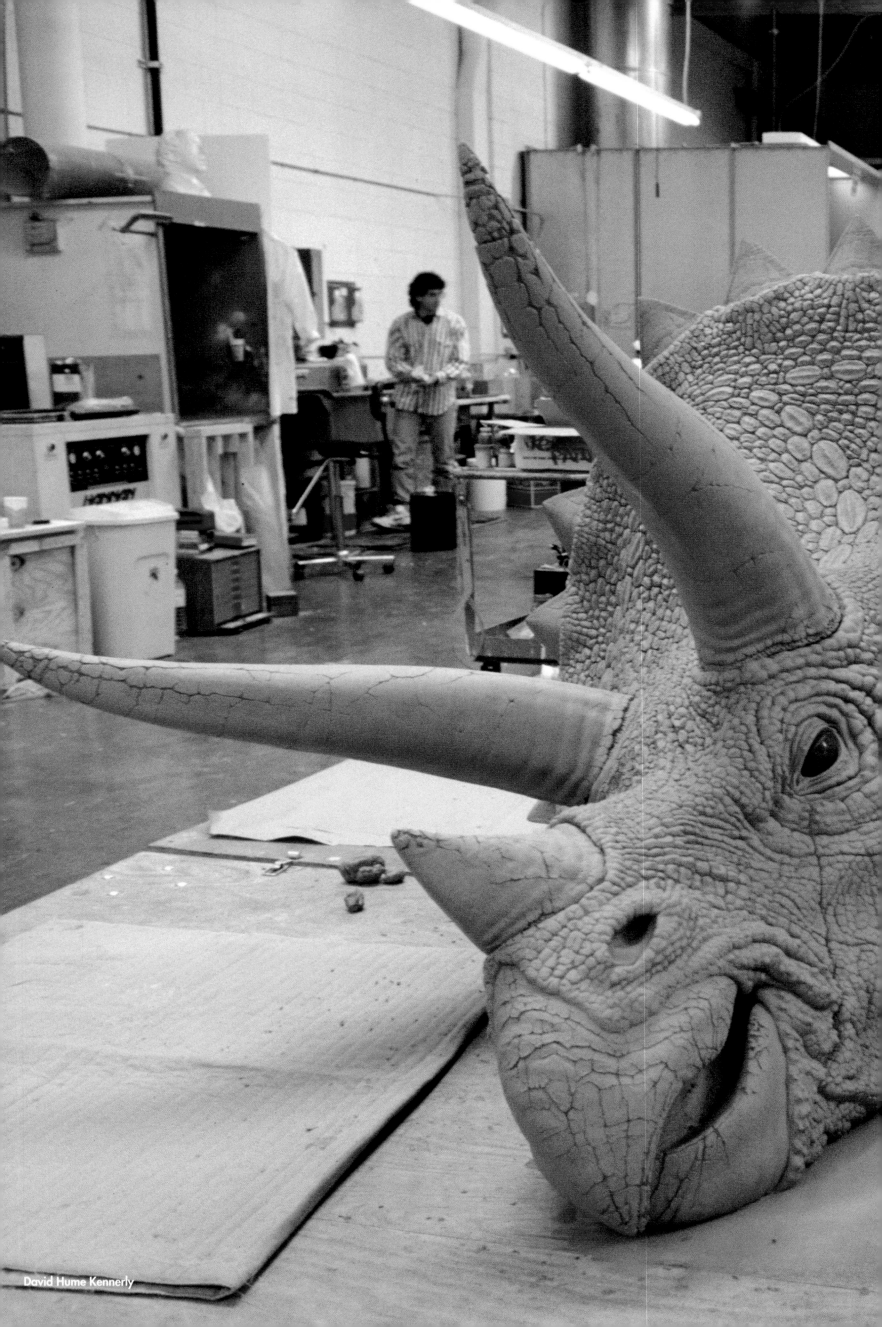

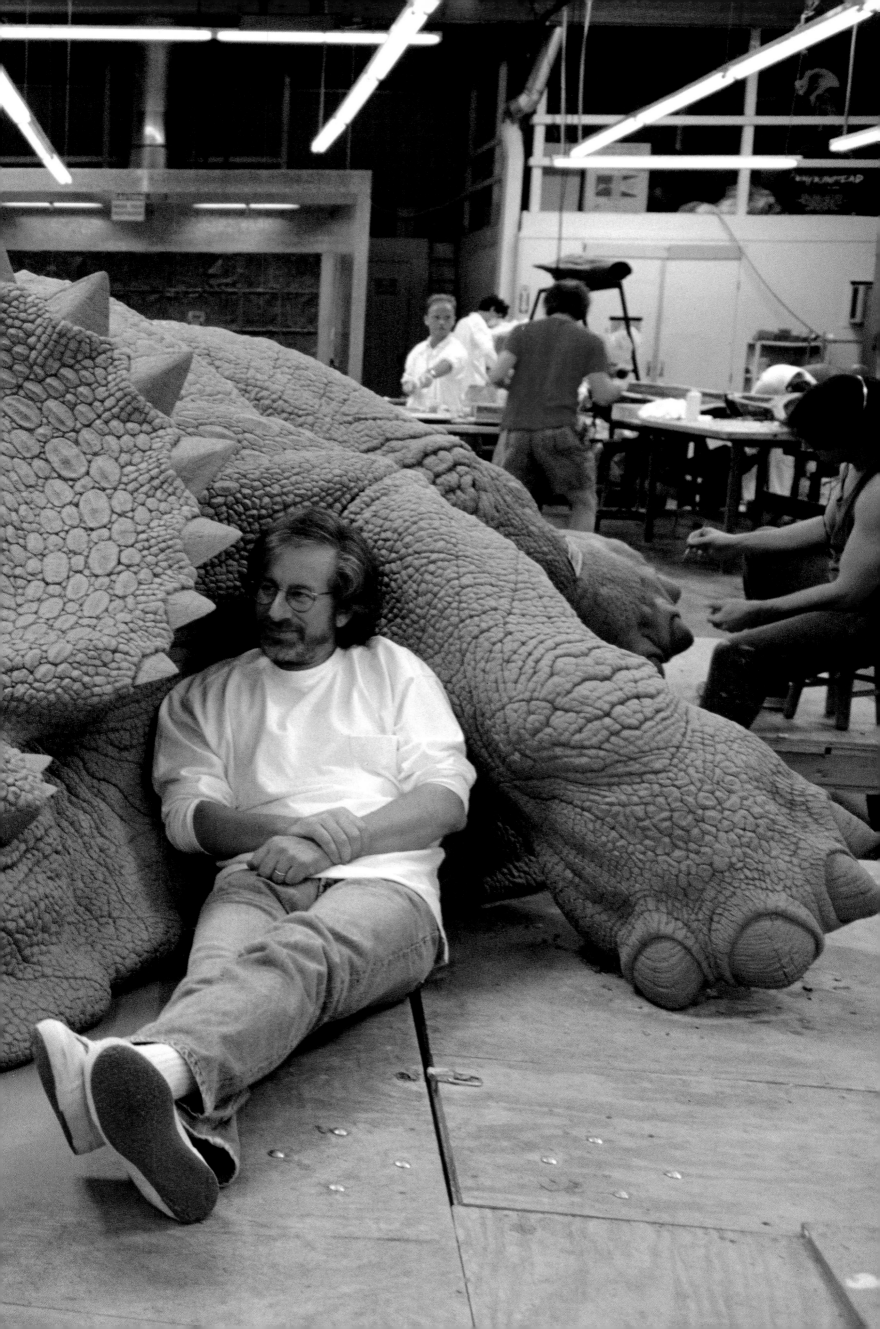

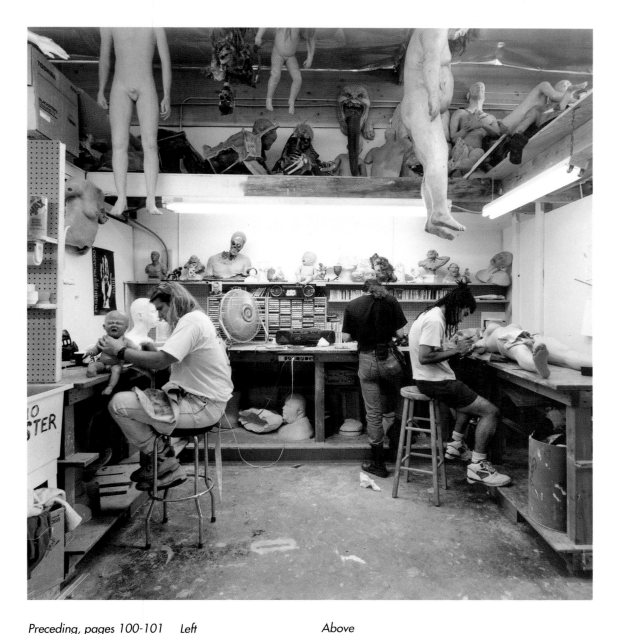

Preceding, pages 100-101

Steven Spielberg warms up to the "Sick Trike," as this Triceratops is affectionately known, at the Stan Winston special-effects studio, where five amazingly lifelike dinosaurs are being created for Spielberg's *Jurassic Park*. Based on the novel by Michael Crichton, the thriller imagines genetically engineered dinosaurs running amok in a theme park. This particular dino, who is supposed to be sick (hence the nick-name), was programmed only for partial body movement and given a labored snort to indicate breathing problems.
Photographer:
David Hume Kennerly

Left

Pamela Gidley gets a makeover from her best friend, hair and makeup artist Jill Fink, in the home they share in Hollywood. Though Fink's work on movie sets involves a lot of waiting around to do touch-ups, it pays up to $500 per day. In her eight-year career, she has worked with Molly Ringwald and *Northern Exposure*'s John Corbett, among others, and she often experi-ments on Pamela. Gidley is set to co-star with Robin Givens in *Polish Hill*, a television series about two sexy detectives in Chicago.
Photographer:
Véronique Vial

Above

The Todd Masters Company is a body shop of sorts. This special-effects prop studio specializes in bodies—"not dummies," according to Masters— which can be rigged for effects difficult or impossible for their human counterparts to achieve. Also, because the use of real babies on movie sets is strictly regulated, it's often more economical to use mechanical ones. Here, artists work on several lifelike creations,

including a crying baby for HBO's *Tales from the Crypt*. The baby hanging from the ceiling was featured in Brian De Palma's *Raising Cain*. When Masters created a severed head at the age of 12, the photo lab which developed pictures of it called the police; today, hundreds of bodies are available for rental from Masters. A full body, which costs $5,000 to make, rents for about $700 a week. Bodies cast to resemble specific stars cost more and are not available for rental.
Photographer:
Richard H. Ross

With the feature film *Toys*, director Barry Levinson, 60, and actor Robin Williams, 40 (*right*), are reunited for the first time since the highly successful and critically acclaimed *Good Morning, Vietnam*. Written by Levinson along with Valerie Curtin, *Toys* is a whimsical comedy about a toymaker, played by Williams, who must save his family's factory from the clutches of a demented uncle. The movie co-stars Michael Gambon, Joan Cusack, Robin Wright and LL Cool J.

On May 20, 56 cast and crew members were working on the *Toys* set in Stage 16 at Twentieth Century Fox, and each stopped for a portrait (*following pages*).

In order to control the visual environment, *Toys* was shot entirely in the studio. In the "War Room" (*page 108*), one of about 50 original sets, kids think they are playing video games but are really being trained to fly radio-controlled war toys. Robin Williams stands at the front of the room, beneath the world map. In post-production, the green panel in front of each child was transformed into the screen of a flight simulator, complete with video images and computer graphics.
Photographer:
Neil Leifer

Page 106:

Robin Williams, "Leslie Zevo"; Joan Cusack, "Alsatia"; Arthur Malet, "Owen"; Taylor Evans, child extra

Dennis Parrish, prop master; Christine Tope, Directors Guild trainee; Jay "Chicago" Gianukos, production assistant; Judy Brown, studio teacher

Peter Giuliano, first assistant director and co-producer; Paul Babin, camera operator; Albert Wolsky, costume designer; Cheri Minns, key makeup

Mark Johnson, producer; Keith Campbell, stunt double for Robin Williams; Mark Daily, first assistant editor; Sidney Baldwin, still photographer

LL Cool J, "Patrick"; Sue Kalinowski, hair stylist; Janine Stillo, stand-in for Robin Wright; Dennis Laine, first assistant camera operator

George Little, costume supervisor; Carlane Passman, costume supervisor; Kate Davey, second assistant director; Kelly Finn, assistant to Barry Levinson

Hallie D'Amore, makeup; Gina Wyatt, driver; Frances Vega-Buck, costumer; Jim Cullen, costumer

Page 107:

Bill Roe, camera operator; Chris Duddy, VistaVision camera operator; Steve Sfetku, camera loader; Adam Greenberg, director of photography

Tove Valentine, boom operator; Larry Aube, grip best boy; Mike Alperson, grip; Willie Radcliff, craft service

Charles Newirth, co-producer and production manager; Mike Balker, set costumer; Jonathan McGarry, production assistant; Steve McGee, gaffer

Alan Shultz, dolly grip; Jeff Clark, first assistant camera operator, B Camera; Sara Dee, assistant to the producer; Blair Daily, first assistant editor

Jeff Kunkel, dolly grip; Clay Pinney, special-effects supervisor; Dave Katz, video assistant; Jack Ellingwood, second assistant camera operator, B Camera

Rick Herres, grip; Julie Pitkanen, script supervisor; David Elzer, unit publicist; Randy Cantor, transportation captain

Kevin Lang, electrical best boy; Lionell Griffin, security; Elliot Zundell, security; Kevin Carty, security

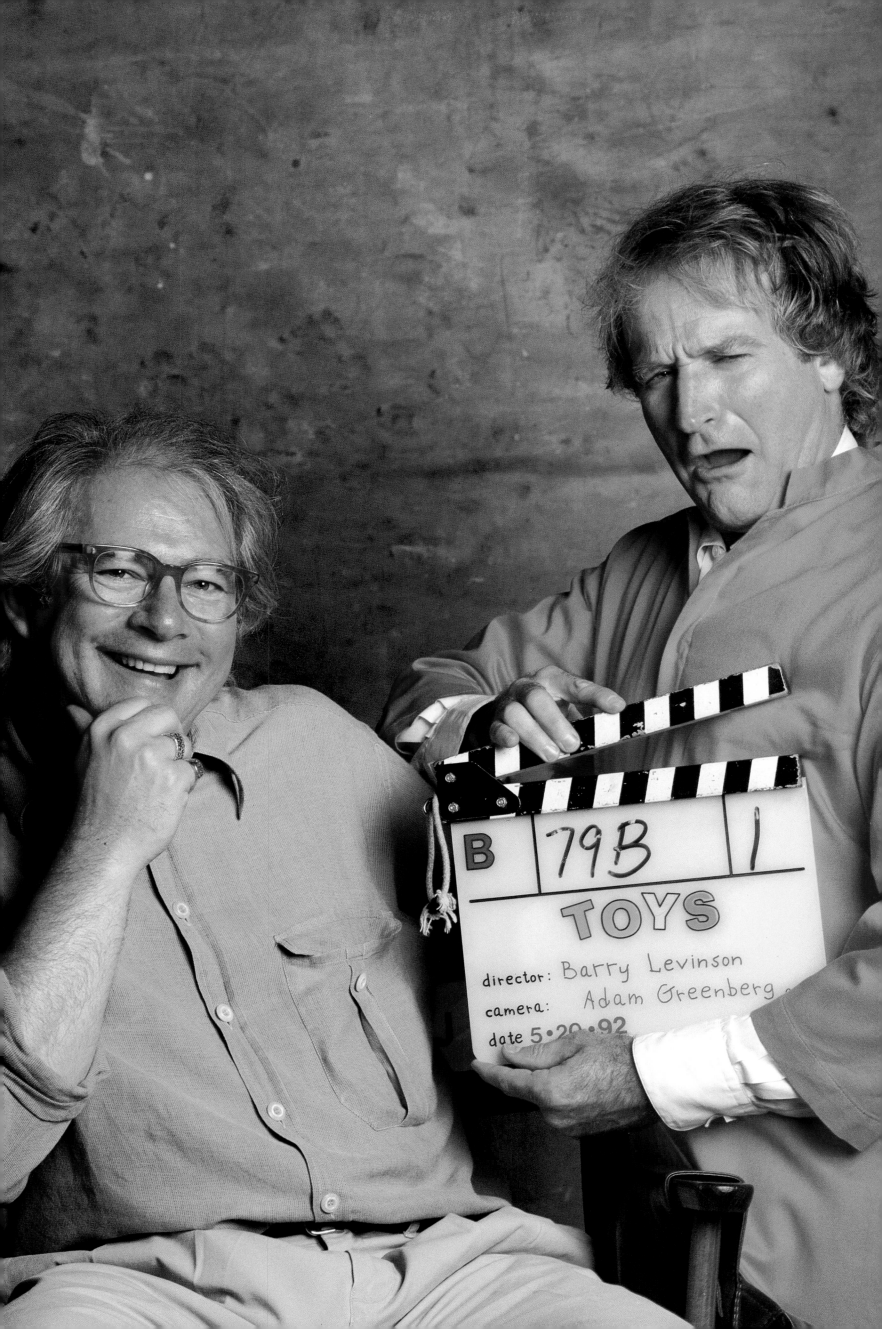

 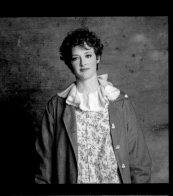
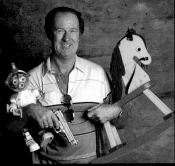 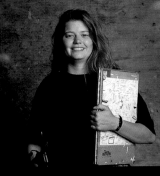

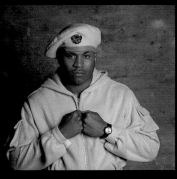
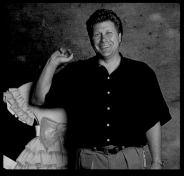
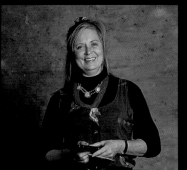

All photographs by Neil Leifer

 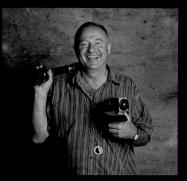

 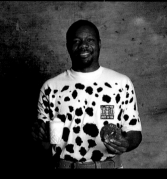

 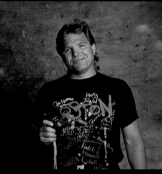

 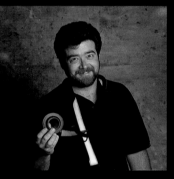

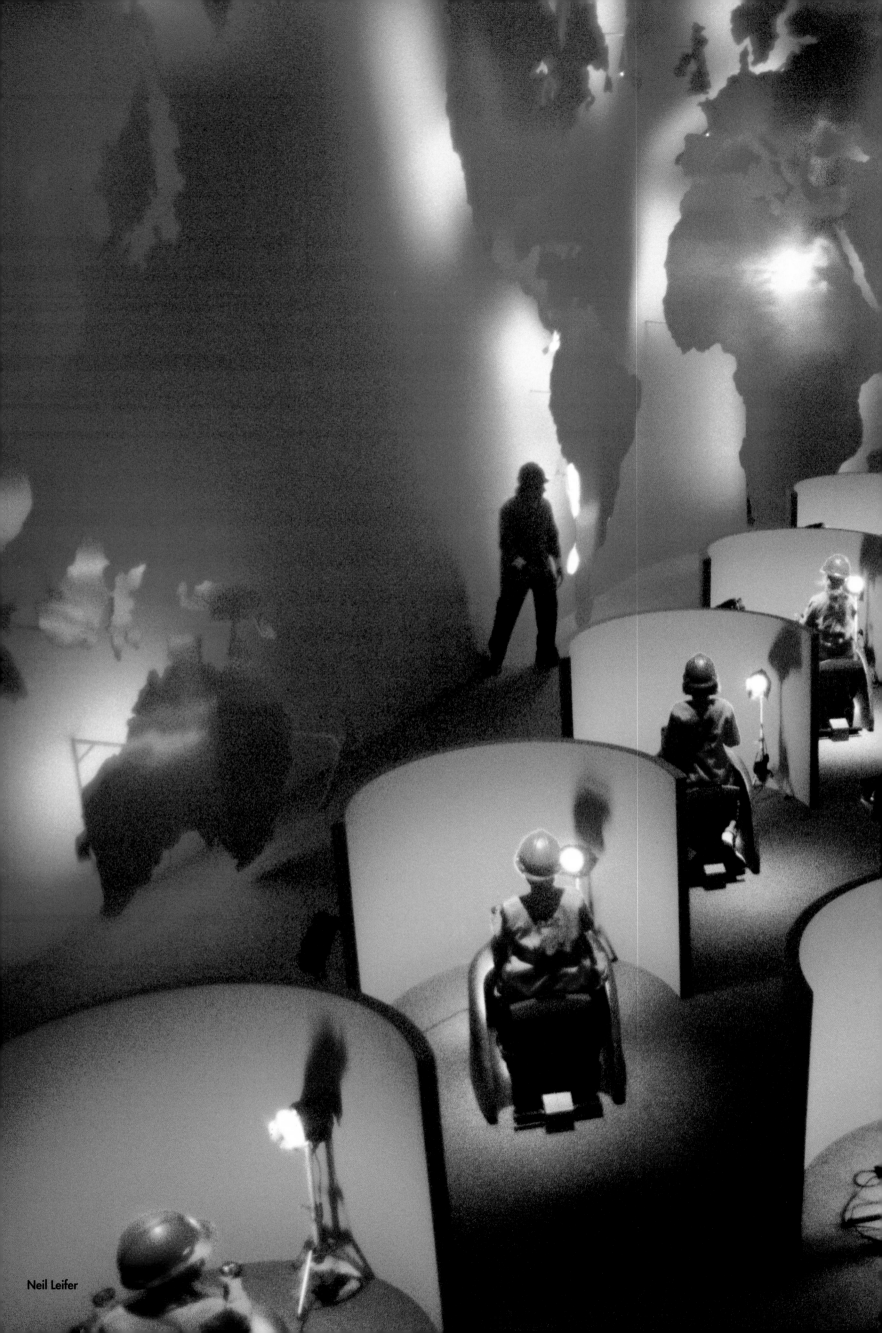

Neil Leifer

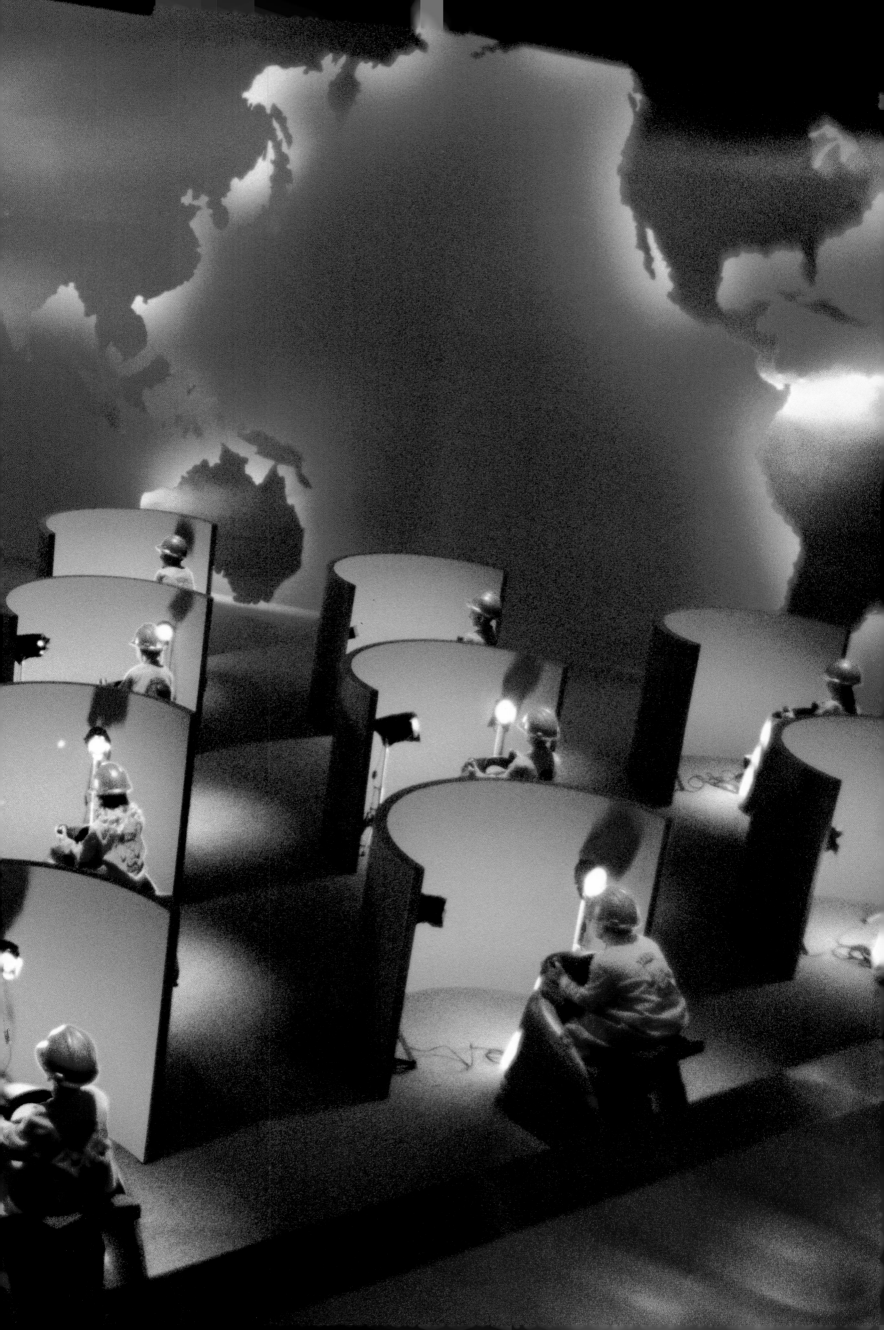

Co-stars on the set of
Alex Winter's *Hideous
Mutant Freekz* get ready
for the milkman scene.
Sockhead (*top*) played by
Karin Serceji, needs to be
sprayed with cool air
periodically or else she'll
curdle in her costume.
The twins, Ernie and Julie
(*bottom*), are connected
at the hip and played,
alternately, by Megan
Ward and Michael
Stoyanov. The actor with
the most lines gets into
costume with his or her
counterpart, a remote-
controlled dummy that
can respond with limited
facial and body move-
ment. In today's scene, all
of the freekz, including
the Worm Man (*far
right*), disguise them-
selves as milkmen to
facilitate a massive
escape from the evil
circus owner played by
Randy Quaid.
Photographer:
Chris Callis

Alex Winter is the only
freek to get as far as the
milkman's van, which is
locked. He finds this
Caddy, but it, too, is
locked. The car was
loaned by a crew
member for the scene.
Will Winter get away?
Will the other freekz go
free? These and other
crucial questions will be
answered when the
movie, billed as an
"extreme comedy,"
arrives in your neighbor
hood theater.
Photographer:
Antonin Kratochvil

ESMERALDA
QUEEN OF THE SERPENTS

PRINCE ABDU[
FEARLESS FIRE EATER

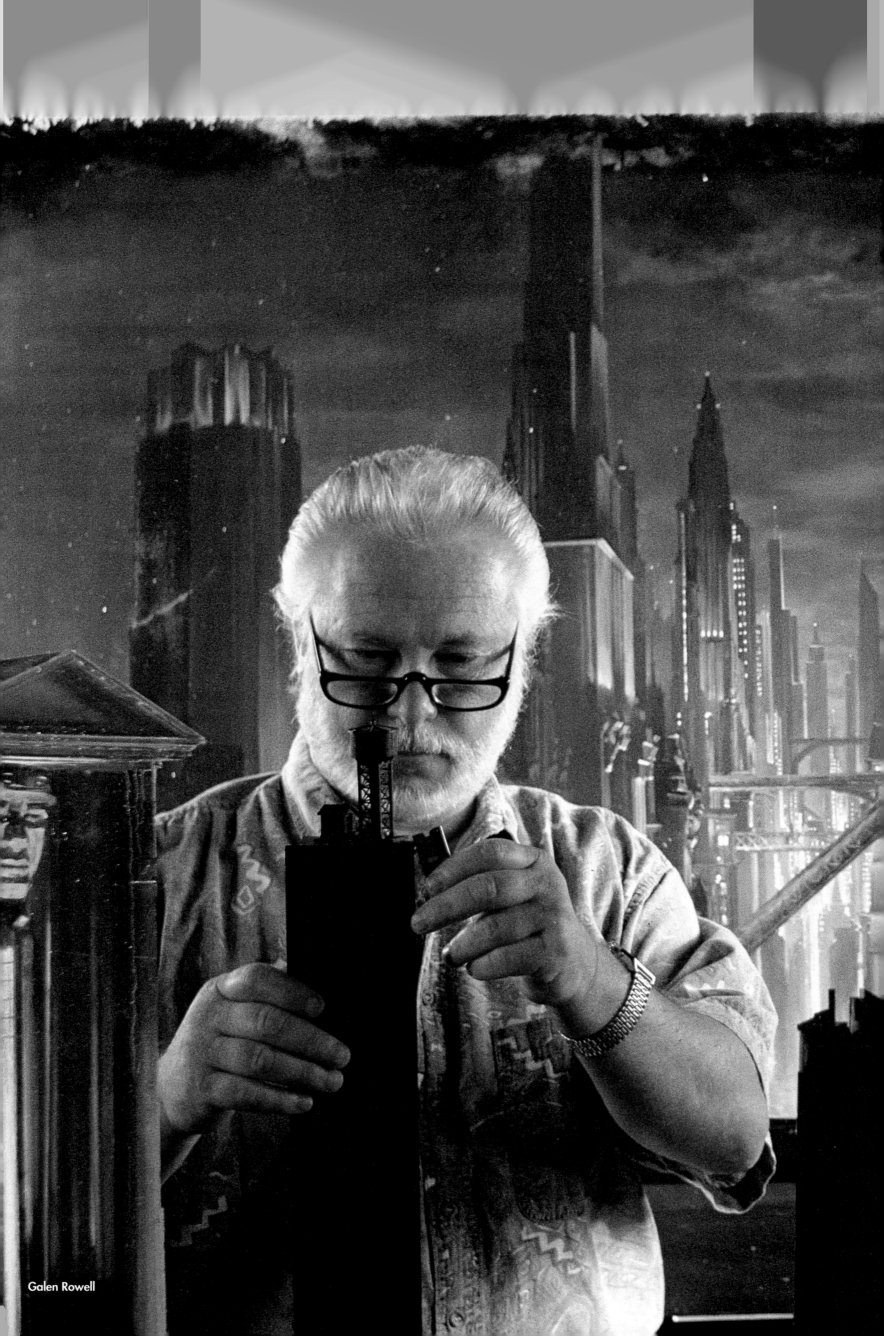

Galen Rowell

Preceding, pages 114-115

Alan Harding photographs a multi-plane matte painting for a scene in *Batman Returns* while Michele Moen does touch-ups between takes. Harding uses a 65-millimeter computer-programmed camera, which travels on a track around the painting. The computer helps direct the angle of the camera to achieve the proper perspective for the scene. Later, the image of Catwoman flying through the night will be added, along with a computer-generated snowstorm. Moen says that she was influenced by photographs from the 1930s and '40s of skyscrapers in New York and Chicago and by the drawings of Anton Furst (production designer on *Batman*) in imagining the bridges between the buildings.
Photographer:
Galen Rowell

Preceding, pages 116-117 and above

Famous for his low-budget movies, Roger Corman, 66, has produced more than 225 films since 1953, and 90 percent of them have turned a profit. He is known for recognizing and hiring new talent, giving some of the most talented writers, directors, and actors in the business their start—including Francis Ford Coppola, Jack Nicholson, Robert De Niro, and John Sayles, among many others. Films to his credit range from *Fantastic Planet* to *Jackson County Jail* to *Rock N' Roll High School.*

On the set of *Blood Fist IV: Die Trying*, starring world-champion kickboxer Don "The Dragon" Wilson, Corman relaxes while actors rehearse a fight (*preceding page*). Wilson plays a car repossessor; when he snatches the wrong BMW, its disgruntled owner storms into Wilson's office and kills everybody in sight (*above*). This scene, called "Weiss kills repo crew" on the call sheet, was shot on the eleventh day of production. A typical Corman movie like this one takes a month to shoot, although some have been completed in 18 days.
Photographer:
Antonin Kratochvil

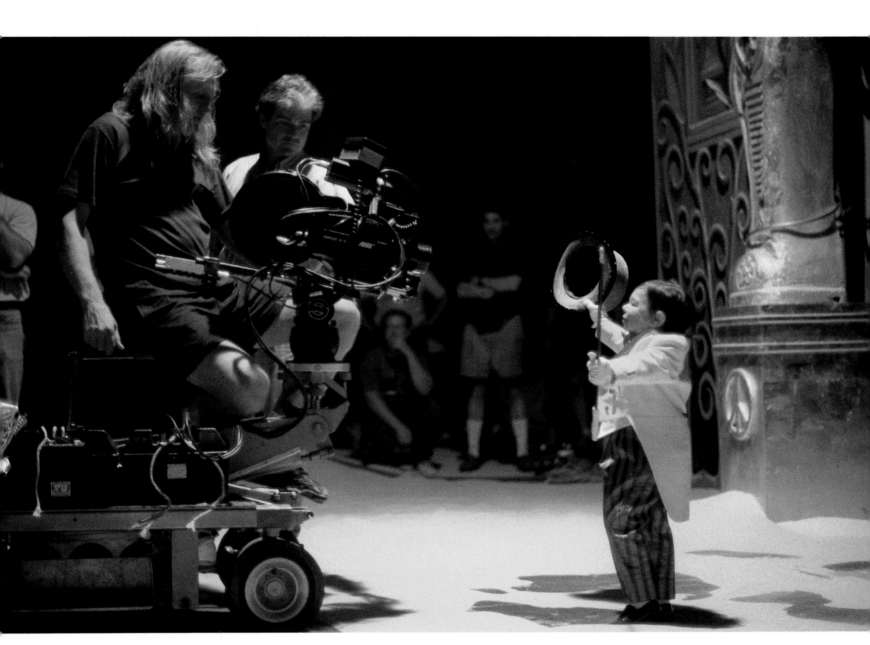

Above

From atop his camera dolly, 6'-6" director Joe Pytka zooms in on the 2'-8" actor Michu. "The world's smallest man" was appearing in a Pepsi commercial that stars Michael Jackson. One of the most elaborate commercials in advertising history, the ad is a 60 second razzle-dazzle of music, dance, and special effects with Jackson performing "Who Is It" from his smash-hit album *Dangerous*.
Photographer:
Timothy White

Following, page 120

Steve Neale, 29, rehearsing for a knees-up body burn in *Warlock II*, was on fire for 40 seconds before being extinguished by his crew. Neale practices with different fuels to make sure the flames show up on camera. His clothing is treated, and his body is covered with a protective gel. A stunt man for eight years, Neale has never been hurt. "If you're a professional, you don't feel the heat," he claims.
Photographer:
Jeffery R. Werner

Following, page 121

Every day, almost 35,000 tourists visit Universal Studios Hollywood, which has been open for the past 25 years and is now the fourth largest tourist attraction in the nation. Among the numerous shows is this "Miami Vice Action Spectacular," where, 10 times a day, two performers demonstrate how the stunts were accomplished on the popular television show. Visitors can also experience "Earthquake: The Big One" and "The Parting of the Red Sea."
Photographer:
José Azel

Following, pages 122-123

Actors Corbin Bernsen and Anne Francis wait for the next take while filming an NBC television movie, *Kindred Spirits*, in the Dreamland Dance Hall in downtown Los Angeles. Dreamland is a "hostess club," one of 13 in Los Angeles, where customers can dance with women of their choice for $21 per hour. The women range in age from 18 to 37 and, with tipping, some customers have spent as much as $500 in a single evening. Dreamland is open seven nights a week and caters to an international clientele.
Photographer:
Jill Hartley

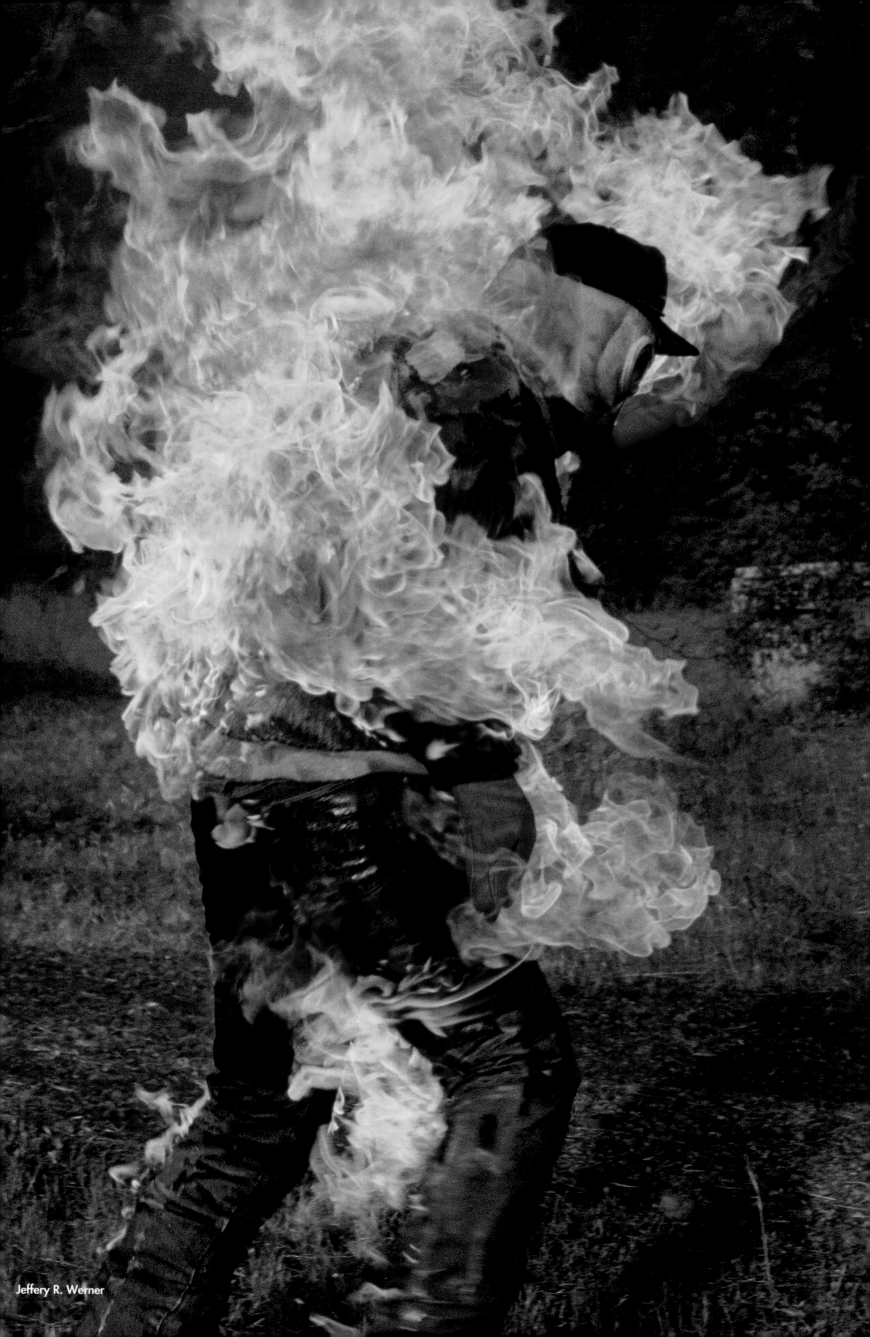

Jeffery R. Werner

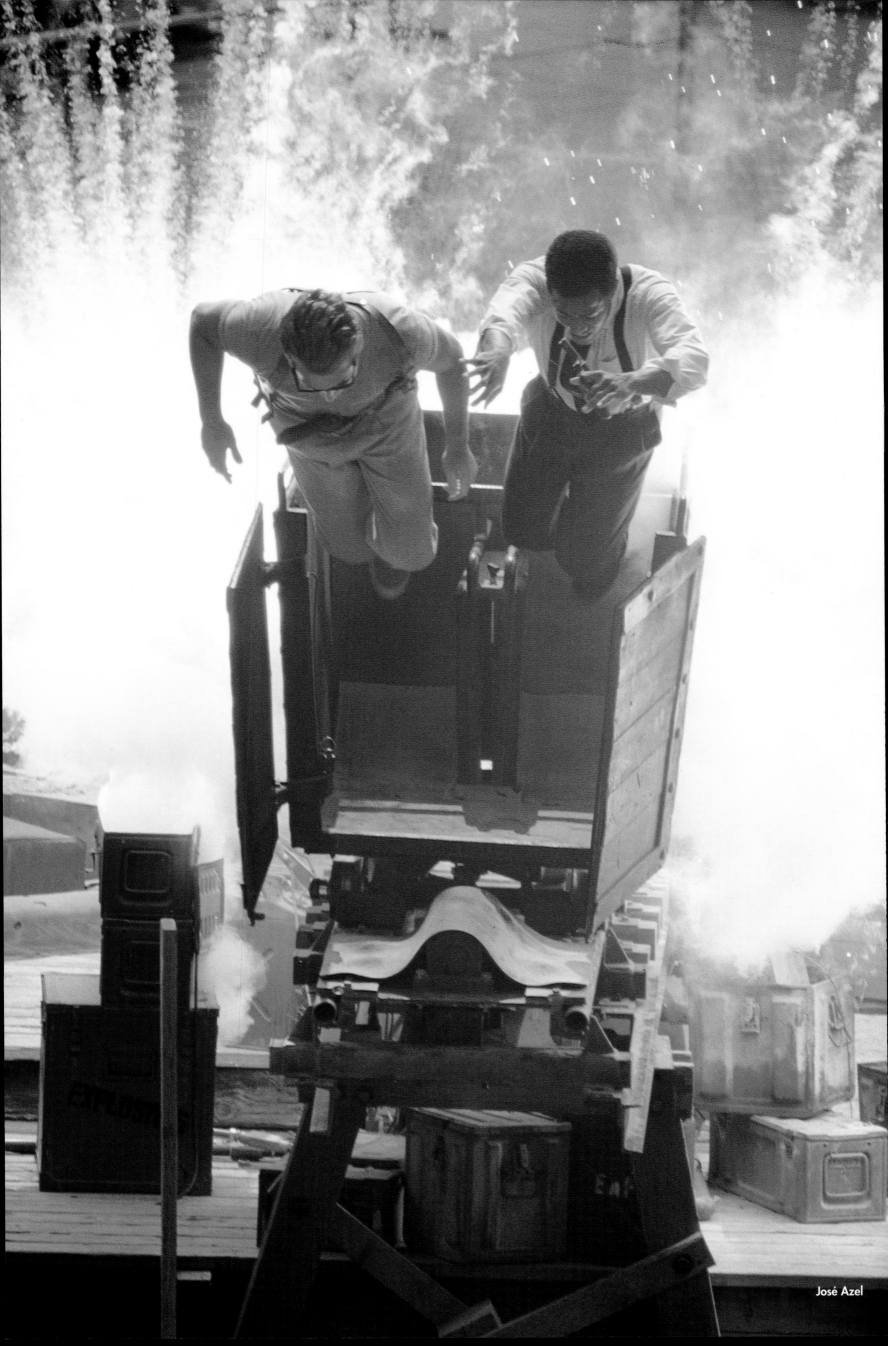
José Azel

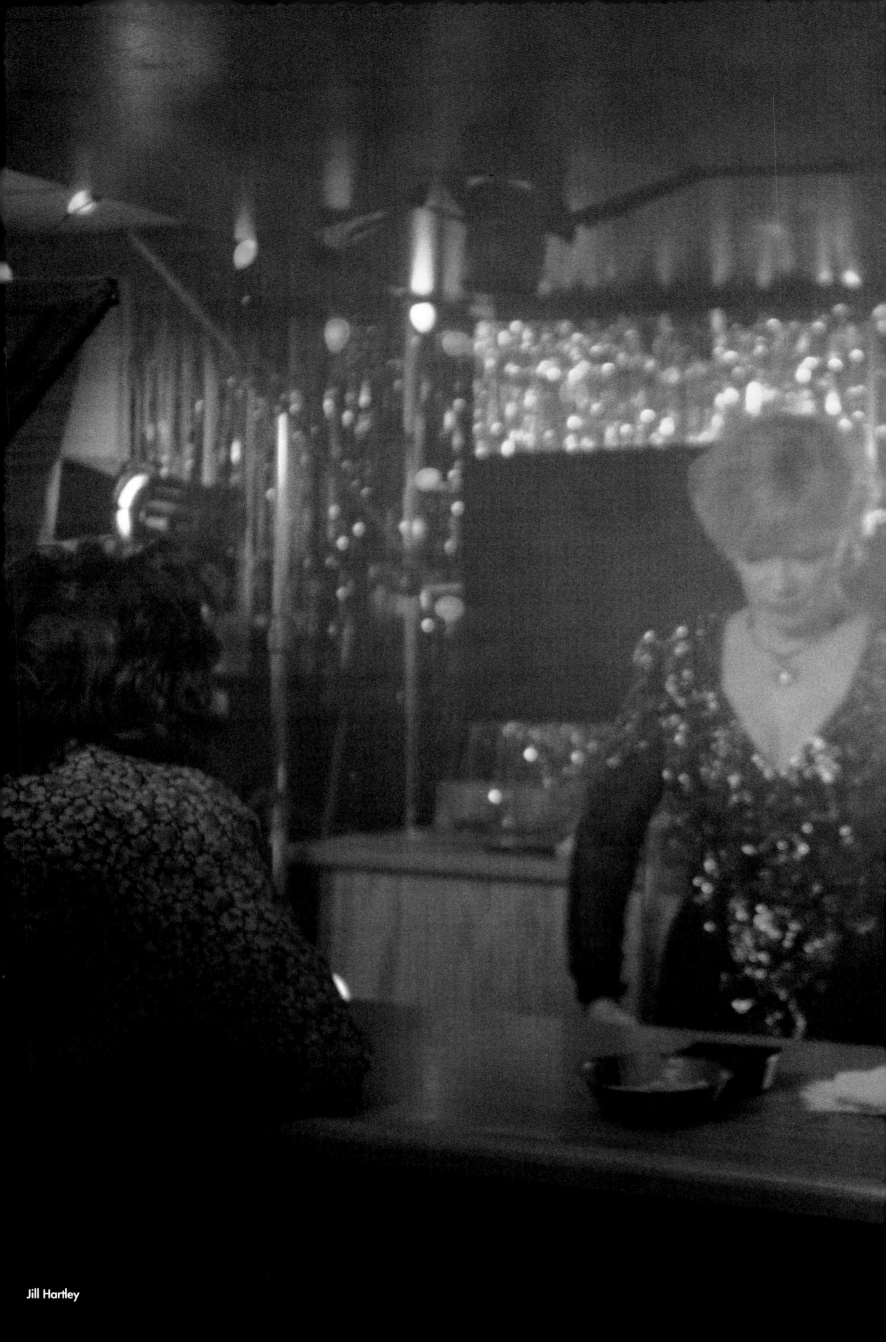

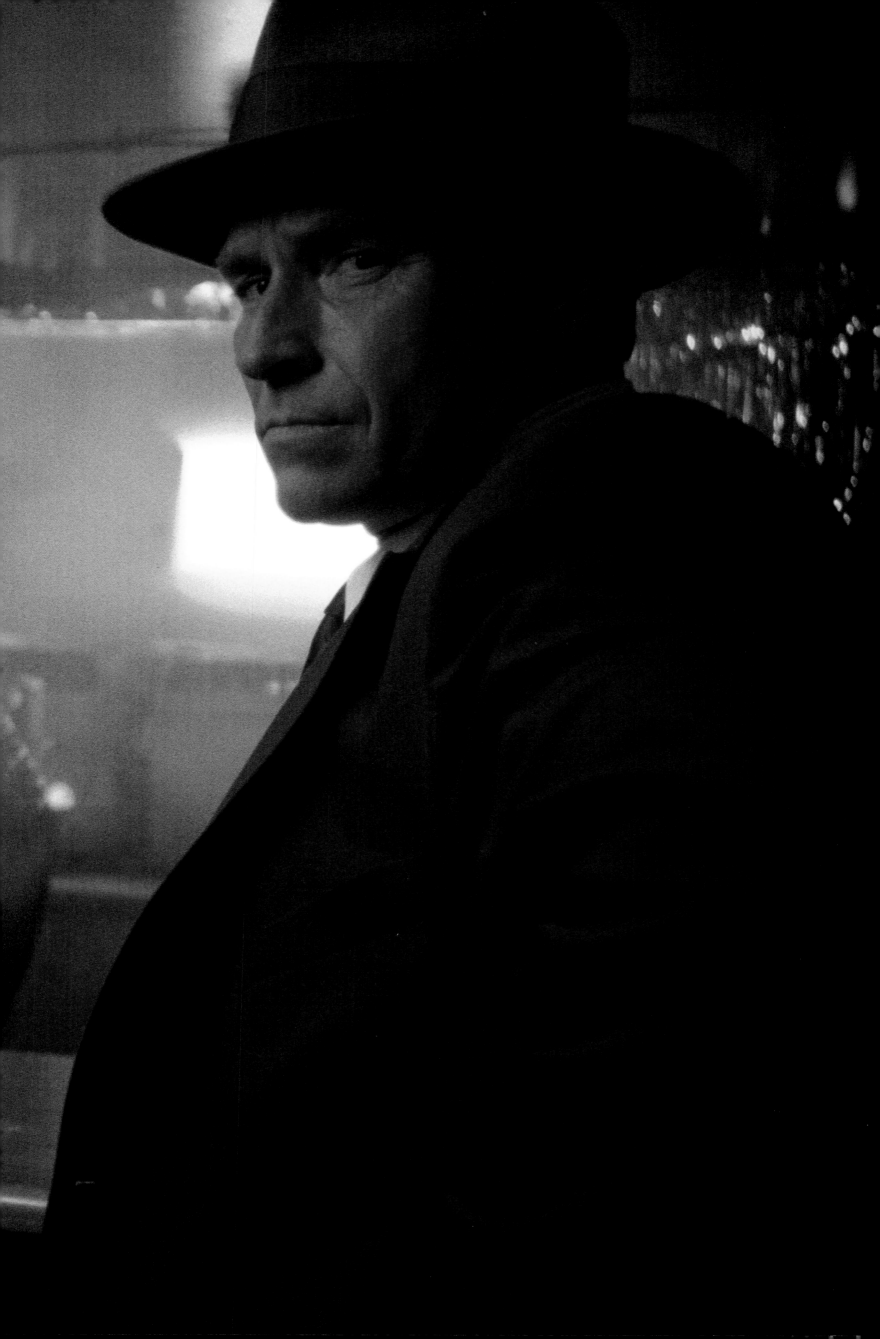

In his directorial debut, producer Joel Silver, far right, consults with his lead actor, Joe Pesci, while twins Jacquelin Alexandra and Kristen Amber relax. Silver, 39, who has produced nine films grossing more than $100 million each (*Lethal Weapon, Die Hard, 48 Hrs.*, and their sequels, to name a few), had decided to try directing an episode of *Tales from the Crypt*, an HBO series he co-produces. Known for his flamboyant personal style, which includes shouting matches and public feuds, Silver is said to be the model for the ruthless Steve Martin character in the film *Grand Canyon*. One of Silver's passions is collecting Frank Lloyd Wright houses, because, as he told the *New York Times*, "I find such a similarity between what he did and what I'm doing."
Photographer:
Stephen Goldblatt

ght

uring a break in the
ming of *Falling Down*,
rector Joel Schu-
acher, actor Michael
ouglas, and producer
rnold Kopelson retreat
 a production trailer on
e Warner Bros. lot to
scuss "something too
icked to be printed,"
cording to Kopelson.
hotographer:
en Regan

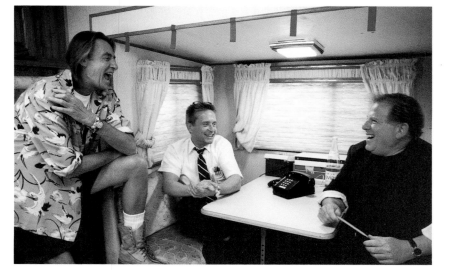

Above

Teen heartthrob Jason
Priestley takes a break
during the filming of his
starring debut in
Calendar Girl. Priestley
catapulted to fame
playing Brandon, the
neo-good-guy hunk, in
Fox Television's hugely
successful *Beverly Hills
90210*, the television
show *Vanity Fair* calls a
"social phenomenon of
worldwide proportions."
After only a year on
television, *90210* is seen
in 20 countries. In
Calendar Girl, set in
1962, Priestley plays a
James Dean-like teenager
who travels to Hollywood
determined to meet
Marilyn Monroe, the
goddess of his dreams.
Photographer:
Peter Sorel

Taking the Driver's Seat

From an interview with John Singleton, writer/director Boyz N the Hood, Poetic Justice

Every day when I come to work, I thank God I have the job that I have, because I've worked other jobs. I've driven for shuttle companies, I worked as a museum docent, giving tours, I've recruited kids for college. This is the best job I've ever had.

I have the opportunity to put things in perspective because I didn't grow up in this industry. I came into it from another perspective altogether. I had production-assistant jobs all through school. I read the trades every day. I wandered about aimlessly thinking about what I was going to do next. And I just got tired of being on the lower ranks. I made a decision to write a screenplay.

I wrote because the only way that I was going to make a movie was on paper. Even if it was on paper, it was important to me. I wrote *Boyz N the Hood* when I was in school. There were a lot of skeptics. I walked into my screenwriting class and told the teacher, "This semester, I'm going to write my magnum opus, and this will be the only film written in this classroom that will actually be made, so I deserve an A." I don't think anybody ever said anything like that to her. It turned out to be true. When I got done writing it, I got signed to CAA based on that screenplay.

In one year I went from being an extra on a movie to being the director of my own movie. I wanted to be the boss for a change. I always thought that it was going to be more difficult than it actually was. As I go along, it seems to get easier. I'm finding out that people who think they know everything don't.

You've got so many people in this town who write because they have something to write about, but then there are a lot who write under contract. A lot of people are into it because they want it to bring them wealth and not because they have something significant to say. I can't see putting two years of your life toward something that isn't significant. There are a lot of those movies around. But if I were going to do that, the two years could be better spent doing other things.

I'm a selfish filmmaker in that I don't make films for anyone else. Ultimately, I make films for myself. I do make them for an audience, but I make the kind of movie that I would want to go see. And it turns out that people in my age range, across the board, want to see the same type of films that I want to make. I make a film for what it can do for the medium, instead of what it can do for me.

If you really are in it for the long run, then you've got to understand that you're constantly in the process of learning your craft. I'm still in film school as far as I'm concerned. There are plenty of young maverick filmmakers who come out with one film and then you never hear of them again. It's all about building the steps of my own ladder.

When I'm writing a script, I'm anxious to get the thing made. When I'm directing, I'm anxious to get into the editing room, and when I'm editing, I'm anxious to write another one and start again. It's cool. It's better than driving a shuttle.

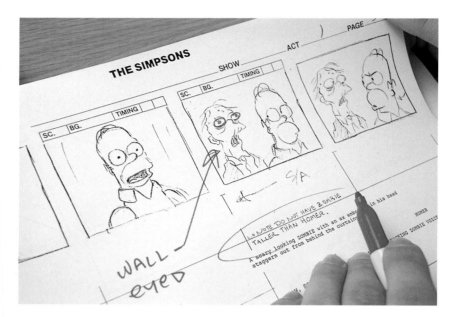

Above and right

Storyboarding (*above*) progresses on *The Simpsons*, which began as a series of 30-second spots on the *Tracey Ullman Show* and graduated to a weekly 30-minute show that, within two months of its premier, skyrocketed into the Nielsen Top 15. The show has become a merchandising bonanza, spinning off posters, hats, bubble gum, and even a talking Bart Simpson doll. At one point, Simpsons T-shirts were selling at a rate of one million per week.

At the Film Roman studios (*right*), Mark Kirkland, David Silverman, and Bart ("Don't have a cow!") Simpson run through a scene. Kirkland and Silverman, co-directors of animation, take the script from the writers and pencil in an entire story; today they were trying to imagine how Homer might look if he were King Kong. Their sketches are sent to creator Matt Groening for approval and then go to animators who complete and color the drawings. The whole process takes about four months. According to the *Los Angeles Times*, the Emmy-winning show "has some of the most incisive writing on TV."
Photographer:
Douglas Kirkland

Following, page 130

Stephen Worth and Lew Stude own Vintage Ink and Paint Company in Burbank, which specializes in the restoration and preservation of animation cels—especially those from the '30s and '40s. (A cel is one frame of art from a cartoon.) To preserve the integrity of the original art, Worth and Stude employ the same paints, pigments, and formulas used in the 1920s. In the foreground, Worth touches up a Pepe Le Pew cel while holding a Yosemite Sam in his hand. The average cel is valued at $400 to $800, but an original "Sleeping Beauty on her Deathbed" was recently priced in a Christie's auction catalogue at $18,000 to $22,000.
Photographer:
Lara Jo Regan

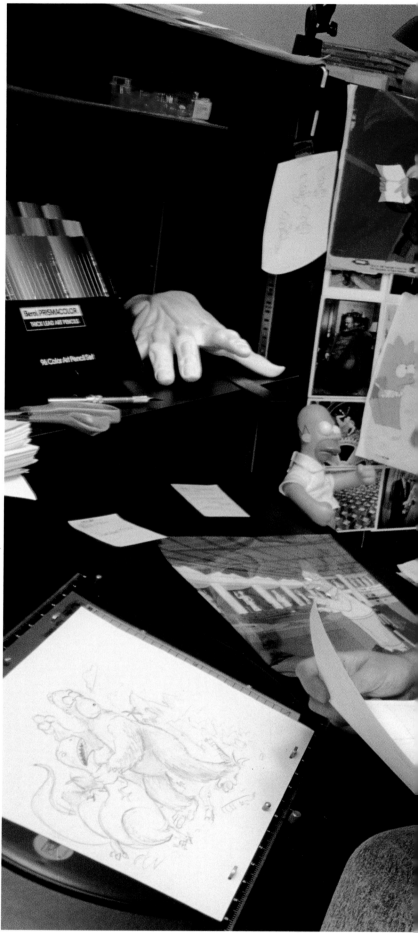

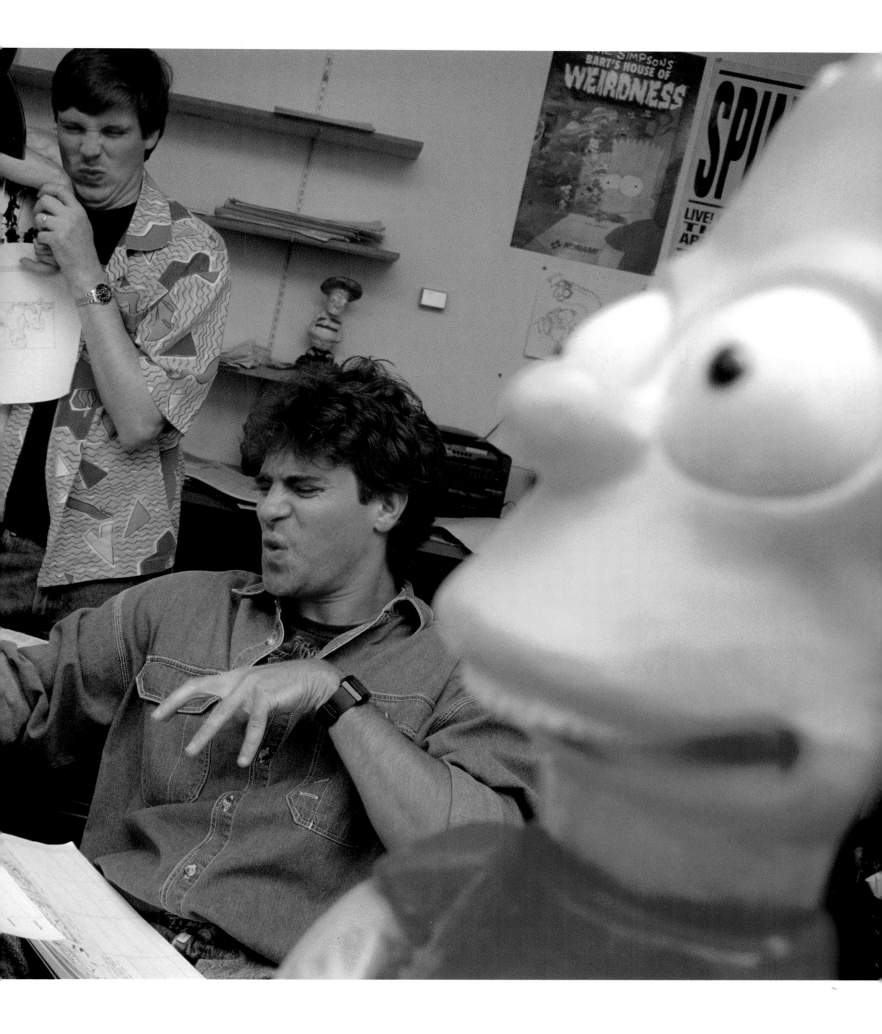

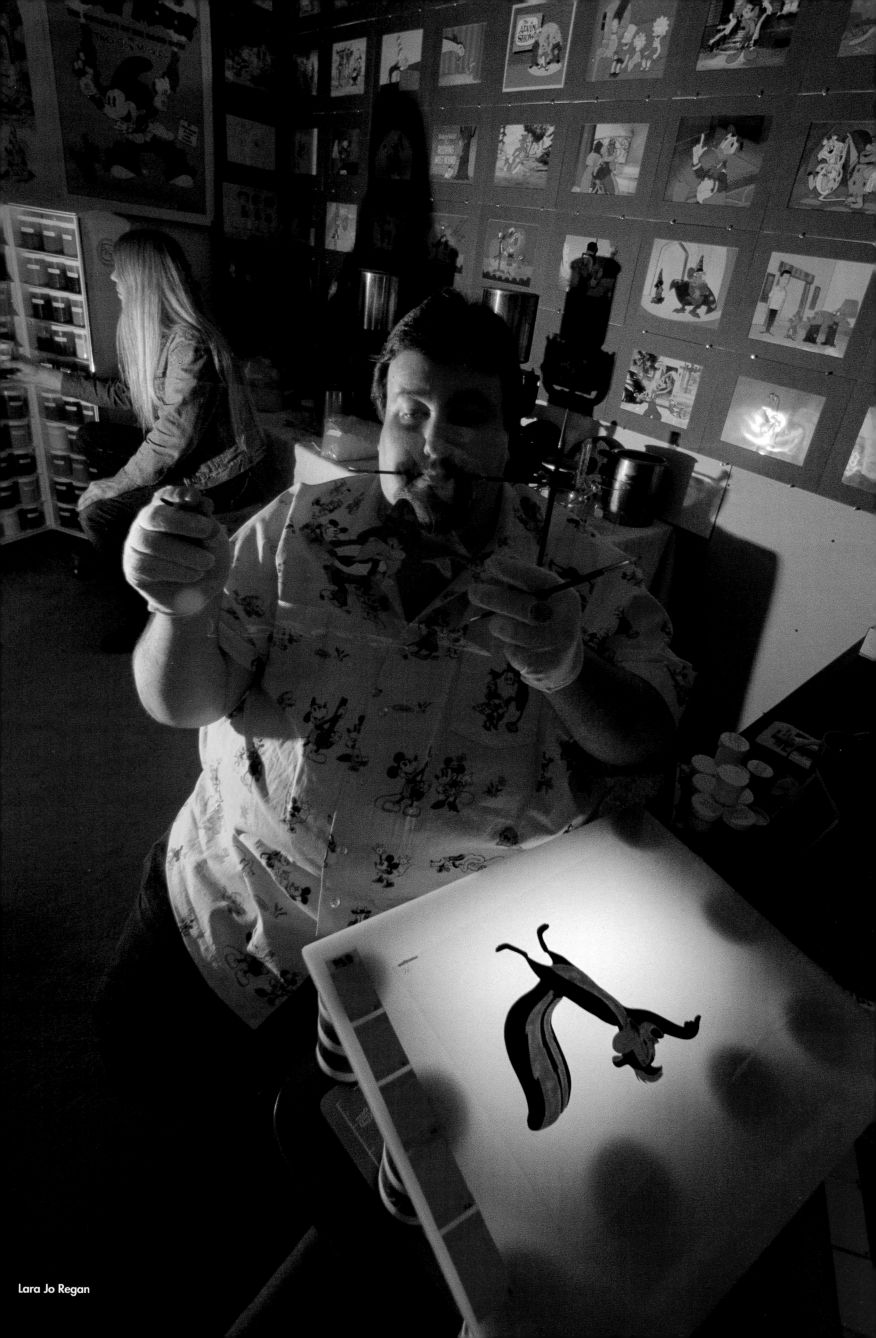

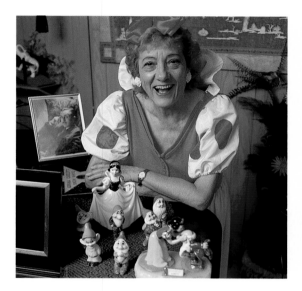

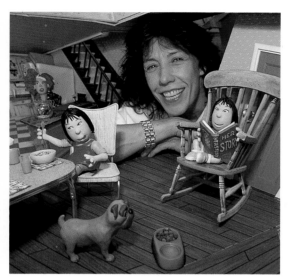

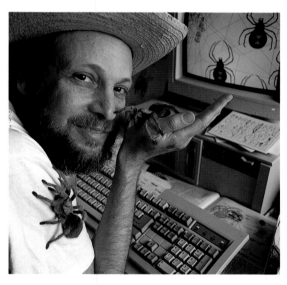

Above, top

Adriana Caselotti, 76, became the voice of Snow White in 1937, when Walt Disney answered an ad placed by Adriana's father, an opera teacher. Paid $20 a day, Adriana earned a total of $970 for the role. Married four times, Adriana lives in a Hancock Park house she designed, complete with a wishing well and bridge in the front yard. On her piano is a photograph of a young Walt Disney bearing the inscription, "Best Wishes Maestro Caselotti, the teacher of Adriana, the voice of Snow White."
Photographer:
Michael O'Neill

Above, bottom

Entomologist Steve Kutchner, 48, is founder of Bugs Are My Business, which has been providing insects of all types for films, television, and commercials for 17 years. In his first film, *Exorcist II*, Kutchner supplied 300 African locusts. He has also made bees swarm indoors for a Kentucky Fried Chicken commercial and arranged a bathtub full of mealworms for David Letterman. The spiders on his computer are just for fun, but those on his body are real tarantulas. Their bites, he maintains, are more a nuisance than a danger.
Photographer:
Theo Westenberger

Above, top

In her garage at home, Lily Tomlin, 52, works on a mixed-media animation special starring Edith Ann, a character she created 20 years ago on *Laugh-In*. "It's another world down there," Tomlin says of her in-home studio. Along with her longtime collaborator Jane Wagner, Tomlin has been working on the Edith Ann project for the past three years and hopes, as in all her work, that it will be "funny, inspiring, poetic."
Photographer:
Annie Griffiths Belt

Above, bottom

Glen Keane, 38, animator and animation director, works on Disney's animated feature *Aladdin*. Keane, who created the Beast in *Beauty and the Beast* and Ariel in *The Little Mermaid*, believes "an animator is an actor with his pencil." He often acts out expressions in order to infuse his characters with emotional depth. After Glen sketches an expression, other artists paint the actual cels, as many as 80 of which may be needed for one second of animation. An animated feature such as *Aladdin* takes about three years to complete.
Photographer:
Jill Hartley

Right

Once a month, mother-and-daughter star polishers Rose and Jeannie Bitters, 69 and 42, shine the sidewalk star of their favorite singer, Barry Manilow. The women provide their own cleaning supplies and knee pads, but Jeannie considers it a privilege to pay back Manilow for his music—"which has gotten me and a lot of other people though a lot of hard times."
Photographer:
Lara Jo Regan

Right

Actor Lou Gossett, Jr., 56, kneels between his children Sharron, 14, and Satie, 17, while being honored with his very own star on the Walk of Fame. Started in 1959 and administered by the Hollywood Chamber of Commerce, the Walk runs for 2.3 miles along Hollywood Boulevard and Vine Street. Each year, several hundred hopefuls are nominated for a star, but only 12 to 15 are selected. Winners are then charged $5,000 to cover the cost of making the star and paying for the ceremony.
Photographer:
D Stevens

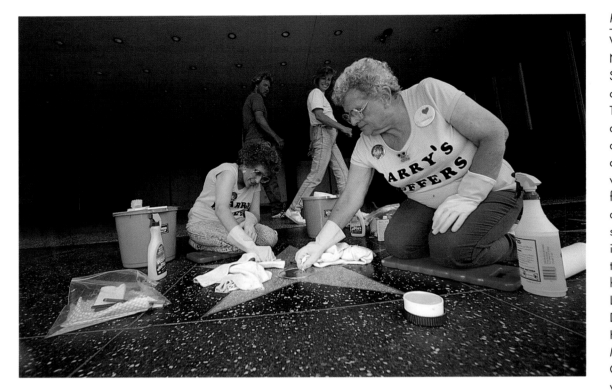

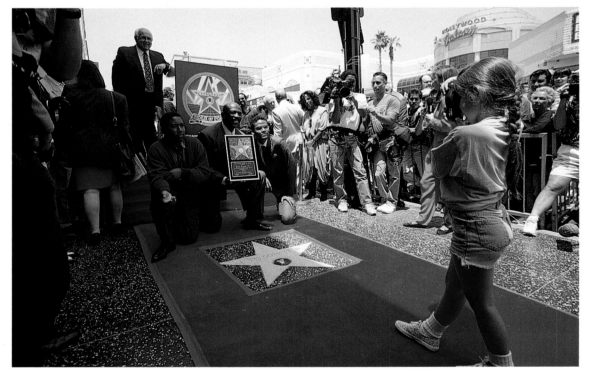

Right and following pag

When silent-screen star Norma Talmadge visited Sid Grauman's newly constructed Chinese Theater in 1927 and accidentally stepped into a sidewalk of wet cement a Hollywood tradition was born. Since then, the footprints, handprints, and signatures of 180 stars have been immortalized in the forecourt of theater, as have Trigger horseshoes, Harold Lloyd's glasses, Jimmy Durante's nose, Sonja Heinie's ice skates, Harpo Marx's harp, Betty Grable's legs, R2D2's wheels and C3PO's mechanical feet, and Donald Duck's webbed feet. But placement in cement in Hollywood's largest autograph album does not guarantee immortality. It's said that the basement of the Chinese Theater is strewn with the concrete slabs of now-forgotten stars.
Photographer:
Ken Duncan

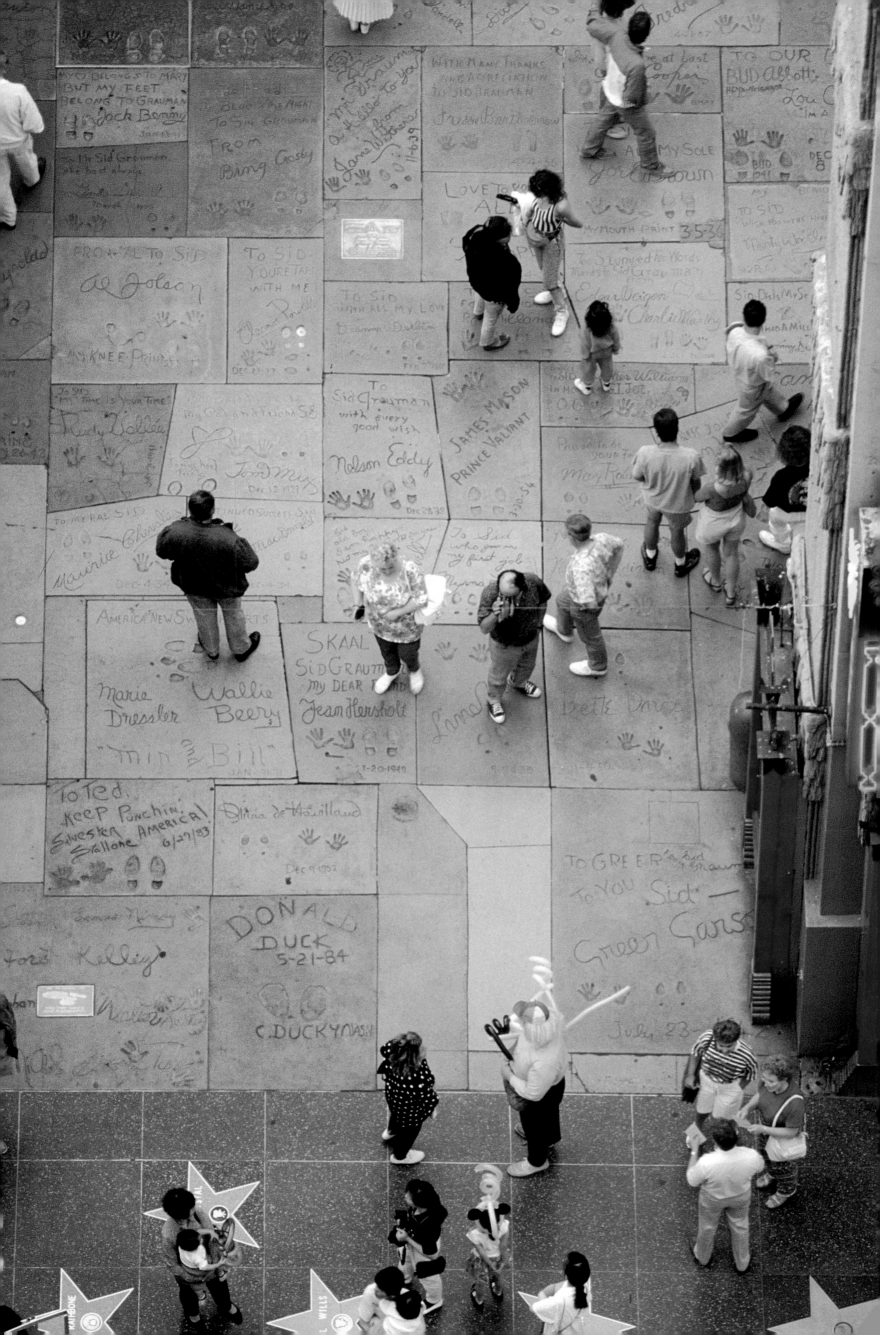

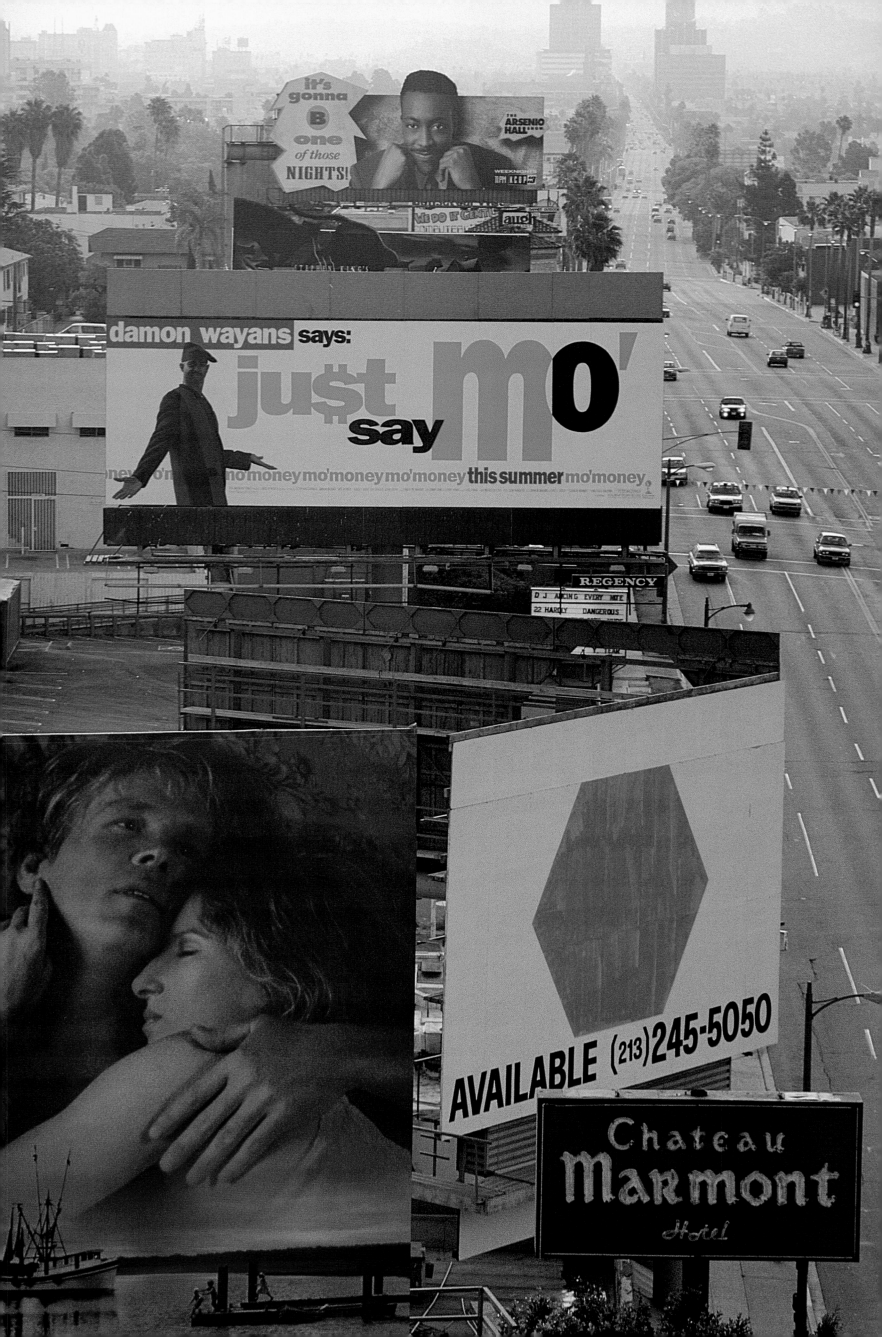

eft

he billboards on Sunset
rip represent the gold
oast of Hollywood
dvertising. "This mile
nd a half is an ego trip
r the motion picture
ompanies," says Alan
ossi, paint-studio director
Gannett Outdoor.
very executive in the
usiness passes this strip
 his or her way into
wn from Malibu, Beverly
lls, or Bel Air." Prices
 the strip are sky-high,
nging from $9,000 to
 5,000 a month per sign.
otographer:
atherine Karnow

ght, top

inted billboards, called
0-sheets," constitute
 important advertising
ol in the marketing of
new film. *Housesitter,*
rring Goldie Hawn,
ent into the market-
ace with 1,200 bill-
oards nationwide. This
e on the Sunset Strip,
owever, was one of
ly two that were hand-
inted (the other one
s located on
nkershim Boulevard
ar Universal Studios).
otographer:
n Ortner

Left, bottom

Eddie Murphy towers
above Sunset Boulevard in
a billboard promoting
Boomerang, a contempo-
rary comedy set in New
York City.
Photographer:
Robert Landau

Following, pages 138-139

Goldie Hawn, 47, takes an
outdoor meeting with writer
Valerie Curtin, at far left,
and Anthea Sylbert,
producer and partner in
the Hawn/Sylbert Motion
Picture Company. Founded
eight years ago to develop
projects for the star, the
company often meets in
Goldie's back yard,
especially when the weather
is as good as it was on May
20th. The day's discussion
concerned an untitled
comedy about a modern
family, written by Curtin,
which Hawn and Sylbert
are considering for
production. "With Goldie,
what you see is what you
get," says Sylbert. "She's
warm and funny and
strong and not at all goofy.
She's also tough, which
surprises those who don't
know her."
Photographer:
David C. Turnley

137

David C. Turnley

ft

ctress Shirley MacLaine
nd producer Larry Mark
o lunch on the beach at
alibu. Mark describes
is impromptu surf walk
a "typical MacLaine
ea." She agrees, "I can't
ay confined too long,
en in a restaurant with
eat food." The two
came friends during the
ming of *Terms of
dearment*, though their
nch was both personal
d professional—

inasmuch as some work-
related topics were
discussed while peeling
bananas and testing the
waters. Asked about her
outfit, MacLaine said the
38F has no significance
except "maybe it's what I
think of my age."
Photographer:
D. Gorton

Above

An exhausted Harrison
Ford, with publicist Jane
E. Russell, unwinds at the
conclusion of a press
junket for Paramount's
$42 million feature *Patriot
Games*, held in the
ballroom of the Four
Seasons Hotel in Beverly
Hills. Six times a year,
Paramount Pictures
arranges for 100-150
print and television
reporters to converge in
one location, hobnob with
the stars, and, ideally, go

home and write something
wonderful about their
hosts' movie. According to
John Scalzi, a film and
video critic who attended
the event for the *Fresno
Bee*, most of the questions
directed at Ford concerned
the issue of violence in the
movies. Ford's response:
he draws the line at
portraying any character
who takes pleasure in
violence or killing.
Photographer:
Barry Lewis

Following, pages 142-143

Los Angeles Times columnist
Charles Champlin interviews
actress Jacqueline Bisset
during lunch in the famed
Polo Lounge at the Beverly
Hills Hotel. Over the course
of his 30-year career,
Champlin estimates that
he has written more than
three million words about
the movies.
Photographer:
Roger Sandler

Roger Sandler

Where the Elephants Go to Die
By Charles Champlin

When Dorothy Parker and her husband Alan Campbell first came to Hollywood to write movies in the early 1930s, there were only two places, Campbell said later, where temporary exiles from New York felt comfortable staying. One was the raffish Garden of Allah, where such celebrated expatriates as Robert Benchley and F. Scott Fitzgerald made their homes away from home. The other was the Beverly Hills Hotel, farther west on Sunset Boulevard. "We chose the Garden," Campbell remembered, "because Dottie said she always thought of the Beverly Hills Hotel as the place where the elephants go to die."

The Garden of Allah, named for the silent star Alla Nazimova, was torn down in 1959 to make way for a savings bank, also long since defunct. But the Beverly Hills Hotel has carried on, the pre-eminent watering hole, in pink and green, for persons of elephantine stature in and out of (but mostly in) the movie business.

Over three decades I've done more interviews and entertained more visitors in the hotel's Polo Lounge than anywhere else in town. Its brick terrace, shaded by a tree which may be the oldest, largest living item in Beverly Hills, is a wonderful place to have lunch, and undoubtedly the best location of all for daytime Hollywood star-gazing. A series of elevated banquettes along one rim of the terrace allow the impression that a world of glamor and power rests at your feet. This may be only another illusion of an illusionary town, but it adds a certain tang to the Neil McCarty chopped salad.

When I wanted to do a luncheon interview on May 20, 1992, with the elegantly beautiful Anglo-French actress Jacqueline Bisset, the terrace of the Polo Lounge was an inevitable and irresistible choice. We had met at the Polo Lounge for the first time a quarter-century ago, when she was in her early twenties and had not long arrived from England to begin her American career.

Although she reached Hollywood too late for the mixed blessings of the studio star system (a kind of financially secure captivity), she has become an indubitable Hollywood star and retained a lively and candid independence in the process. She is now in her forties, and her astonishing beauty has taken on the additional glow that maturity, lit by an inner wisdom and serenity, can bring.

Like Meryl Streep and other post-ingenue actresses, she finds that appealing roles are not as abundant as she would like them to be. But she is one of the Hollywood performers who are in demand abroad. She has recently made a film, *Rossini, Rossini*, in Italy and also starred in *The Maid*, in France, with Martin Sheen as a rich man posing as a maid to court her. Symbolic of a changing film industry, *The Maid* will go directly to the videocassette market in the U.S.

Her long list of credits includes François Truffaut's *Day for Night, Bullitt, Airport, The Grasshopper* (in which she was last seen improbably skywriting a naughty word above Las Vegas), *Murder on the Orient Express, The Greek Tycoon, Someone Is Killing the Great Chefs of Europe*, George Cukor's last film, *Rich and Famous*, and John Huston's *Under the Volcano*. (Some fans are likely to remember her vividly in a wet T-shirt in *The Deep*.)

Still, she admits, with characteristic honesty, that the one, great, mold-breaking role that transmutes the star into the star actress has been elusive. It has been the lament of beautiful women in Hollywood since even before the movies learned to talk. The more beautiful you are, the more difficult it is, apparently, to be taken seriously. Women were more often reactive than active, were romantically decorative, and could aspire to be comediennes, but the dramatic parts went to a memorable few. Yet Ginger Rogers won new respect after *Kitty Foyle* and Elizabeth Taylor after *Who's Afraid of Virginia Woolf*. The situation has begun to change in the last decade or two, but not swiftly enough to satisfy a new generation of smart, well-versed actresses.

Jacqueline Bisset remembers, as a seven-year-old, seeing a Bette Davis film and deciding that it would be very interesting to be an actress. Now she would dearly welcome a role that would test her experience and her intelligence and give her a chance to display some Davis-like dramatic fireworks.

But the Hollywood we talked about at the Polo Lounge in May has changed significantly in the quarter-century since she arrived to star in *The Sweet Ride* for director Harvey Hart and producer Joe Pasternak. There are fewer films being made now than then, which means fewer options for both performers and customers. Production costs have increased at least tenfold, which results in far more timidity in the choice of material, and more reliance on sex, sensation, and violent special effects—none of which are particularly good news for serious actors. Exceptions as

varied as *Dances with Wolves, Driving Miss Daisy*, and *Grand Canyon* do find their way through the system, but somehow they remain orphan ventures, with no descendants. As Adlai Stevenson once remarked about the Republicans, Hollywood sometimes seems willing to try anything, but not for the first time.

But, the shortage of roles aside, Jacqueline Bisset has created a splendidly satisfying life for herself, having mastered the two most difficult of all Hollywood arts: survival, and adjustment to fame and fortune. "It's no longer an effort to live in Los Angeles," she says. She is at home here (in the hills above the hotel) and finds the community growing more interesting right along. It is also, she says, energy addictive, fuller of vitality than Lotus Land used to be.

Her retreat, when the actor's inevitable anxieties get to her, is a 400-year-old thatched-roof family cottage she has inherited in the countryside near Reading, England, where she grew up. ("My father used to drive me past the Reading gaol and tell me that that was where Oscar Wilde wrote the ballad.")

Not long ago, during a stay at the cottage, she had some workmen re-thatching her roof. "Made them cups of tea every afternoon for three weeks and listened to them talk about *Dynasty*. Cheeky devils. I ended up ashamed that I hadn't been on it."

The cottage, and the fields of bluebells and mustard, make a nice antidote to the angst which is as much a part of the local life as Perrier and chardonnay. "Always when I first come back to Hollywood I feel wobbly," Jacqueline Bisset says. "Will the phone ring again? I ask myself, is it worth feeling wobbly? Then the phone rings, and I think, yes it is."

We sat in the spring sunshine, contemplating the terrace's fringe of bougainvillea (plants doubtlessly older than some of the lunchers). The hotel was scheduled to close for renovations at the end of the summer. Newer and shinier hostelries have been eating at the patronage. But I hope the renovators are not too heavy-handed. It seems as true of Hollywood as anywhere else that the more things change (and they certainly do), the more they stay the same (as they do in the town's great alternations of triumph and frustration, anxiety and reassurance). The hotel has been a pink oasis, outlasting all the vicissitudes, rewarding the winners, consoling the losers, symbolizing a continuity that is not really characteristic of Hollywood. If the hotel should become a quite different place, I won't know where to take Jacqueline Bisset to lunch.

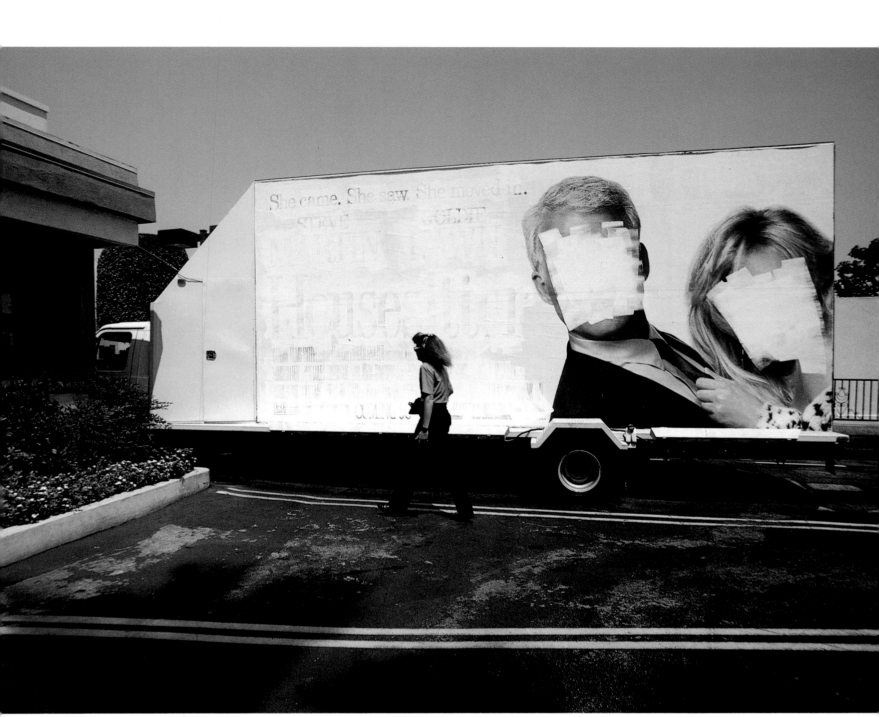

Above

Fame is fleeting in an industry where the notion that you're only as good as your last picture is taken as gospel. Its purpose on the movie *Housesitter* served, a truck-mounted billboard on the Paramount lot awaits its next incarnation.
Photographer:
Joe McNally

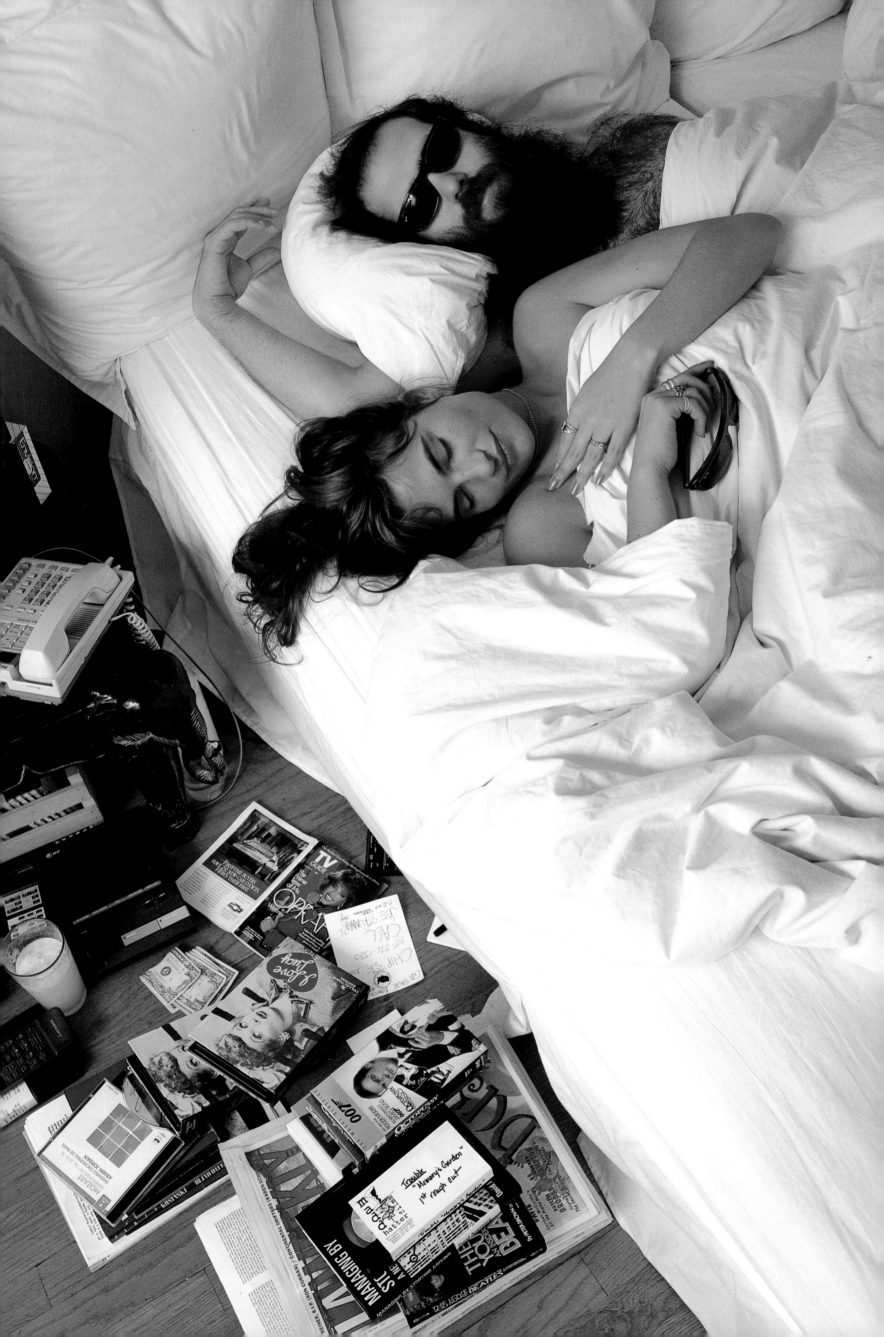

Left

ick Rubin, 29, and his
irlfriend Rosetta, rarely
et out of bed before
:00 p.m. Even when he
oes go to work, Rubin
ostly conducts business
om this bedroom in his
ree-story Mediterranean
ome off Sunset Boule-
ard. As a college
udent, Rubin parlayed
3,000 and a love of rap
nd metal bands into a
600,000 check from
BS Records. He sent a
opy to his parents to let
em know he wouldn't
e attending law school.
partnership with Russell
mmons, Rubin discov-
ed and/or worked with
e Beastie Boys, Public
nemy, LL Cool J, and
ndrew "Dice" Clay,
mong many others.
Vhen he and Simmons
olit, Rubin formed his
wn company, Def
merican, currently
stimated to be worth
etween $75 and $100
illion.
hotographer:
eorge Lange

Actor and comedian
George Burns, 96, plays
a daily game of bridge at
an exclusive Los Angeles
country club. Burns starts
each day at his office,
then heads to the club at
12:15 for lunch and
cards, playing with
whomever is available.
At 3:00 he goes home
for a rest, and at 5:30 he
enjoys a double martini
before dinner. Although
he is offered work
constantly, Burns restricts
himself to about three
engagements a month.
Photographer:
David Burnett

Left

Singer, songwriter, and
record producer Hakeem
Abdulsamad, 16, checks
Billboard to monitor the
status of his latest album.
Hakeem and his brothers
are The Boys, a new
Motown group whose
two albums, *Message
from the Boys* and *The
Boys*, have sold over two
million units. Motown
describes their music as
"a confrontational fusion
of hardline street sounds
to romantic visions, with
a surprising touch of
New Age."
Photographer:
Randy Olson

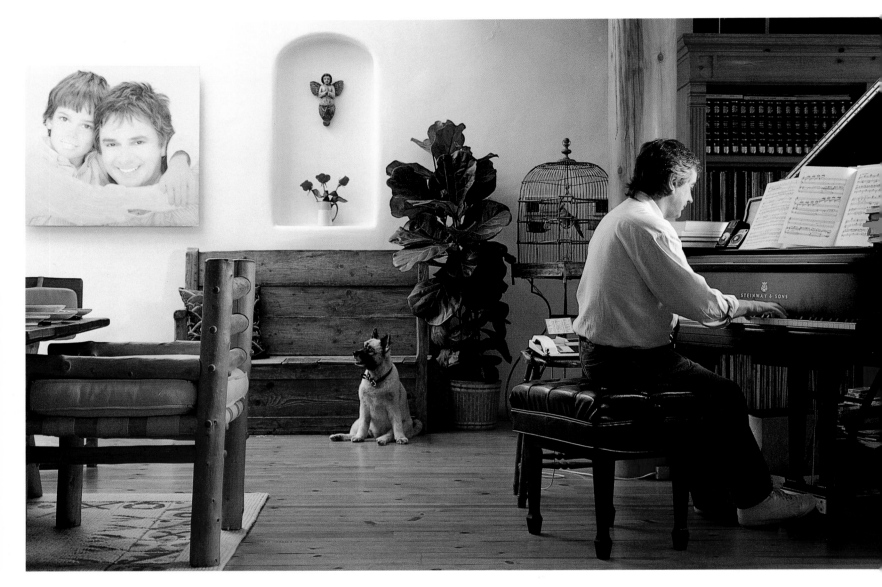

Above

Actor Dudley Moore, 57, spends at least an hour a day at one of the two pianos in the Venice Beach home where he has lived for 16 years. "I am a one-house person," says Moore. "I'm appalled at the thought of moving." On the wall is a portrait of Moore with his son Patrick, now 16, which was painted four years ago. Listening to Moore play is Chelsea, a keeshond puppy. Though Moore has starred in such hits as *10* and *Arthur,* he started out as a composer and says his first love is music. He plays every day to "set the tone so that hopefully the rest of the day will go as well as the music."
Photographer:
Guglielmo de' Micheli

Left

On May 20th, 1992, Jimmy Stewart celebrate his 84th birthday and posed for this portrait ir the back yard of his Beverly Hills home. The African acacia tree behind Stewart was a g from William Holden many years ago.
Photographer:
Theo Westenberger

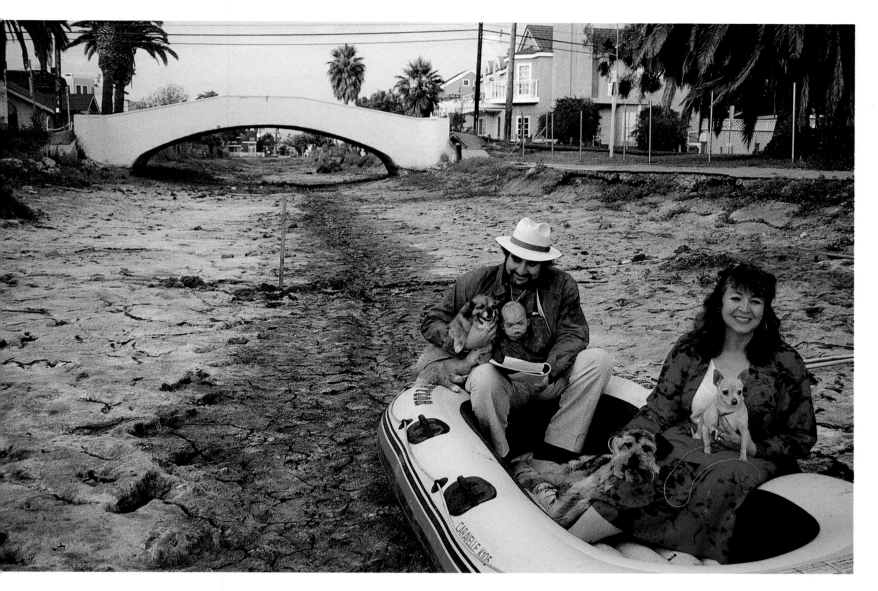

ly Barty, 67, the 3'-9"
ctor who has worked in
m and television for
er four decades,
laxes outside the North
ollywood home where
e has lived with his wife
d children for 30
ars. "Others call this a
cuzzi," says Barty, "but
s my swimming pool."
otographer:
rry C. Price

Above

Ron and Linda Shusett
languish in the recently
drained Sherman Canal
in Venice, California,
near the home where the
couple has lived for the
past 12 years. Ron, who
wrote and co-produced
Alien, wears a head from
his recent production,
Total Recall. Also aboard
the raft are Shana the
Chihuahua, Reggie the
spaniel, and Chewie
(short for Chewbaca in

Star Wars) the terrier.
Asked their destination in
their land-locked raft, Ron
first cried, "To the Oscars!"
before changing his mind
and replying, "To Border-
lands, to the land next to
Fairy Land." *Borderlands*,
it so happens, is the name
of Ron's latest project,
a TV pilot set to run on
NBC in the fall of 1993.
Photographer:
Jill Freedman

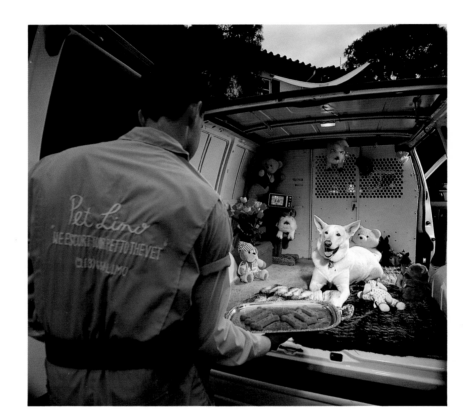

Above

Oso, a purebred white German shepherd, enjoys a biscuit from a sterling silver tray, plenty of chew toys, and a choice of television programming—including videos such as *Felix the Cat.* Owner Steven May charges $50 to $200 to pick up and deliver animals to the airport, the veterinarian, the groomer, or any other appointment. The franchise runs four vans as well as a sideline business providing emergency earthquake kits for pets (enough food, water, medicine, and toys for three days).
Photographer:
Theo Westenberger

Right

Pajama-clad Hugh Hefner fusses with an unruly cowlick while surrounded by, from left to right, his butler Stephen Daniel Martinez, his infant son Casper, Playboy Mansion photographer Elayne Lodge, wife Kimberly, 2-year-old son Marston, nanny Lorie Gertes, and assorted free-roaming flamingoes, African cranes, and peacocks on the Playboy estate over-looking Beverly Hills. Hefner, who rarely leaves the mansion, met Kimberly, his second wife, when she arrived for a Playmate audition. On May 20th, Hef and family were primping for a photograph Lodge was shooting for the *London Times*'s *Saturday Review.*
Photographer:
Michael O'Neill

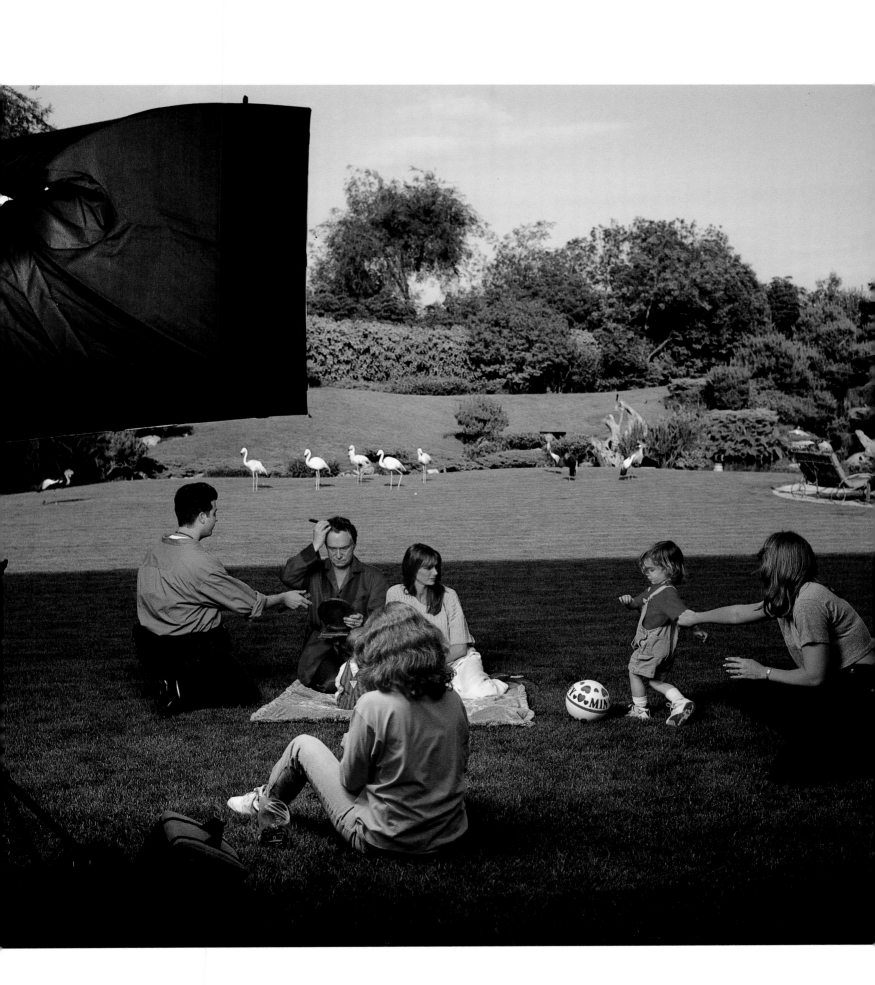

eft and top right

ast-minute preparations
r co-anchors Mary
art, 40, and John Tesh,
9, take place before
ping of the May 20th
stallment of *Entertain-
ent Tonight,* the hit TV
ews series now in its
1th year. This show
atured the *Alien³*
emier, a television
iniseries about the
cksons, and Leonard
altin on the video
lease of *JFK.* Mary
art's much admired
gs (*left*) are highlighted
special "fiber-optic
g lights." As a footnote
the Life-Imitates-A-
y-In-The-Life Depart-
ent: On May 21,
992, *ET* ran a story on
e making of *A Day in
e Life of Hollywood;*
eir camera crews had
ped photographers
oting Billy Barty,
gh Hefner, the *Far
d Away* premier, and,
course, these pictures
Tesh and Hart.
otographer:
nathan Exley

Left, bottom

Actors Carl Weathers
and Dudley Moore make
guest appearances on
KABC's *Michael Jackson
Show* to discuss the
aftermath of the Los
Angeles riots, particularly
the community's efforts to
rebuild. Jackson's four-
hour call-in radio show
reaches about 1,100,000
listeners every week and
has been on the air for
26 years. "I am contro-
versial because I do my
homework, not because I
am rude," says Jackson,
"and I am a liberal who
probably has more
conservative guests than
any other host." The
secret to his success?
"I offer hospitality," he
claims. "To me, to
entertain means to show
hospitality."
Photographer:
David Butow

Right

Hollywood gossip columnist Janet Charlton prepares her notes only minutes before a live broadcast feed to the *Joan Rivers Show* in New York. Tonight Charlton opened with an item about Stephanie Seymour's complicated love life. Seymour, who left Warren Beatty for musician Axl Rose, was now abandoning Axl for Charlie Sheen. Where does Charlton get these stories? Mainly from a complicated network of waiters, limo drivers, and hairdressers who are paid $100 for small squibs and up to $350 for a lead piece of newsworthy gossip. Charlton, who also writes a column for the *Star*, thinks gossip has the positive effect of piquing the public's interest in celebrities and wonders why the stars "aren't sending me Christmas presents."
Photographer:
George Lange

Following, pages 156-157

At the Skywalker Sound studios, Dan O'Connell watches a tape of the movie *Unlawful Entry*, coordinating the action on screen of a man getting whacked on the head with a nightstick to the sound of a watermelon receiving the same treatment. Why a watermelon? "The hollowness and liquidness of the melon are just like that of the human head," says O'Connell. "If you need to add some sounds of bones crunching to the thud, then you just break some celery stalks."
Photographer:
Gerd Ludwig

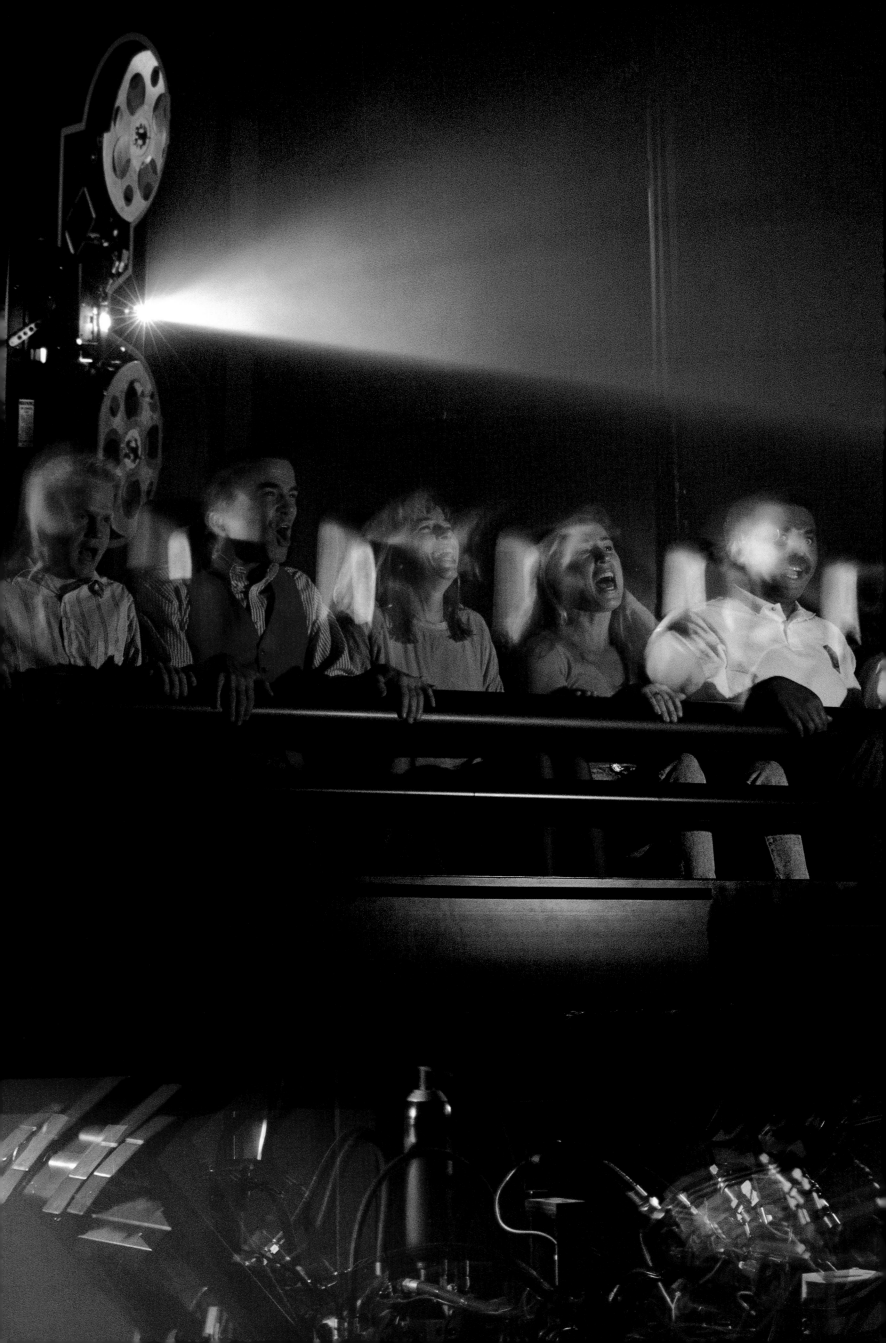

eft

Showscan is a new process that will set audiences spinning, or at least rocking up and down. A mechanical simulator moves each row of ten seats in time with the action shown on screen. The film is projected at 60 frames per second, a rate two-and-a-half times normal, to enhance clarity and increase sensation. Much like the very first motion pictures, the films available for viewing including a roller coaster ride, a car chase, a downhill ski run, and a bobsled ride. Showscan has manufactured 36 of these simulators, but only 14 are in operation—mainly in multiplex theaters and in shopping malls in Europe and Japan. The only one operating in America is in Las Vegas, although Universal Studios plans to install one in its new City Walk complex. It costs between $3.50 and $5.00 to ride in this theater seat.
Photographer:
Peter J. Menzel

Left

In a recording studio at Twentieth Century Fox, a live orchestra plays in time to a running cartoon, *Capitol Critters*, while scoring mixer Armin Steiner works at the console to adjust the sound to the action. Working with the conductor, he can, for example, turn up the sound of the tuba when one of the characters gets hit over the head. The composers have about a week to write the score for a half-hour cartoon, which is recorded in a three-hour session at this studio.
Photographer:
Douglas Kirkland

Left

Clint Eastwood, 61, works with re-recording mixer Les Fresholtz at the dubbing console, laying down the final sound track for *Unforgiven*. The hardest part of merging the dialogue, music, and sound effects in the film was making the dialogue audible in a heavy rainstorm scene and again during a barroom shootout. Eastwood preferred to keep as much of the original dialogue as possible (as opposed to re-recording the voices) for authenticity.
Photographer:
David Hume Kennerly

159

Above

Based in Venice, California, Wildfire, Inc., has pioneered the use and design of fluorescent special effects in television commercials, feature films, music videos, theme parks, and live special events. Using the latest developments in both visible and invisible fluorescent paints, Wildfire has designed sequences in *Alien³*, *Bill and Ted's Bogus Journey*, *The Doors*, and *Star Trek VI*. Founded 10 years ago in Holland, the company moved to the U.S. in 1990 because, according to creative director Leslie Pringle, at right, "In Europe, they can't seem to try anything new until the Americans first have their fingers burned." Pringle is drinking a special fluorescent water which he says is "completely non-toxic."
Photographer:
Peter J. Menzel

Left

The "King of 3-D," Ray Zone, appears double-headed but is really only double-exposed. For the past 10 years, Zone has been converting flat images to 3-D for all sorts of publications, displays, and videos, as well as transferring 3-D to T-shirts, cups, toys, and underwear. Zone recently completed a 3-D issue of *The Simpsons* magazine and, on May 20th, was working on a 3-D Roger Rabbit comic book for Disney. "I'm 45 years old," says Ray, "with the heart of a 12-year-old."
Photographer:
Timothy White

Above

Rob Reiner, 47, supervises the editing of *A Few Good Men*, which stars Tom Cruise, Jack Nicholson (both visible on screen), and Demi Moore, while his wife, Michele Singer, shoots this portrait. Reiner's career began with acting; he starred as Meathead on *All in the Family*. Since then, he has established a distinguished career by directing and producing such hits as *This Is Spinal Tap, Stand By Me, When Harry Met Sally,* and *Misery.* How does Reiner rate himself among directors? "I am the tallest director in Hollywood," he says. "Others may be as tall but not my weight." Hence his claim to the title of "biggest director in Hollywood."

Photographer:
Michele Singer

Producer Sherry Lansing, 47, also oversees the editing of her latest film, *School Ties*. In 1980, Lansing was named President of Production at Twentieth Century Fox, the first woman to hold that position in the film industry. She left in 1983 to work in partnership with Stanley Jaffe, producing *The Accused* and *Fatal Attraction* among other hits. Today she helms her own independent production company at Paramount Pictures and is married to director William Friedkin. She feels privileged, as a producer, to have the opportunity to "think about the things that are important, communicate what you care about to other people, and hopefully affect the way they think or feel."
Photographer:
Joe McNally

ft

irector Tim Burton, 32,
views a scene from
atman Returns. The
quel to his first *Batman*,
hich reportedly earned
ore than $2 billion in
:ket sales, posed some
erplexing problems in
ealing with tempera-
ental penguins. "There
as nothing to base the
xperience on," Burton
ys. "It's not like you
uld say, 'Oh yes, I
member the last movie
hen we had those 50
enguins.'" Often labeled
ollywood's *wunderkind*
cause of his age and
s attraction to comic-
rip themes, Burton has
surreal sense of humor
at infuses his films with
unique and often
sturbing sensibility—
evidenced in *Pee
'ee's Big Adventure*,
etlejuice* and *Edward
:issorhands*.
otographer:
n Regan

Left

Producer Dino De
Laurentiis, 73, previews
footage from *Body of
Evidence* and predicts the
movie will elevate Ma-
donna from pop star to
serious actress. De
Laurentiis's career spans
50 years and over 600
films, including *King Kong,
Serpico, Ragtime, Barbar-
ella*, and *Blue Velvet*. He
came to America in 1962
because, he says, "The
best place to make spa-
ghetti is Italy, the best place
to make wine is France,
and the best place to make
movies is Hollywood."
Photographer:
Murray Close

Left

On May 20th, Richard
Schickel, one of two film
critics for *Time* maga-
zine, privately previewed
Alien³ in the executive
screening room (known
as the Z Room) at
Twentieth Century Fox.
His review appeared in
the June 1 issue and
said, in part, "the 29-
year-old director David
Fincher doesn't yet know
how to scare us witless.
… A lot of good, serious
work went into this film,
but it lacks the conjurer's
touch."
Photographer:
Henry Groskinsky

Heaven Can't Wait

By Mark Matousek

ong before Shirley MacLaine began her cosmic confessions, Hollywood was a mystical town. Mae West conducted seances in her Malibu home. Anne Miller moonlighted as a trance medium. Glenn Ford experimented with past-life regression. Ronald Reagan took advice from a personal astrologer. While these celebrities were obliged to keep their occult lives a secret, however, Hollywood spirituality has finally come out of the closet. It's hip nowadays to know your Higher Power. Movie people are falling to their knees in astounding numbers, being "born again," sampling Eastern religions, embracing New Age philosophy, down-shifting (as Marshall MacLuhan predicted) from the Cadillac to the prayer mat.

What I want to know today is, why?

8:30 a.m.: "There's a spiritual revolution happening here," Diane Ladd explains between sips of coffee. We're in the actress's living room, looking out over the smoggy sprawl of condos, palm trees and swimming pools. "Hollywood is the heart chakra of the country, honey. What happens here determines the future. People are sick and tired of the way things are going in the world. It's time for a paradigm shift."

Until two years ago, Ladd hid her private life as an ordained minister, nutritionist, and healer, fearful of being labeled a "born-again nut" in a rumor-mongering town where "an actress could be a hooker, but not spiritual." Today, her attitude has changed. "Now that I'm in a position to produce my own films," she says, "I'll do what I damn well please." That includes hitting the streets. When the riots broke out this spring, Ladd conned the studios out of sandwiches and porta-potties for the homeless. "I thought, *this* is why I

became a minister. Celebrities are spiritual heroes nowadays. WI did the protestors call to settle the chaos here? Not President Bush Not Cardinal O'Connor. They wanted Oprah Winfrey, Magic Johnson, and Arsenio Hall. And they came."

The telephone rings. It's Ladd's daughter, actress Laura Dern. "Laura's deeply spiritual, as are a lot of the young folks in t town," Ladd says afterward, as we drive down Hollywood Boulevard in her Jeep. "They've had enough sex, drugs, and rock n' ro They want a real high." Stopping in front of my hotel, Ladd leans across the bucket seats to give me a bear hug. "Tell your readers have only one wish for humanity: that the rose of the human hear blossom forth and send love to all those who stumble in dark places. Now get out of here!"

10:00 a.m.: "The riots were a wake-up call," says Rod Stryker, who has been a yoga instructor to such clients as Bette Midler and superagent Paula Wagner for the past 12 years. He claims that people in high places are feeling insecure. "Two week ago this town was on fire. Something's gotta give.

"You see, Hollywood's the land of the dangling carrot," Stryker says. "You never have the sense that where you are is oko It's all about climbing *all* the time. For people trying to get their st on the boulevard, staying grounded in reality is tough. Without turning inward, forget it. You go crazy fast."

Stryker knows this lunacy firsthand. For ten years, he play the role of wannabe actor before finding his true calling. "Hollywood is full of artists—the most sensitive creatures known to man—confronting corporate brutality on a daily basis. That's the reason spirituality's exploding here. It's the only bridge to sanity."

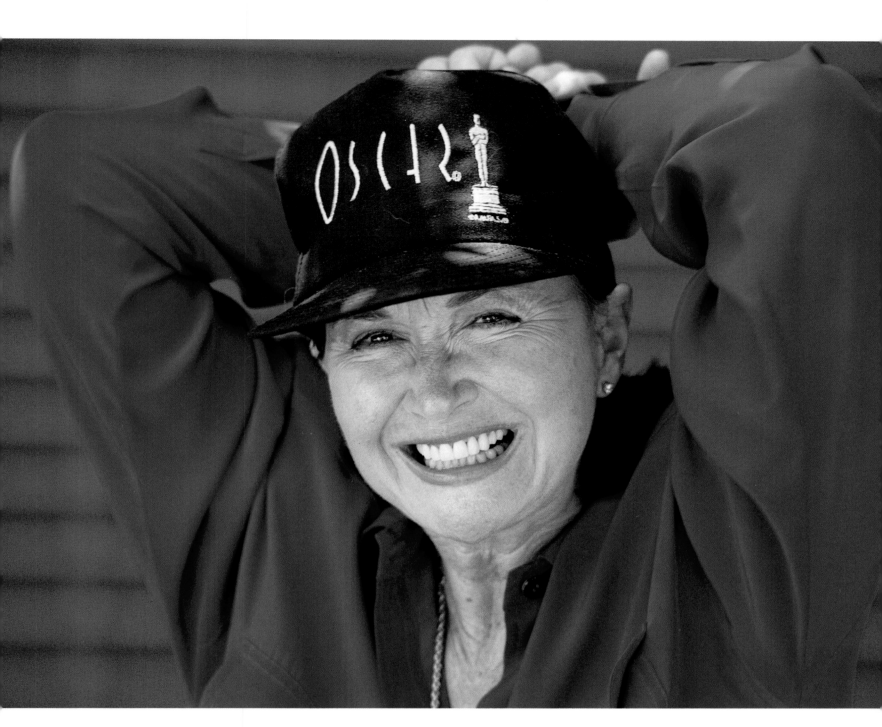

Above

Actress and producer Diane Ladd wears an Oscar cap recalling her three nominations for the movie industry's top awards. With Laura Dern, she is part of the first mother-daughter team nominated for Oscars in the same year for the same film (*Rambling Rose*). Currently producing a movie in which she will play Martha Mitchell, Ladd is a Hollywood veteran who lectures regularly on her spiritual beliefs. "Hollywood is known as Sin City, but it is also a city of incredible creativity—and creativity is a spiritual force," says Ladd. She believes that "Hollywood has the potential to be a bed of spirituality."

Photographer:
Michele Singer

12:15 p.m.: "Stay calm, *nothing* is under control!" cries Susan Strasberg as she dashes into the Bodhi Tree, a metaphysical bookstore, 45 minutes late for our interview. The actress, writer, and only daughter of acting guru Lee Strasberg is just back from filming in Italy and promoting *Marilyn and Me*, her memoir about life as a surrogate sister to Marilyn Monroe. A long-time spiritual seeker, amateur astrologer, and numerologist, Strasberg is a regular at the Bodhi Tree. She pauses for a moment to smell the familiar incense and listen to the wind chimes. Then we get down to gossip.

"If God and the devil made a co-venture, it would be the film business," whispers Strasberg. "The good thing about it is that it makes you examine your life. When you're living in the dark, you don't know that the room is dirty. Hollywood turns the lights on.

"Unfortunately, there are a lot of what I call 'metafizzlers' running around. They're the kind who come up to you at cocktail parties and say, 'I'm very spiritual; are you?' It makes me *very* nervous."

Naturally, no one's tougher than a convert, and Strasberg is certainly a refugee of the New Age wars. "I used to travel with Orgone blankets, megavitamins, pyramids, reflexology combs, crystals, tarot cards, magical stones," she says. "Then I realized that the answer wasn't on the outside."

As for the spiritual life of Marilyn Monroe, Strasberg says, "She was the only one of the addict stars, including Rita Hayworth, Bette Davis, Spencer Tracy, Jimmy Dean, and Montgomery Clift, who made a conscious effort to evolve. There was something deeply humble in Marilyn. Numerologically, her birthpath was seven. Seven is the most mystical number, whose dangers are drinking, drugs, and self-deception. In what happened to her, Marilyn became a sign of the times, an archetype, a mirror of our collective unconscious. That's why people love her."

We talk about Jung, prayer, and reincarnation. When our interview is over, Strasberg invites me to lunch at Ma Maison, where she charts my birthpath and then proceeds to give me a spontaneous reading of my past, present, and future situations astonishing in its accuracy and detail.

"How in the world did you do that?" I ask.

Susan Strasberg smiles like a sphinx and waves good-bye.

3:10 p.m.: Two days ago, Lee Holloway, a professional astrologer and talk-show hostess, suggested that we dig up Hollywood's official birthday so that she could do the town's astrological chart. After a good deal of research, February 1, 1887, emerged as the first time the name was used on a legal bill of sal

"This is fabulous!" she says, scattering diagrams of planet numbers, and geometric forms on my hotel sofa. Determinedly upbeat, Lee is the sort of gracious earth-mother who attempts, wi every breath, to accentuate the positive. Pressing her for the hard news, however, I discover that Hollywood's fate is far from sunny "In the age of Aquarius, all boundaries—ideological, cultural and religious—will be broken," she says. "The riots are part of it. The chart of the nation is undergoing stress. Saturn, which is going ov the moon, represents the downtrodden. The time has come for the blacks to protest."

Although this revolutionary spirit is pervading the country its seeds are being sown on the West Coast. "Hollywood will always be a frontrunner," says Lee. "This is an Aquarius town, indicating invention and originality. Neptune, which is prominent the chart, rules film, magic and allure. Combine this with the daring, assertive, competitive energy of Los Angeles proper—whose birthsign is Aries—and you get fireworks.

"With fireworks come upheaval, however. Astrologically, we've been in a period of disintegration and breakdown since 1987. Hollywood's going through its dark night of the soul, reinventing itself, stripping away what doesn't work. People need accept their responsibilities and re-think the values of the film business. Things can't go on the way they've been."

What about the chart for today? Holloway glows. "We've got Aquarius rising, of course! Uranus, which rules this sign, is making stunning aspects to Mercury, which rules communication, and to Venus, which rules artistic pursuits. Jupiter, which rules publishing, is making a grand Earth trine to Uranus. This forms a pyramid!" says Lee Holloway, clapping her hands. "It will be an extraordinary day!"

5:30 p.m.: Seven years ago, J. Robert Prete quit his job a a big-time show-biz manager to become a priest. "It happened i a flash," says the suntanned, silver-haired Reverend Prete. "I was riding in a limo one night with three of my biggest clients and realized that if the car went off a cliff, it wouldn't matter at all to t scheme of things on this planet."

Stunned by this insight, Prete began to lead a double life, one in synch with Hollywood, the other exploring Eastern and Western religions. "People thought I had a heavy coke problem or was keeping a mistress in Malibu," he laughs. "Actually, I had started a church in the Valley."

Prete's Metaphysical and Self-Awareness Foundation Center grew. He started a spiritual talk show on the radio with Shirley MacLaine as his debut guest. (Ironically, MacLaine will talk about anything *but* spirituality these days, alarmed, according to friends, by the degree to which she has been aggrandized by the New Age public.) Unfortunately, according to Prete, this proliferation of religiosity in Hollywood is a mixed blessing. "I was at Debbie Boone's wedding, listening to a group of influential producers and directors talk about upcoming projects. Every time a name would come up, they'd ask, 'Has he been reborn?' before they'd consider that person."

As for the New Age, Prete is equally critical. "Where I grew up, spirituality was about charity. But where are the New Age hospices, the New Age soup kitchens? They just don't exist," says the Reverend, who has set up such programs himself. "The bottom line to the spiritual movement in Hollywood is dollars. I'm not popular for saying that."

7:00 p.m.: The telephone rings. Shirley Young, Public Relations Director of the Church of Scientology, is waiting downstairs with a press kit. Yesterday, I strolled through the church's Celebrity Center on Franklin Avenue, a plush renovation of a Hollywood landmark building, complete with tennis courts and walking security guards. I've read about the Church's extensive real estate holdings and know that the organization has enlisted 7,000 people in Los Angeles alone, including hundreds of power players like Kirstie Alley, John Travolta, and Tom Cruise.

"Why are so many stars attracted to Scientology?" I ask Young, who has agreed to a 10-minute talk.

"Because it works," she says. Her female companion stares and says nothing.

"Do you think Scientology's popularity is part of a larger spiritual revolution?"

"I've heard people say that."

"Why has your church gotten such a bad rep?"

On this, Young launches into the party line about L. Ron Hubbard's face-off with the major drug companies in the fifties, about corporate conspiracies and smear tactics. It is the same information, nearly verbatim, contained in the hefty folder she will hand me at the end of our interview. "Scientologists stand for social reform and people don't like that," says Young, adding that while the church respects other religious beliefs, the courtesy is not returned. When our brief, colorless talk ends, Young asks to read this text before it's published. I assure her I will invent nothing. She asks again. I politely refuse. We part on rather frigid ground.

8:00 p.m.: Alcoholics Anonymous (AA) and its many offshoots in and around Hollywood have become not only places for moral support, but places where deals are made. The Pacific Group in Brentwood is attended by 1,500 recovering people. Accusations of "addiction chic" and the media backlash are beside the point. What matters is that people are flocking to these rooms.

I opt for a smaller meeting in the heart of Hollywood. When I enter, a busty ingenue in a black leather jacket is reading out loud with tremendous vitality. "I admitted that I had become powerless!" she shouts, "and turned myself over to a higher power!" When she finishes, hands are raised and three dozen people take their turn recounting tales of abuse and excess, histories of self-loathing, ambition and greed, of identity loss and the doomed quest through drugs and alcohol for a feeling of transcendence. Without self-pity, they talk about bottoming out, losing families, hearing voices, waking up on park benches. There are no victims here, they say; only people recovering from a disease, trying to stay sober in an addictive culture stripped of God. As they weep, laugh, and share their gratitude to the program for having "saved their lives," I can't help thinking of confession, atonement and salvation, religious experiences which many used to seek in churches and temples. Today, these people find themselves in anonymous spaces where authority and dogma play no part, where they're invited to worship whatever higher power they please. A Hasid *davons* and prays to himself. A toupeed man in gold chains and a jogging suit sips his coffee. Two punks wearing nose rings touch each other on the shoulder. A matron with beige hair chuckles to herself. All of them in a room in Hollywood, trying to tell the truth.

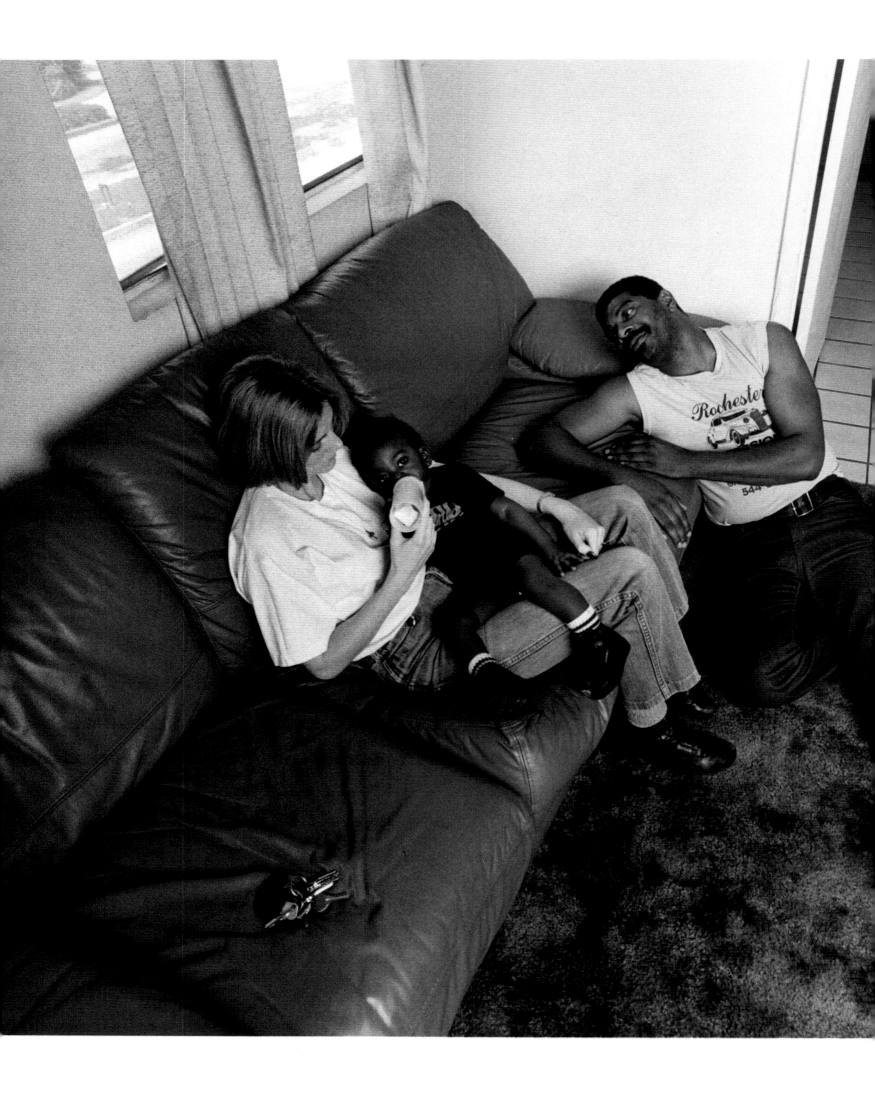

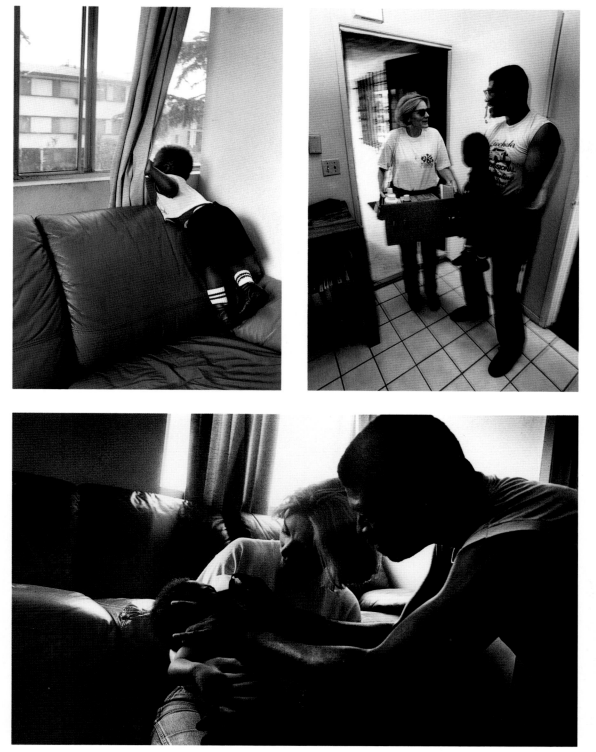

Michael Curtis Parson, 12 months old, awaits the arrival of Alison Arngrim Spenser, who is delivering supplies and emotional support for the HIV-infected baby and his father, Curtis Parson. Alison, an actress and comedienne who's best known for her role as Nellie Olson on the television show *Little House on the Prairie*, now devotes herself full-time to Tuesday's Child, the only organization in Los Angeles that provides diapers, formula, toys, and food for families of children with AIDS. There are about 140 families enrolled with the center, but the number expands weekly. Michael, who only weighed five pounds at birth, was born HIV-positive and chemically depen-

dent. His mother died in 1991. For the most part, Michael is a healthy and happy baby, although since this picture was taken he has had surgery to have a catheter placed in his chest for intravenous therapy. Curtis, who has twice tested negative in the past year, says the supplies and services provided by Tuesday's Child represent about a quarter of the family's income.

The organization was founded four years ago by Barry Horton, who says, "Tuesday's Child is about the dignity of the human spirit: we do what is needed to help preserve that dignity." It receives no government funding and relies primarily on individual donations.
Photographer: **Scott Thode**

On May 28, 1992, 100 Los Angeles schoolchildren photographed Hollywood from their point of view. Each received a 435 camera from Kodak, two rolls of Kodacolor film, and a lesson from one of the world's great photographers. Some of their best work appears on these pages.

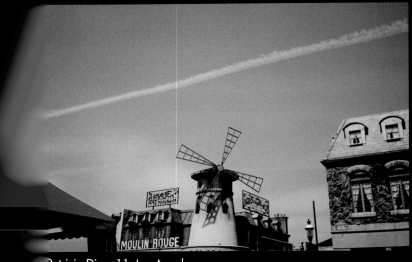

Patricia Diaz, 11, Los Angeles

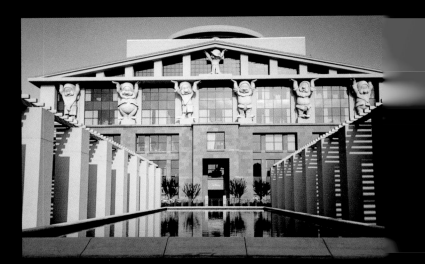

Aaron Benjamin Wolf, 11, Glendale

Andrew Pinkard, 12, Los Angeles

André Walker, 10, Los Angeles

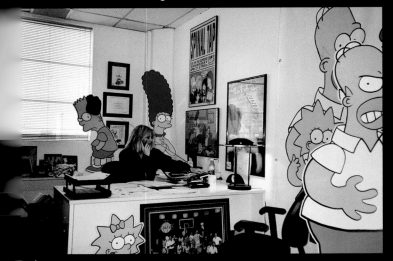

Calista Carter, 8, Burbank

Justin Brown, 9, Burbank

Christina Bobek, 8, Simi Valley

Thomas Berman, 10, Sherman Oaks

David Mannix, 10, Valencia

Nicole Varela, 11, Studio City

Aaron Benjamin Wolf, 11, Glendale

Alyssa E. Nelson, 10, Newbury Park

Latica Scott, 12, Los Angeles

Terrell Rambo, 11, Los Angeles

Chris Howells, 11, Pacific Palisades

Calista Carter, 8, Burbank

Chris Custudio, 9, Chatsworth

Jamar Blacksher, 11, Los Angeles

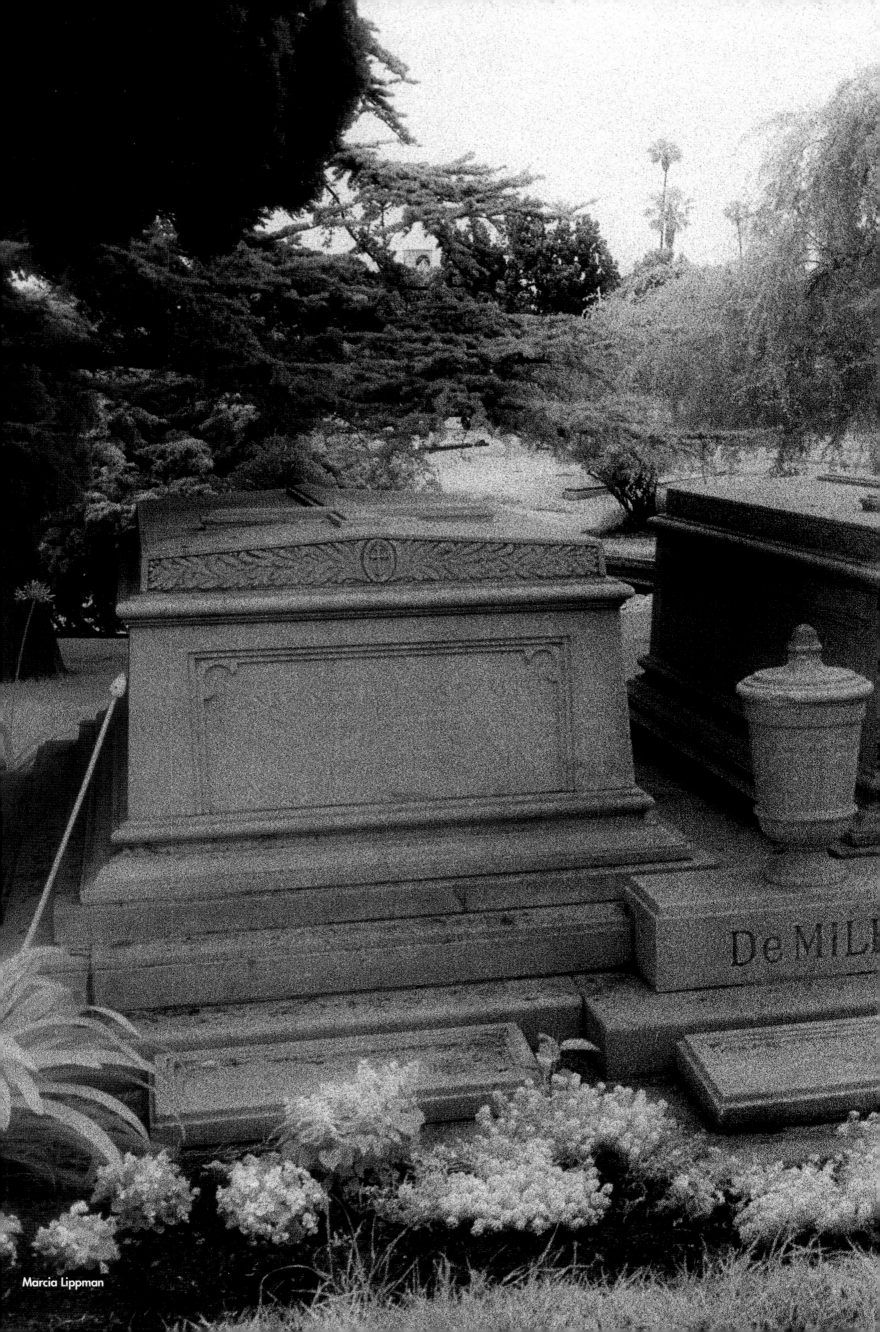

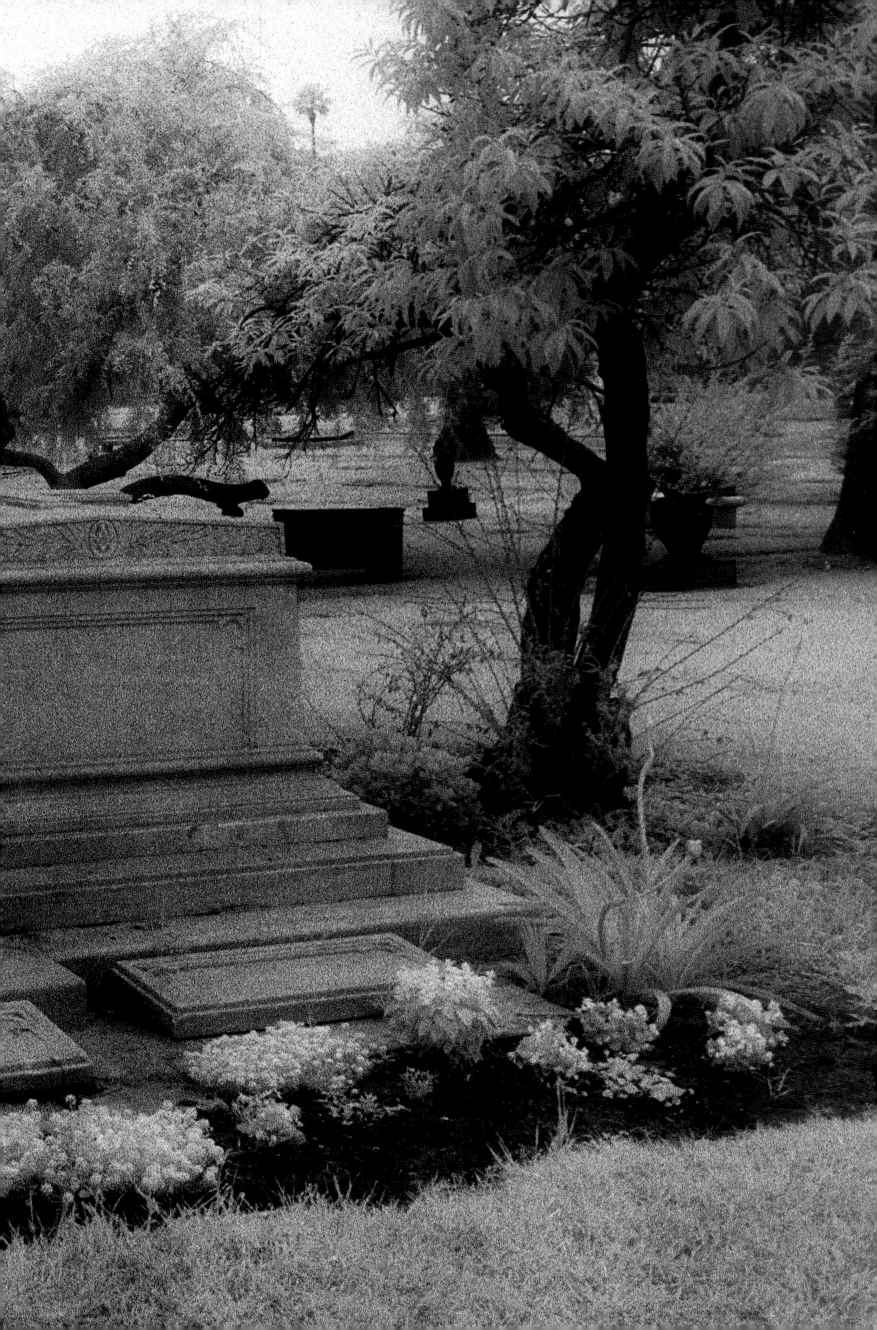

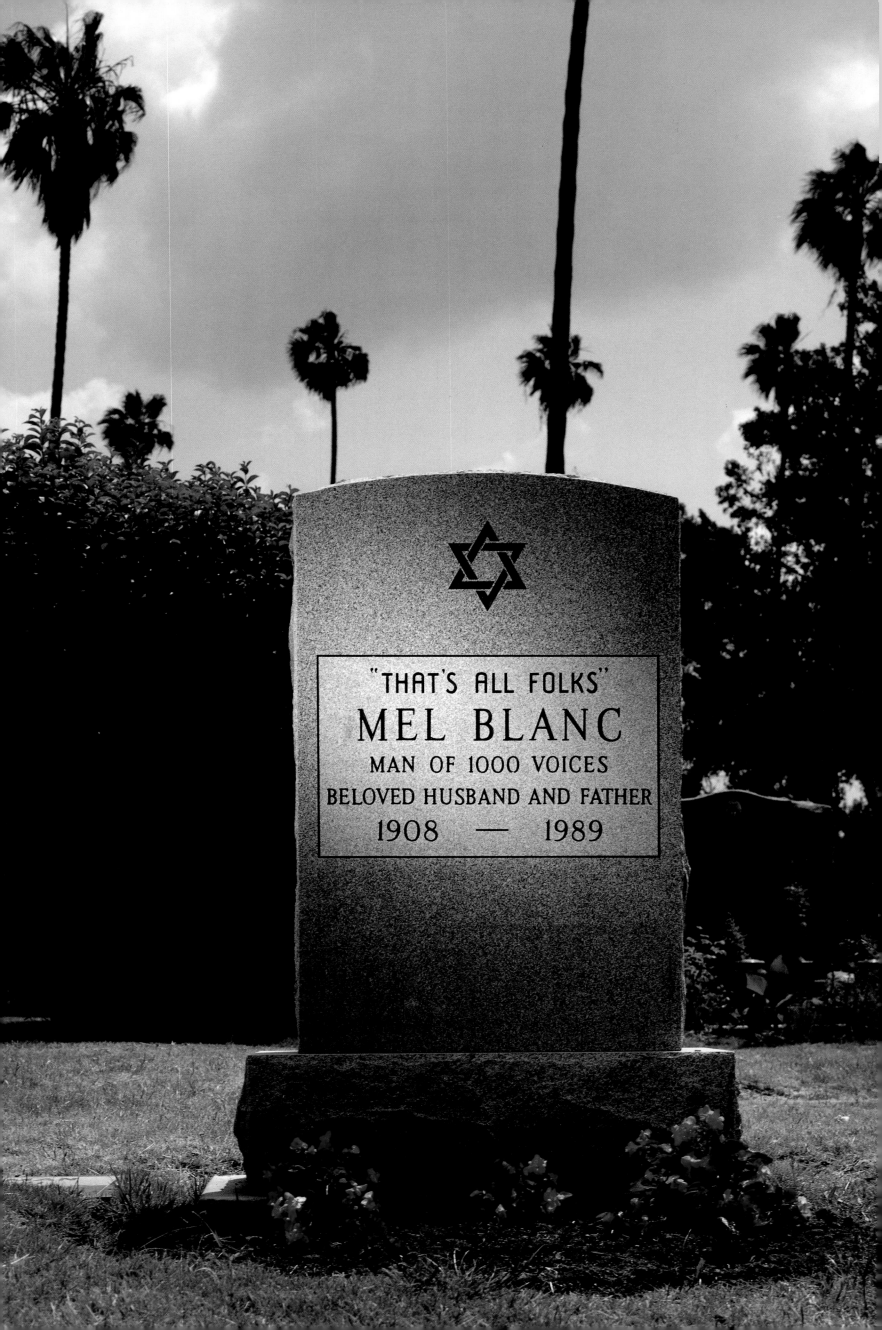

Preceding, pages 174-175

With its reflecting pools, Egyptian, Roman, and Greek temples, obelisks, urns, and palm trees, the Hollywood Memorial Park Cemetery is so grandiose that it might have served as a backdrop for one of Cecil B. deMille's epic films. Instead, it is the final resting place of the great director himself and his wife, Constance Adam deMille. C.B. deMille died of a heart attack in 1959, at the age of 77, only hours after he wrote: "The Lord giveth and the Lord taketh away. Blessed be the Lord. It can only be a short time … until these words are spoken over me." Appropriate final words for the man who directed *King of Kings*, *The Sign of the Cross*, and two versions of *The Ten Commandments*.
Photographer:
Marcia Lippman

Left

A veritable legend, Mel Blanc was the voice of over 400 cartoon characters, including Bugs Bunny, Porky Pig, Daffy Duck, Yosemite Sam, Barney Rubble, Woody Woodpecker and many others. Blanc revolutionized cartoons by infusing his characters' voices with depth, motive, and a point of view that appealed to adults as well as children. Before he died, Blanc taught everything he knew to his son, Noel, who records cartoon characters to this day and fondly describes his father as "a babysitter to generations of kids."
Photographer:
Max Aguilera-Hellweg

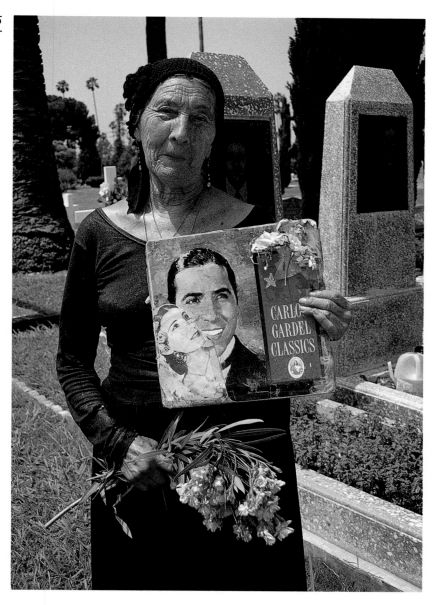

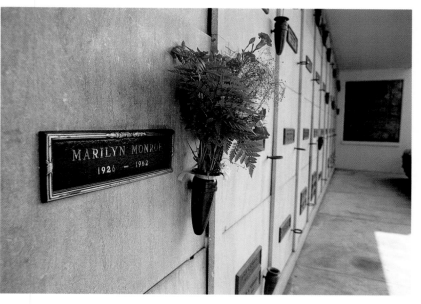

Left, top

Carlos Gardel was a famous Argentine tango singer when he died in a plane crash over the Andes in 1935. Every day for the past 57 years, his widow, Señora Estrellita Del Regil, has dressed in black and visited his grave, even though the couple had only been married for four years. "He was my only husband and I was his only wife," says the Señora. "Each was married only once to the other." Of all his songs, her favorite is "El Dia Que Me Querros" (The One That I Want).
Photographer:
Jill Freedman

Left, bottom

Marilyn Monroe died of a drug overdose on August 5th, 1962, but her appeal lives on. Her crypt in the Corridor of Memories of the Westwood Memorial Park cemetery is visited by more people than any other Hollywood gravesite. Her estate continues to earn over $1 million annually selling her likeness and name (benefitting the Strasberg Institute and a London-based training center for child therapists), and she has been the subject of more than 75 books as well as dozens of plays, films, documentaries, and television projects. "They have great respect for the dead in Hollywood," Errol Flynn once remarked, "but none for the living."
Photographer:
Michele Singer

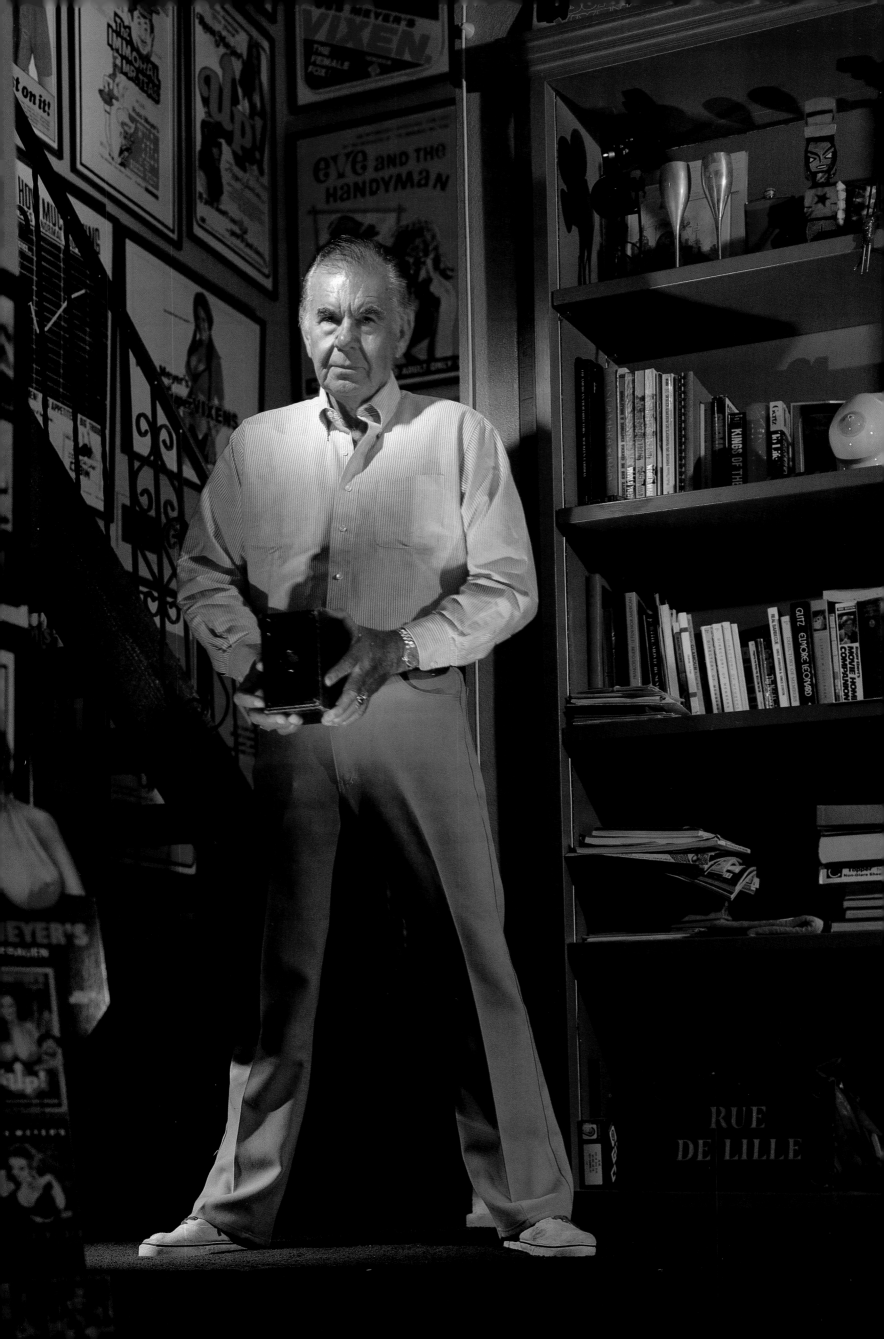

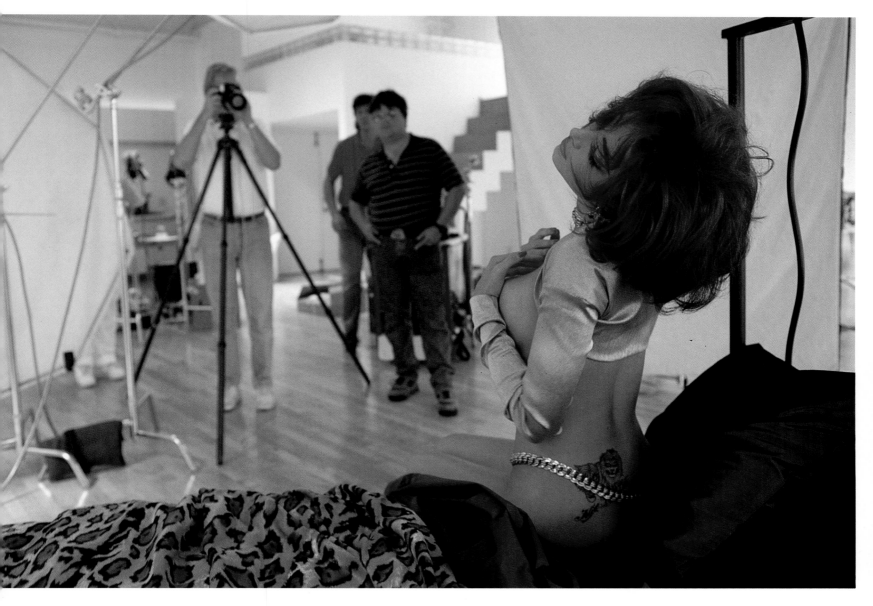

eft

uss Meyer, 69, crown
rince of the B movie,
oses in his self-
escribed "shrine" to his
areer in the office of his
ollywood Hills home,
olding an antique
amera that belonged to
is mother. (The Oscar
atue at right is a fake,
iven to Meyer by his
mployees.) A producer,
irector and writer,
1eyer has made hugely
uccessful films (*Beyond
1e Valley of the Dolls,
aster Pussycat! Kill! Kill!,*
nd *Mondo Topless,* to

name a few) featuring
big-breasted women,
disjointed camera
movement, stylized
humor, and exaggerated
violence. "Sure I exploit
women," says Meyer,
"and they love it!" Meyer
has been married three
times and points out that
two of his wives were
Playboy models. He has
recently completed his
autobiography, *A Clean
Breast,* which he
describes as "like a kiss
and tell, only I use a
stronger term."
Photographer:
Max Aguilera-Hellweg

Above

On May 20th, Catya
Sassoon, 23, posed for
Playboy. While a
centerfold shoot can take
as long as two weeks, a
smaller feature like this
one usually runs about
four days. In theory, at
least, *Playboy* tries to
shoot women in ways
that bring out their
personalities, and it was
Catya's "cat-like"
qualities (which include
her wildcat tattoos) that
inspired photographer
Arny Freytag to shoot
her in natural light on
leopard skins—and, in

another session, with live
cougars. Catya, who will
appear in Roger
Corman's forthcoming
film *Angelfist,* is the
daughter of hairdressing
magnate Vidal Sassoon.
Photographer:
Mark Harris

Right

A lingerie model flaunts the multiple faces (and other body parts) of Frederick's of Hollywood. Founded by Frederick Mellinger in New York as"Frederick's of Fifth Avenue," the company changed its name when it moved west. The store has always specialized in sexy lingerie and for years had a monopoly on the business. Today the company, encompassing 200 retail outlets and a brisk catalogue business, is represented on the New York Stock Exchange. The flagship store on Hollywood Boulevard is known for its Lingerie Museum, which houses Judy Garland's nightgown, Mae West's peignoir, and Tony Curtis's bra from *Some Like It Hot,* among other items. Madonna's bustier, long a popular attraction, was stolen when the store was looted during the L.A. riots.
Photographer:
Elliott Erwitt

Left, bottom

Angelyne, the quintessential wannabe, calls herself "the billboard goddess," and for good reason— she's been displayed on as many as 200 at a time in Hollywood since 1984. Though they've cost her a fortune, she says the billboards "portray the magic I possess." The advertising generates work in European print ads and movies (where she always plays herself).
Photographer:
Catherine Karnow

Right

Courting stardom, the singing Del Rubio sisters stand at the corner of Hollywood and Vine. Since arriving in the U.S. from their native Panama 35 years ago, they've recorded three albums, including *Three Gals, Three Guitars.* They didn't find their niche until 1974, however, when they played for their ailing mother in a hospital. Today the Del Rubios perform as many as 1,000 shows a year, mainly at convalescent hospitals, benefits, weddings, and parties. Milly, Elena and Eadie have always lived together; none of them has ever been married. "Mother used to compare us to the Holy Trinity, where the whole is greater than the parts," says Milly.
Photographer:
Mark S. Wexler

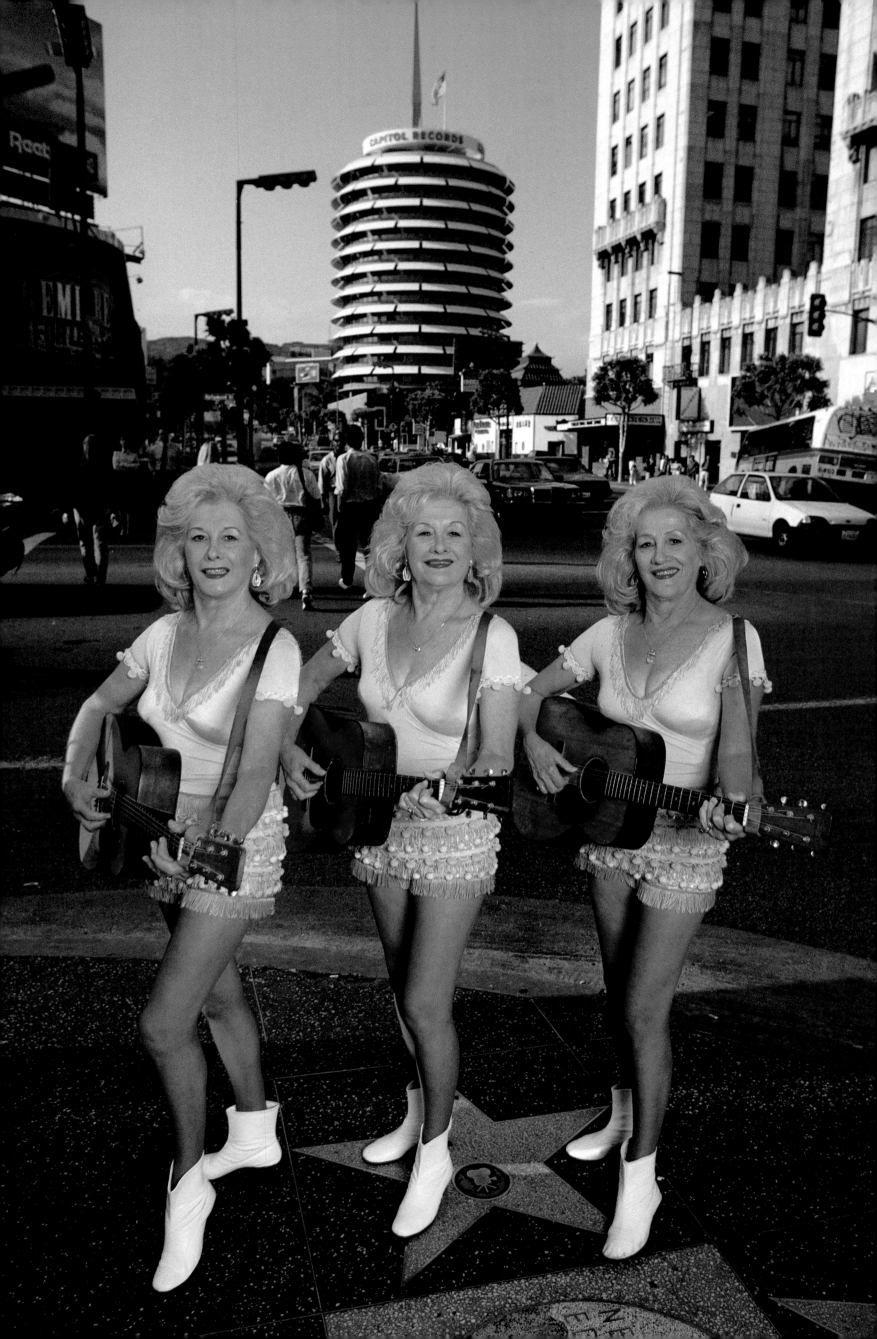

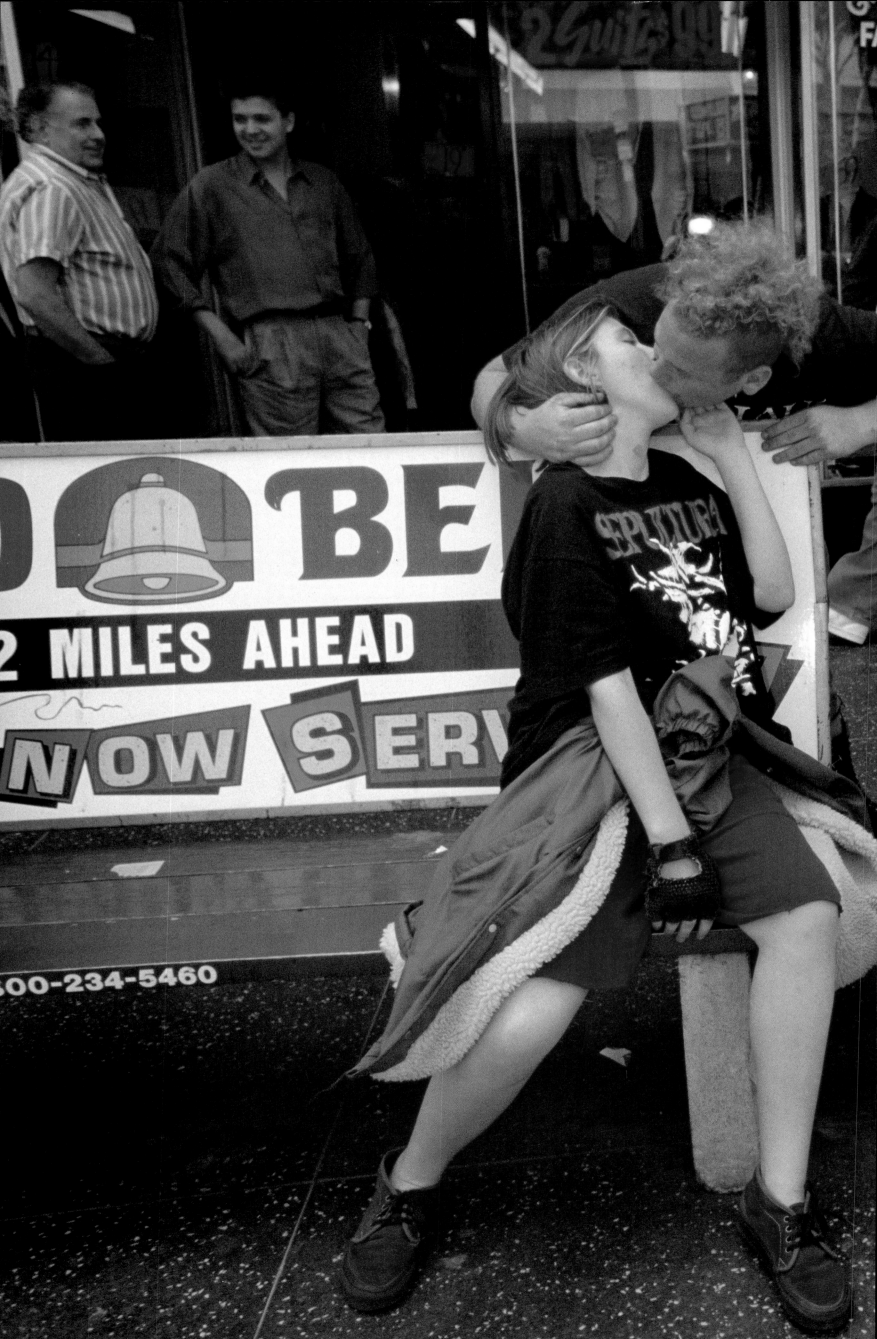

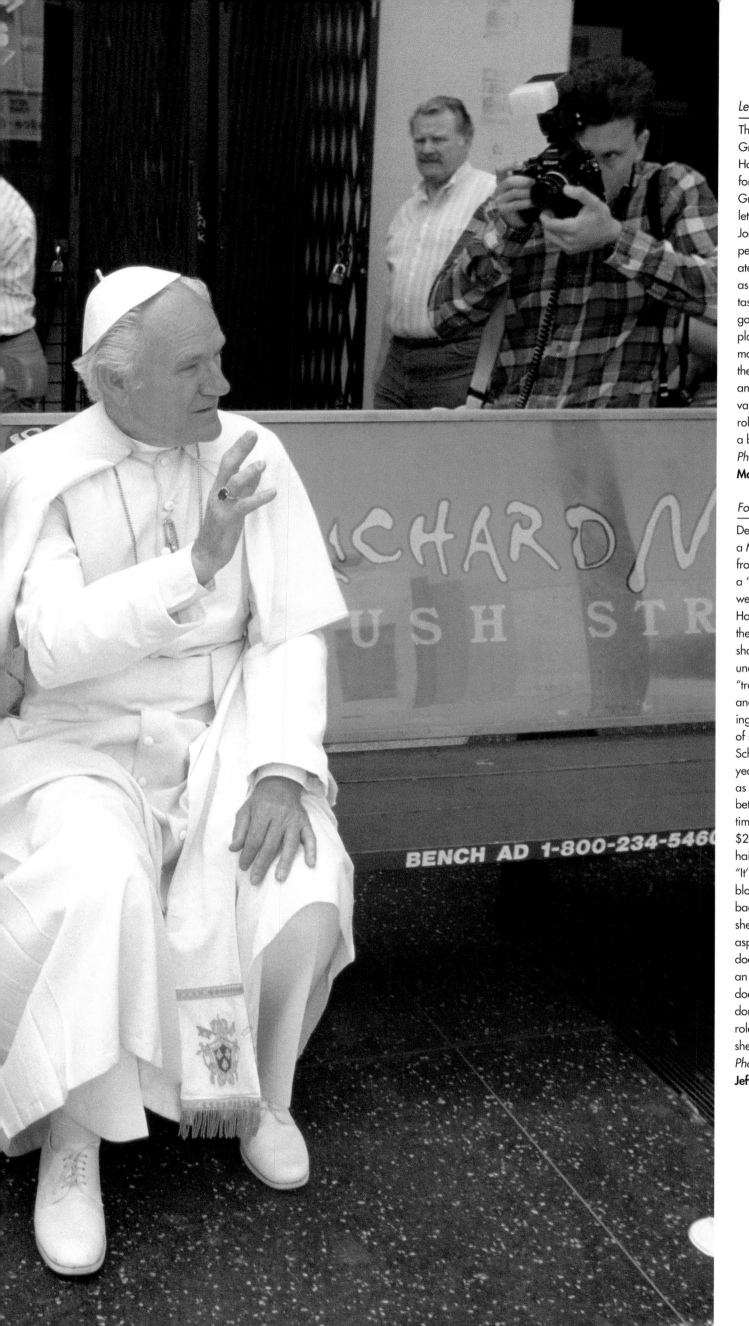

183

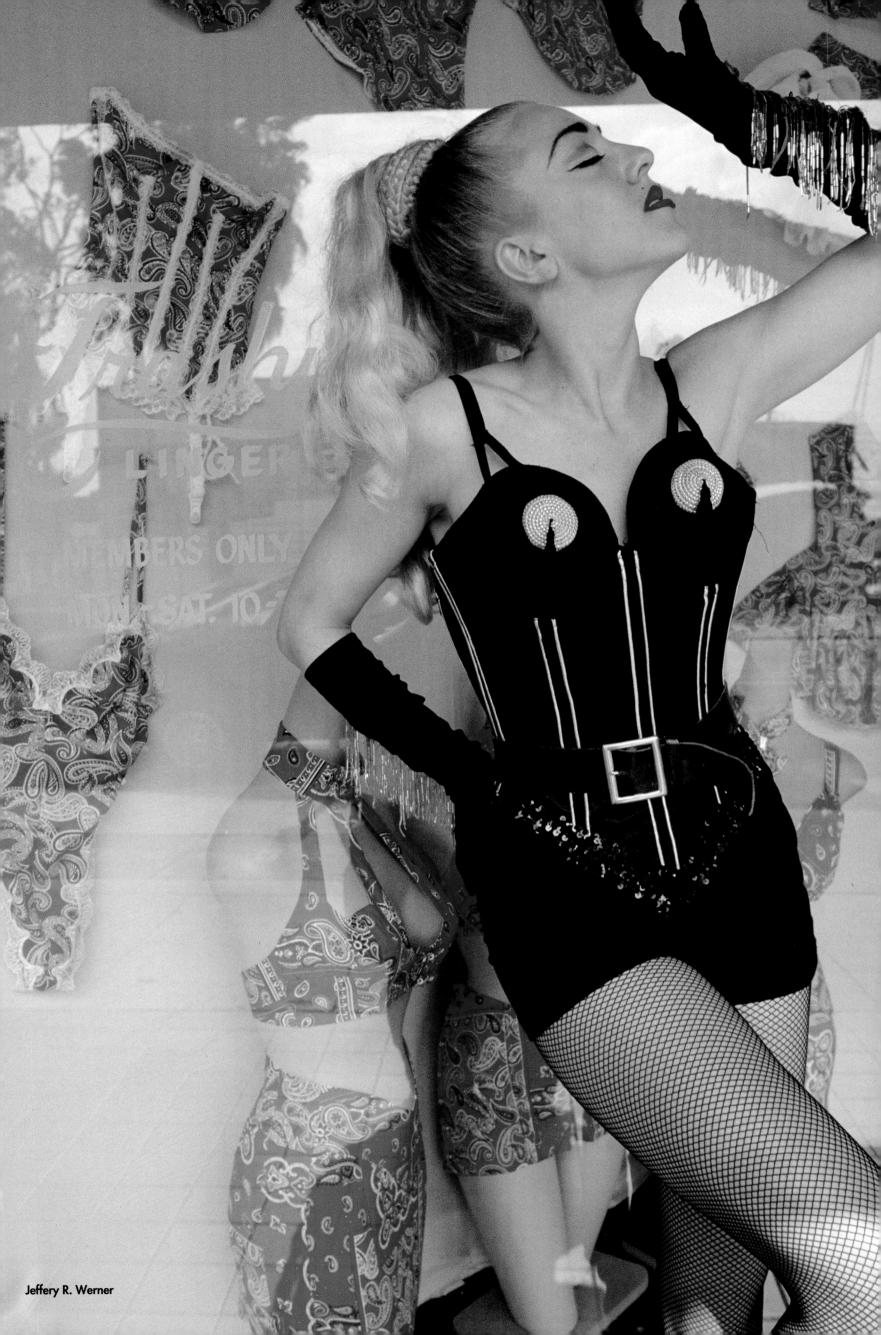

Jeffery R. Werner

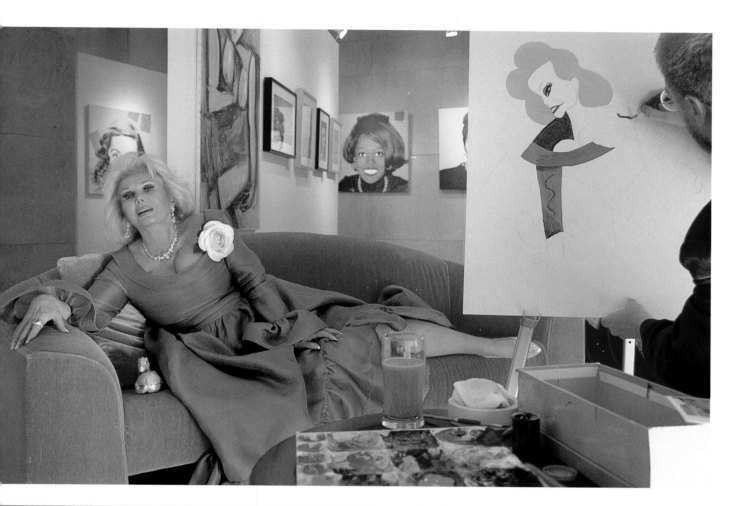

Left

Left

Artist David Cowles, 30, paints a caricature of Zsa Zsa Gabor at the Artik Gallery. Zsa Zsa has at least 15 portraits of herself hanging in her homes in Palm Beach, Bel Air, and New York, because the various artists usually make gifts of the paintings. ("If I do not like it, I do not hang it, darling.") Cowles does portraits which sell for between $500 and $1,000 and have been bought by Richard Lewis, Burt Reynolds, and Natalie Cole, among others. Of Zsa Zsa, Cowles says, "She's just what you would expect her to be."
Photographer:
Guglielmo de' Micheli

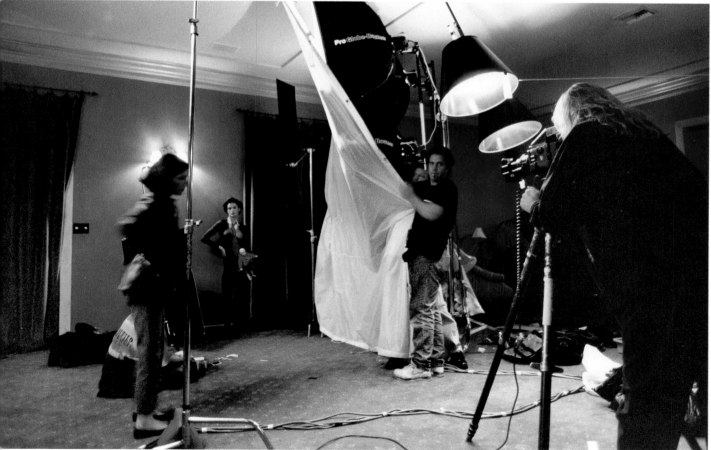

Left

A year after Demi Moore, 29, appeared nakedly pregnant on the cover of *Vanity Fair*, she again posed naked, albeit painted, for photographer Annie Leibovitz. "I said I would get better with each baby, and I have," Moore told the magazine—and then proved it in several shots. For this August cover, Moore was made up from her neck to her ankles by body-painting artist Joanne Gair. Photographer Wendy Werris, a close friend, says the actress remained in makeup for two days and had to sleep in it overnight.
Photographer:
Wendy Werris

185

Rick Smolan

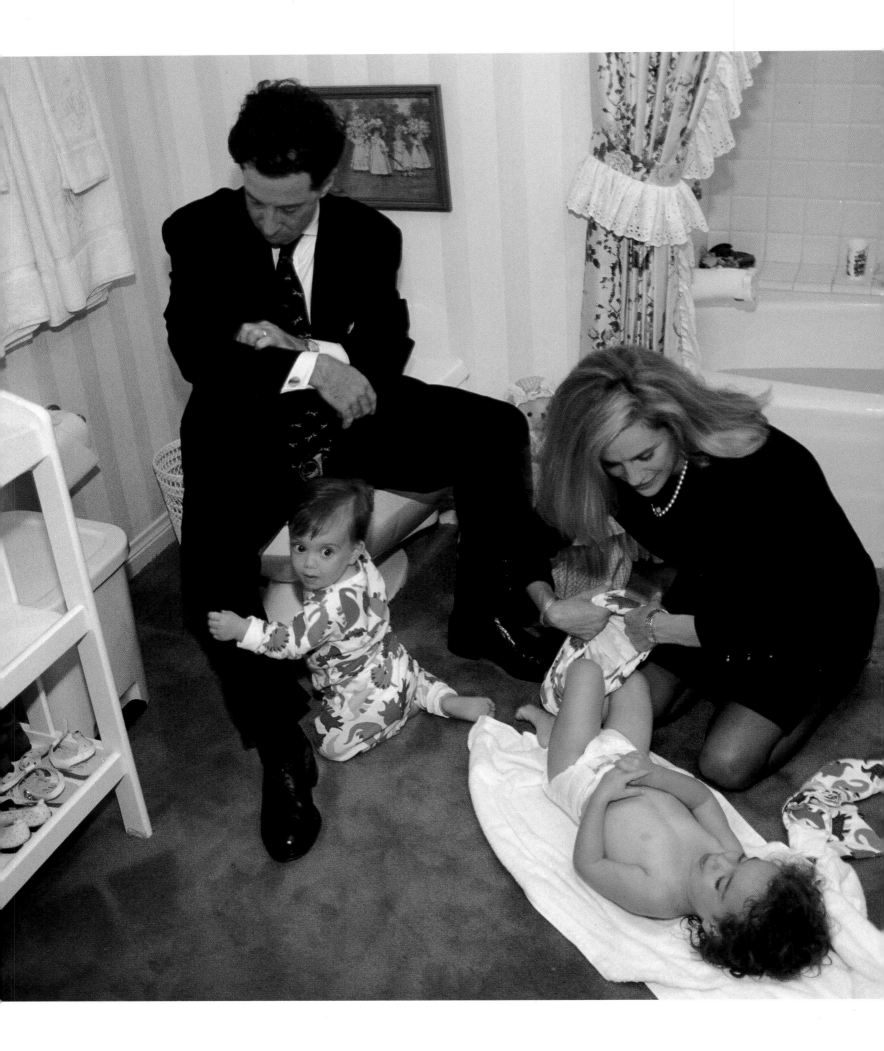

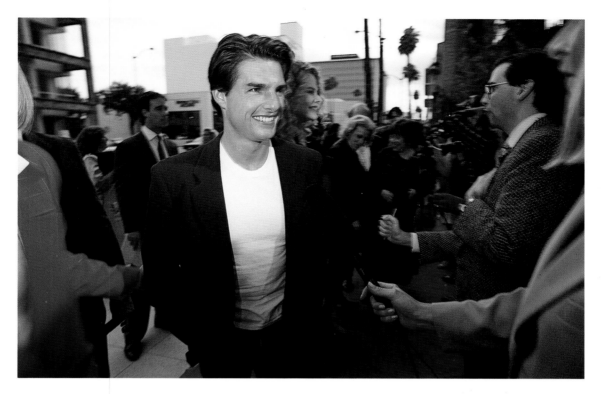

Preceding, pages 186-187

Director Ron Howard and producer Brian Grazer travel by limousine to the premier of *Far and Away*, the latest release from their company, Imagine Films Entertainment. According to Grazer, he and Howard have a tradition (or is it a superstition?) that during the premier of any of their movies, they always sit together and "never let some producer get between us." The formula has certainly worked in the past: previous Imagine hits include *Backdraft*, *Parenthood*, *Splash*, and *Night Shift*.
Photographer:
Rick Smolan

Left

Mark Canton and Wendy Finerman get their children Henry, 12 months, and Dorothy, 3 years, bathed and ready for bed before joining Sally Field and her husband for dinner at Morton's. Canton and Finerman have been married for seven years; they met when she interviewed for a job and instead he asked her for a date. Finerman is an independent producer, currently working on *Into the Land of Nod* for Warner Bros.
Photographer:
David Butow

Above, top

Tom Cruise, 30, arrives at the *Far and Away* premier flanked by his costar, Nicole Kidman, 24, and his publicist (in red), Pat Kingsley. This movie, a transatlantic immigrant saga, marked the first time Cruise and Kidman had worked together as husband and wife. According to Howard, they were the consummate professionals and could take direction even while kissing.
Photographer:
Peter Turnley

Above, bottom

Chic California dining finds star chef Wolfgang Puck and his wife Barbara Lazaroff, standing, celebrating their eighth wedding anniversary among friends at Spago, the restaurant they've made into a Hollywood landmark. At right, Sally Field and her husband, Alan Greisman, share a table with Mark Canton at Morton's on Melrose Avenue.
Photographer:
Douglas Kirkland

Preceding, pages 190-191

Singer Belinda Skinner, 31, warms up her voice by practicing scales while facing a wall or corner so she can hear her voice reverberating in the hall. "People give me strange looks, but this system works for me," she says. Five years ago, Skinner moved to Los Angeles from Seattle "because this is where the music business is." She recently cut her first single, "I Smell Love," and her album will be released shortly. She adds that coming to Hollywood is the toughest thing a singer can do. If you're not strong, they'll chew you up and spit you out." Photographer: **Nubar Alexanian**

Left

May 20th was the first day of rehearsals on the West Coast for actor Ron Silver, 46, appearing in the 2½-hour, one-man play And, which ran for four weeks in New York and another month at the Hollywood Theater in Los Angeles. "Performing a play in Los Angeles feels like a subversive act," says Silver. "I feel like Ché coming down from the hills." He claims that movie people are generally not interested in theater: "Images are important in Hollywood and Hollywood has made images important in the world. In New York, it's the words that matter." Does Silver prefer working in movies or theater? "I always want to do what I'm not doing," he says. Photographer: **William Claxton**

Left, top

Davis Gaines, 33, (a.k.a. the Phantom) agrees that "L.A. isn't a theater town—which makes the success of Phantom even more astonishing." After more than 1,300 performances, The Phantom of the Opera is the longest-running musical in Los Angeles and is still sold out nightly. With tickets costing $60 a seat, the show has generated more than $110 million in revenues for the Ahmanson Theater and has been seen by more than two million people. Gaines's favorite fan, though, is a six-year-old girl who wrote: "If I was in the play I would have married you because you were so lonely, and I know if somebody had loved you, you wouldn't have been so mean." Photographer: **Claus C. Meyer**

Left, bottom

Produced on a shoe-string budget, Only Live Once started shooting on the day the riots broke out in Los Angeles, and production shut down because of the smoke. Later, the city revoked its permit to shoot on the streets. So, the producers moved the crew into a big nightclub and rewrote the script. On May 20th, producer/director/writer Richard Park (at right, with cap) directed a gang fight scene between Sung Ki Jun (in red) and Matt Zafonte (with sticks). Photographer: **Mark S. Wexler**

Right

An updated version of the grand movie palaces of Hollywood's past, the Galaxy Cinema complex, built in 1991 on Hollywood Boulevard, features a multi-screen cinema plus several cafes and restaurants.
Photographer:
Jon Ortner

Following, pages 196-197

The Griffith Park Observatory commands a stellar view of Los Angeles. The tall buildings left of center are the hotels and office skyscrapers of the downtown business district.
Photographer:
Jon Ortner

Following, page 198

Miss Holly Woodlawn, 45, became known as an Andy Warhol Superstar after Warhol cast her in his now-legendary underground film *Trash*. She refers to herself as a professional transvestite. When asked which gender she prefers being called, Holly says, "When I'm in pants, call me a he. When I'm in a gown, call me a limo."
Photographer:
Max Aguilera-Hellweg

Following, page 199

In preparation for a night on the town, clothing designer Star Boot irons the pants that match his pearl-encrusted, ostrich-feather jacket. He says he always dresses like this, even when he's just going to the grocery store, because people come to Hollywood expecting glamor and glitter. "I bring extravagance back to Hollywood simply by walking outside," he says.
Photographer:
Catherine Karnow

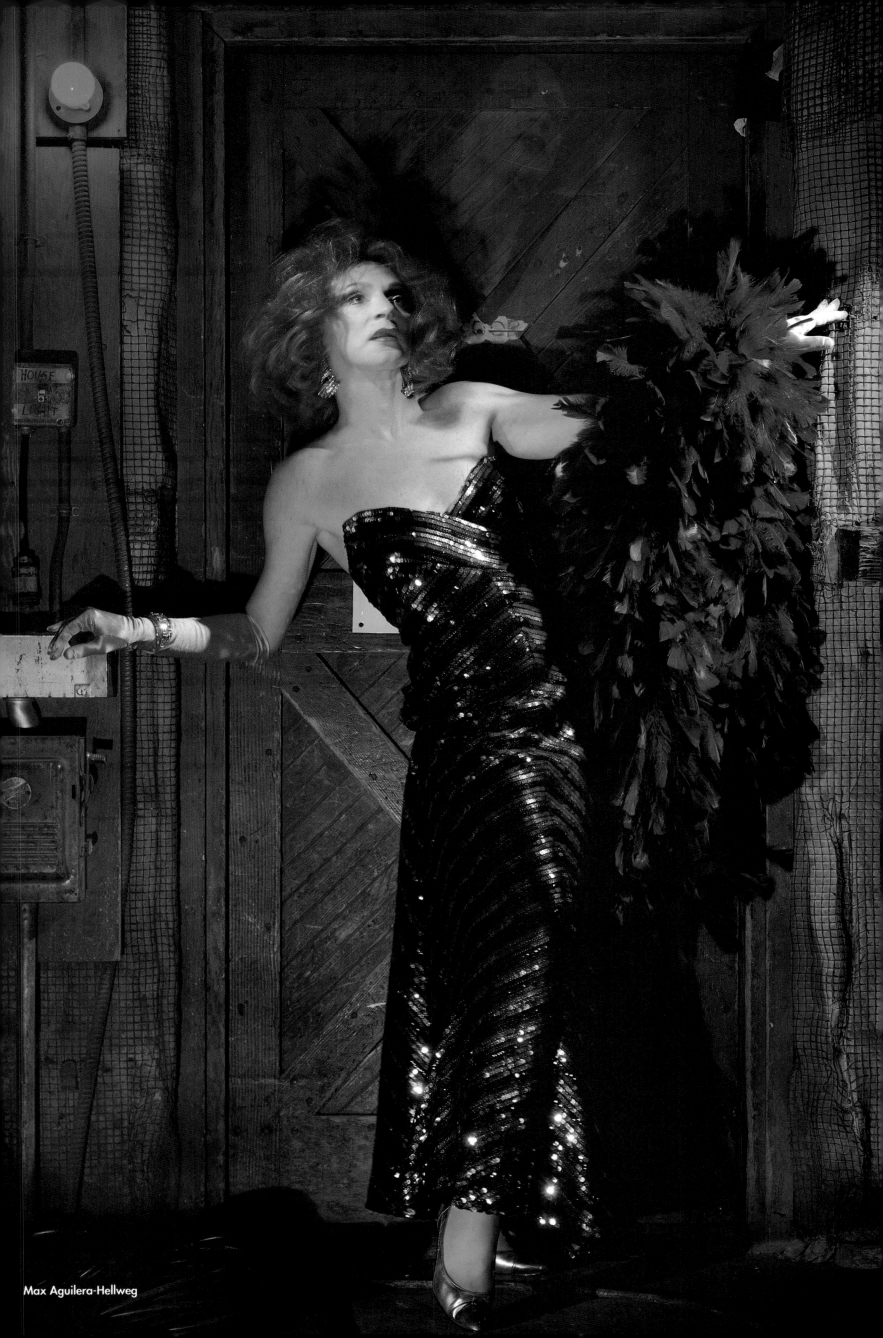

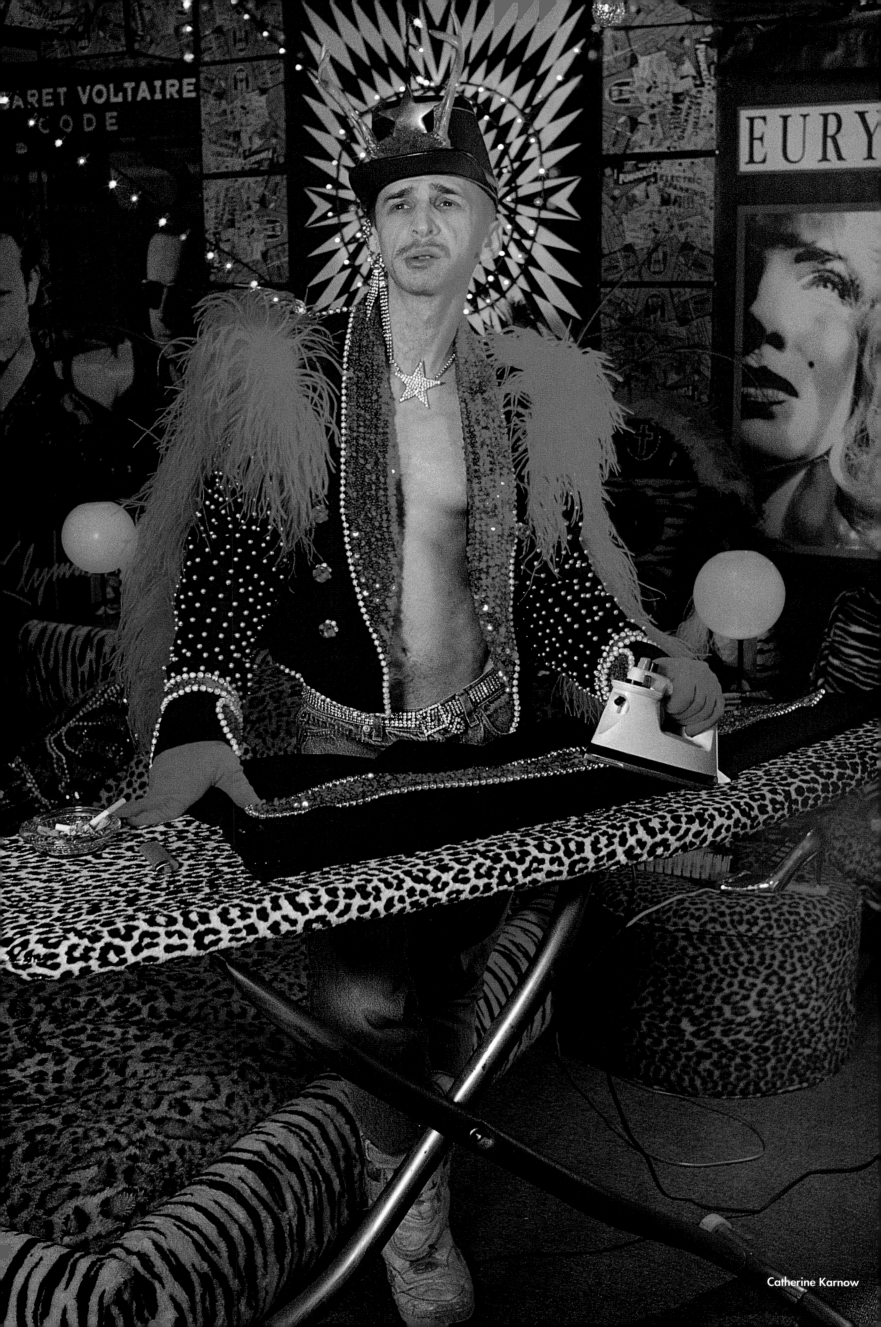

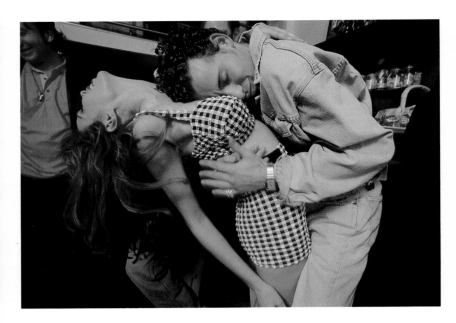

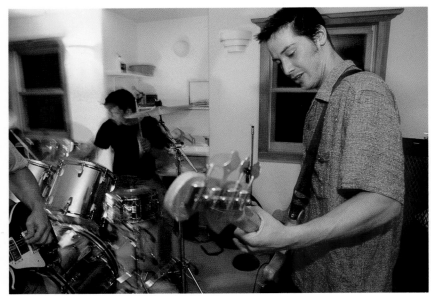

Above, top and right

At the Living Room, room-mates Fawna McClaren, 26, and Sean Sager, 25 (*top*), enjoy dancing together. Fawna, a model and actress, was *Playboy*'s 35th Playmate of the Year; Sean is a talent agent, actor, model, and event promoter, "the next David Geffen," he says. Late night cafe/pool halls like the Living Room have grown popular in Hollywood during the past few years as people look for non-alcoholic environments where they feel comfortable meeting new people and hanging out. Patrons don't need reservations, a special friend at the door, or an excess of money. Robert Kass, who started the cafe three ago, says that his clientele consists main-ly of young entertainment and fashion types.
Photographer:
Dana Fineman

Above, bottom

At his Hollywood Hills home, actor and musician Keanu Reeves, 27, practices with members of his band, Dogstar. The group has been together for about a year, playing at local clubs and at the Milwaukee Punk and Metal Fest. They write all of their own material, share the singing, hope to cut an album one day and, according to band member Greg Miller, seek to make music that will "brighten someone's day."
Photographer:
José Azel

Dharma, who serves as lead singer and manager for the band Haight Ashbury, rocks out with guitarist Kenny Steiger at a "showcase" conducted for an audience of half a dozen concert promoters in a Hollywood rehearsal studio. As a result of the brief performance, Haight Ashbury secured gigs at several local clubs. Dharma describes the band's music as "a cross between Ella Smith, the Red Hot Chili Peppers, and Janis Joplin."
Photographer:
Scott Thode

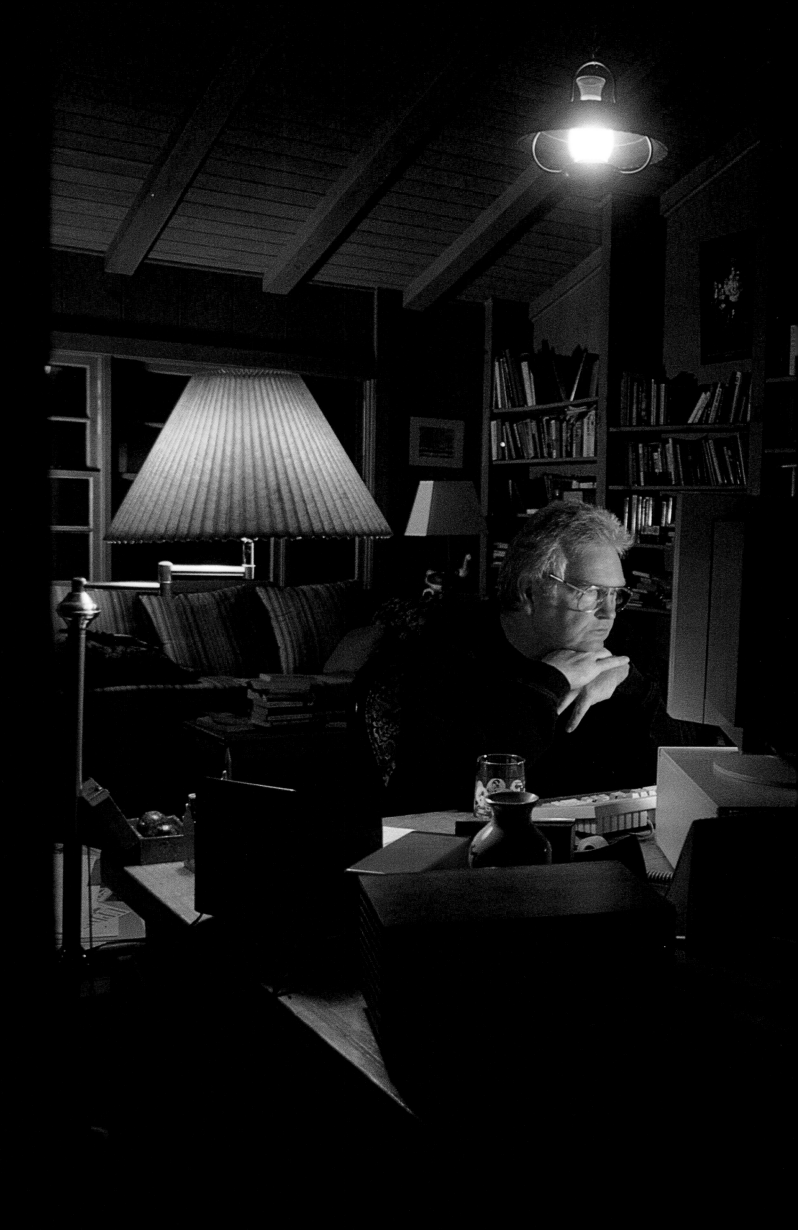

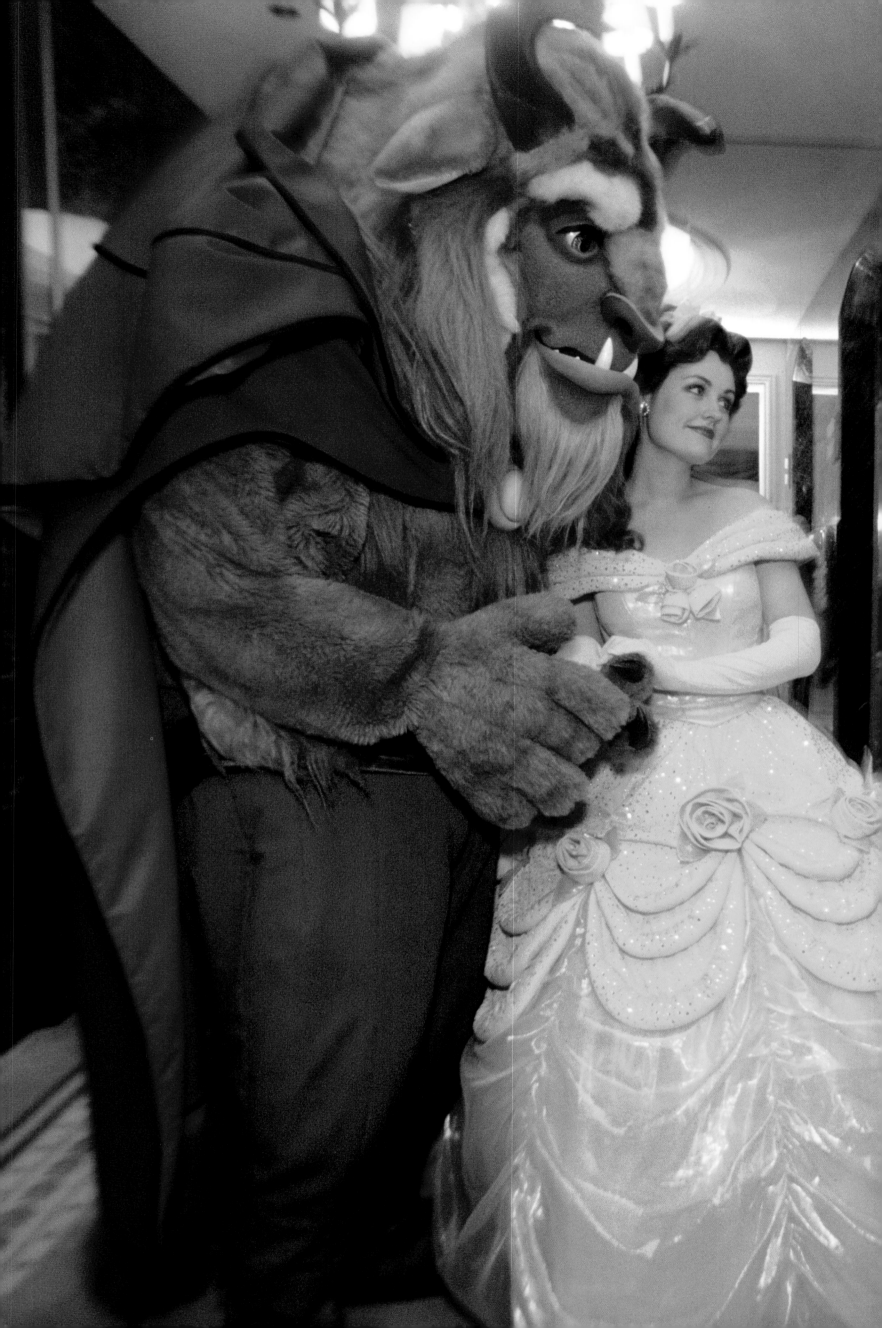

Left

Turn a corner in Hollywood and anything can happen. You might, for example, discover Beauty and the Beast awaiting an elevator at the Regent Beverly Wilshire Hotel. Fairy tales can come true, it can happen to you, especially in this town.
Photographer:
Joe McNally

Following, pages 210-211

A moment of quiet descends on one of the three Culver Studios sound stages used to shoot a Pepsi commercial starring Michael Jackson. At left stands the back of a set representing the house where Michael grew up. The bright spotlight creates the illusion of sunlight streaming into the house, and the backdrop looks like sky when seen through the windows. The cost of the sets alone was estimated at between three and four million dollars.
Photographer:
Timothy White

Following, pages 212-213

Day in the Life photographers and staff assemble for a group portrait on the Western Street at Warner Bros. before heading out on assignment.
Photographer:
Henry Groskinsky

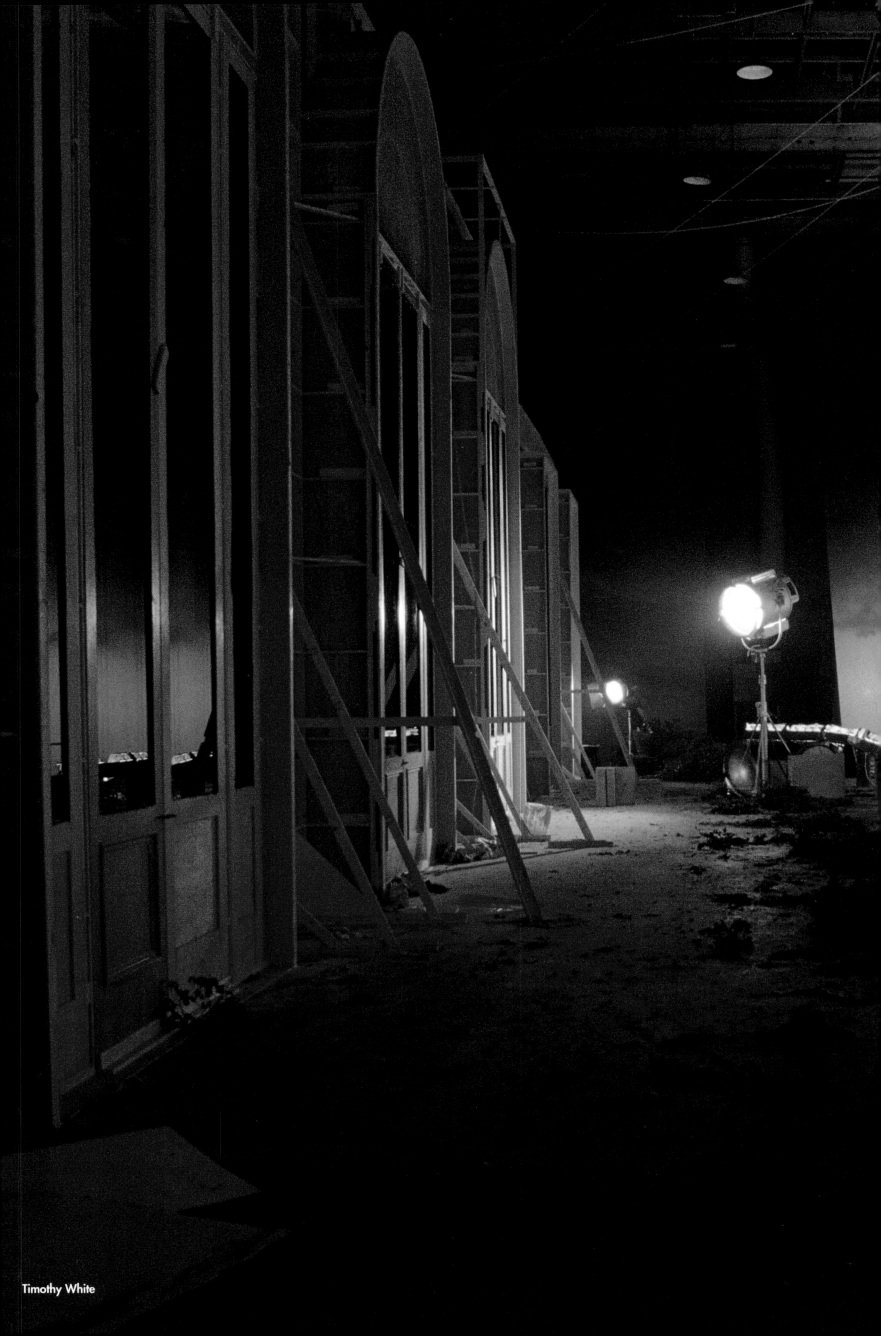

Timothy White

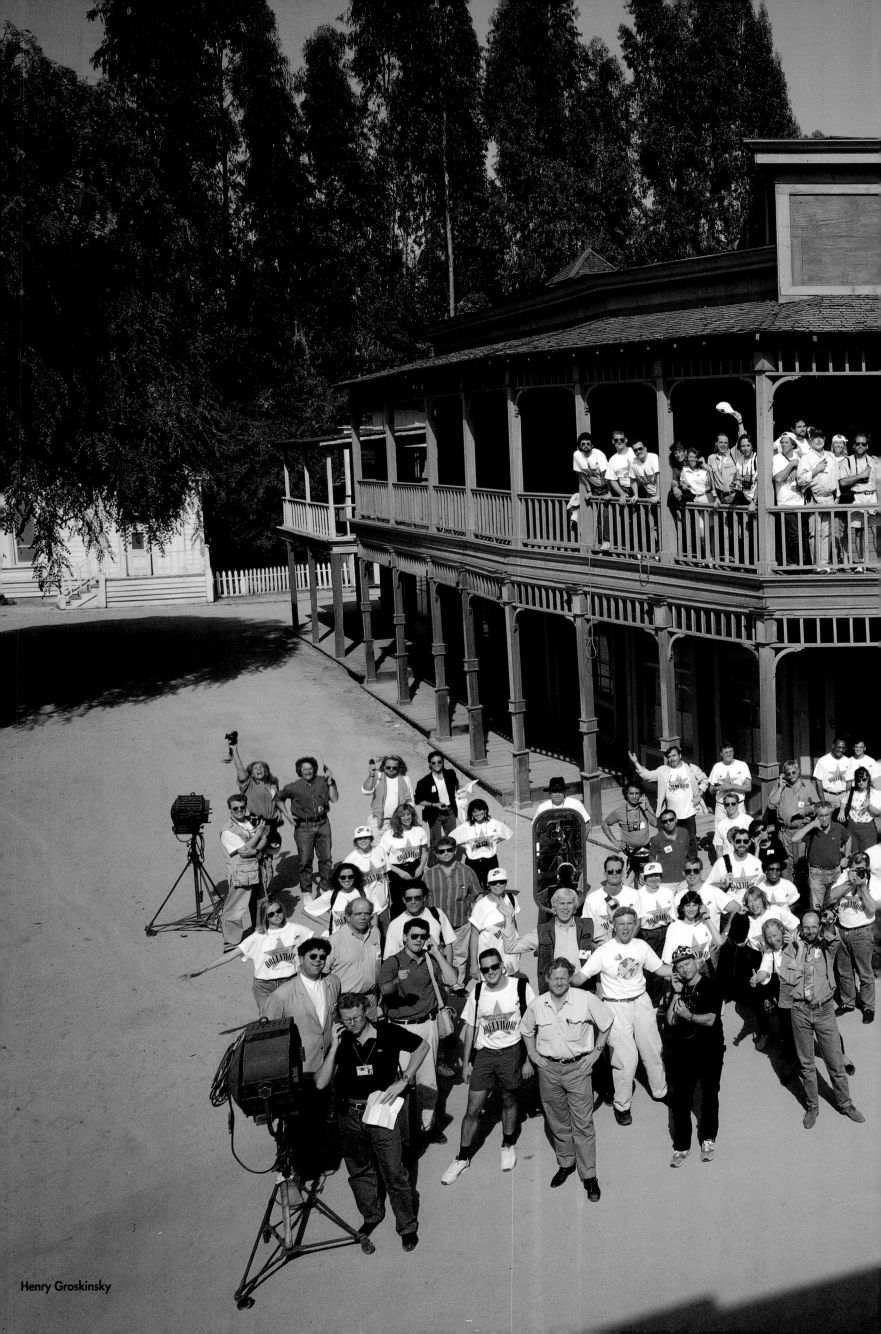

Henry Groskinsky

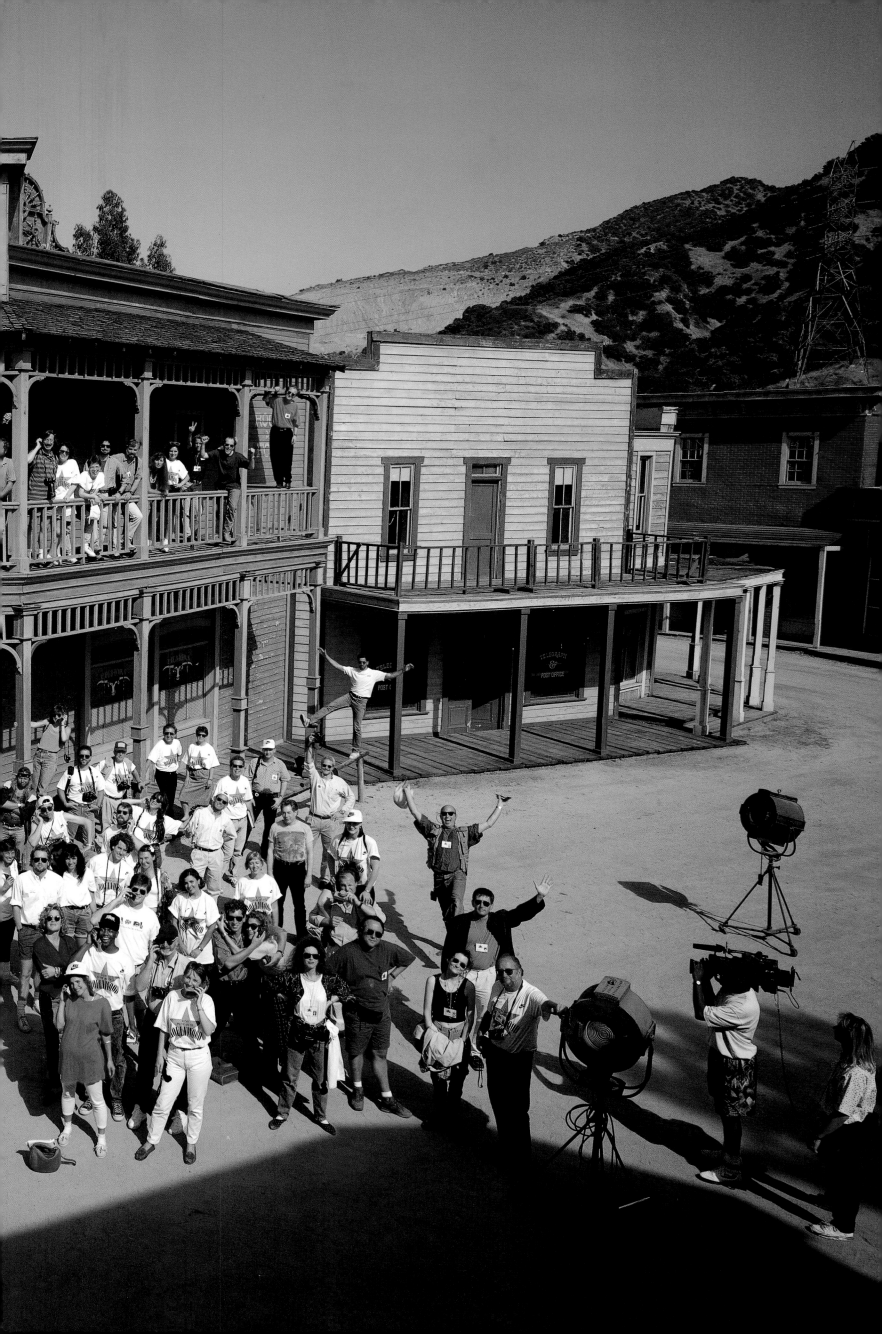

1. Deborah Goldblatt, Janek Boniecki, Bryn Freedman, Claudia Lasky, Linda Ferrer
2. Belma Johnson at the Hollywood office
3. Bill Messing, Beth Rickman, Janek Boniecki, Deborah Goldblatt
4. Mark Matousek, Linda Sunshine, Andrew Hathaway
5. At the Kodak Children's Workshop
6. Alan Everton, Linda Lamb
7. Cathy Quealy, Ellen Georgiou, Monica Baltz with Nike bags

Hollywood is a bright, glittering nightclub at the edge of town. It's the place you go when you want to dress up and lose yourself. It's a dream factory. It doesn't really exist. It's gossamer. When the day is done and people get in their cars and go home, there's nothing left behind. It's all empty and completely silent. And nothing actually happened except what you see on film.
—D. Gorton

I started my day with Steve Crisman, his wife, Mariel Hemingway, and their two cute-as-a-button kids. You think of celebrities with nannies and housemaids but here's a mother who has a terrific rapport with her kids.
—Neil Leifer

Photographing blind children was totally fascinating for me as a visual person. They had this three-dimensional globe which they could feel with their hands, saying, "This is the Pacific Ocean, the Himalayas, the Rocky Mountains, Mexico, America." They know the world through touching it. And then this little blind girl said, "I want to touch your camera. What's a camera?" So I explained how the camera worked and where to touch the button. She would push down the automatic focus but not the shutter because she was afraid of the noise. It was very difficult to explain "focus" to her.
—Jean-Pierre Laffont

On May 20th, 1992, photographer Jeffery Werner was assigned to shoot several stunts, including a car crash, a motorcycle accident, a man on fire, a woman on horseback, second unit stunt photography on the set of *Dark Justice,* the firestorming of a building in south central Los Angeles for an Acura commercial, and an air-ram jump. The air ram is a device that propels humans skyward, and Werner wanted a photo of the stunt man sailing overhead like Superman. "I had him do it a dozen times," says Werner, "and he was good. I usually use a remote shutter release when I'm in harm's way, but I was stressed for time and it seemed like more fun if I sat in front of the air ram, about six or eight feet away. He said, 'No problem, I'll go right over you.' Gets on this thing. Instead of going up, he goes out. He came right at me. I didn't realize it until he hit me. It was real quick. The camera went right into my head and into my glasses. I fell back. I tried to get up but the safety guys held me down. I felt warm liquid all over. I guess it was a lot of blood." Instead of going to the emergency room, though, Werner continued on to his next assignment. "I didn't feel dizzy and I was just catching my eighth wind of the day," he said.

Werner's reaction was typical of the way *A Day in the Life of Hollywood* operated from the very beginning. The staff arrived in Los Angeles to begin work in February and immediately got hit with the worst flooding Angelenos had seen in years. The city had barely dried off when it was rattled by a major earthquake and its aftershocks. Still, things quieted down long enough for the staff to settle into its offices at Raleigh Studios. A month later, the riots hit. With the city in flames, a curfew was imposed on May 1. "We stayed at Raleigh until about 3:00 on Friday, listening to the reports on the radio and watching the columns of smoke rising nearby. Once we started hearing the TV helicopters out the window, we knew it was time to go," said managing editor Bill Messing. With that, the Collins crew retreated to their quarters at the Hollywood Roosevelt Hotel. Like the rest of the world, they held their breath and waited.

By Monday, the worst of the disturbances had subsided, and the staff tentatively returned to the office. Though the deadline for assignments was less than three weeks away, confirming appointments remained nearly impossible in an industry where "I'll get back to you" is probably the most common response to every inquiry.

"This is a town known for its mirages, and things change quickly here," commented assignment editor Janek Boniecki. "On *A Day in the Life of Ireland,* for example, if you assigned someone to shoot a butcher shop or a school, you pretty much knew the place would be there at a certain day and time. Here we never knew what to expect."

The day before the shoot, the project got an enormous boost of publicity from articles in *Daily Variety,* the *Hollywood Reporter* and the *Los Angeles Times.* The calls flooded in. "Word was out that this was real, and the publicity took hold," explained Boniecki. "As we opened the office door on Tuesday morning, everything we could have wanted was waiting. That's Hollywood—it always operates at the eleventh hour."

On May 20th, the assignments were in place and the weather held. "L.A. looked sparkling. Every shot I did was sparkling," said Jon Ortner. "My assistant, who lives here, said, 'This is an unbelieveable day, this weather.'"

Out on assignment, photographers had varying experiences. Henry Groskinsky was scheduled to photograph the entire staff of Creative Artists Agency in the lobby of their building at 4:00. "At two minutes to four, they all just appeared," said Groskinsky. "I'm up on this big ladder with a big tripod and I'm shooting with big flashbulbs. I shot six pic-

8. Maria Hjelm, Carole
 Bidnick, Jenny Barry,
 Jennifer Ward
9. Lara Morris at the
 Collins office
10. Michael Dare being
 interviewed
11. At the group portrait
12. Picture editors at work
13. The pool at the Holly-
 wood Roosevelt Hotel
14. Patti Richards,
 Curt Sanburn
15. Lena Tabori,
 Linda Ferrer
16. Cecile Chronister

...ures and said, 'That's it!' and they all applauded. They all stood there and applauded, which to me was great fun."

Douglas Kirkland, who photographed Joe Roth, chairman of Twentieth Century Fox, had expected Roth to be "an older, Louis B. Mayer type—manicured, suit and tie. I was surprised to find a fortyish guy in an open white shirt who looked like he hadn't shaved for a day or two. It's hard to believe he's the head of this company."

Other assignments fulfilled the Hollywood fantasy. Theo Westenberger, who shot a limousine service for pets, said, "You can't take this kind of picture in most other places in the world. I think it reflects that you can get away with anything in Hollywood."

Michael O'Neill described his day as "total fantasy." After shooting Hugh Hefner's portrait, O'Neill visited the home of Adriana Caselotti, the woman who sang the original part of Snow White in the 1930s Disney movie. "There was a wishing well outside her house," said O'Neill. "I went to the door and it rang: 'I'm Wishing ...' I just stood there cracking up. From Hugh Hefner's mansion to Snow White's lodge! I just couldn't believe it."

Certainly, there were problems. Dilip Mehta was pickpocketed of all his cash, credit cards, and passport. (Fortunately, his wallet was returned, without his cash, of course.) Nicole Bengiveno lost her portable phone. And model releases were a headache for everyone. Joyce Ravid spent the morning shooting superstar manager Sandy Gallin; as he drove away from the session, she suddenly remembered she'd never gotten Gallin's signature on a release form. After a series of frantic phone calls, the release was faxed to Gallin on his plane, signed, and faxed back to Ravid. "You had to get a model release for everything," complained photographer Ken Duncan. "At one stage, we were thinking of getting the pawprints of the dogs we were shooting."

But, for all the uniquely L.A. headaches, there was a connection to the other books in the series. Nicole Bengiveno brought the voice of experience to Hollywood. "I've done 11 of these *Day in the Life* projects," she said, "and you always go out thinking everything is important, each moment for moment, images in between images. And usually the picture you least expect gets in the book."

Certainly, expectations were challenged upon returning to San Francisco with over 100,000 slides, prints and negatives. On occasion, photographs of big-name stars were sacrificed (though not without a struggle) in order to eliminate all but the very best images. The talented picture editors worked in perfect harmony until it came to choosing between two Dana Fineman photographs of casting agent Sheila Manning puckering up to a pet Vietnamese pig. The editors quickly divided into two groups: those who wanted the photo where the pig's tongue was visible, and those who wanted the shot without it. The debate continued for hours until the group reluctantly agreed to disagree, although the issue was never entirely forgotten.

Despite its inauspicious start amid natural and unnatural disasters, the book was finally completed in early August. Neither earthquakes, floods, rioting, the Cannes Film Festival, smog, accidents, disputes, nor differences of opinion succeeded in delaying its completion. In the end, one hopes, the book is richer for having survived its many traumas. Perhaps Dana Fineman spoke for the majority when, relieved to come to the end of her shoot day, she said, "Hollywood is a surreal, unreal place. It seemed like I was in a movie." —*Linda Sunshine*

I find that Hollywood has a broader range of voltage than almost anywhere else I've been. There are people here with the highest voltage in America and, boy, are there some low-voltage types out in the streets. Basically, I'm used to photographing wilderness, and Hollywood is just another, different kind of wilderness.
—*Galen Rowell*

When I was photographing Ron Silver it reminded me of photographing a jazz musician. I had to improvise on his theme.
—*William Claxton*

You can find every American dynamic in Hollywood. Every extreme. I get the sense this place is a haven for exhibitionists.
—*David C. Turnley*

My first shoot was of a medium, so we went to a cemetery near his home. I had visions of shooting him under a big sheltering angel, but there were only little ones there. As we continued to look, I saw this beautiful old lady dressed all in black, like an ancient Spanish gypsy. She was carrying a bunch of wilted, dying flowers and a tattered record album of her dead husband. He had been a singing star in the twenties; he was very handsome and, oh, how she loved him! So I photographed her in the cemetery and felt she was sent to me. She was a gift.
—*Jill Freedman*

Photographers' Biographies

Max Aguilera-Hellweg
Mexican-American/ New York

The son of an aerial photographer, Aguilera-Hellweg acquired an interest in photography at an early age. Since then, a special interest in environmental portraits and dark psychological subjects has led him on assignments from girl gangs in Los Angeles to schizophrenic twins. His photographs appear regularly in *Fortune, GEO, Esquire, Entertainment Weekly,* and *GQ,* among other publications. In 1981 he received an American Film Institute Independent Filmmaker Grant to make a short film called *A Perfect Couple.* He is currently writing a novel and working on a photographic book about surgery.
Pgs. 176, 178, 198

Nubar Alexanian
American/Boston

Alexanian is a documentary photographer whose work has been widely published in the *New York Times Magazine, Life, Fortune, GEO,* the London *Sunday Times,* and others. His first book, *Stones in the Road: Photographs of Peru,* was recently published in the U.S. He has received numerous awards, including a Fulbright Fellowship in 1983 for work in Peru.
Pg. 190

Nubar Alexanian

Andrew J. Hathaway

José Azel
Cuban-American/ Portland, Maine

After completing a Master's degree in journalism at the University of Missouri, Azel was hired as staff photographer for the *Miami Herald.* He specializes in broad geographic reportage, an interest that has led him from Alaskan glaciers to the jungles of Borneo. His spectacular coverage of the 1984 and 1988 summer Olympics earned him the World Press Photo Foundation Amsterdam Olympic Award and the Marion Scubin Sports Award. A member of Contact Press Images since 1983, he continues to travel widely, shooting regularly for *National Geographic, Smithsonian, Time,* the London *Sunday Times* and *GEO.*
Pgs. 121, 200, 206

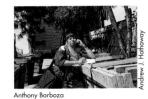
Anthony Barboza

Andrew J. Hathaway

Anthony Barboza
American/New York

An editorial and corporate photographer whose work has appeared in the *New York Times Magazine, Life, Time, Newsweek, National Geographic, Elle, Vogue, Esquire,* and *GQ,* Barboza has also worked on advertising campaigns for major corporations including Coca-Cola, Sony, General Motors, and Columbia Records. His work hangs in the permanent collection of New York's Museum of Modern Art and appears in the book *Black Borders.* He is currently working on a book about musicians in New York City jazz clubs. Pgs. 40, 127

Nicole Bengiveno
American/Brooklyn, New York

Bengiveno joined the *New York Daily News* in 1986 after eight years with the *San Francisco Examiner.* She was named Bay Area Press Photographer of the Year in 1979. In 1985 she was a finalist for the W. Eugene Smith Award for her work on the AIDS epidemic, and in 1987 and 1989 she won first-place honors in feature photography from the New York Associated Press for her work from the Soviet Union. Recently she has been on a four-month assignment in Albania for the National Geographic Society. This is her eleventh *Day in the Life* project.

P.F. Bentley
American/Stinson Beach, California

Bentley is a *Time* magazine photographer whose numerous assignments have included election coverage in both El Salvador and Panama. His awards include first-place honors in the National Press Photographers Association Pictures of the Year competition in 1984 and 1988 for his coverage of the U.S. presidential campaigns. Most recently he followed the 1992 presidential campaign trail with Bill Clinton for *Time.* Hollywood is his eighth *Day in the Life* book.
Pg. 91

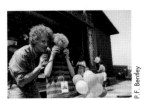
David Burnett

P.F. Bentley

David Burnett
American/Washington, D.C.

A founding member of Contact Press Images, Burnett has covered such diverse subjects as the Iranian revolution, political developments in the Philippines, Korea, Portugal, and Yugoslavia, Sadat's Egypt, and Cambodian refugees in Thailand. In 1980 he was named Photographer of the Year by the National Press Photographers Association, in 1985 he won the Olivier Rebbot Award from the Overseas Press Club, and in 1986 he was honored with the American Society of Magazine Photographers' Philippe Halsman Award for his contribution to photojournalism over the last decade.
Pgs. 40, 63, 147

David Butow
American/Los Angeles

A graduate of the University of Texas, Butow is a freelance photojournalist whose pictures have appeared in *U.S. News & World Report, Life, Time, Stern,* the *Los Angeles Times,* and the *Los Angeles Daily News,* among others. He is a member of the Black Star photo agency. Pgs. 52, 57, 62, 63, 153, 188

Chris Callis
American/New York

After studying photography at the Art Center College of Design in Pasadena, Callis opened his New York studio in 1974. An editorial, corporate, and advertising photographer with a special interest in technique, he is known for incorporating an original sense of movement and light in all his work. His photographs have appeared in *Vogue, Rolling Stone, Esquire, GQ,* and the *New York Times Magazine,* as well as in advertisements for Pepsi and AT&T.
Pgs. 110, 111

Michele Singer, Chris Callis

William Claxton
American/Santa Monica, California

Claxton started shooting jazz musicians while a student at UCLA and later photographed album covers for major record companies. In 1967 he and his wife, model Peggy Moffitt, completed the fashion film *Basic Black,* which won several awards; he then became a member of the Directors Guild of America and went on to direct television shows and commercials. He has worked on assignment for *Life, Time, Harper's Bazaar, Paris Match,* and *Vogue,* among others, and has published numerous books, including *The Rudi Gernreich Book; Jazz;* and *Jazz: A Photo History.* The book *Jazz, Volume* is forthcoming.
Pg. 192, back cover

Murray Close
British/Beverly Hills, California
Originally a saxophone player, Close found himself taking pictures of the bands he was playing with and soon became an entertainment photographer. After covering the punk music scene in London in the late 1970s, he broke into the movie business working with Stanley Kubrick on *The Shining*. Since then, he has worked with many directors as a set photographer and on special projects such as movie stills for *Batman* and *Hook*. Represented by the Sygma photo agency, he is currently working with Madonna on a new music video. Pgs. 96, 165

Guglielmo de' Micheli (left)

Guglielmo de' Micheli
Italian/Florence
De' Micheli began publishing his photography in 1979, at the age of 17. In addition to his work for corporate clients in Europe, his pictures have appeared in *Forbes, Sports Illustrated, Life*, the *New York Times Magazine*, and other publications. He also served as production manager on a Bill Moyers television project on the Renaissance. Pgs. 17, 148, 185

Philip-Lorca diCorcia
American/New York
A fine art photographer, diCorcia was the recipient of several National Endowment for the Arts fellowships and a Guggenheim Fellowship. As a contract photographer for Conde Nast Traveler, he has worked at locations throughout the world. His work appears in the collections of New York's Museum of Modern Art, the Videothèque Nationale in Paris, and the Los Angeles County Museum of Art. Pg. 43

Ken Duncan

Ken Duncan
Australian/Sydney
Specializing in panoramic photography, Duncan has had two books of his photographs published; his latest, *Australia Wide: A Panoramic View* was released in the U.S. by Collins. In addition, he has contributed to the books *China: The Long March* and *Malaysia: Heart of Southeast Asia* and has worked for major international magazines including *National Geographic*. He has won numerous awards, including the Diamond Award for Music Photographer of the Year in 1989 for his work with the Australian band Midnight Oil. Pgs. 20, 69, 70, 133, 134

Elliott Erwitt

Elliott Erwitt
American/New York
Erwitt was born in Paris, grew up in Milan, moved to the United States at age 11, and has been an obsessive traveler ever since. Exhibitions of his work have appeared in museums and galleries throughout the world, including New York's Museum of Modern Art, the Smithsonian Institution, the Chicago Art Institute, and the Kunsthaus Zürich. A large retrospective exhibition of his work took place in Paris, Cologne, and Tokyo in the fall of 1988 to accompany publication of his book *Elliott Erwitt/Personal Exposures*. His latest book, *Elliott Erwitt: To the Dogs*, has just been published. Pg. 180

Jonathan Exley
American/Los Angeles
A freelance entertainment photographer for 18 years, Exley has shot celebrities including Michael Jackson, Crystal Gayle, and Kevin Costner for magazines, posters, tour books, and album covers. His pictures have been published in *People, Shape*, and *GQ*, as well as in European magazines. He has been recognized by Hasselblad and Norman Strobe and recently received awards from the Art Directors Club of Los Angeles and *Art Direction* magazine. Pgs. 90, 152, 153

Dana Fineman

Dana Fineman
American/Los Angeles
A member of the Sygma photo agency, Fineman studied at the Art Center College of Design in Pasadena. Her work appears regularly in *New York, People, Time, Newsweek*, and *Stern*. In May of 1986, following shoot day for *A Day in the Life of America*, she married photographer Gerd Ludwig with 200 of the world's best photojournalists covering the wedding. Pgs. 74, 75, 79, 200, 201, front cover

Jill Freedman
American/Miami
Freedman is a freelance photographer whose work has appeared in numerous publications. She has published five books of her own photos, including *A Time that Was: Irish Moments; Street Cops*; and *Circus Days*. Her photographs are in the permanent collections of New York's Museum of Modern Art, the International Center of Photography, Eastman House, the Smithsonian Institution, the Ringling Museum of Art, the Bibliothèque Nationale, and the Israel Museum, among others. Pgs. 149, 177

Diego Goldberg
Argentine/Buenos Aires
After beginning his photographic career in Latin America as a correspondent for *Camera Press*, Goldberg moved to Paris in 1977 as a Sygma staff photographer. In 1980 he moved to New York, only returning to his native Argentina in 1985. His work has been featured in the world's major magazines, and in 1984 he won a World Press Photo Foundation award. He has participated in all 12 *Day in the Life* projects. Pgs. 59, 64, 86

Stephen Goldblatt
British/Hollywood
Goldblatt started out as a London-based freelance photojournalist covering the rock-'n-roll scene in the 1970s before turning to commercials and feature films. He moved to Hollywood in 1984 and has since worked as a director of photography on movies including *The Cotton Club, For the Boys, Lethal Weapon I and II*, and *Joe Versus the Volcano*. He was nominated for an Academy Award for cinematography on *The Prince of Tides*, and he recently finished filming *Consenting Adults*. He is a member of the American Society of Cinematographers, the British Society of Cinematographers, the Directors Guild of America, and the Academy of Motion Picture Arts and Sciences. Pgs. 26, 124

D. Gorton
American/Jackson, Mississippi
Gorton has served as chief photographer for the *Philadelphia Inquirer* and worked on the staff of the *New York Times* in New York and Washington, D.C., where he covered the White House and Capitol Hill. He was an assignment editor and photographer on *A Day in the Life of America* and *A Day in the Life of the Soviet Union*. His photographs have appeared in *Stern, National Geographic, Smithsonian*, and *People*, as well as on movie posters and album covers. Pg. 140

David Graham
American/Philadelphia
A member of the Black Star photo agency, Graham has published two books, *American Beauty* and *Only in America*; a third, *Road Scholar*, with writer Andrei Codrescu, is forthcoming. His photographs also appear in a variety of magazines including *Details, Esquire, Newsweek*, and the *New York Times Magazine*, and in museum collections including that of New York's Museum of Modern Art. Winner of several grants and awards, Graham was named the 1985 Emerging Photographer of the Year by the American Society of Magazine Photographers and Nikon. He currently teaches photography at the School of the Visual Arts in New York City. Pg. 83

Michael Grecco
American/Santa Monica, California
Grecco is best known for his dramatic celebrity portraiture and environmental lighting. Among his major clients are *Entertainment Weekly, L.A. Style, Premiere, Mirabella* and Fox Television. He recently completed a portfolio of the L.A. blues scene for *Buzz* magazine and was featured in *American Photo* magazine's California Photographers issue. He is affiliated with the Sygma photo agency. Pg. 80

Annie Griffiths Belt
American/Silver Spring, Maryland
Griffiths Belt began assignment work for *National Geographic* in 1978 and has since worked on more than two dozen magazine and book projects. Her work has also appeared in *Smithsonian, Newsweek, GEO, American Photo, Merian*, and *Stern*, and she has exhibited in New York, Washington, Moscow, and Tokyo. She has received awards from the National Press Photographers Association, the Associated Press, the National Organization for Women, and the White House News Photographers Association and is currently working on a documentary entitled *Life Before Birth*. Pg. 47, 68, 88, 131

Henry Groskinsky
American/New York
Groskinsky found himself attracted to large-format cameras at the age of nine and has been using them ever since. He was a staff photographer at *Life* magazine from 1965 to 1972 and continues to shoot feature stories for *Life* and other magazines. He is well known for making group portraits in complicated settings, such as his *Life* shot of 500 clowns and a recent photo of the New York Stock Exchange. This is his first *Day in the Life* project. Pgs. 73, 165, 212

Jill Hartley
American/Paris
Born and raised in Hollywood, Hartley left during her college years to see what the rest of the world looked like. She turned to photography while working for a television station in Chicago and went on to publish pictures in *Rolling Stone, Esquire, Forbes,* and the *New York Times Magazine.* In 1984 she moved to Paris, where she continues to freelance for European and American publications. Recently she completed work on a photographic book about Poland. Pgs. 94, 122, 131

Volker Hinz
German/New York
For the last 17 years Hinz has been a staff photographer for *Stern* magazine. His pictures also appear in many other news and feature magazines including *Vanity Fair, Time, Newsweek, New York, Life, Paris Match,* and *GEO.* Pgs. 78, 87

Jeff Jacobson
American/Los Angeles
Jacobson worked as a lawyer until 1974, when he embarked on a new career as a freelance photographer. Since then, his work has appeared in the *New York Times Magazine, Life, Rolling Stone, Forbes, Fortune,* and *Stern.* He was the recipient of a National Endowment for the Arts Fellowship in 1990 and a New York Foundation for the Arts grant in 1988. His pictures have been featured in several books, and in 1991 he published a book of his own photographs entitled *My Fellow Americans.* Pgs. 50, 93

Steven-Charles Jaffe
American/Los Angeles
Jaffe began his career in the film business in the mail room of the ICM talent agency in Los Angeles. He went on to study film at the University of Southern California and helped to produce several film documentaries before moving on to feature production and special effects. In 1989 he was executive producer of the Academy Award-winning movie *Ghost.* He currently works with writer/director Nicholas Meyer as a producer at Paramount Pictures. This is his first *Day in the Life* project. Pg. 6

Catherine Karnow

Catherine Karnow
American/Washington, D.C.
A 1983 graduate of Brown University with a degree in semiotics, Karnow is known for her vivid portraits and travel photography and has worked in France, Australia, Scotland, and Vietnam. Her short film *Brooklyn Bridge* premiered at the Berlin Film Festival in 1984. Her photographs have been featured in several books, including *Return to the Glen: Adventures on the Scotch Whiskey Trail* and the Insight Guides to France; Provence; Washington, D.C.; and Los Angeles. Represented by Woodfin Camp, Karnow also contributes to *Smithsonian, Audubon, Time* and *GEO.* Pgs. 40, 136, 180, 199

David Hume Kennerly

David Hume Kennerly
American/Los Angeles
Winner of the Pulitzer Prize in 1972 for his feature photography in Vietnam, Kennerly was Gerald Ford's official White House photographer from 1974 to 1977. His autobiography, *Shooter,* recounts the highlights of a career that has taken him to 125 countries. He was awarded the Overseas Press Club's Olivier Rebbot Award in 1986 and is currently a contract photographer for *Time* magazine. Kennerly's motion-picture credits include producing *The Taking of Flight 847: The Uli Dickerson Story,* which was nominated for five Emmy awards in 1988, and directing a 30-minute dramatic film, *Bao Chi,* for the American Film Institute. Pgs. 68, 100, 159, 204

Douglas Kirkland

Douglas Kirkland
Canadian/Los Angeles
Kirkland is one of the world's best-known glamor and personality photographers. His 30 years in the business include camera work with Marilyn Monroe, Judy Garland, Barbra Streisand and Christie Brinkley. He was one of the founding members of Contact Press Images. His richly-illustrated memoir, *Lightyears,* documents his career photographing film stars and celebrities. Pgs. 61, 128, 129, 159, 189

Antonin Kratochvil
American/New York
Born in Czechoslovakia in 1947, Kratochvil has been working in the U.S. as a freelance photographer since 1972. He continues to travel the world on assignment for Time-Life publications, *Fortune, Conde Nast Traveler, Rolling Stone,* and the *New York Times Magazine.* His work has appeared in numerous books, and he was named the 1991 Journalist of the Year by the International Center of Photography. Recently he won a silver medal from the Art Directors Club of New York for a photo essay on polluted lands in eastern Europe. Pgs. 32, 112, 116, 118

Jean-Pierre Laffont

Jean-Pierre Laffont
French/New York
Laffont attended the prestigious School of Graphic Arts in Vevey, Switzerland and later became a founding member of both Gamma and Sygma photo agencies. He is the recipient of awards from the New York Newspaper Guild and the Overseas Press Club of America; he has also received the Madelein Dane Ross Award, the World Press General Picture Award, and the Nikon World Understanding Award. His work appears regularly in the world's leading news magazines.

Robert Landau
American/Los Angeles
A freelance photographer for 16 years, Landau explores in his work the relationship between urban landscapes and pop culture. His photographs have appeared in *Rolling Stone, Forbes, GEO, Time, US,* and *Travel & Leisure,* and he has published three books: *Billboard Art, Outrageous L.A.,* and *Airstream.* He is currently working on a project about graffiti as a social art form. Pg. 137

George Lange
American/Santa Monica, California
A graduate of the Rhode Island School of Design, Lange spent 13 years as a photographer in New York before moving to the West Coast in 1991. His work appears regularly in a wide array of magazines including *Vogue, House & Garden, Vanity Fair, Fortune, Rolling Stone,* and *Sports Illustrated.* He is affiliated with the Outline photo agency. Pgs. 146, 154

Tom Lawlor
Irish/Dublin
With assignments in the Soviet Union, Greenland, Bangladesh, and throughout Europe to his credit, Lawlor is among the most well-traveled and decorated photographers in Ireland. He was named Ireland's Photographer of the Year in 1982 and published the bestselling book *Dublin: One in a Thousand* to mark the city's millennium anniversary; in addition, he served as project co-director on Collins' *A Day in the Life of Ireland.*

Neil Leifer (center)

Neil Leifer
American/New York
Leifer was a staff photographer for *Sports Illustrated* from 1972 to 1978 before joining *Time* magazine, where he covered events ranging from the Liberty Centennial weekend to the Space Shuttle. Over the years, he has traveled the globe covering major sports heroes and events including 13 Olympic Games. His photographs have appeared on over 200 covers of *Sports Illustrated, Time,* and *People* and he has produced six books, including *Sports!* and *Neil Leifer's Sports Stars.* His *Sports* is currently in release from Collins. Pgs. 44, 105, 106, 107, 108

Andy Levin (center)

Andy Levin
American/New York
A participant in 10 *Day in the Life* projects, Levin has published photographs in an array of publications including *Life, Aperture, People,* the *New York Times Magazine,* and *Sports Illustrated.* In 1985 he received top honors in the National Press Photographers Association Pictures of the Year competition for his essay on a Nebraska farm family. In 1986 his essay on the Statue of Liberty won similar honors. Today he works on a freelance basis for clients nationwide.

Barry Lewis, Carole Bidnick

Barry Lewis
British/London
Originally a science teacher, Lewis holds a Master's degree from the Royal College of Art and is a founding member of the Network agency. He shoots regularly for *Life, GEO,* the London *Sunday Times,* and the *Observer* and has photos on display in several U.S. and British museums. He was the 1990 recipient of the World Press Photo Foundation's Oskar Barnack Award for his work in Romania. Pgs. 92, 141

Marcia Lippman

Marcia Lippman
American/New York
A freelance photographer, Lippman also teaches at Parsons School of Design. She balances her time between editorial and advertising assignments, and frequently travels to eastern Europe and Asia. A recipient of a New York Foundation for the Arts fellowship, she is currently completing a two-year photo project at West Point. Pgs. 85, 98, 174

John Loengard
American/New York
A Harvard graduate, Loengard was on the staff of *Life* magazine from 1961 to 1972, during which time *American Photographer* hailed him as "*Life*'s most influential photographer." He was the founding picture editor of *People* magazine and later served as picture editor for *Life* after its rebirth as a monthly in 1978. His book *Pictures Under Discussion* won the Ansel Adams Award for Book Photography from the American Society of Magazine Photographers. Today Loengard writes a column for *American Photo* magazine and teaches at the International Center of Photography in New York City. Pgs. 76, 91

Gerd Ludwig

Gerd Ludwig
German/Los Angeles
A founding member of the Visum photo agency in Hamburg, Ludwig is a regular contributor to *GEO, Life, Stern, Fortune,* and *Zeit Magazin.* He is the veteran of numerous *Day in the Life* projects and an honorary member of the Deutsche Gesellschaft für Fotografie. Pg. 156

Joe McNally
American/New York
McNally started his career in 1976 with the *New York Daily News* and went on to spend two years as a still photographer with ABC-TV. He has been a magazine freelancer since 1981, publishing pictures primarily in *Life, National Geographic,* and *Sports Illustrated.* Affiliated with the Sygma photo agency, McNally won first prize in magazine illustration in the 1988 University of Missouri Picture of the Year awards. Pgs. 58, 68, 87, 145, 163, 208

Dilip Mehta
Canadian/Toronto
An original member of Contact Press Images, Mehta began his career in 1971 as a graphic designer before turning to photography and documentary filmmaking. He has covered such diverse subjects as the Bhopal tragedy and political developments in India, Pakistan, the U.S., and Afghanistan. Mehta's pictorial essays have been published in *Time, Newsweek, GEO, Bunte,* the *New York Times, Paris Match, Figaro,* the London *Sunday Times,* and other major publications around the world. He has won two World Press Photo Gold Awards and the Overseas Press Club Award. Pg. 90

Peter J. Menzel
American/Napa, California
A photojournalist with 22 years of experience, Menzel shoots regularly for magazines in the U.S. and Europe. His pictures have appeared in *Fortune, GEO, Life, National Geographic, Newsweek,* the *New York Times Magazine,* and other publications. The recipient of numerous awards in the annual World Press Photo Picture of the Year competition, including a first-place science award in 1991, Menzel is represented by 12 agencies around the world. Pgs. 158, 160

Claus C. Meyer

Claus C. Meyer
German/Rio de Janeiro
The winner of many prizes and awards, Meyer was selected in 1985 by *Communications World* as one of the top annual-report photographers in the world. His color photography has been recognized by Kodak and Nikon, and in 1981 he won a Nikon International Grand Prize. He has published several books on Brazil. Pgs. 46, 51, 193

Randy Olson
American/Pittsburgh
Olson worked at the *San Jose Mercury News,* West Virginia's *Charleston Gazette,* the *Milwaukee Journal,* and the *West Palm Beach Post* before joining the staff of the *Pittsburgh Press.* He received the Robert F. Kennedy Award for social documentary in 1991, and he freelances for *National Geographic, Fortune,* and *Time.* While teaching photojournalism at the University of Missouri, he received a National Archives grant for work with the Pictures of the Year archives. Pgs. 47, 56, 89, 147

Antonin Kratochvil, Timothy White, Michael O'Neill

Michael O'Neill
American/New York
Since the early 1970s, O'Neill has operated his own studio specializing in print and television advertising. He specializes in large-format portraiture, platinum printing, and editorial assignments in the areas of fashion and beauty. His photographs have appeared in *Interview, Mirabella, Newsweek, Life,* and *Conde Nast Traveler,* and in 1991 he was director of photography on David Byrne's music video for *Red, Hot and Blue.* Pgs. 28, 43, 131, 151

Jon Ortner
American/New York
Although he travels worldwide, Ortner finds New York City the most visually striking location anywhere. Specializing in scenic and architectural photography, he counts I.B.M., Marriott Hotels, American Express, and Lever Brothers among his corporate clients. His editorial work has appeared in *GEO, Popular Photography, Modern Photography,* and *Travel & Leisure,* and his images have been exhibited at the Kodak Gallery, the Nikon Gallery, and the Museum of the City of New York. Pgs. 18, 137, 194, 196, 224

Graeme Outerbridge, Ken Duncan

Graeme Outerbridge
Bermudian/Southampton
Named Young Person of the Year in Bermuda in 1985, Outerbridge is active in both politics and photography. When not working as chairman of the National Liberal Party, he is usually on assignment for clients including *Vogue, House & Garden,* and *Signature.* He has published two books, *Bermuda Abstracts* and *Bridges.* Pgs. 48, 149

Larry C. Price
American/Fort Worth, Texas
A native Texan, Price began his photographic career at the *El Paso Times.* Later he worked for the *Fort Worth Star-Telegram,* where he won a Pulitzer Prize for his coverage of the 1980 Liberian coup. His photographs from El Salvador and Angola for the *Philadelphia Inquirer* won him a second Pulitzer in 1985. His work has been honored by the Overseas Press Club, the National Press Photographers Association, the Associated Press, and the World Press competition. Pgs. 48, 149

Joyce Ravid, Theo Westenberger

Joyce Ravid
American/New York
A native New Yorker, Ravid has been taking pictures since childhood. Her work has been published in *Fortune, Rolling Stone, US, GQ,* and *Conde Nast Traveler,* among others. In addition, her photographs have been exhibited in shows in the U.S. and Europe and have appeared in various books; her own book of photographs, *Here and There,* will be published in January 1993. Pg. 39

Ken Regan
American/New York
After studying journalism at Columbia University, Regan worked as a picture editor before pursuing a career behind the camera. Since then, he has covered events ranging from the Olympics and presidential campaigns to riots and rock-'n-roll tours for *Sports Illustrated, Life, Time,* and *People.* He has shot more than 200 magazine covers and has received awards from the World Press Photo Foundation, the New York Newspaper Guild, and the University of Missouri School of Journalism. Regan is the founding owner of the Camera 5 photo agency. Pgs. 55, 125, 164

Alon Reininger
American/Los Angeles
Following a stint as a commercial photographer and assistant cameraman in Israel, Reininger turned to photojournalism in 1973 during the October War between Egypt and Israel, which he covered for UPI. Since then he has traveled extensively, documenting political and social change throughout the world. His work has appeared in *Time, Life,* the *New York Times Magazine,* and the London *Sunday Times,* and his coverage of the AIDS crisis has earned him awards from the National Press Photographers Association, the World Press Photo Foundation, and the American Society of Magazine Photographers.

Mark Richards
American/Mill Valley, California
A staff photographer for the *Orange County Register* from 1984 to 1987, Richards is now a freelance photojournalist specializing in human-interest stories. During his career, he has photographed subjects ranging from street gangs in south-central L.A. to computer geniuses to wars throughout the world. His work has appeared in *Time, Life, Business Week, Fortune, Stern,* and several books, including Collins' *Christmas in America.* He is represented by the Dot agency. Pgs. 10, 81

Merlyn J. Rosenberg
American/Los Angeles
Rosenberg is a freelance entertainment photographer whose work has appeared in *Interview, L.A. Style, Entertainment Weekly, US,* and *Time,* as well as on numerous album covers. She also teaches portraiture at the Art Center College of Design in Pasadena, California. Pg. 59

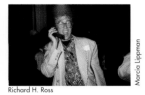

Richard H. Ross

Richard H. Ross
American/Santa Barbara, California
A professor of art at the University of California at Santa Barbara, Ross has exhibited his photographs at museums and galleries throughout the world. In addition, his pictures have appeared in *American Photo*, *Esquire*, *Interview*, *Life*, and the *New York Times Magazine*. Pg. 103

Galen & Barbara Rowell

Galen Rowell
American/Albany, California
Rowell sold his auto repair shop in 1972 to devote himself to mountaineering and photography. He won the first of many *National Geographic* assignments a year later and has since published 10 books, including *Mountains of the Middle Kingdom*, *Mountain Light*, Collins' *The Art of Adventure*, and an extraordinary collaboration with the Dalai Lama entitled *My Tibet*. He has participated in more than 1,000 climbs, including 23 trips to the Himalaya, and was the recipient of the Ansel Adams Award from the American Society of Magazine Photographers in 1984 for his contribution to the art of wilderness photography. Pgs. 14, 30, 114

Roger Sandler
American/Los Angeles
A freelance photographer for 20 years, Sandler specializes in behind-the-scenes coverage of sports, entertainment and politics. He has captured candid moments with the Los Angeles Dodgers, the Rolling Stones on tour, and presidential candidates. His pictures are published in an array of magazines including *Time*, *Newsweek*, *Vanity Fair*, *Fortune*, and *Forbes*, as well as on book covers and record album covers. He is a member of the Picture Group photo agency. Pg. 142

Bonnie Schiffman
American/Los Angeles
For the last 15 years, Schiffman has worked as a portrait photographer in the entertainment industry. Her work has appeared in *Rolling Stone*, *Vanity Fair*, the *New York Times Magazine*, and *Esquire*, as well as in movie posters. Recently, her photos were published in *The Rolling Stone Book of Comedy*. Pg. 12

Michele Singer
American/Hollywood
Singer is an editorial and entertainment photographer whose work has appeared in magazines including *Fortune*, *Time*, and the *New York Times Magazine*. Her photographs have also been featured in movie posters and in annual reports. She is married to film director Rob Reiner; Hollywood is her first *Day in the Life* project. Pgs. 63, 162, 167, 177

Rick Smolan

Rick Smolan
American/Mill Valley, California
Creator of the *Day in the Life* series, Smolan was a founding member of Contact Press Images and one of *Time* magazine's chief photographers in Asia and Australia. In 1985 he was selected as a member of *Esquire* magazine's Register of influential men and women under 40, and in 1990 he co-directed a book project on health care around the world entitled *The Power to Heal*. Pgs. 62, 186

Peter Sorel
American/Los Angeles
Sorel wanted to be a photographer from the age of 13, when his father bought him a camera. Born and raised in Hungary, he has worked as a freelance entertainment and set photographer in Hollywood for the last 29 years. His photographs have appeared in *Time*, *Life*, *Newsweek*, *Premiere*, and *Look* magazines, as well as in ads for movies from *The Rose* to *Dead Again*. In his free time, he pursues personal interests in architectural photography and photojournalism. Pgs. 25, 71, 125

Scott Thode
American/New York
Though he had planned to become an actor, Thode turned to a career in photography after working part-time as a photo assistant at *U.S. News & World Report* in 1981. Since then, he has devoted much of his personal time and resources to documenting the AIDS crisis, which has resulted in several major photo essays. His pictures have been featured in *Life*, *Newsweek*, *The Independent*, *Il Venerdi*, and other American and European publications. Pgs. 2, 8, 170, 171, 202

David C. Turnley
American/Paris
Turnley is a staff photographer for the *Detroit Free Press* and is affiliated with the Black Star photo agency. He won the 1990 Pulitzer Prize and the 1989 Overseas Press Club Robert Capa Gold Medal for his images of political and social turmoil in the socialist countries; in 1988, he won Picture of the Year from the World Press Photo Foundation for a photograph of a father grieving in the aftermath of the Armenian earthquake. His most recent book is *Moments of Revolution*, a photographic account of the events in Eastern Europe in 1989, created jointly with his twin brother Peter. Pgs. 36, 138

Peter Turnley
American/Paris
Peter Turnley is a contract photographer for *Newsweek*, and his work is distributed worldwide by the Black Star photo agency. He has received numerous awards, including the Overseas Press Club's Olivier Rebbot Award in 1989 and awards from the World Press Photo Foundation. He has photographed more Soviet leaders than any other Western photographer. In 1989 he traveled to China, East Germany, Czechoslovakia, Romania, Hungary, Poland, and the Soviet Union, producing seven cover photographs for *Newsweek*. His work has been published in two books co-authored with his twin brother David, *Beijing Spring* and *Moments of Revolution*. Pgs. 4, 68, 189

Jeffery R. Werner

Jeffery R. Werner
American/Los Angeles
Werner has traveled the globe covering subjects ranging from the World Champion Dog Sled Races in Alaska to a Vietnamese refugee camp. Since 1981, he has specialized in photographing television and movie stunts, pictures that have been featured on TV shows such as *That's Incredible!*, *The World's Greatest Stunts*, and *Stuntmasters*. His work has also been published in *Time*, *Newsweek*, *People*, *Life*, *Outside*, and the *New York Times Magazine*. In 1989 Werner started his own agency, Incredible Features. Pgs. 120, 184

Theo Westenberger
American/New York
Westenberger has won numerous prizes and awards, including a 1982 World Press Photo Foundation award. Her pictures have appeared in *Life*, *Time*, *Newsweek*, *Sports Illustrated*, and *People*, as well as in exhibitions at Nikon House, New York's Metropolitan Museum, the Smithsonian Institution, and the International Center of Photography. She specializes in celebrity portraiture, examples of which are featured in the book *Shooting Stars*. Pgs. 78, 131, 148, 150

Mark S. Wexler
American/Los Angeles
Wexler's interest in photojournalism was sparked in college while using a camera as a research tool in cultural-anthropology studies. Since then he has traveled the world as a photographer for editorial and corporate clients including *Time*, *Life*, *National Geographic*, *Smithsonian*, and *GEO*. He won three World Press Photo Foundation awards for his work on *A Day in the Life of Japan*. Recently he completed work on a photographic guide to Los Angeles. Pgs. 181, 182, 193

Timothy White
American/New York
Though he has a studio in New York, White spends most of his time in Los Angeles shooting celebrities in the entertainment industry. His work has appeared in *Rolling Stone*, *Time* and other publications and his pictures of movie stars are featured in the book *Shooting Stars*. Hollywood is his first *Day in the Life* project. Pgs. 1, 119, 161, 210

Brian R. Wolff
American/Washington, D.C.
During the last 17 years, Wolff has published his photographs in magazines including *Time*, *Smithsonian*, the *Los Angeles Times*, and *Paris Match*. He is currently nearing completion of a two-year book project documenting the U.S. Navy's activities around the world. This is his first *Day in the Life* project.

Contributing Photographers

Don Cochran
American/Rochester, New York
A graduate of the Rochester Institute of Technology, Cochran has been a staff photographer for the Eastman Kodak Company since 1981. Currently he is photo/project manager for Kodak's Kodarama in Times Square in New York as well as for the company's Colorama programs. His work has been displayed in New York, Denver, Puerto Rico, and other locations internationally.

Mark Harris
American/Los Angeles
Pg. 179

Lara Jo Regan
American/Los Angeles
Pgs. 130, 132

D Stevens
American/Santa Monica, California
Pg. 132

Véronique Vial
French/Los Angeles
Pgs. 41, 102

Wendy Werris
American/Los Angeles
Pg. 185

Writers' Biographies

Charles Champlin
American/Los Angeles
Champlin was arts editor and columnist for the *Los Angeles Times* from 1965-1991 and continues to contribute articles. He hosts "Champlin on Film" on Bravo Cable nationally and is the author of *The Movies Grow Up 1940-80* and other books. He is an honorary lifetime member of the Directors Guild of America.

Andy Marx
American/Los Angeles
Marx has covered the entertainment industry for publications including the *Los Angeles Times, Premiere, Entertainment Weekly, Movieline,* and *US.* He was senior editor of *Hollywood* magazine and has appeared on the E! channel, American Movie Classics, and the Movie Channel.

Mark Matousek
American/New York
Matousek was a 1991 finalist for the National Magazine Award. Formerly senior editor of *Interview* magazine, he has written extensively on art, psychology, and spirituality. A contributing editor to *Common Boundary* and columnist for *Details,* he is working on a book about spiritual evolution.

Linda Sunshine
American/New York
Sunshine is the author of 13 books, including the bestselling *Plain Jane Works Out* and *How Not to Turn into Your Mother.* Her most recent book, *Lovers,* was about great screen couples. She is currently writing a collection of essays and *The Illustrated Woody Allen Reader.*

Board of Advisors

Woolsey Ackerman, Turner Entertainment Company
Daniel Adler, Creative Artists Agency
Peter Bart, *Variety*
Charles Champlin
Rob Friedman, Warner Bros.
Sidney Ganis, Sony Pictures Entertainment
Howard Green, Buena Vista Pictures
Lyle Gregory, KABC Radio
Nanci Griffin, *Premiere*
Susan Grode, Hall, Dickler, Lawler, Kent & Friedman
Peter Guber, Sony Pictures Entertainment
Howard W. Koch, Aries Films, Inc.
Leo Lerman, Conde Nast Publications, Inc.
Kathy O'Hearn, ABC News
Dennis Petroskey, Fox Inc.
Stephen Rivers, Creative Artists Agency
Carl Samrock, Warner Communications
Amy Schiffman, William Morris Agency
Ron Shapiro, MCA Records
Paula Silver, Paula Silver Unlimited
Sally Van Slyke, Universal Pictures Marketing
J. C. Suarès
David E. Vogel, Walt Disney Pictures
Marc Wanamaker, Bison Archives
Chuck Warn, Directors Guild of America
Joel Wayne, Warner Bros.

Project staff

Project Director
Lena Tabori

Sponsorship Director
Cathy Quealy

Director of Photography
Linda Ferrer

Project Editor
Deborah Goldblatt

Managing Editor
Bill Messing

Senior Consultant
Beth Rickman

Project Publicist
Patti Richards

Assignment Editors
Janek Boniecki
Michael Dare
Bryn Freedman
Belma Johnson
Claudia Lasky
Curt Sanburn

Picture Editors
Elisabeth Biondi, *Stern*
Mary Dunn, *Entertainment Weekly*
Sandra Eisert
Alfonso Gutiérrez Escera, A.G.E. Fotostock
Charlie Holland, *Premiere*
Robert Pledge, Contact Press Images
Daniel Roebuck, Onyx
Jim Roehrig, Outline
Kathy Ryan, *New York Times Magazine*
Michele Stephenson, *Time*

Design Director
Jennifer Barry

Design Consultant
J. C. Suarès

Production Directors
Lynne Noone
Jonathan Mills

Attorneys
Kathy Hersh
Jim Fox
Matthew Martin

Acknowledgments

Many movies are filmed on a tight schedule, but as far as we know no one has ever tried to shoot an entire feature in a single day. And yet that's the kind of effort it took to create *A Day in the Life of Hollywood.* Months of pre-production finally yielded to a single, explosive, million-dollar day, followed by more months of post-production to bring the book into its final shape.

Many hundreds of people contributed to this unlikely venture, giving freely of their time, talent, and enthusiasm in large ways and small. At the earliest stages were our publicity director Patti Richards and managing editor Bill Messing, responsible for locating and interviewing assignment editors; our Sponsorship VP, Cathy Quealy, and photographer Graeme Outerbridge, making appointments with everyone from Peter Guber to Raleigh Studios in search of financial support; and our newly appointed Director of Photography, Linda Ferrer, who landed in San Francisco with the task of creating a list of great editorial, news, fashion, art, and portrait photographers—different from any previous *Day in the Life* projects—under a two-week deadline. Early on, too, came our consultant Beth Donohue (soon to be Beth Rickman), who, among other gifts, brought us to the simply superb project editor Deborah Goldblatt.

Credit for countless assignment ideas and innumerable logistical headaches goes to an exceptional group of assignment editors, each of whom brought a wealth of experience and creativity to the project: Janek Boniecki (from the fabulous *LA 411*), Michael Dare (whose video column runs in *Billboard*), Bryn Freedman (an investigative reporter), Belma Johnson (our expert on the music world), Claudia Lasky (a caterer by profession), and Curt Sanburn (a returnee from previous *Day in the Life* projects). Steady and ever responsive, production coordinator Steve Plutte joined our indomitable office manager Linda Lamb, and project assistant Sean Marshall displayed continual grace.

Monica Baltz and Ellen Georgiou added their energies to Sponsorship, from aiding Cathy in our funding to seeing to it that the Kodak Children's Workshop went off brilliantly for the hundred children involved. David Carriere and Molly Schaeffer joined in juggling the monumental publicity efforts, and Andrew Hathaway and Jona Frank kept track of endless rolls of film while Diane Lind and Rita Laing kept track of the dollars and cents. As the film moved through processing into the hands of the picture editors, our design director, Jennifer Barry, became a major player, incorporating brilliantly the advice of our own consultant and friend, J. C. Suarès, as well as that of Contact's Robert Pledge, not to mention the rest of us. From there it fell to our incomparable and indefatigable Cecile Chronister to implement the design, with assistance from Violeta Díaz, and to Lynne Noone and Jonathan Mills to oversee production of bound books.

Barbara Roether and Lara Morris supplied reams of research to the irrepressible caption writer Linda Sunshine. Andy Marx (yes, he is Groucho's grandson) undertook numerous interviews, Ray Bradbury gave us loving support, and Bill Messing, who had never strayed far from those earliest days, was, to the end, watching and caring for the text with help from Jenny Collins.

Our Sales VP, Carole Bidnick, and her associates Jennifer Ward, Maria Hjelm and Anney Siegel, never wavered for a single second in their support of this crazy adventure. And, finally, Judy Arthur stepped in to handle the publicity at a time when only the fearless tread.

The list, of course, goes on, as will be apparent from the next two pages. To all those mentioned here, to Clayton Carlson, our Group VP, who approved this project well before he had right to believe it would work, to the "godparents" we found in Hollywood, to the photographers, the writers, and the picture editors, all of whom made this project magic, and to the many more who expressed their interest and support in the project, our continuing thanks. —*L.T.*

The one-hour documentary on *A Day in the Life of Hollywood* broadcast on Showtime Networks, Inc. is a co-production of Collins Publishers San Francisco and ZM Productions.

Sponsors and Contributors

Sponsors
Eastman Kodak Company
 Professional Imaging
 Motion Picture &
 Television Imaging
 Consumer Imaging
Hollywood Roosevelt
 Hotel
American Express Travel
 Related Services
 Company, Inc.

Major Contributors
Bedford Hotel,
 San Francisco
Nike
Raleigh Studios
Sunset Marquis Hotel
 & Villas

Contributors
A & I Photo Lab,
 Los Angeles
Boulevard Balloons,
 Sherman Oaks
British Airways, Ltd.
Computer Rental Center,
 Los Angeles
Express Furniture Rental,
 Los Angeles
Image Photo Lab,
 New York
Pallas Photo Labs, Denver
Road & Show Cellular
 Phone Company
Universal Studios
 Hollywood

Associates
ABC
American Society of
 Cinematographers
Amblin Entertainment
Academy of Motion
 Picture Arts & Sciences
Boss Films
Broadcast Music, Inc.
The Casting Company
CBS
Coralei Junior Agency
CNN
Creative Artists Agency
Creative Communications
 Services
Digital Magic
Directors Guild of
 America
E! Entertainment Television
Frederick's of Hollywood
Haskin Press
HBO
Hollywood Reporter
Hollywood Chamber of
 Commerce
Imagine Films
International Alliance of
 Theatrical Stage
 Employees
International Creative
 Management

International
 Photographers Guild,
 Local 659
J.C. Backings
LA 411
The Mayan
Media Source
Megadeth
Morton's
Motown Records
NBC
News Corp.
Omnicomp
Palace Costume
Paramount Pictures
 Corporation
Pinnacle Type
Playboy Enterprises
Pro Camera,
 San Francisco
Screen Actors Guild
Skywalker Sound
Sony Pictures
 Entertainment
Twentieth Century Fox
 Film Corporation
Under Associates
Walt Disney Pictures &
 Television
Warner Bros., Inc.
William Morris Agency
Writers Guild of America
Xylon and the Space
 Rangers
ZM Productions

Friends and Advisors

Rachel Aberly
Robert Able
Donna Abraham
Anne Abrams
Forest Ackerman
Jackie Ackerman
Don Adams
Joerg Agin
Julia Airey
Tim Albro
David Alexander
Rick Allen
Rennie Allinger
Raymond Almario
Sony Alonso
Herb Alpert
Andrea Alsberg
John Altberg
Robert Altman
John Altschuler
Emie Amemiya
Dianna Anderson
Eric Anderson
Harry Anderson
Michael Andreen
Jayne Andrews
Larry Anreder
Beth Anthony
Robert Antibe

Doug Aptel
Army Archerd
Gordon Armstorng
Lewis Arquette
Oscar Arslanian
Jeanne Ashby
Richard Atkins
Dorothy Austin
Jim Bacon
Rebecca Baehler
Joslyn Bain
Prudence Baird
Sarah Baisley
Karen & Eric Bakke
Roger H. Ballou
Steve Banderman
Alix Baptiste
Tony Barbera
Marco Barla
Christine Barnes
Norman G. Barnett
Diana Baron
Patti Baxter
Michelle Bega
Steve Behen
Tyger Beider
Nusrat Beigel
Richard Belasco
Godwin C. Bernard
David Biehn
Chuck Binder
Roger Bishop
Michael Black
Noel Blanc
Larry Blaustein
Tom Blevins
Paul Bloch
David Block
Gail Block
John Bloom
Larry Bloustein
Keith Boas
Mike Bober
Joel Bogardus
Michael Bolton
Amy Bonetti
Marc Boris
Gary Borton
Scott Boses
Howard Bragman
Stephanie Bramson
Howard Brandy
David Brokaw
Michele Brookman
Mel Brooks
Peter Brosnan
Joyce Brouwers
Donald Brown
Glenn Brown
Harold Brown
Jennifer Brown
John Bruno
Joan Bullard
Stephanie Burchfield
Diana Burgerman
Stoney Burke
Greg Burson
Ben Bushmen
Craig Butcher
Mara Buxbaum
Caroline Byers
Terry Caccia
Shaun Caley

Michelle Callahan
David Calloway
Raul Canas
Walter Canton
Clayton Carlson
Diahann Carroll
Tom Carshai
Jolie Chain
Dave Chambers
Sammy Chao
Margaret Chastain
Maryanne Cheyne
Ward Childs
Gary Christensen
Derek Church
Beth Churchill-Fantz
Michael Cipley
Scott Clair
Dennis Clark
Elizabeth Clark
Gene Clark
Joseph Cleary
Louise Coffee
Antonia Coffman
David Cohen
Bob Coleman
Kelly Coleman
Beate Collas
Mike Comstock
Teresa Conboy
Becky Conti
Alesia Cook
Colin Cook
Martha Coolidge
Cathy Cooper
Jack Cooperman
Kathleen Corcoran
Fernando Corrado
Jim Coupe
Warren Cowan
George Craig
Theresa Craig
Candace Croteau
Sarah Crowner
Tom Cruise
Denis Curtain
Bonnie Curtis
David Daniels
Severn Darden
Buster Dare
Paulette Dauber
Paula David
Al Davis
Ed Deal
Jim Deglau
Kristi DeLano
Raymond De Moulin
Marie Devito
Violeta Diaz
Ed Diba
George Dibie
Barry Diller
Lorraine DiMango
Al Di Noble
Bruce Doering
Pia Dominguez
Mike Donahue
Jeff Dowd
Bob Downey
Debi Drake
Ralph Drayton
Relford E. Drayton
Ruth Dresser

Bob Dual
Tony Duquette
Kevin Dwinell
Oscar Dystel
Julia Earp
Richard Edlund
Tanya Edmunds
Lisa Edmundsen
Daphne Edwards
David Ehrenstein
Stephanie Eis
Danny Elfman
Julie Ellis
Curtis English
Joy Ephron
Julius Epstein
Jennifer Erwitt
Michael Escher
Andres Espinoza
Terry Everett
Craig Farnham
Jeanne Farrugia
Judy Feder
Stephanie Ferra
Bernadette Ferrer
Pablo Ferro
Richard Fibbio
Jim Fiedler
Robert Figueroa
Gus Fisher
Paul Flaherty
Leon Fontova
James Fox
Georgiana Francisco
Bob Freeman
Katrina Fried
Natasha Fried
Jeff Friedman
Bill Frischette
Mary F. Fry
Nancye Furgeson
Gabrielle
Signe Gallagher
Crystal Lee Garcia
David Geffen
Hersahl Gilbert
Sheila Gillis
Joan Gilshian
Peter Ginter
Karen Gledhill
Steve Glenn
Cathy Goldberg
Jennifer Goldberg
Eddie Goldblatt
Jeff Goldblum
Pamela Goldblum
Danny Goldman
Mike Gonzalez
Cuba Gooding, Jr.
Barry Gordon
Carl Gottleib
Robert Gould
Johnny Grant
Kathryn Grayson
Richard Green
Trudy Green
Bonnie Greenberg
Robert Greenberg
Ike Greene
Lauren Greenfield

Harry Grosinsky
Garry Gross
Rod Gruendyke
Lynda Guber
Glen Gumpell
Dick Guttman
Guadalupe Guzman
Lisa Hagen
Alyce Hahn
Randa Haines
Brian Hajducek
Maggie Hamilton
Tim Hamilton
Bill Hammond
Larry Hankin
Jim Hannafin
Darryl Hannah
Tracy Hardy
Jeff Harnett
Bob Harrell
John Hart
Rowley Hartley
Laurie Harvey
Verna Harvey
David Hasselhoff
Steve Haugen
Billy Hayes
Mike Hayes
Trish Hayes
Cordis Heard
Kathleen Helppie
Tina Helsell
Luc Hermann
Paul Herrod
Leon Hertz
Melissa Higgins
Don Hilliker
Laura Hinds
Sam Hoffman
Dennis Hofilena
Jonathan Hogan
Daryn Holland
Tate Holland
Amber Holloway
Lee Holloway
Barry Horton
Thomas Horton
Lucille Hoshabjian
Diane Howie
Nancy Hudsen
Roger Hunter
Carol Houston
Stephanie Hurkos
Helen Hyatt
Peter Iannucci
Tino Insana
Carole Isenberg
James Ishihara
Cheryl Boone Isaacs
Vern Iuppa
Allison Jackson
Elizabeth James
Ray Javapour
Claudia Jenny
Christy M. Jewell
John Johns
Diane Johnson
Mark & Lezlie Johnson
Mary Johnson
Stephen Johnson
Tom Johnson
Becky Johnstone
Chuck Jones

Cindy D. Jones
Kevin Jones
Brenda Jordan
Tony Joseph
Gil Kaan
Diane Kamp
Charlotte Kandel
Carole Kanne
Kim Kapin
Roy Karch
Steve Karkus
Michael Karnow
Bill Kartosian
Troy Kashon
Irv Katz
Jeffrey Katzenberg
Frank Kaye
Linda Kazynski
Karen Kearns
Phil Keene III
Susan Kelejian
Ed Kelly
Jack Kelly
Bob Kennedy
Basia Kenton
Greg Kilday
Jack Kindberg
Janette King
Calman King
Pat Kingsley
Françoise Kirkland
Victor Kitpetnee
Michael Klastorin
Richard Kline
Brooke Knapp
Patricia Knop
Howard & Ruth Koch
Michael Kochman
Phyllis Koenig
Stacey Koontz
Melody Korenbrot
Maureen Koski
Richard Kramer
Paul Krassner
Gretchen Kreiger
Jeff Kriendler
David Krinsky
Michael Kunkes
Susan Kunze
Michael Kurcfeld
Jim Kush
Nadia Kuzmenko
Jeanne Lafond
Michele Laird
Stuart & Laurina Lamb
Stuart Lamb, Jr.
Ilda Lambert
Laura Lambert
Mike Lamendola
John Lampl
Jane Lancellotti
Andreas Landshoff
Jeffrey Lane
Jack Langdon
Sherry Lansing
Connie Lardner
Bill LaRue
Rick Laserini
Maureen Lasky
Vanessa Lasky
Billie Jeanne Lebda
Bill Leibowitz

Gary Lemel
Wynona Lemond
Danny Lemos
David Lemos
Gary Leonard
Gloria Leonard
Madelaine Leonard
Darcy Leslie
Phyllis Levine
Christine Levite
Rebecca Lewis
Frank Lieberman
Danny Linden
Heather Lindquist
David Lipman
Ed Lister
Lisa Lodder
Elayne Lodge
James Logan
Peter Lopez
Barbara Loren
Richard Lovrin
Tressa Lucas
David Lust
Lawrence Lust
A.C. Lyles
Jean MacCurdy
Patty Mack
Ed Maeder
Jasmine Madatian
Barry Manilow
Eric Mankin
Jon Manning
Todd Marburg
Sharon Margulies
Mindy Marin
William Markovich
Keith Martell
Bill Martin
Ana Martinez-Haller
Marysa Maslansky
Anthony Masterson
Richard Christian
 Matheson
Harry Mathias
Lynn Matsumoto
Aldo Mauro
Ken Maurray
Virginia Mayo
Ignacio Maza
Richard McAlpin
Denny McCarthy
Peter McCoy
Mary McCusker
Julie McDonald
Michelle McElroy
Jerry McGee
Thomas McGovern
Joseph McLaughlin
Ginger McTighe
Suren Melkonian
David Messing
Morgan Messing
Claus Messner
Galen Metz
Jerry Meunier
Gary Mezzatesta
Katherine Michon
Lisa Migaiolo
Suzanne Migaiolo
Julia Migenes
Donna Miller
Greg Miller
Sidney Miller

Elliot Mintz
Bill Mish
Michael Mitchell
James Mojica
Paul Monette
Benny Montano
Kathleen Moran
William Moritz
Meredith Morris
Cathy Morton
Kathaleen Morton
Pam Morton
Ann Moscicki
Sue Moss
Elizabeth Much
Ralph Mulet
Robert Mundy
Tracy Murray
Bruce Mutz
Tom Myers
Richard Natale
Jean Jacques Naudet
Antoinette M. Nell
Jason Ness
Steve Netburn
Paul Netikosol
Mace Neufeld
Terry Nicastro
Stacy Nick
Steve Nicolaides
Geoffrey Nightingale
Drew Noone
Shannon Margaret Noone
Natalie Norton
Blaise Noto
Jeff Notte
Carol Nyman
Dan O'Connell
C.G. O'Connor
Sean Ogrady
Olafur J. Olafsson
Catherine Olim
John Olivan
Woody Omens
Bruce Oppenheim
Peggy Orr
Dan Oshima
William Otto
Howard Paar
Phil Paladino
Rick Pallack
Rusty Pallas
Anthony Palmieri
Korla Pandit
Gregory Panos
Nick Pappas
Charlotte Parker
Tammy Parkhurst
Jim Patton
Daniel Paul
Jeffrey Paul
Victor Paul
Britton Payne
Leanne Payne
Brittany Pedersen
Francisco Peña
Jose Perez
Josephine Perez
Rosie Perez
Kari Perin
Gabe Perle
Marty Perlmutter

Tricia Peters
Donald Petrie
Clyde Phillips
Chuck Pick
Helene Pierson
Ron Pivik
Armand Plasencia
Pledger
Lara Plutte
Elizabeth Pope
Beata Posniak
Stephanie Powell
Jack Prasertsitt
Carol Preston
Barry Price
Dan Price
Terry Priess
Anthony Radziwill
Gabriel Ramirez
Jodi Rappaport
Edan Rattner
Rachel Rausch
Miki Raver
Mark Ray
James A. Rea
Barry Reardon
Edna Recidoro
Julia Reed
Michelle Reese
Laura Regan
Bob Rehme
Anne Reilly
Barbara Remsen
Rick Riccobono
Sandy Rice
Eliot Rich
Phil Riley
Hal Roach
Jacqueline Roberts
Chris Robichaud
Neal Robin
Ruth Robinson
Stephanie Robinson
Cheryl Rodin
Jose Romo
Andrea Rosario
Carl Rosendahl
George Rosenthal
Susan Roth
Kevin Roznowski
Susan Rubio
Alejandra Ruiz
Alison Rumery
Joe Runde
Kristen Rupert
Nancy Rushlow
Julie Ruthenbeck
Lori Rynn
Kenny Sacha
Andrea Sachs
Sean Sager
Jessica St. John
Ismael Salazar
Lutis Salin
Carlos Salvador
Chen Sam
Karen Samfilippo
Carl Samrock
Monika Sandblad
Bill Sanders
Monica Sands
Carla Sanger
Rene Santoni

Lilla Santullo
Vito Sanzone
Elizabeth E. Savage
Wendy Saxe
Laura Schiff
Steve Schklair
Jan Schmidt
Rich Schmitt
Robert Schrock
Mark Schwaas
Jim Schwab
Sam Schwartz
Nancy Seltzer
Scott Seomin
Jeff Sewell
John Shaffer
Joe Shanis
Kim Sharman
Mel Shavelson
Mike Shaw
Jack Sheldon
Jed Simmons
Tammy Sims
Alex Singer
Mary Sipe
Lorie Sisca
Doree Sitterly
Jill Skinner
Jane Slater
Sylvia Sleight
Dan Slusser
Lois Smith
Peter Smith
Patti Snyder
Andy Spahn
John Spence
Diane Sponsler
Judy Stabile
Debbie Stambaugh
Suzanne Stangel
Lowell Stanley
John Starr
Richard Stein
Bill Stemm
John Stevens
Alicia Stevenson
Larry Stewart
Barry Stich
Robert Stigwood
David Stiles
John Strauss
Tyler W. Stringer
Nicole Stuart
Lew Stude
Charlie Styles
Jeffrey Sudzin
Mora Sullivan
Robbie Sunder
Sara Supes
Ed Sussman
Vic Sutton
Chris Swain
Jules Sylvester
Steven Sylvester
Magdi Szaktilla
Henry Taejoon-Lee
Robert Takata
Joan Takenaka
Fred Talmadge
Mario Tamayo
Tom Tardio
Sylvia Tchakmakjian

Jack Teahan
Karen Teitlebaum
Al Teller
Dennis & Cindy Thomann
Mark Thomashow
Chuck Thurston
Saadia Tiare
Michael Tolkin
Neil Topham
April Traum
Larry Tripi
Phillip Trulove
Fredy Turcios
Nelson Tyler
Beverly Underwood
Lily Unger
Karen Utter
Marilyn Vance
Catherine Vandecasteele
Christy Vaughn
Nick Vilay
Bruce Villanch
Katharine & David Viscott
Constance Von Briesen
Julia Wachbrit
Kevin Wafford
Greg Walker
Brian Walten
Jerry Ward
Stan Washington
Cathy Watson
Jim Watters
Ruth Webb
Sharon Weil
Stanley Weisburg
Chuck Weiss
Al Weitz
Robin Welch
Kirsten Weldon
John Wentworth
Bob West
Denise Wheeler
Dawnelle White
Kimberly White
Susan White
John Whitney Jr.
Jim Wiatt
Ken Wiederhorn
Pepper Williams
Annette Williams-Davis
Keith Williamson
Kelvin Willis
Claire Wilson
Marian Witt
Annet Wolf
Amy Womack
Cincy Woods
Karla Woodward
Steve Worth
Jennifer Wread
Jan Yarborough
Jim Yeager
Alice Yeghiayan
John Zabrucky
Memo Zack
Bobby Zajonc
Rick Zeckendorf
Ken Zelden
Richard Zelden
Jason Zelin
Elizabeth Ziegler
Dennis Zier
Susan & Vilmos Zsigmond
David Zucker
Joe Zucker

Ever glamorous—if somewhat threadbare—the Los
Angeles Theatre endures, still showing first-run features
to an enraptured audience. *Photographer:* **Jon Ortner**